£1-20

COLOUR IN FOCUS

JORGE LEWINSKI
BOB CLARK

Fountain Press,
Argus Books Limited,
Station Road, King's Langley,
Hertfordshire, England.

First Published in England 1976
© Agfa-Gevaert AG
Leverkusen, W. Germany
ISBN 0 85242 439 6

Printed in Great Britain by W. S. Cowell Ltd., Ipswich, Suffolk.

Foreword

The objective of this book on photography is to examine the main features which have made it the most widely used, familiar and yet least understood medium of personal self-expression in the twentieth century. As popular as the motor-car as a means of expanding our horizons and enjoying the pleasures of the world around us, it has become so prolific in output that its intrinsic values have never been fully established. Prior to 1900, when the practice of photography was more exclusive than it is today, attempts were made to establish its identity within the sphere of art. These misguided attempts were received with hostility and indifference by the art world and were overtaken by events as the camera became an instrument of science and popular journalism. Mass production of film and cameras turned photography from an exclusive medium of a dedicated few to a form of popular art, without ambition or pretences.

Photography nevertheless is a serious medium because of its wide appeal and unique power and this book is aimed at those serious photographers, amateur and professional, who wish to analyse the tools and techniques of expression that they have experienced at first hand intuitively and that have, by personal contact, become second nature.

The book is basically divided into three sections. The first deals with a discourse into the implications of the making of images using an extension of our eyes—the camera; the confused relationship between the science and art of photography and the growth of a new medium of personal self-expression trying to establish itself within a cultural context. By examining the background issues, the assumptions often implied but not stated, it is hoped that the reader can bring his own attitude to the medium more clearly into focus and clarify his own motivations.

The central section is concerned more with the aesthetic practicalities than theory. It is a serious attempt to outline the multiplicity of visual opportunities open to the sensitive photographer when he makes a camera exposure. In analysing the many decisions required before taking a picture, we hope to reveal the creative 'tools of the trade', how a photograph is fashioned from the visual experience of life; how intuitive response is based on objective decisions and how each individual can express something of his own attitude and personality through a mechanical record of what he perceives.

The third section is devoted to giving a practical guide to the process of recording colour and concentrates on both principles and practice. The detailed descriptions of materials and methods, processes and procedures have been applied specifically to those supplied and manufactured by Agfa-Gevaert Ltd. The processes of reversal and negative film are fully explained. At the same time as giving essential practical advice, reference is made to the reasons for the implications of any decisions that have been made in the broader context of the earlier sections of the book.

The book has been written by two authors as a complementary dialogue between the objective and subjective poles inherent within the photographic medium. It expresses both fact and opinion from two points of view arrived at by reasoned analysis and intuitive belief and based on personal experience and conviction.

J. L. Lewinski
B. Clark

Contents

The Photographic Medium

I The Nature of Photography

II An Analysis of the Photographic Medium

III Photography and Art

IV Colour and Black and White Photography

"The democratization of the image was one of the universal triumphs of the machine . . . by perfecting a mechanical method of 'taking of pictures' by the mere registration of sensation, it was democratized. Anyone could use a camera. Anyone could develop a picture . . . What had been in the seventeenth century a slow handicraft process requiring well trained eyes and extremely skilled hands, with all the rewards that accompany such highly organized bodily activities, now became an all-but-automatic gesture."

L. Mumford, *Art and Technics*

I The Nature of Photography

Photography is concerned with observation and seeing. The camera is an extension of the eye and responds in part to the processes of visual perception, it reflects the real world. But photography is also concerned with recording our impressions of the world as we see it, our responses, a tangible statement of our feelings, in the form of an image which is created by combining a mechanical record with our human perceptual processes. Light and the camera act as a mediator between the external physical world and the inner world of our own responses. They mediate between common public experiences and the personal orbit of our own private feelings. The balance between light and dark, sun and shadow, is the essence of the photographic process. The tangible world of objects is converted, through the medium of light, into an illusive image, substance into shadow. The object becomes an inverted image, linked directly through the lens by the linearity of the rays of light that transform the object into an image. This existential bond, as direct as the distance between two points, is forged at the speed of light; it is the source of the medium's magical power.

Photography joins together the inner and outer worlds, with all the illusion of art and the objectivity of science. Through the aperture of the lens a marriage is contracted between the actual and the virtual, there is a union between nature and culture, reality and the imagination. The dual existence of object and image in the camera is also linked with the objectivity and subjectivity of the human response, and this essential inter-action becomes the central concern in any discussion of the nature of photography. For as Henri Cartier-Bresson wrote, "A balance must be established between these worlds – the one inside us and the one outside us. As the result of a constant reciprocal process both these worlds come to form a single one." To be a creative photographer one needs the cool detachment of the scientific mind and the emotional involvement of the artistic temperament, balancing intelligence with feeling. One needs to be both observer and interpreter, simultaneously seeing and revealing. The camera becomes the instrument of seeing and recording, but only the photographer, in unison with the object and image, can project a personal vision on to the real event, his "points de vue", as Nicéphore Niépce called his pioneer attempts in 1829.

Whereas the machine, a mechanical eye, can create a latent image, only a human mind can construct a latent idea, the pictorial object of which represents our own subjective feelings. This intimate relationship of object and image gives photography its unique character.

Although it has an affinity to the other graphic arts, it should be evaluated on its own criteria; requiring an aesthetic, not based on 'fine art' but on the nature of the medium and its mode of operation, a feature recognized as early as 1862 when, in *L'Art de la Photographie*, Disdéri wrote "Photography is an art; it uses its own means; it has its own original standard of aesthetic." Photography is not like the other visual arts, standing between art and life, it operates most effectively in the gap between. The argument, indulged in by artists and photographers alike, as to whether photography is a 'fine art', is a total misconception. Whether a visual image is an art object is partly a matter of intent, governed by a system of values arrived at by common consent. It is also largely a matter of semantics and the definitions are vague, flexible and arbitrary.

Photography is a process of drawing with light or in the words of Fox-Talbot, a "Pencil of Nature". It can be used for any purpose or intent from archival recording to personal expression; it can be a public record or a private diary. It functions best when its unique character is recognized and respected, although its range and flexibility allow a multiplicity of uses. Its affinity to Nature allows it to penetrate the full range of human experiences, including the aesthetic. But it is a medium of surfaces and its penetration below the epiderm of life is limited, it sticks close to the surface realities, and is inseparable from them. As Lewis Mumford, talking of Alfred Stieglitz, wrote in *Technics and Civilization*, "The mission of the photograph is to clarify the object. This objectification, this clarification are important developments in the mind itself: it is perhaps the prime psychological fact that emerges with our rational assimilation of the machines. To see as they are, as if for the first time, a boatload of immigrants, a tree in Madison Square Park, a woman's breast, a cloud lowering over a black mountain—that requires patience and understanding. Ordinarily we skip over and schematize these objects, relate them to some practical need or subordinate them to some immediate wish! Photography gives us the ability to recognize them in an independent form created by light and shade and shadow. Good photography, then, is one of the best educations towards a rounded sense of reality." Art can be seen as the rival of life and photography its constant companion and true friend; idealist and realist, eager to expose the hypocrisies and paradoxes of life and to observe and share its joys.

Photography is like a chameleon, it can imitate or adopt any 'colour' to merge into any cultural context and, being a perfect mimic, it is sometimes hard to identify its own true nature. It is the most transparent medium of visual expression. It identifies so closely with the natural world and can reproduce it with such fidelity that the medium itself appears invisible. Neither a language of expression nor a code are apparent. The hand of the artist is absent for, as André Bazin emphasized, "All the arts depend on the presence of man; only photography lets us delight in his absence. Photography affects us like a phenomenon in nature, like a flower or a snowflake whose vegetable or earthy origins are an inseparable part of their beauty . . . The photograph, as such, and the object in itself share a common being, after the fashion of a fingerprint. Wherefore, photography actually contributes something to the order of natural creation, instead of providing a substitute for it." In photography the object and the image become undifferentiated, reality and imagination, conception and perception are unified.

Photography is a way of looking at the world, a means of signifying, of pointing out the beauty and meaning that is contained in our perceptual world of objects and images. Like the human eye, it operates through a process of visual selection, isolating those observable facts that are meaningful or relevant from the chaos of life. The idea that the eye and the camera are equivalent in operation is a tempting proposition. In their search for greater powers of representation to give an illusion of reality, artists looked upon the camera obscura, a forerunner of the camera, as an instrument of truth. It is tempting to speculate whether Leonardo da Vinci, had he been born four hundred years later, would not have been a photographer rather than a painter, for in his study of perspective and the hidden secrets of Nature, he used the camera obscura and other mechanical devices to seek the truth as he considered that "The most excellent painting is that which imitates Nature best and produces pictures which conform most closely to the object portrayed." Later when photography was a reality, Paul Gauguin was led to speculate "Shall I tell you what will soon be the most *faithful* work of art? A photograph, when it can render colours as it will soon be able to. And you would have an intelligent being sweat away for months to achieve the same illusion of reality as an ingenious little machine!"

This belief in the relationship between the imitation of nature and the search for truth is deeply felt. The power of the image over nature is one fundamental explanation for the necessity of art, and the idea that 'realism' and 'truth' can be equated is very strongly held by the public at large, by propagandists, the advertising industry, documentary film makers and photographers alike. The old saying that "the camera cannot lie" is still believed today in spite of much evidence to the contrary. Behind this naive belief is a recognition that photography, by the very nature of the process of the formation of the image, bears a remarkable resemblance to actuality. It is as though we realize that a machine cannot actively create a deception, and that

the absence of man's hand makes it virtuous. In *Art as the Evolution of Visual Knowledge,* Charles Biederman suggests that the progress of art reached a point where only the invention of photography could satisfy our need for realism, and for a greater correspondence between the illusion of reality represented by painting and the vision of reality as seen by the human eye. The hand-made image had to be replaced by the art of the machine. The automation of image-making, as represented by photography, makes a profound change of attitude necessary.

Unlike art, an aesthetic based on realism rather than formalism is more appropriate to photography, and the primacy of nature is the foundation of an aesthetic of realism as proposed by André Bazin. His ideas are poetic and paradoxical, paradoxical in that the concept of realism is itself an illusion as realism can only be achieved by artifice, and in order to succeed needs to deceive the eye and the mind. Perfect realism is the ultimate in illusion. The "inalienable realism" of the camera is without the conventions normally associated with art, with its codes, signs and symbols. Christian Metz, the French linguist, has described the photo-graphic image as a language without a code. The photographic image instead of representing the object, *is* the object *re*-presented: "The photographic image is the object itself. The object freed from the condition of time and space that govern it. No matter how fuzzy, distorted or discoloured, no matter how lacking in documentary value the image may be, it shares by *virtue of the very process of its becoming,* the being of the model of which it is the reproduction; it *is* the model."

The eye sees only what it wants to see, it is blinkered by its own subjectivity, the camera sees all, within its own limited field of vision. Its ability to see everything on equal terms, giving value to nothing, is the source of its objectivity, and its powers of observation. But although it can see with greater precision and clarity than the human eye, it is, as Charles Blanc said, "blind in the world of thought." Vision is only part of the perceptual process. Just as the brain is needed to interpret the retinal image, so the camera needs the photographer to think for it. The camera is a mechanical eye and cannot think for itself, it has no mind of its own, and is totally incapable of making a decision, it lacks judg-ment, and is quite indiscriminate in the way it views the objective world within its sight. Showing great attention to detail, the camera sometimes misses the point, not able to separate the significant from the insignificant, its penetrating gaze is fixed and unimaginative. It has no opinions, and no taste. The human eye also has its limitations. What the eye sees is transient and unstable, the fleeting retinal images are focused by the brain only on that which interests and holds attention. The brain is highly selective, it ignores the irrelevant and is

liable to be confused by the unexpected. Everything it sees is filtered through our imagination to be modified to match our own beliefs and expectations. We can easily be deceived and deceive ourselves easily, see-ing what we want to believe as much as believing what we see.

Illusions are man-made, and are as real to us as the tactile world of our senses. In photography the camera and eye can be combined for a perfect match: the camera's superiority in observation and image reten-tion is balanced by the faculties of human perception; the imagination of the mind, its search for meaning and the expression of feeling, is complemented by the cool objectivity of the lens and its special relationship to the natural world. The inner and outer worlds of experience that make up human awareness are brought together and the transitory world of the eye is fixed by the lens of the camera. The role of the photographic process is as an instrument of perception, to enable us to see more clearly, to give significance to our everyday experiences and to deepen our responses to nature.

If the camera has an affinity to nature, it also has a unique power over space and time. Oliver Wendell Holmes in 1859 described the daguerreotype as "the mirror with a memory". His anthropomorphic descrip-tion is most fitting to a machine that is so much an ex-tension of the human eye and is capable of recording in permanent form our intangible sense data. The need to make our impressions permanent through creativity and art is a natural instinct in mankind. Man wishes to make his mark, as well as transform nature. This deep psychological desire to immortalize his presence can be seen from the cave painting of Altamira to the family snapshot, a word coined by Sir John Herschel, the Victorian scientist and pioneer worker in the early days of photography. Whether it is art or graffiti, we need to say "I was here" and the holiday snapshot, a universal preoccupation of modern man, exemplifies this be-haviour.

When it became technically possible in 1880 to have a photographic process that could take instantaneous pictures with little expert knowledge of the science of photography, a new era in picture-making became possible. The art of the image was democratized. Representation, so long the goal and exclusive pre-occupation of artists, was brought within the range of ability of everyone, a new folk-art was born. As the printing press had broken the monopoly of scholars in the fifteenth century, so the camera broke the monopoly of artists in the twentieth. The automation of cameras has brought the possibility of universal visual literacy and, in Lewis Mumford's words, "What had been a slow handicraft process requiring well trained eyes and extremely skilled hands, with all the rewards that

accompany such highly organised bodily activities, now became an all-but-automatic gesture . . . the first effect of the machine process was to deliver people from the specialist and to restore the status of the amateur. Thanks to the camera, the eye at least was re-educated.''

The popularization of the photograph and its universal appeal is based on a need to give expression to the individual experience, to record, as in a diary, the events that make up human existence. The irresistible passage of time is our remorseless enemy and in the camera we have the ability to stop its progress, at least in the symbolic terms of the image. The ability to stop time in its tracks makes photography a medium of instant art. The time of exposure is the time of creation: in the beginning the duration of exposures was long, in 1839 a typical exposure in daylight would be ten minutes (at f.8). The quest for the freezing of action has progressed throughout the technological history of photography, with the demand for faster and faster emulsions and shorter and shorter shutter speeds and wider and wider lens apertures. When Nicéphore Niépce made the first photograph in 1826 it took eight hours to expose; today one thousandth of a second is commonplace on most camera shutters. A moment in time can now be frozen and captured, helping to fulfil man's desire for permanence for, as André Bazin said when he was describing the compelling charm of the family snapshot, ''Those grey or sepia shadows, phantom-like and almost undecipherable, are no longer traditional family portraits, but rather the disturbing presence of lives halted at a set moment in their duration freed from their destiny; not, however, by the prestige of art but by the power of an impassive mechanical process: for photography does not create eternity, as art does, it embalms time, rescuing it simply from its proper corruption.''

II An Analysis of the Photographic Medium

Perhaps the greatest moment in the history of the evolution of the human race was when man for the first time not only noted an object or an event but simultaneously converted this perceptual experience into a thought. From then, man's progress depended entirely on this new-found power of the mind to perform a dual role, to receive information passively and instinctively and to digest it, retain it and process it. This ability to connect information, interpret it and store it for future use became the foundation stone of all man's knowledge. Yet, in time, these two functions of the brain, perception and thought, though working in unison were categorized separately. Once divided, thought became elevated to the status of the most prestigious of all human functions while the province of feeding the brain's computer with perceptual information became regarded as far inferior. Perception was relegated to the role of an ordinary, uninspired craftsman, while the thinking processes were considered the sole basis of man's intellectual greatness.

This curious division and separation of the two functions persisted uninterrupted throughout the whole period of the evolution of Western civilization, from Plato, right through the Renaissance down to nineteenth and twentieth century thinkers. Because of the disdain accorded to purely perceptual processes, poets, philosophers, even musicians, were treated with due respect, while painters and sculptors, supposedly merely recording the perceptual data, were thought of as essentially no more than honest journeymen. This pernicious theory is slowly being refuted and reassessed and more painstaking research into our mental processes reveals a far greater complexity than hitherto assumed. A number of accepted notions have been questioned and reconsidered and the relationship between perceptual processes and the mental activities of the brain have come under closer scrutiny. It immediately became apparent that 'seeing' is not entirely a simple recording and note-taking function. The eye not only looks, it also instantaneously interprets and processes visual information, it possesses, as it were, intelligence of its own. In his book, *Visual Thinking,* Professor Arnheim contends that ''operations called thinking are not the privilege of mental processes above and beyond perception, but the essential ingredients of perception itself; . . . such operations as active exploration, selection, grasping of the essentials, simplification, abstraction, analysis and synthesis, completion, correction, comparison, problem solving, as well as combining, separating, putting in context''. These functions cannot be merely passive and

'unintelligent', they are an integral part of 'thinking' and it follows that perception and thought cannot be divided functions since it appears that they are so closely inter-related.

In one of his earlier books, Professor Arnheim defines the process of looking as: "In looking at an object we reach out for it. With an invisible finger we move through the space around us, go out to the distant places where things are found, touch them, catch them, scan their surfaces, trace their borders, explore their texture." These various manners of 'looking' imply an instantaneous and autonomous directional apparatus involving perception itself which selects various implications and makes rapid decisions. Perception is obviously correlated with and not inferior to or divorced from thought. It is enough to consider how the eye can complete visually the rest of a face if it is in complete shadow or correct distorted shapes, so that the oval of the *piazza* in front of St. Peter's which is actually seen distorted by the eye is interpreted as a perfect circle. The importance of perception is slowly being re-assessed, and not only its importance but also its sheer virtuosity and refinement. The eye is not only a very acute and precise instrument, it is also an intelligent, thoughtful and discerning one.

From the day of its discovery, photography was accorded the status of a 'super-eye'. Arago, who intro-duced Daguerre's invention to the French Academy, spoke of its "mathematical exactness" and "un-imaginative precision", and the celebrated English critic John Ruskin enthused over its "sensational realism", adding poetically "as if a magician had reduced the reality to be carried away into an en-chanted land". But after the initial joy of precise recording, photographers soon started to claim other attributes for the camera. Going beyond its initial description as an unintelligent "mirror of nature", they started to assert their right to create as well as describe, to have their images praised for their beauty and imagination as well as for their accuracy.

As early as the second half of the nineteenth century it seemed that this claim would be met. Artistic photo-graphers proliferated, Queen Victoria purchased an elaborate allegory of *The Two Ways of Life* by the famous pictorialist Rejlander, as a gift for Prince Albert, and later, on the other side of the Atlantic, Alfred Stieglitz, perhaps photography's greatest pioneer, managed to get photographs exhibited in museums, alongside paintings. These examples, however, were only short-term successes, some skirmishes won, while the major battle, the approval of the general public, remained always beyond reach. Photography was too much of a handmaiden of perception, and perception had for far too long been considered an inferior of thought and intelligence.

The blame for the confusion over the status of photo-graphy cannot be solely laid at the door of jealous realistic painters or unfriendly art critics. Photogra-phers themselves must take some responsibility for they took such a very long time to decide what, in fact, was the nature and scope of their own medium. A clear definition of the nature of the photographic medium was sorely lacking. Many literate and clear thinking photographers did, indeed, write occasionally about their own approach and to some extent about the medium as a whole. But since most of these pronounce-ments were in the form of articles or prefaces to exhibitions, they were soon lost and forgotten. Until much later, photography also never quite managed to attract the attention and respect of significant critics of art, consequently it was never given sufficient thought and consideration so that some coherent and deep analysis of the medium could be developed.

And yet a clear understanding of the medium is of utmost importance. In his illuminating chapter on photography in his *Theory of Film*, Professor Kracauer wrote that "the achievements within a particular medium are all the more satisfying aesthetically if they build from the specific properties of the medium". Every creative medium, be it painting, sculpture, drawing, printmaking or photography, possesses its own peculiarities, its own weak and strong points. Let us start with the raw material of photography – its subject matter. At once we can see that it is limitless. The flexibility of modern cameras and materials is such that virtually the whole world is photography's oyster. Yet there is a limitation in subject matter. Since, to continue quoting Professor Kracauer, "by the nature of the medium, the photographic vision must be rooted in reality", this completely integral and unbreakable bond with reality is both the photographer's strength and his limitation. "Photography has an outspoken affinity for unstaged reality . . . Pictures which strike us as intrinsically photographic seem intended to render nature in the raw, nature as it exists independently of us." That photography's source of subject matter must be drawn from "nature as it exists independent of us" is of crucial importance. A photographer can tamper with his subject matter, alter it or improve it, as Academic painters attempted to do, only at his peril. Photography's true kingdom is undoubtedly "unstaged reality".

"The contemplation of things as they are
Without error or confusion
Without substitution or imposture
Is in itself a nobler thing
Than a whole harvest of invention."

This poem by Francis Bacon was firmly pasted to the darkroom door of Dorothea Lange from 1923 till her death in 1965. She was undoubtedly one of the great realistic photographers of the famous American post-

depression school of photography of the 1930s. But to call her merely a realist would be an error of judgement. Though she only used "unstaged reality" as her subject matter, she was at the same time one of the most sensitive and moving photographers that ever held a camera. The depiction of pure and cold truth and reality is clearly not enough in itself. Our desire for information and knowledge is satisfied and this represents a valuable service but, if all the photographs were merely detached purveyors of information, the world would be a poorer place. Therefore we must not only consider the message but also the manner in which it is presented. For apart from the form and formalization of the image there is the question of emotion.

The problem of emotion is a complex one, the complexity arising from a division of opinion. Some writers on photography feel that the photographer should be completely objective, uninvolved and emotionally detached, a witness or observer and no more. This is how Marcel Proust sees a photographer in *The Guermantes Way,* as a totally alien and remote on-looker. But this point of view is difficult to uphold. A sensitive human being cannot easily turn into a cold, objective observer, and even if it were possible, his work would probably be too clinical and uninteresting. A study of the work of significant photographers of the past and present shows that it is the imagery of the photographers who cared in some way that is the most memorable. Successful work is the result of deep involvement, care and interest and not of cold objectivity and indifference. Dorothea Lange felt deeply for the displaced and humiliated people she photographed. She did not try to change anything, invent or falsify, but merely to relate the things she noted with feeling and compassion. It seems that a certain identification and affection, an empathy with and for the subject is indispensable. There is certainly a need for love and understanding, both of the medium and medium's field of enquiry, be it people, landscape or things, for, as Cartier-Bresson wrote, "Without the participation of intuition, sensibility and understanding, photography is nothing."

Further on in his preface to *The World of Henri Cartier-Bresson,* speaking of composition, Cartier-Bresson remarked that "the recognition in real life of a rhythm of surfaces, lines and values is for me the essence of photography; composition should be a constant pre-occupation, being a simultaneous coalition – an organic co-ordination of visual elements". In these words lies the summation of yet another difficulty inherent in creative photography. Should a photographer tap "unstaged reality", his raw material, without any regard to the formal qualities of the image, he would, most likely, fail to communicate his message in a

distinctive and forceful manner. There is an inborn need in us for simplicity and order. The first law of the Gestalt theory of perception states that "Any stimulus pattern tends to be seen in such a way that the resulting structure is as simple as the given condition permits", or, more simply, "Every psychological field tends towards the simplest, most balanced, most regular organisation possible." Our perceptual forces show a distinct preference for simple structural organizations, and display a dislike, expressed in tension and unease, for irregularity and disorder. Thus unless the viewer is offered a coherent and organized image, he will most likely fail to pay attention to it or perhaps even avoid looking at it, and the message will remain un-communicated. A successful photograph must be then "a joint product of organising mind and physical reality". From the chaos, disarray and fortuitousness of the world the photographer has to extract a certain part or fragment, which, while retaining the essence of the meaning, also acquires a visual sense of order and balance.

When Matisse says that "Composition is the art of arranging in decorative manner the various elements at the painter's disposal for the expression of his feelings", he is speaking of the leisurely pursuit of painting. The painter is obviously able to contemplate and arrange various elements without haste whereas, in Cartier-Bresson's words, "Photography is an instantaneous operation, both sensory and intel-lectual." How then, can one reconcile two almost contradictory aspects – the formalization and organ-ization of the photographic image on the one hand, and its instantaneity on the other. For a fundamental aspect of the nature of photography is Cartier-Bresson's "instinctive" but also *momentary* realization of the photographic image. The essence of photography lies in freshness, spontaneity and immediacy of vision. A painter can, if he wants, be systematic, painstaking and pedantic, the photographer, in the moment of shooting, can be none of these things. On the contrary, his decisions must be made at the speed of thought and his reactions must be based solely on intuition and an instinctive sense of rightness and form. A true photo-graphic image, faithful to the nature of its medium, should, at best, possess both a sense of reality and this element of arrested moment, a fragment of life.

This unique feature of the photographic medium which is rooted in the immediacy and spontaneity of the photographer's reaction to essentially unorganized subject matter, makes photography one of the most difficult creative activities. There is no easy way of mastering photography, no set of rules which can be learnt and then applied at leisure until a high quality image is achieved. Technically this may be possible but from the aesthetic point of view the method of trial

and error is hardly applicable. The painter can scrape his painting, and alter it partly or completely, the photographer either achieves his aim in a short burst of activity or not at all. For often it is only a fraction of a second that secures the image, a fraction within which all the elements of visualization must fall into their rightful place.

The photographer, unless born with a natural gift, must acquire his sense of arrangement, balance and harmony through a lengthy process of visual apprenticeship. It is an apprenticeship which involves not only an initial familiarization with a set of rules and principles and their subsequent, constant application, but also the analysis of the multitude of visual images by which one is surrounded, whether in books, magazines or the cinema, exhibitions, prints or posters. Only through this endless absorption of images is an almost subconscious feeling for the elements of form and order acquired, "the recognition . . . of a rhythm of surfaces, lines and values", and an instantaneous visual mastery. In time, the rudimentary principles of composition learnt as a beginner become no more than a background to an individually developed sense of formal perception and the element of order. If, according to Adrian Stokes, the "search for coherence or clarity of form is the basic desire in artistic creation", it is the great quandary of the photographic medium that this search must be sometimes accomplished in the space of an instant.

A comparison between two different creative media is difficult and often misleading, especially if they are related and yet dissimilar, but it can be useful. The image in both painting and photography is a two-dimensional representation of a three-dimensional scene. At one time photographers tried to bridge the gap between painting and photography and find even more points of similarity; photographs were made to appear as close to painting as possible, to no avail as the differences considerably outweighed any similarities. The instantaneity of a photograph, as contrasted with a painting's long period of creative gestation, is, of course, the greatest element of dissimilarity. Photography is potentially a dynamic medium, operating on the verge of the dynamic flow of life, while painting depicts arrested, motionless life, and only with difficulty escapes being a static medium. The comparison of two characteristic figures in both media is revealing. Cézanne insisted on a profound realization of the reality of nature. In order to achieve it he used to isolate one element – a figure, a mountain or a group of objects – and by intensive, lengthy and concentrated examination, tried to represent an archetype, a generalization of the essential, fundamental qualities of his subject. He was not interested in surface values, only in organic ones. His counterpart in photography,

The Bareback Riders page 11
An essentially "photographic" image, virtually unattainable in any other medium, it relies on instantaneity and dynamism. The composition owes little to the classical precepts of the Renaissance and is based on dynamic, rather than symmetrical balance with strong, overall diagonal thrust. The idea of photographic frame is also strongly underlined—the lines of the frame sharply cutting into the subject and a lot of the image, outside the frame, is left to the viewer's imagination. The effect was very deliberately created to fit the idea of a circus—all explosive energy, incessant movement, brilliant colours and noise. Consequently a slow speed of the shutter introduces a strong effect of blur, which is further accentuated by sharpness of the girl's head.

Series by David Lavender page 12
As a reflection of life, art imitates Nature by recreating its forms. Photography, by the action of light, makes an imprint directly from Nature. The duality of pictorial existence, at the same time both reality and optical illusion, are seen reflected in a series of shop-windows. A double image is created by direct observation from life, which is both factually real and bizarre. Unstaged accidental juxtapositions transfixed by the camera give the medium its surrealist overtones.

 page 13
By the selectivity of multiple forms the restructuring of perceptual phenomena is organised into pictorial meaning. The photographer, through his choice of subject and viewpoint, abstracts visual form rather than syntheses it, as does the painter. Like the painter, however, he does restrict his palette limiting his choice of colours aiming at the simplicity of direct observation whether the subject be a panoramic landscape or an isolated detail.

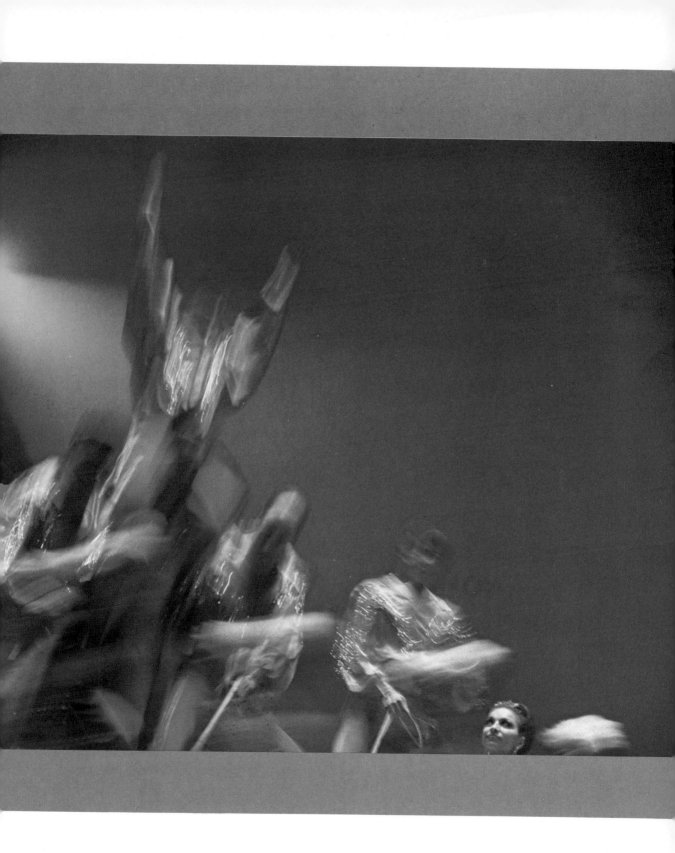

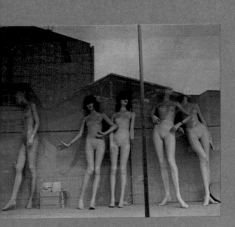

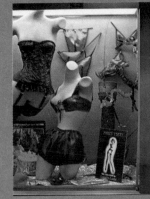
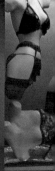

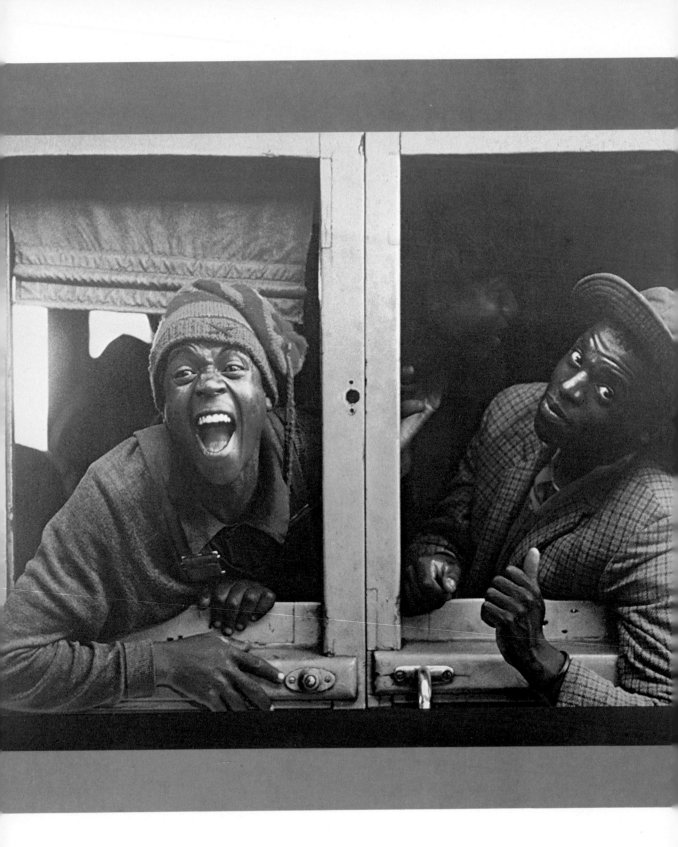

Henri Cartier-Bresson, performed marvels of instantaneous vision. By his ability to stop a decisive moment he captured a fragment of passing life and embalmed it for posterity. Which of the two is more valuable, the meticulous contemplation of Cézanne or the immediate reactions of Cartier-Bresson, is irrelevant. It is the manner of *using* the medium that concerns us. In one case a slow, progressive and painstaking shaping of the reality of a subjective image, and in the other, a fresh, direct and largely objective representation. A static image against a dynamic one. The psychological approach in each case is totally different.

But the incompatibility between the two media assumes even greater proportions when the manner in which the two images are put together is considered. Cézanne isolates his subject, takes it, as it were, away from its natural environment and in order to be able to observe it with greater detachment and precision, removes the exterior, environmental influences. It is the subject itself that fascinates him, what is on the right or left does not concern him unduly. Some painters did not work in this way, Degas used to cut the figure on the edge of his canvas in order to suggest a large crowd, a fragment of which he was representing; the Italian Futurists also tried to suggest a simultaneity of environmental influences in their work. But both these are exceptional examples and were profoundly influenced by photographic snapshots. The photographer cannot avoid the environment of his subject, it encroaches, overlays and overlaps his theme, it is always an integral part of the whole. He cannot isolate his subject as did Cézanne, he cannot place it in the centre of his composition and use the edges of the image merely as a frame. Since the whole shot is a fragment of the image of reality, one part of the image cannot be dismissed as less important than the other. A photograph is so completely related to the part which was left outside it that there is a quality of unending infinity in each true photographic image. The edges of the frame of the film are not the physical enclosures of the image, but windows behind which the rest, though invisible, exists. A frame is never entirely finite, definite, a completed sentence, it is a passing fragment of life, of space and of time.

Each time a photographic frame is shot, at the precise moment of exposure the photographer has an infinite number of possibilities at his disposal. His choice of 'frames' is unlimited, he can shift his camera to either side, come closer or step further away, press the release immediately or defer the moment of exposure indefinitely. Each of these shifts, each different moment of time alters the image partially or entirely. The final choice he makes among all these variables constitutes his most important photographic freedom – the ability to select. The precise moment of making a creative decision, often represented by a fraction of the second,

South African Scene—Raimo Gareis page 14
The directness and immediacy which characterise the nature of photographic vision are not so concerned with the formal intellectual values of High Art, but the expression of human values and emotions that relate directly to everyday life. Photography, better than any other medium, can capture the simple pleasures of human existence, as well as its more tragic moments or endless banalities.

is what Cartier-Bresson called "the decisive moment". The final option that is taken will often determine how good, important or significant the image will be.

A photographic image, like any other visual statement, works on many levels and is made up of many elements. On the graphic level it represents a formal arrangement of some light and dark areas and shapes, it is cut and criss-crossed by various directional lines and it is a pattern of juxtaposed zones of colour. It is also an area of interplay of figurative and recognizable features, people in various attitudes, their faces expressing certain feelings, landscapes and interiors, objects, indication of action, happenings and movement. All these features affect the spectator in a number of ways, emotionally or aesthetically or both. They can inform or surprise, fill him with joy or resentment. And each of these experiences are the result of a certain decision and choice that the photographer took, the significance or insignificance of an image is of his making. The ability to select between complete and finite images, and thereby to affect their meaning and their message, is yet another unique feature of the photographic medium. The photographer is the only creative image maker who is offered a choice of this kind and he has the ability to make the selection at two distinct stages. In the first place during the moment of recording, where he chooses a variety of possible interpretations of the scene in front of him and secondly when the negatives are processed and his contact sheet offers him a more leisurely chance to select the most significant image from those he recorded.

"I have often thought that if photography were difficult, in the true sense of the term – meaning that the creation of a simple photograph would entail as much time and effort as the production of a good watercolour or etching – there would be a vast improvement in total output. The sheer ease with which we can produce a superficial image often leads to creative disaster." There is certainly a great deal of justification in Ansel Adams' remark. The facility of photography today often results in carelessness and looseness of visual thinking. But in spite of this apparent technical ease, photography remains one of the most complex and difficult media to assess. There is a certain inherent heterogeneity and contradiction in the philosophy of the medium. An examination of significant photography of the past and present confirms that an overwhelming majority of these photographs was the result of a conscious and sensitive attitude and deliberate creative choice and not a fortuitous accident. And yet chance, unpremeditated occurrence and contingency are very much the essence of photography.

Accident and chance always played a considerable role in the modern art. Some Dadaists of the early

twenties virtually based their entire work on fate and fortuity. Arp chose shapes blindfolded and then fitted them together; Schwitters collected bus tickets, match boxes and pieces of paper on the streets and then used them in his collage compositions; Marcel Duchamp hurled matches dipped in paint at his masterpiece, *The Bride Stripped Bare by the Bachelors, Even,* and was delighted to incorporate in it a patch of dust which settled down while he was away. But in spite of these marvellous innovations and discoveries, the painters' use of chance always seemed somehow artificial and strained, it never convincingly fitted the medium. For photography, with its immediacy and dynamism unpremeditation, the unexpected and accidental seem ideally suited. In his searching analysis of the affinities of photography, Professor Kracauer includes randomness, actually placing it as second in importance to the use of "unstaged reality".

Perhaps terms like chance, accident, fate and fortuitousness may appear too flippant and supercilious, serious creation should surely not be shaped by chance. As in everything else this is a question of degree. For his personal creative work a well-known British advertising photographer dips his Box Brownie (not his Nikkon of course) in sea water with exposed film, thus manufacturing his own accidents. This indeed may be taking a chance too literally, but one cannot dismiss equally lightly many fascinating and fortuitous discoveries that the camera can make. The chance juxtaposition of shapes, a coincidence of a reflected image combined with reality behind the glass of the window, the blur of the passing train which somehow reveals the landscape behind it, the sudden irreverent gesture of a boy during the solemn speech of a politician. All this is pure photography which sometimes may shun the expected and revel in the painter Lautreamont's search for "—the fortuitous encounter on a dissecting table of a sewing machine and an umbrella".

III Photography and Art

The camera is a creative tool in the service of man: in the hands of an artist it can create a work of art, in the laboratory it can be an instrument of science. The camera obscura, the forerunner of the camera, first described in 1558 in the book *Natural Magic* by Giovanni Battista della Porta, was an instrument for creating natural images and transforming the physical dimensions of the outside world into shadows on a surface. It was used by artists to study nature and solve problems of perspective, artists often tracing the two-dimensional image of the camera obscura rather than working directly from observation of a three-dimensional reality. The motivation of the inventors of photography was to "draw with light", combining art and nature. But it took two centuries before it was possible to make the light itself trace the image directly, without the hand of the artist. When the achievement was made public in 1839, the general public were fired with enthusiasm for this miraculous discovery.

Artists were less excited, and some were apprehensive. The painter Paul Delaroche exclaimed almost hysterically, "From today, painting is dead." So began a long relationship between art and photography; at times hostile, occasionally tolerant, but always in awe of each other. Artists admired the speed and facility of the camera to render so precisely and the photographer felt the need to prove himself in the eyes of artists. Ingres admired the power of photography but was reluctant to admit it; Charles Baudelaire, the poet, was the most outspoken critic of photography as art, describing it as "art's most mortal enemy". It became a turning-point in the history of art as painting, recognizing reluctantly the superior power of accurate representation, abandoned the quest for realism, and embraced the romantic aesthetic. Whilst the obsessive camera was greedily exploring the external world of objects and events, painting turned inwards to explore the psyche of the artist and the inner structures of the art process itself. The camera was a soulless instrument damned forever, because of its mechanical power over nature and because it represented the rationality of science and technology.

The Romantic Movement was an emotional reaction to the age of reason, with its intellectual and scientific outlook and the romantic aesthetic began with the seventeenth century Germany Idealist philosophers and the writings of Kant, Schiller and Hegel. Immanuel Kant in his *Critique of Judgement*, 1790, laid the foundations for modern aesthetics, which are still the philosophical basis on which the fine arts operate today. In an attempt to reconcile the division in man, the dichotomy between his sensual, impulsive nature and his higher faculties of intellect and reason, art was to be a mediator. The aesthetic surfaces of art, appealing directly to the bodily senses and emotions, would balance the restraint imposed by morality and intellect. It would become a language of feelings rather than reason. Unfortunately, in an attempt to restore the equilibrium it over-reacted and became itself reactionary. As science became more dominant, the reaction of art was to divorce itself from everyday life, taking refuge in 'art for art's sake' and retreating either into the past or into the realms of imagination. Freudian psychology with its overtones of sensuality and repression of the instincts matched perfectly the Romantic Ideal and became a confirmation of the Romantic spirit. The invention of the photograph merely accelerated the process of reaction in the visual arts. It forced the fine arts to abandon naturalism for expressionism. Art became more gestural and organic in response to the onslaught of the machine, against the collective spirit of the times it became aggressively individualistic. Photography, firmly rooted in everyday reality, was at a loss. It represented the exact opposite of the Romantic vision in which art could transcend the limits of such a confined world and escape into a limitless universe of the imagination.

The increasing hostility between art and science was perfectly embodied in this little black box, because it removed the monopoly held by artists over the image along with its magic power. Photography had democratized the pictorial arts, and was an instant success with the public at large. Within ten years of its invention, and in spite of the initial long exposures of several minutes, it has been estimated that in 1849 alone over 100,000 daguerreotype portraits were taken in Paris. As it became more convenient and less cumbersome equipment was developed, and the chemistry was made less dangerous with the elimination of mercury and cyanide of the earlier processes, its popularity reached staggering dimensions. In Britain there are over fifteen million cameras and their owners expose about two million pictures per day averaged over the year. If to this you add the number of hours per day the population watches television, with its photographically derived images, plus the millions who visit the cinema each week, one begins to understand the enormous impact that the invention of photography has had upon our lives. For, as Marshall McLuhan has observed, "Society is shaped more by the nature of the medium by which men communicate than by its content" and it could be claimed that photography has transformed our lives on the cultural level equal to that of the invention of the printing press and as much as the motor car has changed our social environment.

The industrial, machine age we live in was given the perfect instrument with which to express itself, both individually and collectively. The camera can record with equal facility personal events for the family album, or great historical moments for the archives of history. The camera has penetrated every facet of life: it has seen the unborn baby in the womb and has photographed our world from outer space. It has stood alongside men on the highest mountain and on the surface of the moon, not only to record an historic event, but to take a 'family snap', as a proof that it really did happen and can later be re-lived through the image as a vicarious experience. The medium has expanded our horizons and enlarged our narrow window on the world. By using the non-visible spectrum of electromagnetic energy it can see, or make visible, the cosmos and the microcosm; the photograph, in conjunction with the radio telescope or the electron-microscope, can reveal the hidden worlds of space. Time can be stopped: a fragment exposed to considered analysis. Time can be expanded or contracted: the movement of planets, or golf-balls, subjected to scrutiny. The camera's presence is all pervading. It was present at the Crimean War, and has travelled ninety million miles on a space probe to the planet Mercury. The vision of its eye can take in a bullet in flight and record its shock waves; detect invisible flaws in a machine casting or see the molecular structure of a crystal lattice.

The dimensions of man's experience have been transformed by the camera. He is no longer absolutely bounded by his own senses or isolated by the mortality of his own individual being. It has extended his power over nature and his own physical limitations, no longer a prisoner of time and space, but it also has challenged the exclusive position of art in the making of illusion. When Paul Klee said the function of art was to make the invisible visible, he was merely acknowledging the role of the visual arts, to reveal subjective states by objective means. Art has always sought to balance the physical and the spiritual, to create illusions of reality through increasingly realistic representation, and at the same time to project, by means of signs and symbols, style and form, other more intangible forms of experience. This balance between the sensual and the cerebral responses has been the essence of the aesthetic experience.

Much modern thinking on the visual arts is influenced by the pioneer teachings of the Bauhaus in Germany in the 1920s. Founded in 1919 by the architect Walter Gropius, it was constructivist and scientific in its approach to the problems facing modern art. At one time Klee, Kandinsky, Ittens, Albers and Moholy-Nagy were working at the Bauhaus together, attempting to create a new philosophy of art which truly expressed the age we live in, to industrialize art, not distinguishing between fine arts and applied art, and remove the cultural isolation of the artist. Photography was seen as a new medium of exploration in art, particularly when used in combination with constructions, with graphics or photo-montage but it was not really seen as a pure medium of expression in its own right. Moholy-Nagy, a Constructivist, did extensive experiments with cameraless photography, to create his photograms, expressive virtual objects created by the inter-action of light with real objects. For expression had become equated with distortion or manipulation.

During his period at the Bauhaus Paul Klee formulated his ideas on modern art and the creative process and in On Modern Art, based on a lecture given in 1924, Klee graphically describes the transformation from nature to culture, in the form of an analogy: a tree. He describes the tree as consisting of three parts: the crown with its visual array, the trunk and the hidden roots as an invisible array below ground. Klee likens the root and sap to the source of creation, the inspiration of nature and life. The artist is the trunk through which the sap flows. The canopy of branches and leaves is his crown, the visual display of his work. The root and the crown represent a duality of existence and creativity: the conscious and the subconscious, the real and the imaginary, reason and instinct, the sensual and the spiritual, visible and invisible. The structure and form of the root and the crown have similarities but they are at the same time in opposition, a total inversion of each other. One draws life-giving energy from the soil, the other gives life-supporting oxygen to the air. They are complementary to each other, and joined and separated by the trunk, they make an organic whole.

This metaphoric statement could be transposed to represent a credo for the photographer and his medium. The camera could replace the tree, the machine substituted for the living organism. The photographer and the camera lens become the trunk but because photography operates by different methods to other visual arts, and in reverse, the source of inspiration for the photographer is above ground exposed to the sunlight. The photographer takes pictures rather than makes them. He selects from life experiences rather than creating new experiences of a different order. The inverted image, in the dark on the ground-glass screen, is a transposition and inversion but it is not a distortion. When the photographer departs from nature it is under the demands of art rather than photography. The degree of abstraction, the artist's mediation between object and image, represents the necessity of art to move from image to archetype. Photography can be, by its very nature, much more ambiguous in this need to formalize in order to make expressive. This machine art can be both expressive and naturalistic, embracing both art and life simultaneously. The sap can travel in both directions.

In an influential article *The Work of Art in the Age of Mechanical Reproduction*, Walter Benjamin, the critic, likened the difference between the artist and the photographer to that between a faith-healer and a surgeon. They can both treat a patient by the laying-on of hands. The faith-healer maintains a psychic distance necessary to exert his power and magic, the surgeon penetrates deep into his body with his surgical knife. "The painter maintains in his work a natural distance from reality, the cameraman penetrates deeply into its web. There is a tremendous difference between the pictures they obtain."

All pictures, whether hand-made or photographic, have the same genus and have a common heritage. In order to survive, man needs power over his physical environment which he exerts through his technical skills and the tools of science but he also needs to exert control of his other world, that of his imagination. It is through language rather than weapons that we exert our will over this universe. We inhabit this world of the imagination, are conditioned by its symbolic structure, as much as by the forces of nature. As we use tools to cultivate the soil, in order to reap a harvest, so we use the symbolizing process of language and art to subjugate nature. The symbolic world of language, with its own codes and internal logic, is to us the real world. We know the world by name, everything is labelled and categorized, ordering our experiences even if it is only in the imagination of the mind. It is the only reality that we know, seeing and perceiving are culturally conditioned. The old joke that "all Chinamen look alike" is partly true because we do not know them and what we do not know we cannot see. Seeing is a habit, conditioned by expectation and convention.

Our sense data, as received by our visual senses, are nothing but chaotic impressions, mere stimuli of light and dark, shifting patterns of shapes and colour. We order them into meaningful structures that we know, we have to learn to see. It is our first and primary language. Seeing is knowledge by acquaintance, by recognition, based on past remembered experiences and beliefs. That something so immediate and of the present moment should rely on past experience and conditioning is the paradox that makes the image so mysterious and potent. We see and read meaning into our perceptions of the here and now, by means of our preconceptions based on the past. In the transient world of everyday experience we need to make these beliefs and values more permanent, so we make objects and pictures to embody them. Picture-making is part of our symbolic universe, ordered to fit our needs and expectations. Like our other languages it imposes its own logic and creates perceptual frames for our imagination. Pictures are more ambiguous than writing but they have their own structure.

As Roland Barthes wrote in *Mythologies*, "Pictures, to be sure, are more imperative than writing, they impose meaning at one stroke, without analysing or diluting it ... Pictures become a kind of writing as soon as they are meaningful: like writing, they call for a lexis." You cannot paint an idea or photograph it directly, expression and meaning are conceptual and abstract in form. It is through formal structures, or syntax, that expression is formulated. Representation with its iconic resemblance to the natural world and the commonplace perceptual experiences, hides its structures. Art reveals these hidden structures by transforming them into a language of form.

Since the invention of the photograph with its direct representation, modern art has increasingly emphasized the expressive nature of form at the expense of content. This has led to increasing separation of art from life experiences, and a concentration on the formal values of shape, line, tone and colour—the syntax of painting. Freed from the need to represent, art has become more self-conscious, with complex symbolic codes and high levels of abstraction and conception. It is approaching the syntactical complexity and remoteness of our verbal languages. Conceptual art, where the perceptual image is totally eliminated, is a logical extension in this process of abstraction. The art object and its sensual appeal is denied and only the concept, the abstract idea, remains. The transformation from nature to culture is complete: imitation gives way to representation, representation to formalization, formalization to signification, signification to symbolization, symbolization to conceptualization.

Art and life are separated and finally divorced so that Clive Bell, the critic, could write in 1913 that an artist should "bring nothing from life, no knowledge of its ideals and affairs, no familiarity with its emotions ... nothing but a sense of form and colour and three-dimensional space". Bell equates the aesthetic experience with "significant form" and rejects all other life experiences as insignificant to the process of art. The language of form is a symbolic code of feeling and aesthetic emotion in which the sensuality of form suffices and gratification of the senses through the articulation of form leads to heightened awareness and self-discovery. This introspection and the externalization of personal feeling through form is the essence of the Romantic Ideal but whereas the camera holds up a mirror to nature, art increasingly held up its mirror to reflect the soul. The Surrealist movement, under the influence of Freudian psychology sought the images of the Unconscious. Following Freud, artists became aware of its creative possibilities as a new world to explore. The images from the "Id" with its freedom from moral restraint, divorced from reason or implication, are an ideal source of inspiration for artistic expression.

The chance juxtaposition of the real and the imaginary created a new level of awareness. Unreal images from landscape of the imagination were portrayed with photographic exactitude. The realistic representation was juxtaposed with the unreality of an inverted logic.

De Chirico held that "Every object has two aspects: the common aspect which is the one we generally see and the one which is seen by everyone, and the ghostly and metaphysical aspect which only rare individuals see at moments of clairvoyance and metaphysical meditation", and in an analogous way all pictures have a dual existence. They are representational in character but exist between the real and the imagination. When one looks at a picture, whether it is naturalistic or expressive, representational or symbolic, one sees two things: one is the image itself; the other the ideas and feelings for which it is standing in. Images are surrogates or transitional objects acting as intermediates between nature and culture and between these two polarities the image can take up any position. Some pictures, particularly photographs, are extremely realistic and close to nature, a painting is inevitably much closer to culture, although the Impressionists and more recently the Photo-realist painters have concentrated on naturalism; one painting effects of light as seen by the retina, the other imitating the harsh, high-definition vision of the camera.

However great the illusion of actuality, the picture can only be trompe d'oeil in effect, no picture is really close to resembling the objects it represents. Richard Wollheim, in his book *Art and its Objects* reminds us that a picture or drawing of Napoleon represents him because it looks like him: it is a 'likeness' but it is not correct to say the converse, that Napoleon is like the drawing. He existed as flesh and blood, had a mind and feelings and by his actions changed the course of history. This picture is a mere shadow, a ghostly reminder of the past consisting of marks and lines on a flat piece of paper.

Representation is a form of expression, linked by the convention of 'likeness' to the object and at the same time expressing its inner meaning through the form it takes. The expressive intention may require a modification of appearance, reproducing natural appearances, either within the convention of Renaissance perspective, or directly with light using a camera, is a particular form of sign. Pictures are a composite of signs and follow the conventions of any sign language, they have to be interpreted. When looking at pictures one must know what is expected of one, otherwise confusion and misunderstanding will blur the visual dialogue. This confusion is well illustrated by a reputed conversation between Matisse and a visitor to his studio who, on examining a painting, remarked that the arm of the

woman was too long. To which Matisse replied, "Madame, you are mistaken. This is not a woman, this is a picture."

Photographs are pictures firstly and representations of reality by convention second. There is no truth in the statement "the camera cannot lie", all pictures are a distortion of physical reality, it is merely a question of degree and intention. The truth is often invisible, and is detected more by the manner than by the surface appearance. The form carries with it an expression of intent. Photography, throughout its pictorial development, has been prepared to modify its appearance to follow conventions of artistic licence, to be poetic, or expressively distort the mirror of nature.

From 1839 to the present day art and photography have pursued divergent courses, one taking on the role of interpreter of the spirit and the other as observer of the world. They have each sought at times to learn something from each other and whilst not wishing to admit it, envied each other for various reasons: art has envied photography's immediacy and its power over a large audience, whereas photography has always desired the cultural status of art. The inter-action of photography and art has been unending and often bitter and the situation has never been truly resolved and, as art has tried to assimilate the machine, so photography has attempted to digest art. The art world has experimented with Surrealism and Super-realism which has affinities to photography, just as photography has imitated the styles and fashion of art. However, in general, the description 'photographic' is a term of abuse in the art world as 'painterly' is an adjective of approval. Photographers themselves have been much more ambivalent towards art. Whilst recognizing its affinity to nature, there has always been a desire towards the manipulation of the photographic image, to use the fine art conventions of aesthetics, rather than establish one on their principles. An example is the move towards pictorialism and narrative in the nineteenth century, which reflected an association with Victorian genre painting and portraiture.

The photographic world is still split between those who want to embrace the fine art aesthetic and those who wish to establish the autonomy of the medium on its own cultural terms. The division takes many forms between the image 'for its own sake' and the illustration for a purpose; the division between the traditionalists and the modernists, the pictorialists and the 'straight' photographers, between the amateur and professional. There are the purists who believe in the unadulterated photographic qualities of the image and those who see the photographs as a starting point for a sequence of expressive derivatives; those who would not crop or re-frame the camera image as contained on the

negative and others who are prepared to re-photograph it, distort it through chemical or physical processes, double exposure or montage it with other images, fragment or recombine it in non-naturalistic ways for pictorial effect. Each has his own justification dependent upon his point of view on the nature of photography and consistency to his own purposes and beliefs in making images.

The degree of individuality or anonymity is a motivating factor in the creation of an artefact such as a photograph. The photographic image is, after all, a man-made object as much as any other cultural artefact and has many reasons for existence, both private and public. There are now basically three schools of thought: the 'straight' photographic approach; the 'pictorial' aesthetic approach and the 'expressive' subjective approach. They span the polarities of objectivity and subjectivity, of observation and imagination from passive perception to active conceptualization. The degree of permissible intervention, whether before or after exposure, is a point of debate. These three approaches can be seen to develop in parallel throughout the history of photography, with shifts of emphasis in response to trends in the art world. The 'straight' approach is the most consistent and persistently photographic and largely ignores or reacts against the aesthetic trends in fine art, except perhaps for having a certain resonance with the Surrealist movement. The 'aesthetic' approach is the most traditional and draws its inspiration from the past, to the principles of organic unity and harmony which were developed during the Renaissance and later in the Romantic movement. It follows the established principles of art history, and has most closely sought links with the fine arts rather than establish photography's own identity. The 'expressive' approach is the most dynamic and has close affinities to developments in modern art. Like contemporary art it has many styles and exploits many techniques from abstraction to optical distortion. Following in the wake of art movements from Impressionism to Abstract Expressionism, it seeks to establish photography as a medium of self-expression. It is dependent on style and individuality for its motivation.

IMPORTANT DATES IN THE HISTORY

OF PHOTOGRAPHY

1826 Nicéphore Niépce took the first photograph and called it heliography, time of exposure eight hours.

1839 J. L. M. Daguerre made public the invention of photography. Free use of the process was given to the people of France in exchange for a life pension. On 19 August 1939 François Arago gave a demonstration of Daguerreotype to the Academy of Science and Fine Art, exposure time fifteen minutes. The French Government offered photography to "all the world". Daguerre patented it in England. Paul Cézanne born.

1841 Exposure reduced to one minute with improved processing. Subject matter ranged from topography to portraiture. Hand-coloured Daguerreotypes began to replace the role of portrait painters and miniaturists. First f.3.6 lenses developed for portraiture by Petzval. William Fox-Talbot patented the Calotype, the first paper print process using a negative.

1844 First book of photographs published, *The Pencil of Nature* by Fox-Talbot.

1852 F. Scott Archer introduced the wet collodion process.

1853 The Royal Photographic Society was formed.

1855 Roger Fenton recorded the Crimean War.

1857 First composite print exhibited by O.G. Rejlander, *The Two Ways of Life*, a self-conscious 'art' photograph made from thirty separate negatives. Bought by Queen Victoria.

1859 Nadar used artificial light in Paris portrait studios in Boulevard des Capucines. Charles Baudelaire launched attack on photography for corrupting art.

1861 Matthew Brady began to document the American Civil War. Disderi exploited the *carte-de-visite* portraits to make a fortune in Paris.

1866 Julia Margaret Cameron started to take portraits of famous men and women of her time. Wassily Kandinsky born.

1869 H. P. Robinson published *Pictorial Effect in Photography*.

1873 First photographs to be printed in a newspaper, *The Daily Graphic*, by new half-tone process.

1874 Impressionist painters held first exhibition in Nadar's studio in Boulevard des Capucines.

1877 J. Thompson's documents of *Street Life in London* published.

1878 First dry-plates made by George Eastman.

1884 First ortho film produced commercially. Pointillist G. Seurat painted *La Grande Jatte*.

1888 Jacob Riis photographed the New York slums. Van Gogh painted *Sunflowers* and *Night Café*.

1889 In his book *Naturalistic Photography* P. H. Emerson, the impressionist photographer of East Anglia, advocated slight out of focus "fuzziness".

1891 Alfred Stieglitz took hand-held studies of New York. Emerson recanted on his earlier opinion and denounced photography as "the lowest of all arts".

1893 First exhibition of London Salon devoted to pictorial photography.

1895 Paul Martin photographed London at night. The Lumière Brothers invented the cinema; Eduard Munch produced *The Scream*.

1898 Jean E. A. Atget started photographing Paris at the age of forty-two.

1901 Picture postcards, a new craze, used photography for the first time.

1902 A group of American photographers, including Stieglitz, Coburn and Steichen, formed the Photo-Secession dedicated to raising the status of photography to that of other arts. Stieglitz published the influential journal, *Camera Work*, which lasted until 1918. The magazine charted the changing attitudes away from Victorian pictorialism of the nineteenth century towards the 'straight' photography of today. The last issue showed only the work of Paul Strand.

1904 *The Daily Mirror* was exclusively illustrated with photographs, the first paper to be so. Cézanne painted *Mont St. Victoire*.

1907 The Lumière Brothers introduced the first practical colour plate, the *Autochrome* process. Picasso outraged conventional art opinion with his *Les Demoiselles d'Avignon* and initiated Cubism.

1911 Wassily Kandinsky's treatise on Non-objective art, *Concerning the Spiritual in Art*, justified the first Abstract painting.

1916 Alvin Coburn's *The Future of Pictorial Photography* devised the abstract photograph the *Vortograph* based on multiple images.

1918 Christian Schad, a Dadaist, discovered the *Schadograph*, prints made directly without a camera, later exploited by Man Ray and Moholy-Nagy as the photogram.

1919 *The Cabinet of Dr. Caligari* started an expressionist cinema style based on shadow effects.

1920 Kurt Schwitters made collages of rubbish and Marcel Duchamp discovered "found" art as their contribution to Dada or anti-art. John Heartfield, Max Ernst, George Grosz used photo-collages.

1923 Moholy-Nagy started a photography department at the Bauhaus in Weimar.

1925 The first Leica marketed.

1927 Atget died at seventy-one, his work virtually unrecognized except by the Surrealists.

1928 As part of the New Objectivity movement, Renger-Patzsch published *The World is Beautiful* illustrated with "straight" photographs to a hostile reception by the Royal Photographic Society.

1931 Dr. Erich Salomon took "candid" newsphotos.

1932 Formation of the F.64 Group, the American "Realist" school, including Edward Weston and Ansel Adams. Henri Cartier-Bresson began photography.

1934 André Kertesz used distorting mirror to photograph nudes.

1936 Roy Strykes headed a team of documentary photographers in U.S. Government project which included Walker Evans, Dorothea Lange and Ben Shahn. *The English at Home* by Bill Brandt published. *Life* magazine started publishing with a Margaret Bourke-White cover.

1937 Walker Evans' one-man show at the Museum of Modern Art, New York.

1938 First issue of *Picture Post* published.

1944 Robert Capa recorded D-Day landings in Normandy.

1947 Magnum photographic agency established by Cartier-Bresson, Robert Capa, David Seymour and George Rodger.

1949 Introduction of Hasselblad camera.

1951 *Masters of Victorian Photography* exhibition at the Victoria and Albert Museum.

	
1953	*The Decisive Moment* by Cartier-Bresson published.
1954	Steichen presented his *Family of Man* exhibition, which travelled the world.
1957	*Picture Post* closed.
1959	Richard Avedon's *Observations* published.
1960	*Moments Preserved* by Irving Penn published. Dr. Edwin Land challenged the established theories of colour vision.
1961	*Perspective of Nudes* by Bill Brandt published.
1962	Pop artists held first shows which exploited photographic images.
1965	Sam Haskins' *Cowboy Kate* published. First photograph of the far side of the moon.
1968	Aaron Scharf's book *Art and Photography* published. Cecil Beaton's one-man photography exhibition at the National Portrait Gallery.
1971	First exclusively photography auction at Sotheby's included works by Fox-Talbot and Julia Margaret Cameron. The Photographers Gallery, London, opened the first British venue devoted only to exhibiting works of photographic art.
1973	Daguerreotype of Edgar Allan Poe auctioned in Chicago for a world record price of $8,000.
1975	Sotheby's held first auction of the work of living photographers.

IV Colour and Black and White Photography

"So many photographs – and paintings too, for that matter – are just tinted black and whites. The prejudice many photographers have against colour photography comes from not thinking of colour as form. You can say things in colour that cannot be said in black and white." Edward Weston's statement immediately introduces several relevant points. It comes from one of the most important artist-photographers of this century who made his name in monochrome photography and who, in fact, hardly ever used colour. Perhaps Weston was himself one of those who distrusted colour. But why the prejudice against colour?

The great period of creative photography, when photography was slowly assuming its rightful place as an independent medium of creative expression, took place in the first decades of this century before colour photography was generally available or indeed readily feasible. Thus everyone became accustomed to reproductions of fine monochrome photographs. Photographers achieved almost total control in the use of black and white, a control which allowed for free creative expression. At the same time, the quality of reproduction in periodicals, and especially in fine books, also attained a great degree of perfection. The same cannot be said of colour. Although colour transparencies were freely available from the early thirties and soon achieved a very fine quality, yet to reproduce accurate reversals or prints in colour proved more difficult. Hence most of the leading photographers, having achieved mastery of one medium, hesitated to switch to another.

In these days the use of colour, and its reproduction, is no longer a problem. More monochrome photographs are still being produced than colour but this imbalance is undoubtedly due to the high cost of colour and not to any aesthetic considerations. In spite of this, there still appears to be a residue of prejudice in some photographers' attitude to colour.

Colour film, of course, often does not allow for as fast a shutter speed as black and white; its grain structure is less fine and in the long run, colour transparencies, and particularly prints, are less permanent than monochrome. But these are purely technical limitations and not of crucial importance. It is far more difficult to assess and to explain the prejudice on aesthetic grounds. These are often unclear, and mostly due, one feels, to habit and old-fashioned thinking. One of the main criticisms is that colour is too bitingly realistic, that it leaves too little to the viewer's imagination. This complaint raises two perhaps contradictory questions:

if realism is the foundation of the photographic medium, why should it be objected to and, secondly, how realistic, in fact, is a photograph?

The objection to realism, which is presumably enhanced and emphasized by colour, is an ancient grudge stemming from resentment that photography did not manage to compete with painting in the 'art for art's sake' stakes. The fact that most people did, and still do, hang paintings on their walls rather than photographs was always blamed on the too-great realism and fine detail inherent in a photograph and that unlike some paintings, a photograph hates to lie and beautify and extol a subject beyond its real appearance. And, of course, colour can show blemishes in nature much more uncompromisingly, particularly if handled by an unskilful hand. Paradoxically, in *Aperture*, Robert Frank, awarded the Guggenheim Foundation grant for the specific purpose of recording contemporary America, is quoted as saying, "Black and white are the colours of photography. To me, they symbolise the alternatives of hope and despair to which mankind is forever subjected. Most of my photographs are of people; they are seen simply, as through the eyes of the man in the street. There is one thing the photograph must contain, the humanity of the moment. This kind of photography is realism. But realism is not enough—there must be vision, and the two together can make a good photograph. It is difficult to describe this thin line where matter ends and mind begins." It would appear that Frank considers black and white photographs not less but more realistic than colour because, through usage and general acceptance, "black and white are the colours of photography".

As to the realism of a photograph: the camera is often likened to an eye. In certain respects both work on similar principles but the differences between the two are still quite extensive. The eye is selective, unlike the camera which must include a certain amount of the adjacent ground in whatever it sees. At the same time, though the eye concentrates on a specific subject, it is *aware* of much more than the photograph is able to show. The stereoscopic vision of the eyes, each eye seeing a slightly different image, records a three-dimensional image, with space and distance well registered; the camera (unless stereoscopic) cannot do this. The eye has an exceptional faculty to open up for low light and close up for too high a degree of brightness, while the camera either records no detail in the shadow or the excess of light bleaches the highlights. An advantage of the camera is its greater sensitivity to slight changes of colour. The eye adjusts so easily to small discrepancies that this often leads to visual divergences between the camera image and the perceptual recognition. Hence the camera is often accused of recording wrong colours, whereas it is

Man on a Bench—Richard Tucker page 25
The natural colours of the original image are contrasted with distorted colours, created by duplication. In spite of the complete change, the distorted colours are visually not too excessively disturbing. Human perception is often capable of adjusting to even strong distortions of natural colours, especially when the divergence suits the emotional character of the image. This is at least partly due to the already generally accepted idea of black and white photography, which is in itself a distortion of natural colours.

The White Tree—Ewald Stark page 26
Often by the effect of light the ordinary becomes phenomenal. At times the photographer by his action or special method makes it possible. At other times, as happened here, he creates it merely by being there at the right moment and by virtue of his sensitive perception.

Portrait of Francis Bacon page 27
In this case the mood of strangeness and unease, suited to the personality and work of the painter, was created by the optical effect of photographing an image of the artist reflected in a damaged mirror. Colour distortion completes the bizarreness of the portrait.

really the eye which errs. A further difference is that of recording perspective. The standard lens, which is the nearest approximation to our vision, does not correspond entirely with the vision of the eye, the camera recording distant objects smaller than the apparent image to the eyes, and the slightest tilt of the camera elicits immediate convergence of verticals which the eyes can adjust and correct.

When one comes to a comparison of colour and black and white photography, most of the preceding points have to be taken into consideration and a few re-examined. A colour photograph effectively gives a relatively more naturalistic and true to life record of reality than one in black and white but there are some reservations. It is remarkable how accustomed we became to looking at monochrome photographs, hardly aware of the lack of colour. We accept a black, white and grey rendering of an obviously colourful scene as a true record and a statement of the fact, another example of how deeply embedded is our belief in the authenticity and reliability of a photograph. Yet it is merely a translation, a graphic copy, an engraving of, as it were, an original Raphael painting in full colour.

Admittedly it is an expert translation, the rendering of light and dark colours in their respective light and dark greys, is now as good as it is possible, but it is still only a translation. Colour film, one would say, is an enormous improvement, our emulsion is no longer blind to all reds and oranges, like early orthochromatic plates, neither is it unresponsive to greens, as the later panchromatic films. Yet certain, even small, inaccuracies of recording colour are far more obvious and more irritating than they are in black and white, and bring a charge of "unrealistic", "un-lifelike", an emotional response never occasioned by black and white. Colour and emotion are clearly bound together as we show in our next chapter but it is not only the experience of colour that affects us emotionally in an image or in nature, shapes and lines can also evoke an emotional reaction, otherwise none of the great black and white photographs could have exerted their impact. The effect of colours is, however, far stronger and much more specifically emotive. There is a marked difference in our response to colour and to shapes and lines, or design: colour involves passive, not consciously controlled emotion and design a certain amount of intellectual activity. As Professor Arnheim states it: "In colour vision, action issues from the object and affects the person: in order to perceive shapes the organising mind goes out to the object." Schachtel, another eminent German Gestalt psychologist, insists quite emphatically that "emotion is not the product of organising mind", hence colour, being an emotion, is an activity outside the control of our intellectual processes.

Photographs by David Lavender pages 28, 30, 31
The photographic process, by its nature, is rooted in the multiplicity of forms and the diversity of events abstracted from the commonplace. By isolating significant detail from the complexity of urban life, a series of variations directly seen and formally recorded, gives expression to a way of life and its social values. The man-made object gives substance to his designs and the camera merely records them for our contemplation. Meaning is revealed through isolation and selectivity.

That colour is a powerful and almost organic emotion is beyond much doubt. It has been established, for example, that pre-school children respond to colour more strongly than the ones who have been already influenced by learning and cultural pressures. Even more interesting are the experiments investigating our personal responses to specific colours. Of these the contrasting sensation of warm and cold colour relationships is, perhaps, the most revealing. From the point of view of physics, since each colour is distinguished by a different length of its wave, the 'warm' band of colours with red at the apex are all characterized by a longer length of wave, red being the longest that human eye perceives. Conversely the 'cold' colours, with dark blue the coldest, are all of short wave characteristic. As far as we know, no logical or scientific connection between the length of the wave and its respective emotional effect exists. But we know that warm colours, like red, do stimulate a strong feeling of excitement, it was even established that the physical reaction can be scientifically demonstrated. Charles Feré discovered that lights of different colours affect our muscular power and also blood circulation. He found that both increase appreciably when a red light is perceived and correspondingly decrease with a change to blue light. Another scientist, Dr. Goldstein, described his experiments with patients affected by serious nervous disorders and brain defects. Apparently they became invariably markedly agitated on seeing red. Though these are scientific confirmations of the strong effects of different colours, they are by no means entirely new discoveries. Some racehorse owners used to paint the stalls of their star-performers in soothing shades of blue, since warm colours made horses excited and sweat before the race. It was also discovered that people feel warm at a temperature of about 52° to 54° in a room painted red-orange, while almost shivering at 59° in one painted blue. Some thoughtful and meticulous lovers, so history relates, took account of this phenomenon and their love-nests were accordingly given a warm and inviting colour scheme.

Warm and cold colours have parallel properties in design and composition. Wassily Kandinsky, reputedly the first artist to paint a totally abstract picture, in 1910, but also an important theorist and writer on emotional effects of colour, wrote that "a yellow circle reveals a spreading movement outwards from the centre, which almost markedly *approaches* the spectator...and a blue circle develops a concentric movement (like a snail hiding in its shell) and moves away from the spectator".

When Weston remarked that "So many photographs... are just tinted black and whites. The prejudice many photographers have against colour photography comes from not thinking of colour as form", he was observing that, since patches of various colours are not merely the counterparts of dark and light areas in a black and white picture, they must possess their own distinct properties and values. Not only will an area of dark red, for example, affect the overall image differently than a corresponding area of dark grey or black, but the combination of redness with a patch of adjacent green will introduce an entirely different visual experience than that encountered in a monochrome image. Insensitive and unthinking photographers, says Weston, in effect, do not alter their way of looking and composing when they change to a colour film. Hence their pictures are merely tinted and not *seen* in colour.

Colour is described as a kind of energy whose forces exert some kind of pressure entailing emotional reaction, the precise nature of which cannot be explained. Naturally the force of impact of different colours, the energy they generate, varies greatly. Goethe in his studies on colour suggests the following values:

Yellow	Orange	Red	Violet	Blue	Green
9	8	6	3	4	6

This can only be an inspired estimate but, as no one seems to have produced a better grading, it should be kept in mind, though not strictly adhered to, in the formulation of colour compositions. It is interesting as a theoretical indication of the wide range of visual impact of different colours. It is not surprising that yellow, the brightest and strongest of the hues, is classified as fully three times as powerful as violet. This would indicate that a patch of yellow, only a third of the size of that of violet, will exert an equal visual power within an image. This kind of visual mathematics in photography should be considered only on a theoretical basis but it does give a more vivid indication of the complexity of problems in colour composition which is further complicated by the problem of real, that is objective, as against unreal, or subjective, colour.

Pure recording, where accuracy and authenticity are of prime importance, naturally requires the use of only objective and realistic colours. But as the eye may perceive a certain colour differently than the camera film, these are the problems that the realistic photographer must resolve, for in some cases a technical, artificial modification of the colour may be a better alternative from a realistic, if not entirely objective, point of view. Whatever the photographer may decide to do, everything should be directed towards an interpretation which matches the image of the eye as closely as possible. In pursuit of objectivity, colour cannot be forced to perform tasks which are at variance with reality, yet the recorded image may still appear to be somehow different than the perceived one. For instance, a certain accent of colour, which might have been hardly noticeable when the scene was viewed, can become pronounced in the finished print or

transparency. Once the movement of the eye viewing the scene is gone, certain features can assume quite different proportions. An objective photographer should, in all fairness, take this discrepancy into account and be able to see the scene, as it were, photographically, be able to adapt his vision to a final photographic impression. This is the reason why one sees some photographers framing the scene by cupping their palms, or using artificially produced frames. The problem is not so much the question of isolation of the image, although this can help, as that most photographs tend to look more colourful than the real scene. Hence more subdued and gentler combinations of colour than those perhaps recorded by the film may be advisable.

Total objectivity and mental passivity is, however, only one way of using photography. Photography can and should concern itself also with expression and should create images which not only inform and explain but also communicate emotion and even subjective, personal points of view. Consequently a creative photographer should not forgo such a powerful, expressive medium as subjective colour.

Since the early 1860s when Rejlander printed thirty negatives on to one piece of photographic paper and produced his monumental *Two Ways of Life,* the debate has continued whether photography should rely only on natural, real sources and one shot negatives or should be allowed an entire freedom of all possible treatments and even a mixture with other media. But the debate should surely be restated as whether any unorthodox treatment can enhance the effect of a photograph and increase the scope of the medium as it has been analysed. For, in the first place, it is almost impossible to establish what is real and what is not; secondly the authenticity of any photograph in comparison with an actual scene which it purports to represent can be questioned in many ways; thirdly the degree of authenticity is even more questionable and open to arguments with regard to colour. Colour is such a flexible and imprecise medium that no two observers and critics can see it in precisely the same way. Lastly, the whole area of creativity, art and freedom of expression is so fluid, tenuous and controversial, that it would be totally arrogant to suggest that only one opinion or one set of principles could be acceptable to all photographers. A simple change in the angle of shooting or an emphasis created by the use of a wide angle lens may represent to some a deviation from reality and a subjective choice. For others a coloured filter, radically altering the whole colour of the scene and its overall mood, may be termed a poetic licence. This decision has, ultimately, to be left to the individual photographer. In later chapters a number of possibilities in controlling artificially introduced colours will be reviewed, but at this stage, it may be interesting to

Boat on the Lake—Richard Tucker **page 34**
Drop of Water—Richard Tucker
Degrees of abstraction are created by the optics of the camera. The first example retains a good deal of its figurative elements, while the second, since it is in fact a large magnification of a drop of water, loses all its real identity.
Photography, by and large, is not a most suitable medium for exploration of total abstraction. The main attraction of "Boat on the Lake" is the fact that the subject of the picture is so highly "abstracted" and yet identifiable. Human perception is highly sensitive and exceptionally adapt in solving visual riddles. While the subject matter of the second example is not so easy to identify, it offers the viewer a chance to interpret it in a number of ways and expand its meaning in his own imagination.

The Golden Frame **page 35**
The previous illustrations were produced solely by the manipulation of camera mechanism; here the "abstraction" from reality is wholly and specifically man-made. It is an image produced by a combination of natural and contrived elements arranged to create an illusion between the dual existence of art and nature.

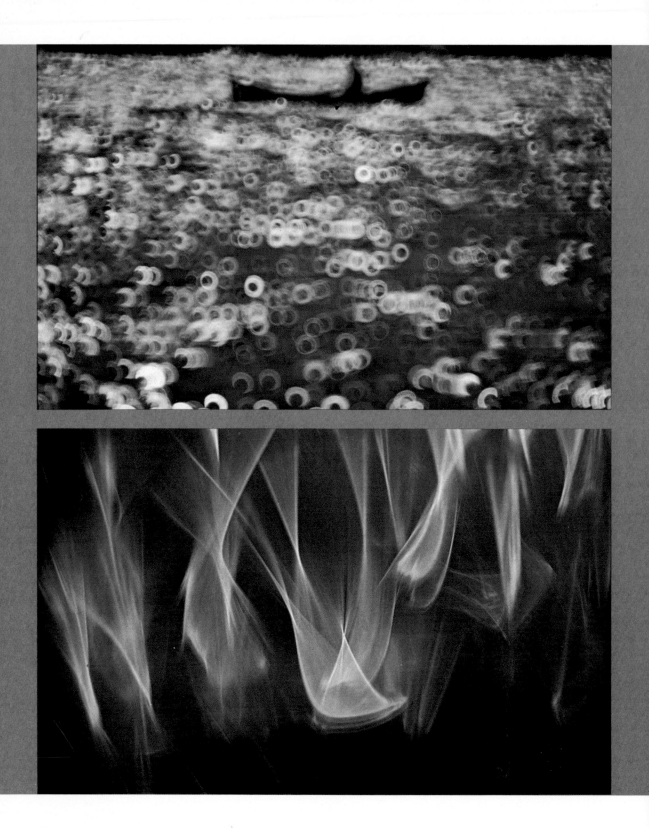

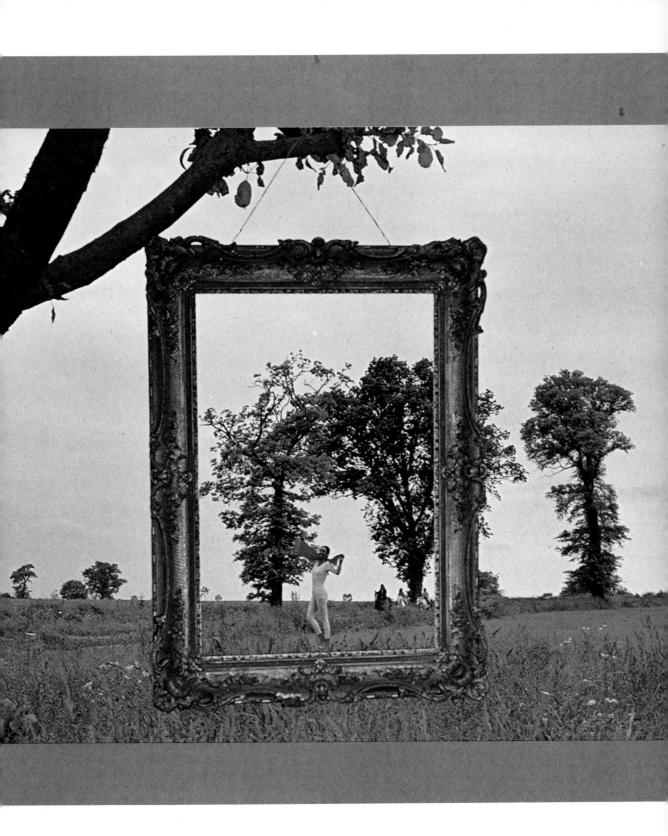

establish some rough guiding lines and to discuss if there should be a limit to such tampering with the colours of reality.

We have said that photography does not thrive on artificial arrangements, invention and sham, and that, generally, a distortion of colour, even small, is discovered more readily by the film than by the eye. Having now combined these two statements, it may be considered that they invalidate any possibility of a deliberate deviation from realistic colour. However, to notice that a colour is not completely natural does not mean that it is also objectionable. Richard Tucker's *Man on a Bench* (p. 25) may serve as an example. It is reproduced here both as it was shot in the natural colours of an overcast, dull morning, and also in an artificially coloured version where the whole image is tinted blue. It is obvious that, side by side, the coloured version jars somewhat but the emotional objection is not too strong and would be even less so if only this version was reproduced. The second example is the portrait of the painter Francis Bacon (p. 27). It was shot on *Agfachrome 50 S* (daylight) but with artificial illumination, hence the overall yellow tone, which is noticeable but not disagreeable. The reason for using an apparently unsuitable film was an attempt to add a sense of distortion and strangeness to the image both in form and in colour which might help in a subjective interpretation of this powerful but haunted artist.

In every day life we are used to seeing scenes, objects and people under different light and colour conditions. Yellow, anti-fog street lighting plays havoc with the faces of our companions, multi-coloured theatre and music hall lights are a fairly common experience. We often see red clouds at sunset and blue lips and noses on a cold January morning. These accepted distortions of colour make us more impervious and tolerant to subjective colours in images especially as we have become accustomed to the liberties taken with colour by modern painters. If certain departures from natural colour, for expressive and aesthetic reasons, are accepted as feasible and palatable, a new field opens for a creative photographer. Some unusual effects of colour can be so efficacious and powerful that perfectly commonplace and otherwise ordinary photographs can become strangely impelling because of one imaginative colour accent. *White Tree* (p. 26) is an example of such a picture, a pleasing but essentially drab landscape is positively lifted visually by the unusual colour of its only tree.

In conclusion we must return to the last sentence of Edward Weston's statement that "You can say things in colour that cannot be said in black and white." It is questionable whether colour is always an advantage. In Robert Frank's raw statements about human relation-

ships, colour would most likely have been a hindrance for it is liable, at times, to add a touch of romanticism or softness to the austerity of a black and white statement. And on occasions colour seems to have some qualities of its own which may present a problem to a photographer. Since colour and the elements of pure design are both to some extent expressive, it does not follow that they both have to express the same visual message. In fact, often, they may not fit one another. Imagine a war picture by Don McCullin containing rough shapes of war-torn landscape, with broken trees and bodies of dead soldiers. This is clearly a violent image, yet it may be accompanied by an early morning romantic mist and the delicate, light pearly-pinks of the rising sun. It can be argued that such a delicacy of colours demonstrates more grimly and ironically the general scene of destruction, but colour, in this case, would not intensify the theme as presented.

Thus it is important that the photographer is aware that colour and design often mean different things within the image, and should be seen as two separate entities. He must be aware of a possibility of a clash between subject matter and the attendant colour scheme. Equally the photographer often may not be able to do much about it, that is why both Frank and Cartier-Bresson avoided colour. But most photographers cannot ignore the issue, most simply want to use colour and perhaps a compromise should be reached. A colour filter, which will minimize the clash, can be used or a different point of view or even, if possible, a different time of the day. There may be occasions when colour interferes with or contradicts the photographer's intention but these are compensated by the times when colour makes the picture. How much more difficult to try to express the freshness of spring without pastel colours of nature or the delicate beauty of a child without the soft colours of skin tones; fire looks dead, and far less frightening, without its rich tones of reds, and water less cool and refreshing without its deep blues and greens.

page 38
When colour is subtle and almost monochromatic, the pictorial values of light and dark, and the richness and delicacy of tonalities normally associated with black and white photography, dominate. Atmosphere is created by the quality of light and the mood is set within tonal scale.

A square in Prague—Gert Koshofer
Capitol—Rome—Gert Koshofer page 39
Complexity of form and contrast in scale evoke their own mood. The special juxtaposition of foreground and background add force to the vitality of city streets, creating a sense of personal involvement of time and place gently observed through the eye of the ultra wide-angle lens.

The Medium of Colour

"When you look into a mirror you do not see your reflection, your reflection sees you."

Japanese Proverb

I The Perception of Colour

Of all the miracles of the human body the act of seeing and perceiving is perhaps the most astounding. We lift our head and see the early morning sun filtering through the branches of the tree, silhouetting the green edges of the leaves, and brushing lightly the crowns of fresh, day-old crocuses. We catch our breath in wonderment and delight but all our awe is reserved for the beauty in front of us and none for the way in which our senses managed to perceive it and to interpret it with such precision. We tend to take the miracle of seeing for granted and yet the incredible intricacy and delicacy of the act of perception becomes apparent only when we examine it more closely.

We have gone a long way from Leonardo da Vinci's drawing of the human head, with the eyes as lenses roughly connected by a few strands of fibres with the brain. Even so Leonardo was the first to think about the eyes as an outpost of the brain. Over the next five hundred years, many of the riddles of human perception were unravelled, peeled off patiently like the layers of skin on an onion. But in spite of precise instruments and immense ingenuity, a great deal still remains uncharted. Certain aspects of our space perception, of our mechanism of seeing movement and certainly a great deal about our vision of colour, remain undetected and unexplained, or at least unproven. We have not reached the central core of the onion.

Some parts of the mechanism of seeing seem simple enough. The eye, we think, is a little like a lens of a camera which records the images of the world and our two-eyed system is something like those stereoscopic pictures we peer at through double lenses. It gives us, we argue, the sense of space, it is our 3D unit. But how about the image itself? Supposing that it is formed as the layman imagines, how is it transmitted to the brain; how is it decoded; is there another image formed within the brain; how, in turn, is the one in the brain explained, by yet another one? The 'photocopy' in the brain theory was advanced at one time by Gestalt psychologists, but was finally rejected as untenable. There are no duplicate images, part or whole, recorded within the brain, merely a multitude of signals, a sort of shower of Morse code pulses, transmitted into the brain. These signals are mostly received in the visual cortex of the brain (which deals largely with visual perception), but some are also received and acted upon in the central portion, the *Superior Colliculus*. As the name implies, this part seems to be a superior general co-ordinating exchange which possibly interprets the more sophisticated parts of the visual message, as well as dealing with other sensory signals like hearing and taste.

Given that approximately one and a half kilograms of grey 'brain cells' are almost completely indistinguishable from one side of the head to the other, one can imagine how immensely difficult it is to establish which parts of the brain handle certain stimuli and how. Moreover, since anatomical investigation of a dead brain is useless, research had had to be confined either to animals or to humans with certain brain damage. Another method of research into the visual mechanism of the brain is through gentle prodding of certain parts of the brain, uncovered during an operation, with tiny electrical shocks. Wilder Penfield, the Canadian neuro-surgeon, discovered that the stimulation of the visual cortex resulted in visions of rotating coloured shapes and that the stimulation of various other parts of the brain often prompted images of objects and even complete and complex visual stories.

We know this happens but not why, for we still know very little about the method of decoding the stream of electrical pulses, the various visual messages, sent continuously from the retina to the brain. The Gestalt theory of perception provided a hint by suggesting that the human eye, with the help of the brain, can extricate a great deal of information from a very small and vague visual stimulus. A shape of the head or a characteristic movement of the body can clearly reveal a friend, a line or two in a drawing will prompt an image of a house. Thus it seems that the messages in the brain can be translated into meanings on minimum information, perhaps a simple pattern of signals can conjure up a complex concept.

The analogy between the brain and an ingenious computer is inescapable. It seems that in the vast memory of the brain resides an incredible store of information and records, from the most trivial to the most complicated and that this store of ideas, shapes, lines, colours and textures is immediately put at the disposal of each incoming message. The message is promptly analysed and related to the relevant stored memory item and, once the match is made, the identification and classification is fed into the appropriate chamber of the brain. The incredible flexibility of the brain seems even greater when we realize that the signals sent from the eye are very uniform. They are always of the same duration, although their frequency and number change all the time according to the nature of the message. These signals are transmitted directly from the retina of the eye, which in itself acts at least partly as a miniature brain, and are conveyed by the *Axon* nerve to one of the nearly 200,000,000,000 cells in the brain and from there distributed by the smaller neurons.

page 42
A sectional, three-dimensional model of the structure of the human eye reveals its camera-like lens, iris and photo-sensitive retina, on which is projected the inverted image of the external world. However the mechanism of "seeing" lies outside the eye as a mental process, and any resemblance of human perception to photography does not extend beyond the "camera/eye" concept.
Photography is mechanical and objective, being scientifically predictable, whereas perception is subjective and influenced by psychological and even cultural factors. Seeing is an intangible, personal construct based on visual experiences, whereas the images of the eye are filtered through a psychological haze of emotions, memory and expectations, the camera merely records patterns of light without meaning or personal involvement. Through the eye the brain constructs meaning, the camera combines with the photographic process to give us perfect visual recall without prejudice or interpretation.

Top illustration **page 43**
The Structure of Photo-Mechanical Images
A magnified section of a printed colour image where the colours of the spectrum are reproduced by three colours—yellow, magenta and cyan. When superimposed they give an illusion of natural colours. The principle is based on subtracting, by absorption, the three primaries—blue, green and red lights from each of the separate images.
Bottom illustration
The Close-Up Structure of a Colour T.V. Screen
The appearance of the screen is similar to Thomas Young's structure of the retina, composed of three colour receptors. The cathode ray tube performs the electronic equivalent of Clerc Maxwell's experiment using three projected images of red, green and blue light. The T.V. mosaic, made of phosphorescent dots, is mixed optically in the eye to recreate the original colours.

43

The eye resembles a camera in many ways, or should one say that the camera design was obviously inspired by the eye. This miniature camera, in the form of a nearly spherical globe, approximately 20 mm in diameter, is wrapped in three membranes and suspended within the socket. The movement of the eye is controlled by six muscles, allowing a variety of movements and these movements are strictly co-ordinated between the two eyes. This co-ordination is essential since on the precise comparison of any slight disparity of the angle of the vision between the two eyes, our judgement of space and distance largely depends. Light having passed through a layer of clear, liquid aqueous humour (which is completely renewed every two hours) penetrates the opening of the pupil, regulated by the iris, and enters the crystalline lens. The incredible precision of the eye's construction is emphasized when we consider that all the substances through which the light has to pass are unique in the human body. Both the cornea, the outer cover of the eye, and the lens are made of a special substance without any blood vessels, which naturally would hamper clear vision. The lens itself is attached to the eye by a membrane, the *zonula,* which can change the shape of the lens by altering its tension. The iris is the 'personalized' part of the eye. It is the pigment in the iris which gives different eyes their distinctive colour – blue, grey, green, brown – but, more to the point, the iris serves as the aperture of the eye. The ciliary muscle controlling it adjusts the opening of the pupil according to the quantity of light striking it. Hence for so-called scotopic seeing (under very low lighting conditions) the iris allows the fullest opening of the pupil to admit the maximum amount of light.

The only somewhat inconsistent and illogical feature of the eye is the retina itself. The image, in the form of particles of light, travels through the lens and lands as a tiny, reversed replica on the light-sensitive rods and cones of the retina at the back of the eye. But these light-sensitive cells are not placed in what would seem to be the logical position, in the front of the retina facing the light. On the contrary, they are right at the back, so that the light has to pass through nerve cells and blood vessels. One would have thought that this kind of arrangement would cause a serious impediment to our vision but the illogicality is relieved by the fact that most of these nerves and blood vessels are twisted away to the sides of the central portion of the eye so that the most sensitive and accurate perceptual area, the layer of rods and cones, is fairly clear.

There are approximately six to seven million cones and in the region of fifty million rods in each eye. The action of the light bleaches the ends of these super-sensitive cells, and creates a minute electrical current which is transmitted to the brain. The role played by rods and cones in vision has been established but the controversy about the way we are able to perceive colour was, and still is, even more heated than the quarrel about the particles or waves theories of light. Some facts are not disputed. We now know that the rods, which far outnumber the cones and which occupy a large proportion of the light-sensitive area of the retina, are only sensitive to black and white stimuli, obviously including various shades of grey. It is the cones, situated mostly in the central, more acutely sensitive area, that are capable of experiencing and transmitting the sensation of colour although the rods are more susceptible to low levels of light. Thus in a darkened room, the rods take over most of the function of seeing and, since they are colour blind, we see shapes and objects virtually devoid of any colour.

The fact that we know that the cones are the actual receptors of colour sensations does not in any way explain how various colours are received, transmitted to the brain, and then decoded. Since all the cones are, as far as our present instruments can tell, entirely identical, there is no way of ascertaining which ones are responsible for the reception of green, red or any other colour.

The first plausible colour receptor theory was advanced by Thomas Young, the English doctor and physicist, more than a century after Newton's revolutionary revelations. Young argued that, since there are well over a hundred different discernible hues in the spectrum, it is virtually impossible that the eye can have receptors for each of these separate colours. Therefore he concluded that there are only three types of receptors, each responsible for one colour. At first he thought that these colours were yellow, red and blue, later he changed his mind and suggested that they were red, green and violet. As we know, the intermixture of any of these three colour combinations will give any imaginable hue. Young's theory was later expanded and improved by the German scientist, Herman von Helmholtz, who substituted blue for Young's violet and who suggested that each colour sensitive cone does not only respond to one specific colour; it responds predominantly to one but also reacts, to a much smaller degree, to the other two. This modification of Young's theory explains more clearly why we are able to distinguish small nuances in colours, as well as impure or desaturated hues. The exclusion of yellow which is also a pure, distinct and fundamental colour of the spectrum constituted the strongest argument against the Young-Helmholtz theory.

In the 1870s, another German scientist, Ewald Hering, advanced an alternative explanation of colour vision. His theory was again based on the assumption that there

are three types of receptors but that each of them reacts to two colours, not one, thus working in pairs. Hering suggested that the colour pairs were black and white (the rods only), red and green and blue and yellow. The hues in each of these pairs are at once 'antagonistic' to each other in that they are incapable of blending – there can be no reddish green for example – and complementary to each other in that only one colour can act within the receptor simultaneously with the other. The exception is black and white which produces various shades of grey.

It is now apparent that though both the Young-Helmholtz and Hering theories have certain advantages, possibly the combination of the two is the real answer. The compromise reminds one of the particle-wave controversy. Recent researches and experiments suggest that the Young-Helmholtz 'alternative' functions at the start of visual sensation, the three types of cones, blue, red and green, receiving the light but that this initial impulse is filtered through to a second line of bipolar and ganglion neuron cells immediately above the cones before transmission to the brain. This second line of detectors, working as a distribution centre, may function on the Hering principle of three pairs, white-black, green-red and blue-yellow, and that it is in this second stage that the colour impulses are sorted out into accurate hues.

It may not be long now before we finally solve completely the riddle of colour vision but at every step one is faced with a host of related questions. Is seeing entirely objective or is it a subjective activity; do we always see only what is really in front of us; do we have to learn to see; is the mechanics of seeing a genetic feature, or does it have to be developed slowly? It was Ruskin who noted how defective and inconsistent our perception of colour is. In an experiment to prove how a perceived colour differs radically from the actual one, he used to ask his students to paint a patch of green corresponding to a specific leaf-covered branch of a tree while sitting at a certain distance from the tree. The students were then asked to take an actual leaf from the branch they had been painting and paint it again, matching the colour as closely as possible. The difference between the colouring of the first and second study invariably astounded them.

This experiment proves how radically we can misinterpret a colour when actually looking at it. Even more startling are the errors of perception in imagined or remembered colour. Sometimes our colour memory is predictably subjective and it seems that we tend to remember colours redder or greener than they were in reality. But one of the reasons for our mistakes is a preference for colour constancy. Our colour memory archives register hundreds of thousands of various

Unusual Objects **page 46**
Our eyes give us much of our information, sometimes useful, but often irrelevant to our particular needs. Some things are worth remembering and recording for their beauty, some for their practicality, others for their strangeness or juxtaposition. "Found objects" were first legitimised by Marcel Duchamp as a new form of art, in an attempt to bridge the gap between life and art.

Accidental Images **page 47**
The act of recording an event, as seen, is transformed by the photographic process through the mechanism involved in fixing the image. Unanticipated changes can occur between seeing and recording. Such chance events can both ruin a pictorial perception or, when fortune is favourable, create a new image beyond expectations.
Faulty camera mechanisms, errors of exposure and even accidental exposures can produce a form of "automatic" art as exploited by the Surrealists.

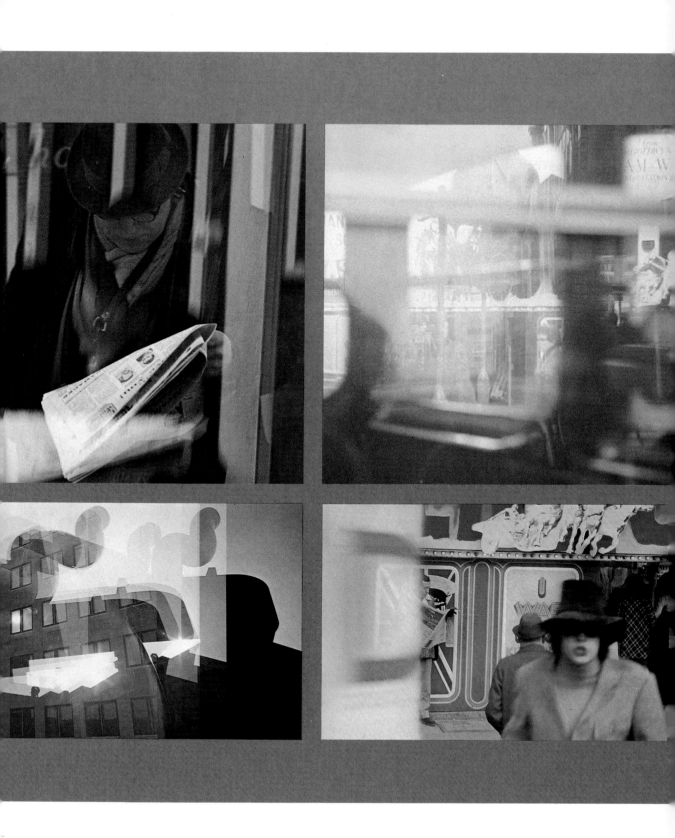

customary hues of objects, scenes and people in the course of a lifetime. These stored conceptual cues are put into operation the moment we look at an object, mental computing occurs, and the brain comes up with an identification. A certain object, for instance a red fire engine, is always painted in the same shade of red but it may appear to vary considerably under different viewing conditions: it may look positively bluish parked next to a blue house, or with the blue sky reflected in it; it is far redder under artificial light than in the daylight; areas in shadow may show tinges of complementary colours, or it may lose a lot of its brilliance in the dusk. Yet the colour constancy phenomenon makes us see and remember the red of the engine fairly uniformly. The constancy phenomenon also relates to remembered shape and form, modifying our perceptual experience in line with our memory cues, with spectacular effect when it comes to the size of objects as seen at various distances from the eyes. Two tennis players, seen from one end of the court, seem hardly different in size, and yet objectively speaking the more distant one must be at the most half the size of the near one. This visual deception can easily be illustrated by holding the palm of one hand close to the eyes and of the other as far away as possible. Although the size of one hand halves with the doubling of the distance, size constancy makes each hand seem almost equal.

How perception is learnt is an even more complex and unexplored question intriguing psychologists and physiologists alike. It is a difficult subject to research scientifically as none of the current lines of possible research can be effectively controlled. Apart from some experiments with animals, the most interesting areas for enquiry are studies of the responses of young children and of people who were blind from infancy but gained sight at a later stage. The analysis of the visual responses of babies is complicated and disputable and the chance to observe people who regained sight infrequent. The most interesting results in the first category were achieved by R. L. Fantz who constructed a special cot with instruments above the babies' heads so that a child could be observed and photographed with some degree of constancy. Images or objects were shown in pairs and the direction of the babies' eyes noted. Dr. Fantz's studies show that small babies already display a certain preference for face-like rather than random patterns, and simple, regularly shaped objects rather than irregular and meaningless ones. From these experiments it can be inferred that a certain amount of perceptual recognition is at least partly hereditary. Another experiment performed by Eleanor Gibson confirms this by showing that the baby will not fall from a high level, that it instinctively notes some primitive spatial discrepancies. R. H. Gregory conducted a series of tests and interviews with a man, who,

page 49
The art of photography is the art of seeing, exploring and sensing the forms, shapes and colours that surround us, not merely to identify or name them as objects, but to delight in their visual structure and variety. An aesthetic response to the external world, through the sensuality of form, finds expression in art and photography.

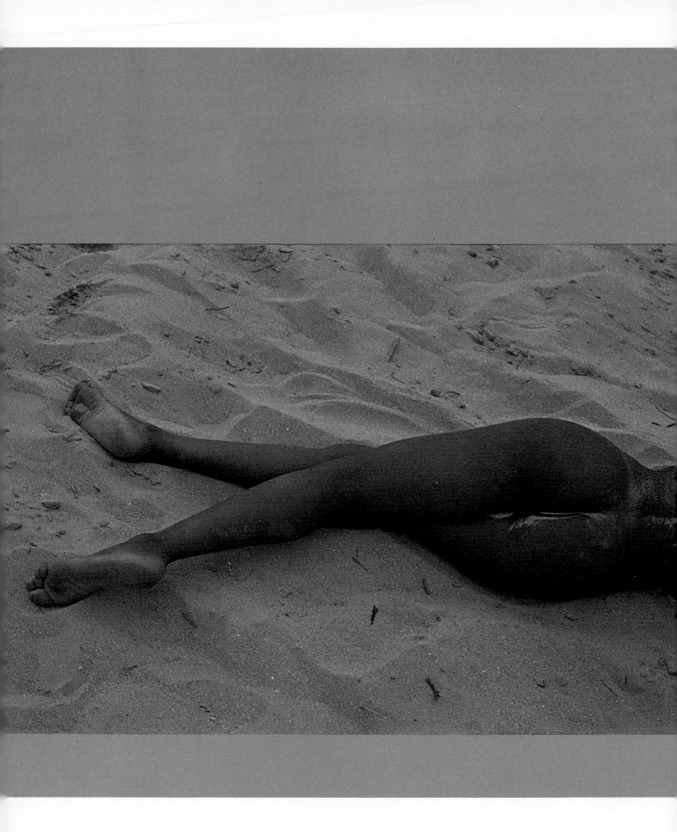

blind from birth, dramatically gained sight on the operating table when he was fifty-two years old. After the bandages were taken off he could hardly see or focus on anything. It took him several days to begin to use his eyes effectively and the process was gradual, although physically his eyes were normal. Most of the perceptual clues had to be learned, space and distance were very difficult to assess, and then only because of his previous touch knowledge. Professor Gregory concluded that his findings were limited and entirely inconclusive and for the patient they ended rather sadly. It seems that, in spite of being able to see, he soon became very depressed and unable to adjust to the new world he had had such a difficulty in learning. Colour seemed to him disappointingly drabber than imagined and the environment strange and frightening. He died a few years later. The case showed, however, how extremely important learning is to our sight and normal perceptual development, but the mystery of how much the child knows and how much he has to learn is still very much with us.

Another aspect of the study of perception is that of visual orientation. The fact that the retina receives a reversed image of the world often perturbed the early researchers, although Helmholtz by the early nineteenth century did not think it very important. Now we know that it is not a reversed image with which the brain is presented but a series of electrical impulses sent from the retina. The American psychologist G. M. Stratton decided to find out what would happen if suddenly we started to see unreversed images on our retina. He constructed and wore for various periods of time special glasses which accomplished this. He found that although at first he could do nothing and hardly move at all, after a few days of wearing these strange glasses his sense of perception was almost completely adjusted. He walked around without any difficulty, and things began to look quite normal except when closely scrutinized. Other researchers followed Stratton with longer periods of experimentation or developed variations of this test, like optical instruments displacing the image by several degrees. Most of them discovered that adjustment to different ways of orientation is quite feasible.

From the point of view of colour, Ivo Kohler's fairly recent experiments and subsequent discovery are even more relevant. Kohler wore glasses which did not displace anything but of which the lenses were half green, on the right, and half red, on the left. Consequently the left half of what he could see looked permanently red and the right green. Kohler found that after a while the brain adapted itself to the new phenomenon and the effect of colour gradually lessened and almost disappeared. The most interesting discovery, though, was made when the glasses were discarded.

Nude on the Sand **page 50**
The exploitation of contrasting tactile surfaces—soft skin and the granularity of sand—is set against subtle harmony of colour and lighting, to create a highly sensual image. Aesthetic distance is achieved by a concentration on form and the depersonalisation of the human body by selective framing.

Suddenly the scene on the right looked red and the one on the left green, the direct reverse of the colour of the glasses. It seems that it was the adjustment and the adaptation in the brain itself which affected the vision. Hence it can be assumed that a great deal of adaptation is possible in the centre of perception, the visual cortex of the brain.

The ability of human senses to adapt to various changes is well known. People who live close to a railway line adjust to excessive noise and after a certain period of time hardly hear it. The same even applies to vibration caused by the passage of a train. The human system of perception seems equally easily adjustable. Take the adaptation of the human eye to darkness for example. It is always fascinating to walk into a darkened room and after having blundered for a little while to be able to see quite well. We know that the iris of the eye retracts to its widest aperture, so that maximum of light can enter the eye and facilitate the perception but it also appears in the light of some new discoveries that the retina also adapts its acuity to low level of light.

The problems of subjective seeing, adaptation and illusion are closely related. It is possible to hold that the fact that we see the shadow area of a coloured object not as it really is but as we think it should be is an ability of the eye to adapt. Perhaps the perception is adapted to the mental image or is it yet something else – an optical illusion? The subject of visual illusion is one of these vexing topics, far too interesting to be left alone and at the same time, because of their vagueness and ambiguity, a slippery and dangerous one to deal with. It also confirms that, while the atom has been split and the moon invaded by men, we still know very little about our own vision.

A few of the standard, text book optical illusions may be helpful. We reproduce them here with short self explanatory captions. The captions, however, are self explanatory only in so far as the effect of the illusion is produced, the case is far from simple. Over the years a number of theories have been advanced, none of them explaining the phenomenon entirely satisfactorily and we shall resist the temptation to follow suit. It is interesting to note, however, that when these and other visual illusions were shown to primitive peoples of central Africa, who had not been exposed to our culture, the illusion did not, on the whole, operate on them. One suspects that the answer to optical illusion is somehow related to this and that our specific visual education which makes us capable of reading our Western pictorial conventions, with one point perspective, foreshortening etc., also renders us liable to be easily misled by certain visual tricks.

The nature of illusion lies in the existence of three distinct stages in the act of perception. In the first place

The Muller-Lyer, or arrow illusion.
The line on the right looks shorter.

The Ponzo, or railway line illusion.
The top line always looks longer.

Hering illusion.
Horizontal lines seem crooked.

there is the real scene in front of us, secondly there is the reversed image of this scene on the retina and thirdly there is the brain's interpretation of the scene. There would be no place for uncertainty or illusion, if all three stages were completely identical and precisely coincided with each other. However, there are certain imperfections and discrepancies at each stage and it is when these discrepancies become more apparent than usual and when some visual cues could be interpreted in a number of ways, creating perceptual uncertainty, that illusions occur.

Professor Gombrich, in an essay in his book *Illusion,* suggests that we often tend to look for meaning rather than to record the real appearance and that this search for overall meaning may prompt a cursory and careless scanning of the object. Certain visual hints are quickly and hastily taken for granted, leading inevitably to an error of judgement, to a perceptual illusion. He quotes an imaginative example of some species of moths, which through evolution acquired facsimiles of eyes on their wings. These giant eye-like markings, which give them an illusionistic appearance of large animals, deter birds from attacking the moths.

It is not entirely fortuitous that this discussion on illusion is followed with some remarks on the inter-relation of the eye and the camera. There are certain aspects of camera representation which could be taken, at least at the first sight, for illusionistic effects. We have mentioned the possible visual discrepancies between the three stages of perceptual notation which may and sometimes do lead to the experience of illusion. With the camera the intervening stages grow in number to four, one can even say five – the scene, the negative, the print, retinal image and visual impression. The 'faulty' and 'misleading' representation of the world by the camera was and still is a serious charge laid at the door of photography and in its short span of existence the camera has been blamed and reviled for a number of sins. John Ruskin who initially preferred the photographic image to a painting by Canaletto finally condemned photography for being too literal, too exact and only partially because of certain representational drawbacks. The Secessionists and photographic Impressionists at the end of the nineteenth and beginning of the twentieth century tried to hide the precision of the photographic image, they were positively embarrassed and ashamed of its detailed description. Later again the pictorialists disliked the distortion created by short focal lenses and tried vainly to make the camera see the scene as they saw it. Now many turn away from anything but a most ordinary and least 'created' snapshot.

It is only fairly recently that the individuality of the camera, its peculiar ability to 'see' the subject in a characteristic and idiosyncratic way, is being hailed and exploited. One is reminded of the story about one of the finest British photographers, Bill Brandt. Many years ago when rummaging in a second-hand shop, he found a very old camera fitted with a particularly wide angle lens. The construction was so ancient and the lens worked at such an impossibly small stop that it was virtually impossible to see the image properly, let alone focus it. Some early, random results convinced Brandt that the camera was worth struggling with and a kind of voluntary cooperation developed between the man and the camera. The lens, in fact, imposed a certain stamp of its own on the whole series of remarkable and revolutionary studies of the nude, subsequently published as *Perspective of Nudes.*

Although it is beyond dispute that some lenses, like extreme wide angle or telephoto, alter the image that our eyes see (or perhaps it would be more precise to say that they enhance or exaggerate certain aspects of vision), by and large the camera image is very nearly identical to the corresponding retinal image. What makes for apparent discrepancy, or illusory divergence, is in the first place the fact that a photographic image is entirely static. The camera frame freezes one specific instant, whereas during the same moment of perception the eyes move continuously, focusing and refocusing, darting about, snapshooting incessantly, thus inevitably giving an impression of a different picture. Secondly one must again take into consideration various tricks of perception. Distant objects in photographs do look invariably smaller, because the camera merely reproduces the retinal image whilst the brain adjusts, in fact distorts, the image in order to make it more acceptable to our perceptual knowledge. We know that the mountains are high and vast, thus we make them appear larger in the visual cortex in the brain. A similar kind of visual adaptation occurs when we look up and tilt our camera upwards while photographing a high building. Both retinal and camera images show a great deal of converging verticals but since we 'know' that the building is straight psychological adjustment is made and we do not 'feel' the convergence to such an extent. The camera, however, cannot avail itself of mental help and records the truth.

II The Nature of Colour

Part physics, part physiology, part psychology, the nature of colour is an ambiguous phenomenon. Colour does not exist except as a trick of light and as a figment of the imagination, it resides in the eye of the beholder. It is a form of communication in which information is transmitted by light waves and received by the human eye, the signal relating to the colour information being coded within the frequency modulated 'carrier wave' of light energy. Without a variable distribution of frequency and wavelength within the energy pattern of the light there would be no colour data transmitted. There is a direct relationship between the frequency of vibration of the light energy and the colour sensation perceived in the eye, the vibrations of light stimulate the eye, like sound vibrations stimulate the human ear. Both sense organs are capable of detecting external transmission of energy and converting the stimuli energy into neural energy which in turn can be decoded to give information about the external environment. Our only contact with the external world is through these channels of perception, they are not very wide but the brain by instinct and experience can maximize the information available from the sense data it receives. Both the eye and the ear can distinguish between frequencies: the frequency response of the human ear being 15 c/s-15,000 cycles/second and the wavelength response of the human eye being 390-700 nanometres Sound-structured information is heard as 'pitch' or musical sound, light-structured information is seen as colour when both are frequency modulated. An amplitude modulated sound is *pianissimo* or *fortissimo*, and an amplitude modulated sight is dark or light. A tonal scale in music refers to a frequency change whereas in the visual arts it means a change of amplitude or amount of light signal received. The parallel with sound is often used in aesthetic theories of colour, where musical terminology is used to describe relationships such as harmony, counterpoint and discord.

When Sir Isaac Newton, in his great scientific work on the nature of light *Opticks* first published in 1704, described the colours of the visible spectrum, he saw seven bands or rays of colour. Natural light from the sun was refracted through a prism and the colours separated spatially into different fractions. These colours he named Violet, Indigo, Blue, Green, Yellow, Orange and Red – the colours of the rainbow. The process of refraction is reversible and the spectral colours can be recombined into their continuous natural state. The prism acts as a decoder, filtering out the component 'sounds', for what is a continuum in the time dimension of frequency it separates in the space dimension of wavelengths. Although Newton identified the connection between the nature of light and the sensation of colour, he was most careful not to ascribe the phenomenon to the rays themselves writing that "If at any time I speak of light and Rays as colours or enduced with colours, I would be understood to speak not philosophically and properly, but grossly, and accordingly to such conceptions as vulgar People in seeing all these Experiments would be apt to frame. For the Rays, to speak properly, are not coloured. In them there is nothing else than the certain Power and Disposition to stir up a Sensation of this or that Colour." Colour as light is pure information about the spectral distribution of energy received as the wavelength or frequency of the waveforms impinging on the sensory receptors of the eye. This sense data is detected by the retina and decoded by the brain, the sensation of colour response within the brain being interpreted as information about the quality of the light received and the object that reflected it. ". . . so Colours in the object are nothing but a disposition to reflect this or that sort of Rays more copiously than the rest; in the Rays they are nothing but their Dispositions to propagate this or that Motion into the Sensorium, and in the Sensorium they are sensations of those Motions under the Forms of Colours." Newton thus finally equated the vibrations of the lightwaves with the sensation of colour. At the same time he recognized the ability of surfaces of objects to imprint a pattern of their own on to the distribution of light energy. By selective absorption of light energy into the surface of the object the distribution pattern is modulated.

The transmission of information by light is directly comparable to the process of communication of other coded data or messages. Making a comparison between these coded systems in terms of communication theory is revealing. Both require energy in the form of waves radiating into space – oscillations of sound, light or electro-magnetic energy are emitted from a central source, and are capable of directly or indirectly stimulating the human senses. A 'carrier wave' transfers this energy through space, from a transmitter to a receiver but is not capable of carrying any information if it is continuous. In order to carry information, the continuous nature of the vibrations must be interrupted or modulated. Interruption creates pulses giving a binary signal, such as YES/NO or ON/OFF; these pulses are combined into series to give more complex information such as the Morse Code, telephone dialling and binary computer systems. The alternative method of superimposing a signal upon the emission wave is not to interrupt its flow but to modulate it. Variations of the amplitude of the wave or its frequency of oscillation in a continuous series of tones on a grey-scale from black to white give a greater capacity for encoding information than the simple YES/NO system. A two-option system is multiplied into one of subtle gradations.

Both the eye and the ear can detect, within certain limitations, variations in the amplitude and pitch of light and sound. It is this capability that allows us to decode informational sense data from our surroundings and translate it into meaningful patterns. Sound is translated into speech and thought; light is translated into images and 'mental' pictures; seeing and hearing are translated into perceiving and knowing. The perceptual process is a complex and mysterious one, the physical world is 'seen' indirectly through the narrow wavebands visible to us and through a chain of conditioned responses based on learning and expectation. We see instantly and automatically, as though without effort and visual perception does not appear to be a mental process at all because it is so spontaneous and easy. But the act of seeing is one of interpreting a coded signal. 'White' sound is an unstructured sound wave carrying no message, it is only when it is frequency modulated that it imparts a musical pitch which is meaningful in human terms. Similarly, 'white' light can also be modulated by reflection from pigmented objects to give information about these objects. Amplitude modulation tells us about size and shape, frequency modulation about its colour. Thus when a pattern or code is imprinted on the unstructured 'white' light, the eye and the brain are capable of detecting the pattern and interpreting it in a meaningful way. Black and white photography is an amplitude modulated signal, colour photography is both amplitude and frequency modulated and is therefore capable of carrying far greater information.

Although colour is an objective function of the source of light, the carrier waves, it is also an objective property of the absorbing object upon which it impinges and by which it is modulated. The sensation of colour, giving us information about the objects we perceive, however, resides solely within us as a subjective experience. Colour is experienced as the culmination of a chain of events linking the objective world of light and physical objects to a subjective world of human sensations and experience. The communications link between these two worlds is energized by electro-magnetic radiation which bridges the gap between transmission and reception. To summarize, the sensation of colour exists because of the nature of:

The Transmission Phase	(a) *Light* – electro-magnetic (amplitude/frequency) waves
	(b) *Objects* – modulating these waves
The Reception Phase	(c) *Human Eye* – receiver-detecting receptor of stimuli
	(d) *Human Brain* – interpreter of signals

The light is the transmitting energy source, the objects the encoder, the eye is the detector of the modulated carrier waves, and the brain is the decoder of the information. We must examine these elements in detail to fully appreciate the complexity of this most immediate and vital phenomenon of colour.

Radiant energy in the form of electro-magnetic vibrations creates both heat and light, it is propagated through space at various wavelengths. A whole family or spectrum of wavelengths exists, and spans such emissions as radio/television carrier waves, through infra-red, ultra-violet waves, to X-rays, gamma and cosmic rays. They all exist naturally in our universe but can be created artificially, or exploited to serve man's needs. The twentieth century is the electro-magnetic age, as the nineteenth was mechanical. Electro-magnetic energy is used to power our industrial society in the form of electricity, to communicate over vast distances through radio/television waves, to explore a hidden interior microcosm through X-rays or the vast outer cosmos through the radio telescope.

The narrow band of frequencies detectable by the human eye is that which Isaac Newton split into its component parts and which can be combined to re-synthesize white light by passing them back through another prism. The seven colours detected by Newton are an arbitrary number based more on magic than actuality; the frequencies and wavelengths of light vary infinitely across the continuous spectrum, from 390 nm to 700 nm. The difference between the longest and shortest wavelength in the visible spectrum is 1/10,000 in. and yet the human eye can detect one thousand distinct colours or lines within its range. But the continuous spectrum of nature is arbitrarily sub-divided into separate colours which are given word names by which we can identify them. A natural phenomenon is categorized and classified through a cultural code of language, yet words are inadequate to meet the needs of the experience perceived. The word Red identifies, without describing, the subjective experience of a light source with an energy distribution of wavelengths between 630-700 nm; within this energy band there are infinite variations of 'redness'. 'White' light is something of a misnomer; white as a colour is in fact the presence of all the colours of the visible spectrum in equal proportion. The problem of naming colours in a systematic way will be dealt with, bearing in mind the limitations of words to describe a process so complex and subjective as colour vision. However it is first necessary to describe how pigments or 'body colour' appear to be coloured in themselves.

Pigments, paints and dyes are real and tangible, you can touch a coloured surface, if the paint chips off, so does the colour, if you grow tired of a colour on a wall

you can paint it another colour, which you can buy by the litre. The colour of orange seems as much a part of the fruit as its fragrance. Or so it would appear! In a darkened room you can still smell the orange but you cannot see its colour. If the smell is still present, so is the colour also; does the colour disappear with the light; if this is not so, what happens if you leave the room; does the colour remain? Colour, like beauty, is only skin deep. The orange acts as a modulator to light. When incident light falls on any objects some is reflected and some is absorbed. The reflected light, bounced off the surface, enables us to see the object against its surroundings and just as we can see an object by the pattern and quality of light it reflects, so we can photograph its positive image. In a sense there is a reversed negative image that is absorbed within the object, which we do not see except indirectly for body colour is perceived because of the selective absorption of a part of the visible spectrum (p. 61).

Light falling on a pigmented object has its spectral distribution of energy altered by a process of *subtraction*. Hence colour produced by the absorption of pigments is a *subtractive* process, representing a 'negative' image. Light, the primary source of colour is a 'positive' process, whereby an image pattern of light energy directly impinges on the senses. Light, as energy, can be combined by direct addition, colour mixing of light is hence an *additive* process.

The mixing of pigments whereby any body colour can be produced is a familiar experience, discovered intuitively in childhood and systematized by artists into primary and secondary colours. The colours when mixed together are physically added to each other, and stirred until the original colours disappear and are replaced by a new colour. Common sense or logic would suggest that this process is one of addition, but this can only be so if pigments and not light are believed to be the primary source of colour. Appearances can be most deceptive; when we mix pigments or pigmented body colour we are, in fact, subtracting light energy from the spectrum. The addition of pigments equals a subtraction of light. Artists, from the Renaissance to the twentieth century, developed formal systems of colour-mixing, with Red, Yellow and Blue as the primary colours, based on a misconception at variance with scientific observation of the nature of colour, that the source of colour is pigment, not light. The artist's pragmatic approach, founded on practical experience of manipulating pigments, led to this conflict and just as Copernicus' proof of a helio-centric universe was accepted with great reluctance, so Newton's discovery that the source of colour resided in the light rather than the object was similarly received. His ideas were either ignored, he often lectured to an empty room, or he was attacked by scientists and artists alike.

Leonardo da Vinci was an early colour theorist, in his *Treatise on Painting* he identified eight colours, or pigments, of which black and white were the most important: "After black and white comes blue and yellow, then green and tawny or amber, and then purple and red." Later both le Blon and Gautier simultaneously discovered that only three primary pigments were necessary. As le Blon wrote in 1730, "Painting can represent all visible objects with three colours, Yellow, Red and Blue; for all other colours can be composed of these three, which I call Primative . . . a mixture of these three original colours makes a Black, and all other colours whatsoever; as I have demonstrated by my invention of Printing Pictures and Figures with their natural colours." Thus the artist's primaries and the principles of pigment mixing were established, based on pragmatic practicalities and springing from alchemy, rather than any sound scientific principle.

It required the experiments and genius of Newton and other scientists to demonstrate that the primary source or centre of the universe of colour is the sun, and the light that emanates from it and, based on the initial discovery of Newton's seven bands of colour and the later work of Thomas Young on a theory of colour perception, the scientist uses Red, Green and Blue as the primary colours. This choice relates directly to *light*, each primary representing one third of the spectrum, for as originally postulated by Thomas Young in 1801 the three receptors of the eye sensitive to red, green and blue light are the basis of colour perception within the retina.

Newton was the first to turn the continuous spectrum of light into a circle of colour, noting the visual similarity of red and violet at the opposite ends of the visible spectrum, he joined them together to form a circle. In any attempt to systematize the phenomenon of colour beyond the arbitrary classification of names, the colour circle of the spectral hues of natural light must be the starting point. Moses Harris in *The Natural System of Colours*, published in 1766, designed a colour wheel of eighteen prismatic colours and three overlapping colour triangles of red, yellow and blue.

Circle and triangles have provided the framework for innumerable rival systems, some of which we discuss starting on p. 59, since that time. The positions of the primaries around the circle vary, as well as the individual names given of which Ruskin's were the most fanciful. He devised a circle based on the zodiac with colours called Jacinth and Or, Lucia and Clarissa; beautiful in themselves, perhaps, but hardly of much help in visualizing the spectral sensations.

Colour as a description of a sensation requires more than to be located within the visible spectrum as a

component of a vibration or wavelength. To find its position in a colour circle is merely to identify one, if the major, of the colour's characteristics but colours have two other dimensions; they can be light or dark, and they can be brilliant or dull. Body colours in nature and pigments and dyes come in all hues, shades and tints. If you look at a manufacturer's swatch it contains a multiplicity of variations within a narrow band of the spectral range. Under the general description of blue, for example, there are variations from a pale sky blue to a deep ultramarine, from a brilliant royal blue to a sombre navy. In order to give a complete and full description of any colour or pigment it is necessary to separate the colour sensation into its component parts. Descriptive words, with references to nature or poetic evocations, like cornflower blue or sapphire, flame red or shocking pink are ideal for selling textiles, paint or cosmetics, but leave too much to the imagination to be an accurate description of the colour's qualities. We need to know where it is located within the visible spectrum, which wavelengths dominate its spectral distribution; its spectral distribution in terms of its purity, how narrow a distribution of wavelengths is reflected from its surface. We need to know if it is a light or dark colour, relative to black and white, how much light is reflected from its surface. These qualities, present in any colour, are quite separate and distinct and can be identified and classified, even quantified on a scale of values. However, when we experience a colour it is a unified sensation, an amalgam of these separate qualities, fused together.

A most detailed and precise analysis of the behaviour of a pigment in absorbing and reflecting light can be plotted scientifically using a spectrophotometer. This instrument can determine the quality and quantity of light, in wavelength and percentages reflected from a surface, by means of a photocell. The results can be plotted as a graph, in visual form, to represent the colour sensation. However, when we experience a colour it is as an amalgam of its separate qualities and there is little resemblance between the analysis of a scientific instrument and the sensation we see with our eyes and perceive in our brain. The objective photocell is no match for the subjectivity of our senses. There is more to colour than bundles of energy – it is a human response, individual and personal, filtered through the imagination and cultural conditioning, as well as our own expectation and individual awareness.

When we look at a colour, what we see or perceive is hue, saturation, and brightness. Hue, based on the Anglo-Saxon word *hiw* meaning skin, or complexion, is the major characteristic of any colour, giving the colour its unique appearance. It is directly related to the colour's dominant wavelength such as Red, Green, Yellow or Blue, which are the major hues. The visible spectrum is of course a continuum, of varying colour and wavelength. Under ideal conditions the human eye can detect as many as two hundred hues across the spectrum. We do not, however, have two hundred names by which to call them. Modern visual colour systems, such as Albert Munsell's, employ ten major hues – red, yellow/red, yellow, green/yellow, green, blue/green, blue, purple/blue, purple and red/purple. The hue circle is divided into these ten segments and each segment subdivided into ten hue variations within the major hues, identified by a number from 1 to 10. The spectrum is thus divided into a hundred hues each identifiable by a code, for example 5R – central hue in Red segment, that is, its major hue. There are, obviously, alternative systems such as Ostwald's in which the colour circle is divided into twenty-four hues.

Saturation is a reference to the purity of a colour, its richness or intensity. The addition of white, black or grey to a saturated colour decreases the amount of pure hue in the mixture and degrades it, lowering its saturation. Vermilion is a saturated red pigment: if white is added, the mixture becomes pink; if black is added, the red becomes dark chocolate brown; if grey is added, the brilliant red is transformed into a dull brick red. All three are desaturated red.

Saturation is directly related to the spectral distribution across the visible spectrum. A narrow band of energy, with a sharp peak at one dominant wavelength, is identified by that particular wavelength which gives it its characteristic hue and the relative distribution of energy either side of that peak indicates the purity of hue or saturation. A broad distribution pattern characterizes a mixture of hues and a low saturation value. To clearly identify this colour characteristic, Albert Munsell called it *Chroma*.

On the Munsell scale a zero *Chroma* is an equal distribution of all wavelengths across the spectrum with no dominant wavelength and therefore no distinguishing hue characteristic – neutral or white. As the hue purity is diluted or degraded with other colours, so the character of the hue is diminished. When the saturation is very low, approaching zero *Chroma*, all hues become closer to a common neutrality. They are reduced to a shade of grey, as the colour is drained from them. This can be represented diagramatically, see p. 58, with a colour circle of pure hues, where the complementary colours are on opposite sides of the circumference. Mixtures of complementaries are represented by areas or points within the circle radiating from the mid-point, the centre marking the point of all equivalent mixtures of complementary colours. This central point is common to all desaturated hues, and is neutral grey and of zero *Chroma*.

There is, however, a complicating third factor at work in any colour system. Firstly, all pure hues are not of the same density or tonality, for example, yellow is very light and blue is very dark at its highest saturation, whereas orange or green are mid-toned. When the complementaries are mixed to give desaturated colours, the tones of grey produced will vary in density or reflectance depending on the tonality of the original hues. This third factor makes a circle inadequate to represent fully the possibilities of colour mixing or combinations of which the primary hues are capable. The tonality of the resultant mixture of hues is an essential part of a hue's character and needs to be represented in a coherent system by a third dimension or axis. Thus the colour circle becomes a sphere or three-dimensional solid in which the vertical axis is the central core to a series of horizontal colour circles of gradations of equal neutrality from white to mid-grey to black stacked vertically. This third dimension completes the world of colour and is called brightness, a confusing term as it can be mistakenly used to mean saturation instead of tone value.

In terms of light-energy, brightness represents the total amount of light reflected from the colour surface, rather than the distribution pattern. The reflectance power is measured as the proportion of incident light not absorbed. In the Munsell system, which is a visual representation, it is measured on a grey-scale of equal steps of grey, graduating from black to white. To avoid confusion with ambiguous words used to describe colours, such as shades, tones, tints, which are too imprecise in their distinction between saturation and brightness, purity and tonality, Albert Munsell chose the word *Value* to complete the third dimension of colour. It was derived from a term used by Hermann von Helmholtz, the famous German physicist and physiologist, who with Clerk Maxwell established the three receptor theory. Munsell gave each tone in his grey-scale a number: white is 10 and black 0, there are nine intermediate greys numbered from 1 to 9 and the mid tone, visually half way between black and white is 5.

The colour solid created by Munsell in 1915, and internationally standardized in the 1930s, is widely used in industry for naming and matching colours of pigments, dyes and fabrics. In *The Munsell Book of Colour* any colour can be matched to a series of colour patches representing 1,150 variations of Hue, Value and Chroma. For example, *Lavender* is coded 5P 8/4: its *Hue* is 5P or the principle of ten major hues named Purple on the colour circle; its *Value* is 8, two steps of grey tone below white (i.e. it is a light colour); its *Chroma* is 4, four steps of saturation above neutral grey (i.e. it is only moderately saturated). *Violet*, coded 10PB 3/10, is a little bluer, much darker and highly saturated compared to *Lavender*.

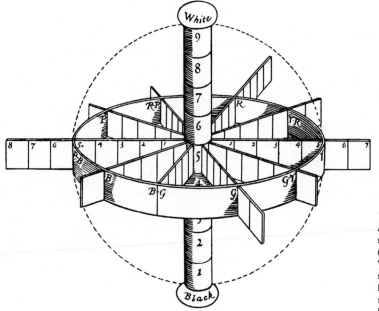

The Munsell System
An original illustration from Albert Munsell's early work on colour classification, (republished as "A Grammar of Color" by Van Nostrand Reinhold—1969), clearly shows the three dimensions of colour. Hue is arranged in a colour circle, with saturation radiating from the centre and brightness as the central vertical core of the system.

As new pigments or dyes are discovered or synthesized by the chemical industry and the limits of saturation are expanded, more highly saturated colours can be added to the system. The maximum saturation obtainable in pigments is below that of the spectral colours of light which are our theoretical limits. The saturation at present obtainable varies from one hue to another. For instance, the red and yellow part of the colour circle give good maximum saturations with *Chroma* of 14 for Red and 12 for Yellow but the blue/green part of the hue circle has not achieved high saturations, reaching a *Chroma* of 6 only at its maximum. The inadequacy of blue/green dyes in their purity accounts for the poor performance of the cyan dyes used in all pigmented processes of colour reproduction, thus major problems are created in mechanical and photographic printing due to the deficiency of the cyan inks or dyes available.

III Aesthetic Theories of Colour

The essence of all the aesthetic theories is a desire to explain and codify the elusive nature of a work of art, to answer such questions as: why and how did the artistic urge to 'create' originate; what is the nature of creative 'inspiration'; what are the elements which make one image beautiful and exciting and yet another, seemingly similar, a failure? Concomitant with these fundamental questions is an ever present quest for the proverbial alchemist's stone. For if the ingredients of an admittedly beautiful painting can be analysed then it might be logically possible to arrive at an infallible recipe for a work of art. Since a human being is distinguished from lower animals by his ability to acquire a discipline and to be largely motivated by logic and reason, the idea of being able to control, affect and influence his aesthetic responses in a predictable manner has attracted artists and philosophers alike.

Theories of aesthetics are as old as Western philosophy itself. Plato and Aristotle gave pride of place to considerations of beauty and artistic creation; Socrates, Plotinus and Christian thinkers like St. Augustine, head a succession of brilliant Western philosophers, most of whom found the subject of aesthetics irresistible. Yet with such an array of talent it is rather curious that colour on the whole was treated in a very superficial and perfunctory way. Plato mentions the formal qualities of colour, and St. Augustine speaks of the "agreeableness of colour", but until fairly recently colour was never fully integrated into various aesthetic theories.

From the Renaissance the 'unpredictability' of colour was clearly perceived; the fact that the effect of colour is felt and experienced rather than seen, and that it does not readily lend itself to logical analysis. Writers on aesthetics, basing their philosophy on the art of the Renaissance, felt a positive distrust for colour and consistently played down its importance, despite the fact that the High Renaissance produced two distinct schools of approach to colour; that based largely on Roman and Florentine painters like Raphael, Leonardo and Botticelli which believed in the complete supremacy of line and drawing over colour; and that centred around the Venetian painters Giorgione and Titian who used colour in a more conscious, powerful and direct way.

As late as 1800 the great philosopher Kant wrote, "In all visual arts, design is essential, for design constitutes the foundation of taste, only by what pleases by its shape and not by what entertains the sensations. The

colours which illuminate the outline belong to stimulation. They may animate the sensation of the object but cannot make it worthy of contemplation and beautiful." And Charles Blanc, writing in the 1870s, puts it more bluntly: "The union of design and colour is necessary to beget a painting, just as is the union of man and woman necessary to beget mankind, but design must maintain its preponderance over colour. Otherwise painting speeds to ruin; it will fall through colour, just as mankind fell through Eve."

In 1666 Newton 'split the atom' as far as colour was concerned, by showing, for the first time, that white light consists of all the colours of the rainbow. This finally demolished the Aristotelian notion that colour resides in surfaces and objects, and that its appearance is the result of a transition of light from white to dark. Newton also drew the first colour circle by joining, so to speak, the two ends of the rainbow, which appeared on the other side of his prism. But it was not before the beginning of the nineteenth century that the first coherent discussions and theories on colour began to appear.

In any discussion of the history of science, it is practically impossible not to encounter someone who suddenly jumps a century or two ahead of anybody else. On a number of occasions this turns out to be the same disconcerting individual – Leonardo da Vinci. The story of colour is no different. In his *Treatise on Painting* written between 1510 and 1519, Leonardo already singled out the qualities of four primaries – red, yellow, blue and green. He also pointed out the harmonious qualities of opposite colours, and even wrote eloquently on the change of colour in the shadow area, due to the reflection of other colours. But all these were merely inspired guesses and speculations. It was not until the 1730s that a German engraver, J. C. Le Blond, discovered that the admixture of blue, red and yellow can produce any colour of the rainbow and it was not until the 1850s that someone advanced a serious theory of colour.

The German scientist Tobias Mayer is credited with the construction of the first, very primitive, colour 'solid' – a sort of three-dimensional model consisting of triangles with three primary colours at each angle and descending at one side towards the black, with the gradual darkening of the colour, and on the other side towards the white. Since Mayer's solid appeared in 1758, it is quite possible that Johann Wolfgang von Goethe might have seen it, and that it may have given him an initial idea for his revolutionary work *The Theory of Colour* published in 1810. This was the first book to discuss colour, not only in a novel but also in a thorough way. Over a twenty-year period, Goethe made innumerable experiments with colour mixing and perception and in

Light and Pigment—Colour Mixing pages 61, 62, 63
The colour of an orange is created by the light falling upon it. The incident daylight consists of red, green and blue components. Absorbtion into the surface subtracts certain wavelengths and reflects others. Natural body colours are thus produced by a *subtractive* process, whether they are opaque pigments or transparent dyes.

Alternatively colour can be synthesised by combining light energy directly, by an *additive* process, using the three primary—red, green and blue—components of daylight. These colours are complementary to the cyan, magenta and yellow dyes, the primary colours of the subtractive system.

In a colour circle primaries are diametrically opposite to their complementary or secondary colours. The mixture of two primaries gives a secondary colour. When a primary and secondary are mixed the resultant tertiary is a desaturated colour. This colour mixing is systematically illustrated in a colour triangle.

Body Colour
Orange Positive Image = Reflected Red + part of Green Light
Cyan Negative Image = Absorbed Blue + part of Green Light

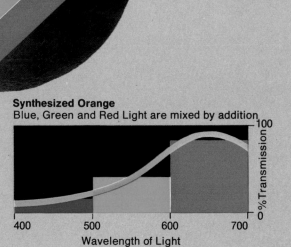

Natural Orange
Light from the visible spectrum is subtracted by absorption

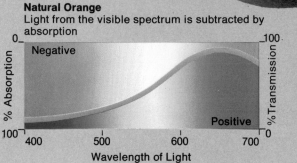

Synthesized Orange
Blue, Green and Red Light are mixed by addition

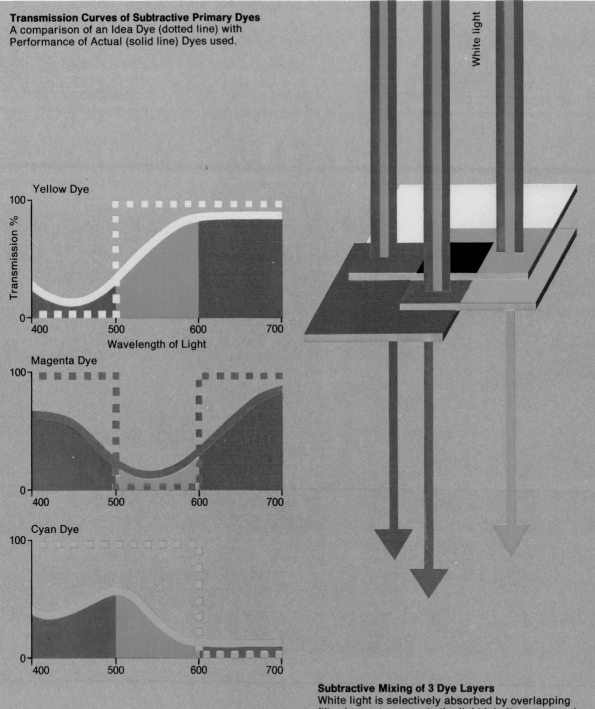

Transmission Curves of Subtractive Primary Dyes
A comparison of an Idea Dye (dotted line) with
Performance of Actual (solid line) Dyes used.

White light

Yellow Dye

100

Transmission %

0
400 500 600 700
Wavelength of Light

Magenta Dye

100

0
400 500 600 700

Cyan Dye

100

0
400 500 600 700

Subtractive Mixing of 3 Dye Layers
White light is selectively absorbed by overlapping
filter layers to separate the light into its component
primaries. All the colours of the spectrum can be
mixed by using these filters.

Colour Circle
Based on Goethe's theories of Colour showing the
complementaries in opposition

Colour Triangle
Showing Primary, Secondary and
Tertiary Colour relationships

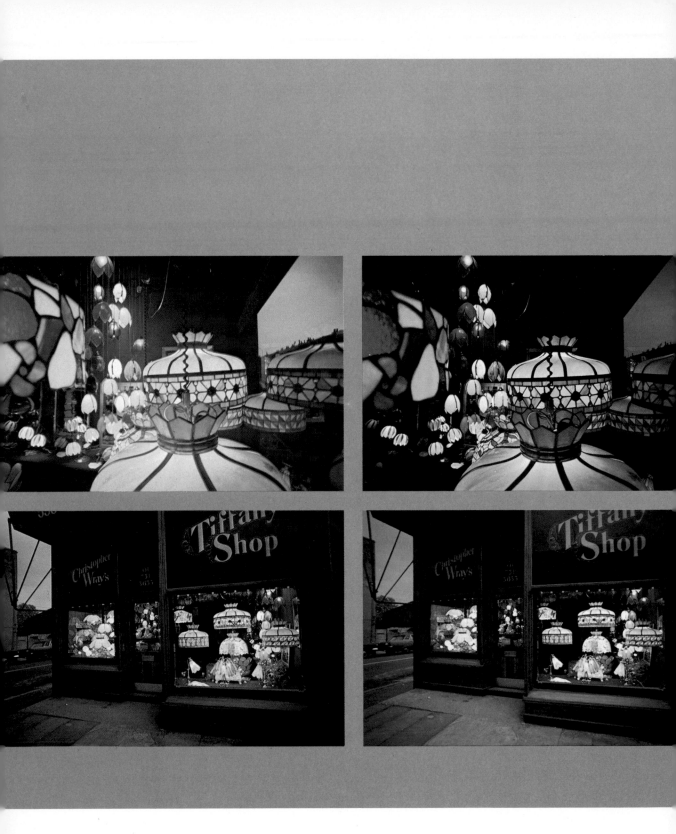

his magnificent book he discussed the harmony and contrast of colours, as well as speculating in detail on their psychological impact. Written with vigour, poetry and scholarship, the book and the fundamental backbone of his theory alas suffer from a vital flaw: Goethe could not or would not understand the scientific principles of Newton's great discovery. He renounced it in a most emphatic way but did not replace it with anything more than a vague return to Aristotle's from white to black theory. Goethe's book is still readable and interesting today, his discussion of the properties of various colours and particularly his analysis of simultaneous contrast, on which he bases his whole theory of harmony, is fascinating. But due to basic scientific errors it never gained universal acceptance although it was widely read by artists and philosophers who were perhaps equally wary of mathematics and science.

The greatest scientist apart from Newton himself, who first grappled with the problems of colour is undoubtedly the Frenchman M. E. Chevreul. The publication of his book *The Principles of Harmony and Contrast in Colour* coincided, strangely enough, with the announcement, in 1839, by yet another Frenchman, Daguerre, of the discovery of photography. Chevreul's book was not such a truly revolutionary event as the invention of photography, but it became, nonetheless, the cornerstone for the use of colour by a whole generation of modern painters. The foremost romantic painter, Delacroix, was deeply impressed with Chevreul's theories and many pages of his remarkable notebooks were devoted to the discussion of his investigations. It was, however, the Impressionists and even more so the Pointillists and their leader, Seurat, who embraced the theories of Chevreul most fervently.

In spite of the many scientific aspects of Chevreul's work, it is the more intangible properties of colour that get pride of place in his treatise. Like Goethe before him Chevreul looked at colour as an experience invoking an emotional reaction, rather than as a purely physical phenomenon. Unlike Goethe he accepted Newton's theory but went no further in discussing its scientific implications. He concentrated on the heart of the matter, the effect of colour on the human eye, which he, for the first time, discussed systematically, thoroughly and without prejudice.

Chevreul's book made significant contributions to the knowledge of colour in three important areas. In the first place it dealt fully with the phenomena of simultaneous and successive contrast, secondly it explored the problem of visual mixture of colours in the human eye and lastly it presented a complete theory of harmony of colours, a theory of syntax and discord which is taught with small additions in art schools all over the world to the present day.

Mixed Lighting page 64
The eye is very tolerant to changes in the colour quality of light and only by conscious effort can we see colour variations in natural light, or the vast colour difference between daylight and tungsten illumination. As light is the source of colour, photography records these variations without adaptation.
The Tiffany shop, Kings Road, Chelsea, was photographed at dusk with both Daylight film, Agfachrome 50S, and Tungsten film, Agfachrome 50L. The mixture of daylight and tungsten is recorded showing the particular bias of each film to one of the light sources present. The colour temperatures of the light sources were 2800°K and 7000°K whilst the films are balanced to 5500°K (50S) and 3100°K (50L).

Newton had been the first to draw up a colour circle after his experiments with the prism. But, influenced by his interest in mysticism, he arrived at a magical number of seven colours linked to the seven planets and to the seven notes of the diatonic scale. Almost exactly a century later, an English engraver, Moses Harris, prepared a first full colour circle, featuring three primary and three secondary colours as well as twelve intermediate hues. Goethe worked with a simple six colour circle (see p. 63) though he believed that only two colours were pure primaries, yellow and blue. In this he followed Aristotle's theory that yellow comes from light and blue from dark. In Goethe's view even red could be achieved from their intermixture!

Chevreul was the first to adopt a full circle of twelve colours, three primary colours (blue, yellow and red), three secondary or complementary hues, arrived at by mixing successively two primaries with each other (thus: red + yellow = orange; red + blue = violet and blue + yellow = green) plus a further six intermediate hues achieved from the mixing of primaries with complementaries.

Chevreul noted, as Goethe did before, that when we look at a patch of colour for some time and then shift our gaze rapidly to a blank piece of paper, a patch of illusory colour uncannily forms itself on a white page and this colour is precisely opposite to the one we looked at. In Goethe's words: "When the eye sees a colour it is immediately excited, and it is its nature, spontaneously and of necessity, at once to produce another, which with the original colour comprehends the whole chromatic scale. A single colour excites, by a specific sensation, the tendency to universality. To experience this completeness, to satisfy itself, the eye seeks for a colourless space next every hue in order to produce the complemental hue upon it." If, for example, we look at a red patch, the resultant after-image, the successive contrast to it, will be green. Green is complementary to red and is obtained by intermixture of the remaining two primaries – blue and yellow. Here is the answer to Goethe's "tendency to universality". Red and its after-image green complete the scale – their intermixture is white. In understanding the principle of successive contrast, it is useful to bear in mind that Newton's revolutionary discovery was not so much that the prism divides the beam of white light into colours of the rainbow, but that another prism, placed in the path of this 'rainbow' will assemble all these colours again into a white ray of light.

The effect of simultaneous contrast becomes apparent when we view two colour patches placed close to one another. As in successive contrast the eye forms an after-image, which, since there is no empty space to fall upon, will be deposited on to an adjacent colour patch instead. Obviously the mixture of real and illusory colour created by the reaction of the eye will affect the nature of the hue actually perceived. Now if the adjacent patches viewed are direct complementaries, red and green, for example, the respective after-images will also match each other, hence there will be hardly any modification of colour seen except a certain invigoration of its brilliance. It is when two colour areas are colour circle neighbours that the effect of simultaneous contrast is most vivid. Take yellow and orange. The after-image of orange being blue, it will modify the yellow by making it appear greener, while the after-image of yellow being violet, it will push orange in the direction of red. Hence our original yellow and orange will appear as a much more vivid combination of red/orange and green/yellow respectively. Goethe based his whole theory of colour harmony on simultaneous contrast and both simultaneous and successive contrasts play an important part in the general theory of colour harmony formulated by Chevreul.

Chevreul is the first writer to note and study the effect of the inter-penetration and inter-reaction of adjacent colour areas. He called attention to the fact that when two small units of colour, say a dot or a line, are closely juxtaposed, they will influence each other and interpenetrate to such an extent that the eye will effect a visual mixture so that a blue dot near to a yellow dot will appear green. He also noted that this kind of mixture does not degrade the colour but on the contrary increases its vibrancy, far more so than could be achieved by a mixture of the two on the palette. This was his greatest gift to Impressionist and Pointillist painters.

As a result of his studies Chevreul was able to present an orderly and systematic theory of colour harmony. He realized that the harmonious arrangements of colour fell into two main groups: the first consisting of colour combinations of two or more colours analogous or adjacent on the colour circle and the second consisting of either directly or nearly directly opposites on the colour circle. The first group provides quiet and sensitive harmonies, since the colours being close to one another are either predominantly warm or cold and melt into one another rather than inter-acting dynamically. Chevreul himself shows greater preference for the second group of harmonies which, being combinations of two opposing and dissimilar hues, create, as it were, a dynamic concord. The law of successive contrast demonstrated that a red patch, if seen alone, would demand its counterpart, the complementary green, which in its absence would have been provided as an after-image. But in the second group of harmonious colours, there is no need for the eye to exert itself, the demanded complementary is provided in the arrangement. Not only is the harmonious balance present but the simultaneous contrast provides additionally a cer-

tain heightening of the visual experience by the inter-penetration of complementary hues.

In this brief summary of Chevreul's theory there is no place to discuss his detailed classification of various combinations of harmonies; his exhaustive study of the various degrees of inter-action both of harmonies and contrasts, which shows how a degradation of a pure hue by mixing it either with a complementary or with a grey destroys the resonance of the colour itself and affects the overall harmony. He also dealt with harmonies of split-complementaries, primary colour combined with two hues adjacent to its complementary, and harmonies of triads, all three primaries or near primaries, and mentioned a harmony of dominant hue, which will be discussed later as it has an interesting application to colour photography. If one defines the theory of colour harmony as an enquiry into systematic colour inter-relation capable of being used as a foundation for composition, then the treatise of Chevreul seems useful and worthwhile but at the same time totally inadequate. Chevreul's theory was copied, rewritten, added to, extended and enlarged by a succession of writers and teachers of whom Itten was, perhaps, the most influential. Itten systematized and reorganized the whole theory and extended it particularly with regard to the second group of Chevreul's harmonies, that dealing with harmonies of contrast. He itemized as many as seven different contrasts: 1. Contrast of hue; 2. Contrast of light and dark; 3. Complementary contrast; 4. Warm-cold contrast; 5. Simultaneous contrast; 6. Contrast of saturation; 7. Contrast of extension. Itten's first, third and fifth categories are adequately discussed by Chevreul who also mentions but perhaps does not sufficiently emphasize the contrast of light and dark which is certainly one of the most fundamental relationships in the composition of a photographic image whether in colour or in monochrome. The harmony of contrast of two similar or identical hues differing in their degree of tone is also very relevant in its application to colour photography. Since the emotive value of colour became known, the emotion laden combination of warm and cold colours has been singled out as of particular interest and the contrast of warm and cold hues is usually given an important place in modern colour manuals. The warm-cold relationship is similar to that of complementary contrast. If, on the colour circle, the band of colours from yellow-orange down to red-violet could be termed as predominantly warm and the curve from yellow-green to blue-violet cold, then one can see that both these bands lie directly opposite each other and hence are complementaries or near complementaries. Thus, although it is largely a question of terminology, the complementary contrast of colours is, as it were, enhanced by the emotional implication of warm and cold concord. Cézanne in his late paintings explores and uses these relationships

particularly powerfully, his juxtapositioning of small patches of warm and cold colours creating an exciting harmony of contrasts. The sixth category, that of the contrast of saturation is of relatively less importance. Since saturation or quality in a colour depends on its purity, it refers to placement of pure undiluted hue next to the same colour which already contains a certain intermixture, whether of grey or another colour. It is obvious that pure colour, thus juxtaposed, will shine more intensely, creating a vivid contrast of tone. Of all Itten's categories, the seventh, that of contrast of extension, was least exhaustively treated by Chevreul and yet should be emphasized. Its importance is vividly demonstrated by its use in the modern Post-Painterly school of abstraction and in the works of artists like Noland, Barnett Newman or Elsworth Kelly, whose paintings are usually of a very large size. They show how the positioning of an extensive area of one colour can be dramatically opposed by a small patch of contrasting colour. Thus the contrast of hue alone can be enhanced or minimized by careful control of the size of the colour area and the judicious handling of contrast of extension can be a very powerful feature in the theory of colour composition.

One could add yet another contrast to the list – contrast of placement. The weight of a patch of colour, and its visual and emotional impact, can vary considerably according to its placement within the area of the image. Since this involves considerations of the assessment of the relative importance of different segments of the rectangle of the image, it will be dealt with fully in the chapter concerned with design but it must be apparent that, for example, a red area at the bottom of the picture adds stability to the image, whereas a similar area at the top appears burdensome. Such extensions and additions are no more than small embellishments to Chevreul's theory and the fact remains that this kind of theorizing can offer only a very limited answer to problems of composition. Theories of harmony and contrast are reminiscent of a cook who tries to prepare a dish that will please all the guests – not too salty, not too sweet, not too sour – and ends up with a concoction utterly devoid of any taste. The final refinement of Chevreul's theory of harmony, by Ostwald and Munsell, was based on mathematical colour assessment. All is calculated, nothing is left to chance and it makes very boring and depressing reading. Too often theories and treatises on colour seem to be strong on generalizations but totally inadequate in stressing the need for originality and unconventionality. Even if one takes into consideration the most modern theories of psychology of art one tends to feel that they try to cater to and analyse the most simple and common of tastes.

There are, currently, four major schools in the study of the psychology of art: the psychoanalytical, based on

Freud, behaviourism, information theory and Gestalt. Of these, the psychoanalytical asserts that since our drives and desires, through social and environmental repressions and taboos, mostly remain on the most basic and infantile level, art experience offers a gratification and release – something of a dream-fantasy sublimation. The theory of behaviourism is somewhat similar in that it contends that the expectation of art experience coincides with the increase of psychic 'arousal' caused by its novelty or surprise. This is gratified by the subsequent release of tension on viewing. Information theory started as a part of much wider mathematical study and was only later applied to psychology. It lays a particular stress on the human need for information. Accordingly any state of psychological equilibrium is constantly disturbed by a feeling of dissatisfaction and desire for new input of information. This in turn creates a pressure and tension, which will be relieved only by satisfaction of the need. An art experience may serve as one of such tension-relieving functions and hence its pleasurable, desirable effect. The theory of Gestalt, possibly the best known, is perhaps the most interesting, particularly since some of its practitioners have extended it beyond its original fundamental stages. The main body of the theory originated among several German scientists in the 30s and 40s who contended that the whole is more than its constituent parts. That is to say, that human perception tends to gravitate towards the simplest, i.e. Gestalt or good, in a form, or shape or a pattern. Hence the human eye will tend to choose the most balanced and elementary, the least confusing arrangement or pattern in an artwork and experience tension in the perception of more chaotic and complicated 'Gestalts'.

These theories revolve basically, in various degrees, around the principle of 'tension-release of tension' and, although some of these concepts may come in useful in discussions of design and compositional problems, they are not immediately related to our assessment of the aesthetics of colour. However, Rudolf Arnheim, one of the later adherents of the Gestalt theory, by pursuing its general tenets, developed a fascinating sideline which has a direct bearing on colour theories. Most of the aesthetic theories of colour harmony aim at the achievement of balance and serenity. Even if harmony of contrast was cited and direct opposites juxtaposed, it was found that balance was still preserved. Our brief excursion into the realms of the studies in the psychology of art would suggest that the desire for stability and equilibrium is essentially what the human psyche seeks, and that the 'pleasurability' of art experience is the release of tension by the return to the *homeostasis*, the state of equilibrium, brought about by a balanced and satisfying art experience. If this were the sole criterion of a work of art, then Chevreul and even Munsell would have been entirely justified in not going

beyond their basic assumption that in a theory of colour harmony lay the answer to the aesthetic problems of colour. But various experiments in perception show only too conclusively that no two humans perceive in exactly the same manner. Perhaps the majority of people would settle for an art experience which brings serenity and quiet satisfaction but there are many for whom this kind of placid experience is not enough. Individuals who are liberally exposed to many visual experiences have been known to tire of commonplace images offering invariable balance and serenity and ultimately crave for a stronger diet. Art experience may in itself have many different connotations involving different kinds of emotion. An art object may invoke not only a feeling of pleasure and satisfaction but also one of wonderment, surprise, excitement, even shock or revulsion. It is doubtful whether any theory of the harmony of colour can offer much in this direction and if one of the attributes of a work of art is its expressiveness – its ability to move and evoke emotion – it is obvious that one must go beyond the classical theory of harmony.

In his important book *Art and Visual Perception*, Rudolf Arnheim suggests that pure, primary colours are not essentially emotive and that even strong contrasts of pure hues do not exert a particularly strong visual impact. He contends that his experiments show, though not conclusively, that it is colours which deviate from their pure hues that are most expressive and that one colour exerts "a dynamic tension effect by leaning towards another colour . . . Pure red, yellow or blue may be zero (expressively) levels of colour, slight in dynamics and therefore slight in expression, but reddishness, yellowishness and bluishness, by drawing another colour away from its own fundamental character, would produce the tension without which no expression is possible." We shall return to this interesting conjecture for it must be obvious that our response to colours is far more complicated and sophisticated than some earlier writers have suggested.

So far we have dealt with colour and its perception purely from the abstract point of view and the discussion has revolved around the concept of colour *per se*, unconnected to objects, their association with past experiences, or with their acquired symbolic meaning. Yet it is virtually impossible to see one single colour alone as it is possible to hear one single note from a tuning fork. Colour cannot be isolated even under laboratory conditions, it is always seen as a part of experience. Josef Albers, yet another student and subsequently a teacher at the Bauhaus in Germany, devoted a major section of his book, *The Interaction of Colour*, to the analysis of colour in relation to other colours present during the perceptual experience. He

pointed out the variable factors which intervene during the viewing of colour, amongst them listing: changing light conditions or several light sources present; interference caused by reflections of other colours or lights; our habit of left to right reading may affect our response to colour combinations; the varying materials on which colours are reproduced; the juxtaposition of unrelated objects. All these affect our experience of colour profoundly and make the analysis of colour even more difficult. Albers also pointed out an obvious fact which complicates the question still further, namely our own very defective colour memory, far inferior to our memory of sounds.

Is the study of colour a science; could it be as precise as mathematics or astronomy? Newton was the first to approach it purely scientifically, and yet he promptly assigned seven mythical planets to his newly separated colours. With the ever growing body of knowledge about colour and its properties, the doubts about the nature of colour also increased rendering it a study falling more into the field of psychologists than physicists. We know that colour is an experience but know little of what we mean by this experience. Take a colour like red. We know that there is no such thing as a separate concept of redness: red like what – a rose, fire, a pillar box or a Mark Rothko painting? Fifty different people will each see and react differently to a specific patch of red. Why this should be so is capable of many explanations amongst them that the experience of colour may be affected by our personal preferences; associations with past experiences will also play a role and our responses may be conditioned by conscious or unconscious symbolic connotations attached to the colour.

Colour preferences have been investigated by a number of researchers, most of whom agreed that the data gathered was not sufficient to supply any kind of dogmatic answer. Such preferences are affected by social, cultural and environmental conditions and even by sex. It seems, for example, that the majority of men prefer blue while women mostly favour red. Red and green, however, seem to be fairly consistent favourites and it is thought that when the human race initially evolved a sense of colour recognition, it was the red hue which was one of the first to be identified. Blind people gaining sight through an operation tend to pick out red before full colour vision is restored and it is an established fact that we tend to remember the colours of objects almost invariably redder and greener than they are. It is of interest to note that green was always thought to be a life-enhancing colour by the Egyptians, perhaps because it was associated with life-giving Nile in its June flooding and Pliny records that tired eyes can be restored by looking at green, whilst Freud, in his analysis of dreams, suggests that the combination of red and green seen in a dream can be interpreted as a tendency to bisexuality and a castration anxiety.

Colour symbolism, an important factor in our reaction to colour, has its roots in tradition, common usage, fashion, even language and response to it is a direct result of certain preconceptions which obviously differ in different cultures, countries and eras. In the West, we stop automatically at the sight of a red signal and a red patch on the pavement is immediately associated with blood; some colours are conducive to evoking a specific mood, black, for example, is the colour of mourning, fear and sadness. In China it is white that symbolizes mourning for in Chinese tradition it helped the dead to the kingdom of purity and light. Yellow was a colour of sun – and of the most powerful of the gods in Egypt; it was reserved for the Emperors in China; Greeks clothed Athena in yellow robes and Brahma and Vishna were similarly attired; Buddha wore yellow but so too did Judas; it is mostly associated with understanding, knowledge and intellect but it also represents hatred and in English, cowards are called 'yellow'.

Some psychologists believe that the meanings of symbolic associations are not merely the result of cultural conditioning but lie profoundly etched in our subconscious and are rooted in archetypes. Hence the powerful symbolic meaning of the colour red; it is connected with fire, blood, war, sacrifice in the rites of fertility, thus with excitement, stimulation, dread and pain. Black is linked with the concept of death, fear and evil because it is associated with the darkness and insecurity of night. Similarly the most archetypal association of blue is with the ocean, with water and its coolness, as well as with the infinity and sublimity of sky. Green evokes the primordial bounty of nature and hence the joyfulness of youth, hope, tranquillity and fruitfulness. Such archetypal colour associates, if they are accepted, must help to formulate a strong basis for our colour re ponses. More specifically, it has been established that our response to colour may not necessarily be registered solely by our sense of sight and decoded in the brain. The phenomenon called *synesthesia* involves a response in a different sense: the sight of red may produce in us a distinct feeling of warmth and blue will elicit a shiver. Similarly a black object is judged to be heavier than a white and a white space to be larger than a black.

IV The Reproduction of Colour

The eye is prone to deception and the brain to illusion. When our expectations are aroused we are easily deceived and on the scantiest of sense data we will accept an interpretation which matches our inclination. A line can become the horizon, a circle the sun. We will readily accept a schematic diagram to represent information about a house or a hill and the convention of perspective is accepted as a substitute for the reduction of three dimensions to two. The eye is easily satisfied and will quickly jump to conclusions. Art and magic rely on both our tolerant senses, and on our conditioned reflexes, to create their illusion. The reproduction of natural colour phenomenon by the mixing of pigments is essentially based on these fallibilities. Three layers of colour can appear to be a multitude of subtle shades in modern colour photography, blue dye, as if by magic, has become an azure sky. It is a most effective illusion.

The process of colour photography is basically divided in two parts: the first is the division of the light forming the camera image into its component parts, the Red, Green and Blue primary colours. This process of *analysis* is similar to Sir Isaac Newton's original analysis of light into its component parts, using his refracting prism; the second is the recombination of the three separate images recorded on film to create the illusion of the original natural colours. The re-created experience is totally convincing although it is a pale imitation, lacking the complexity of stimulation of the original. It is only our visual tolerance that allows us to accept it for, like instant coffee, it is near to the real experience. But the copy loses something in translation, like imitation, reproduction is part flattery, part deception.

With colour analysis, complex stimuli of *all* wavelengths of the visible spectrum can be effectively reproduced by only *three* bands of colour, red, green and blue, because they match the responses given by the three receptors of the human retina. The sensitivity of these receptors makes it possible to reproduce a mental picture of the continuous spectrum, or any hue contained within it, by separately stimulating the three receptors simultaneously to register the red, green and blue components of the original subject. If a photographic record is made of the light reflected from an object, we have, in metallic silver, a permanent impression of the variation in light intensity translated into a variety of tones of grey that make up the pattern of the visual image. Light-sensitive emulsion reacts to all visible wavelenths, it is panchromatic and records all colours as tones of grey silver. It is colour blind seeing only the intensity of light and is unable to detect the nature of the wavelengths or their distribution. In order to detect any variation in colour as well as intensity, the sensitivity of the emulsion must be limited, as in the eye, to that of one of the primary colours.

A photographic emulsion sensitive *only* to red light records only those parts of the subject reflecting red light. The image is an analysis of the colour of the original subject in terms of its red components, and contains no information of the green or blue components. A red-sensitive emulsion performs a function similar to the red receptor of the human eye. But to obtain a complete record of the distribution of colour within a subject, we need similar information on the green and blue components. This can be achieved by recording on two or more silver halide emulsions that are only sensitive to green and blue light respectively. Then using three separate emulsions, and recording three separate images each representing one third of the spectrum, we have on film a permanent record of the *spectral information* needed to reconstitute the picture as seen by the three receptors of the human eye.

This information is not itself in colour, however, but has been translated into monochrome images in silver through the photographic process. The colour data coded in this form cannot be experienced as colour as we know and see it, for this we require a method of reconstituting the colour. This can be done directly using coloured lights, or indirectly, using colour dyes. When the colour is synthesized and the separated images are reassembled and superimposed we have achieved our objective; an image that resembles in light intensity and colour the patterns of light as detected by the eye. The performance of the photographic film matches the performance of our visual senses and on the level of sensation and appearance we have deceived the eye.

Apart from the problem of resynthesizing the colour from our monochrome records, there is the difficulty of making three photographic emulsions that are sensitive *only* to red, green or blue light. By the nature of their chemical structure and properties silver halide emulsions are normally only sensitive to wavelengths from the blue into the ultra-violet end of the spectrum. These were the only emulsions available to early Victorian photographers who took their photographs by the blue light present in the spectrum, operating on only a third of the actinic light available to the human eye, greens and reds being reproduced in unnaturally dark tones. The discovery of colour sensitizing by H. W. Vogel in 1873 made possible a photographic recording of green light. These orthochromatic emulsions were sensitive to ultra-violet, blue and green light and made two-thirds of the spectrum visible to the camera eye. The blue and green receptors of the human eye now had their photographic equivalents. The development of red-sensitive

emulsions at the beginning of this century, capable of recording an image from the whole of the visible spectrum, finally made possible the complete recording of the colour information available to the eye.

We now have the photographic equivalents of the tri-receptor theory of colour vision in the modern tri-pack colour films with three layers each capable of recording the blue, green and red components of light reflected from the physical world around us. In our photographic 'retina' of three emulsions the blue sensitive emulsion (ordinary) acts as the *blue receptor*; the green sensitive emulsion (ortho) acts as the *green receptor;* the red sensitive emulsion (panchro) acts as the *red receptor.* The photographic green and red receptors unfortunately are also sensitive to ultra-violet and blue light. Silver halide emulsion technology can extend the spectral range into the green and red through dye sensitization but it cannot remove the natural blue sensitivity. In order to effectively eliminate any recording of ultra-violet and blue light, in the green and red sensitive layers, light must be prevented from passing beyond the top layer. This is achieved by absorbing the blue light by means of a yellow filter located between the top and middle layers.

The principle of colour separation, first suggested by Thomas Young in 1801, had to wait for a hundred years before photographic technology could realize its full potential. There was a similar delay before the principles of colour synthesis, by which the information recorded in tones of silver grey, as we have shown, could be reconstituted as colour, could be applied to the photographic process as we know it today. Since James Clerk Maxwell, the Scottish physicist did his experiments in colour perception in 1860 and established the principles of additive synthesis and colour photography, the ingenuity of photographers, scientists and the photographic industry has been engaged on a constant search for the perfect colour process. There are two basic systems of colour synthesis, the additive and subtractive and it is on these that all colour photography has been based.

That colour as light energy can be added is the principle of additive synthesis. The combinations of wavelengths in varying proportions stimulate the eye to perceive colour. In 1855, Clerk Maxwell demonstrated experimentally that the colours of nature could be reproduced or imitated by mixing varying proportions of light from the three primary colours. Basing his theory on Thomas Young's theory of colour vision, Maxwell realized how it could be applied to colour mixing, using light. In a lecture to The Royal Institution on colour vision in 1861, Clerk Maxwell, who had conceived the nature of light as electro-magnetic energy, illustrated his talk with lantern slides in the fashion of the time. In a dramatic illustration of the three receptors theory he superimposed three black and white photographs of a tartan ribbon on the screen. Each of the photographs had been printed from negatives exposed through a red, green and blue filter respectively, that is, they were colour separated. The original colours were recombined on the screen for the audience by using three separate magic lanterns for each of the colour separations, one lantern had a red filter over its lens, the others green and blue. On the screen appeared an image of the tartan ribbon in full colour.

The success of the demonstration was as fortuitous as it was dramatic. Using the collodion plates of his day which were only blue-sensitive, the experiment should have been a failure. Although Maxwell's theory of additive colour photographs was characteristically sound, the materials of his experiment were deficient as the emulsions available were insensitive to green and red light. Technically these records should have been blank and he was saved by a deficiency in the green filter used to record the green image and in a spectral bonus from the red ribbon. The dye used in the red ribbon, unseen to the eye but visible to the camera, recorded an image of ultra-violet light. This was not filtered out by the red filter used and neither was the blue light in the deficient green filter. It is by such accidents and good fortune that man and science make progress. When panchromatic emulsions became available this additive system of mixing light became the basis of many successful systems. All have now been superseded, although one, *Dufaycolor*, did survive into the 1950s.

Additive colour, however, is now used not in a photographic system but in colour television. Colour television reproduces colour using an electronic equivalent of Maxwell's original demonstration. The television screen, today's magic lantern, is excited by three electron guns. The screen is coated with a mosaic of coloured phosphor dots which on excitation from the electron guns radiate red, green or blue light. By means of a shadow mask, consisting of three-quarters of a million holes immediately behind the screen, the red dots are masked from the electron beams of all but the red electron gun, which is modulated by the red component of the original subject image. Similarly the green and blue guns are in register with the green and blue dots. The picture we see on the screen is a regular mosaic of two million dots radiating red, green and blue light of varying intensity. The dots do not overlap each other and their separation means that there is no colour mixing on the screen itself. What we see is, in effect, three separate images of red, green and blue light simultaneously and in register. The mosaic screen of phosphor dots converts the electron energy into fluorescent colour light, as the separate beams

scan the surface of the tube. The fineness of the mosaic screen ensures that the eye cannot resolve the individual dots and so they are in effect mixed in the eye. Thus Red + Green combine to form Yellow; Red + Blue, Magenta; Blue + Green, Cyan and Red + Green + Blue to form White.

Although as a system of colour reproduction it is perfectly sound and capable of high saturation and subtle graduation of hue, the additive system does suffer from a number of severe limitations on a practical level. It is basically cumbersome, relying on a system of separate projectors and the inevitable problems of image registration, and the mosaic screen, difficult and expensive to manufacture, substantially lowers the sharpness and resolution of the silver image by superimposing a 'pointillist' colour screen which is much coarser than the photographic image. These disadvantages are not so apparent in colour television as it is an inherently low definition, electronic projection system with an existing coarse 'raster' scanning beam of 625 lines producing the picture, rather than high definition silver grains. But the additive system does not lend itself to reflection prints or reproduction by half-tone printing, due to the problem of registering two sets of dot screens together. Even as a transparency system, used for projection, it is grossly inefficient in the use of light. Not only does it require three separate light sources but each is filtered with a dense colour which absorbs three-quarters of the light emitted. When the red, green and blue light is recombined to give white light the maximum brightness available is only a quarter of that available from the projectors. These serious limitations meant the eventual obsolescence of the process, except for the special case of television. It was replaced by the much more versatile system of subtractive dye synthesis which overcomes all of these objections.

Colour can be synthesized by subtracting light from the complete visible spectrum. Just as white light can be built up from its component parts by addition so, by a reverse process of subtraction, can the component colours by synthesized. Take the colour Yellow for example: Yellow is synthesized by adding Red and Green light, R + G = Yellow. It can also be synthesized by starting with white light, composed of Red, Green and Blue light, and removing the blue light, $(R + G + B) - B = R + G =$ Yellow light. Thus using a dye or pigment which absorbs the blue third of the spectrum, the remaining two-thirds of the spectrum are reflected or transmitted as yellow light. Similarly a magenta dye filter will transmit red and blue light and absorb green and cyan, an additive mixture of green and blue light, will absorb the remaining third of the spectrum, red. In this system of subtraction, by using three colour dye filters in overlapping combina-

tions, we can control the amount of primary light transmitted or reflected. Each of these subtractive colours, yellow, magenta and cyan, allow two-thirds of the visible spectrum to pass freely, and absorb one-third each. Because yellow dye absorbs blue light it can be designated *Minus Blue*; magenta can be called *Minus Green*; and cyan, *Minus Red*. These complementary colours, in the form of separate dye images, can be superimposed in three layers to resynthesize the colours of the original subject.

The transmission and absorption characteristics shown in fig. p. 62 are 'ideal', that is, they represent the performance of a perfect dye, where complete transmission of two-thirds of the spectrum and total absorption of one-third is achieved. In practice such dyes do not exist in our imperfect world. We make do with the best that are at present available, see fig. p. 62.

When the subtractive primaries are used in overlapping combinations their individual absorption characteristics are combined together. Paired in combination this results in the synthesis of the additive primaries:

Subtractive Primaries		Additive Primaries
Yellow + Magenta	=	Red
Yellow + Cyan	=	Green
Magenta + Cyan	=	Blue

If all three are superimposed, with each removing by absorption a third of the spectrum, no light remains to be transmitted and the result is black, or neutral grey.

Thus we have a system that is capable of reproducing any colour or shade of colour, within the visible spectrum, by progressively removing layer by layer the negative components of the pattern of light from reaching the eye. It is an exact reversal of the additive system where the components are built up, by the addition of light, to stimulate the three receptors of the eye. It does not suffer from the disadvantages of the additive process: there is no coarse mosaic screen to destroy the resolution of the image; it can easily, as a tri-pack, be projected with one light source or printed on paper; the brilliance of the highlights is undiminished by any dense mosaic filters: the development of integral tri-packs creates the three images in situ and eliminates any problems of registration of separate images and mechanical reproduction, by using half-tone dot screens, presents no difficulties.

It is an ideal system, on which all modern colour processes are founded. Modern colour photography analyses the original colours as light by the additive primaries Red, Green and Blue and then reconstitutes them as dyes using the subtractive primaries, Yellow, Magenta and Cyan. Although the names vary, the

photographer's palette is the same as the painter's pigments as they both are using a subtractive system. The artist calls his primaries Red, Yellow and Blue, the photographer, more scientifically precise in sympathy with his medium, calls them Magenta, Yellow and Cyan. However, no colour reproduction based on three colours is an exact match to the original but it can give an impression to the eye that is in appearance identical to the original colours, if performing to the limits of the theory outlined.

Just as colours cannot be reproduced exactly, neither can theory in practice. Individuals vary in their colour perception; the filters used, or the emulsion sensitivities designed to separate into the analytical colours of red, green and blue, do not match the theoretical ideal or the performance of the receptors in the human retina as they should and inevitably colour distortion will occur when the synthesis is made in colour reproduction. Moreover, the 'ideal' dyes of the subtractive synthesis do not exist in actuality. Even with an unlimited choice of natural or synthetic dye-stuffs it is not possible to reach this level of perfection. For instance, the cyan dyes available do not perform to the standard required, they should absorb all the red light and transmit all the green and blue but in practice they achieve only partial success, with some red light transmitted and partial absorption of both green and blue light. This leads to a desaturation of the colours on reproduction, with the red lightened and the greens and blues darkened. The yellow and magenta dyes available for use in the subtractive process are much more efficient in approaching an ideal performance.

The design of colour emulsions and the matching of dye characteristics is a subtle art and with technological skill combined with artistic imagination the illusion can be almost complete. The inevitable distortions in colour and saturation can be visually compensated by subtle adjustments in contrast levels. When reproduced colours are themselves reproduced, there is a multiplication of the distorting errors. If a colour transparency is copied, by half-tone mechanical printing or a duplicate transparency made, it is desirable to counteract the increased distortion by using sophisticated methods of masking thus minimizing the errors due to the dye deficiencies. The Negative/Positive process, for producing colour prints, is a two-stage operation involving two colour/dye emulsions. To improve the quality of reproduction, the first stage of the process is 'masked' automatically. The negative has incorporated within its structure a series of integral masks which improve the performance of the dyes available. By masking the negative the cumulative effect of one set of dyes is eliminated. This enables a double reproduction process to have the same level of fidelity as that of a single one.

In spite of these deficiencies, colour as reproduced is remarkably convincing to the viewer, particularly when taken at face value and direct comparisons are not made. Such comparisons are in themselves unreal as the whole process of perception and representation of images is an illusive one in itself. A subjective experience does not lend itself to objective comparisons. To reach today's level of perfection is a miracle of science and technology. It has, since the possibilities were first demonstrated by Clerk Maxwell over a hundred years ago, been a long struggle involving many blind alleys and failures. To solve the formidable problems has required the ingenuity and scientific knowledge of physicists, chemists and manufacturing engineers, discoveries in photo-chemistry, emulsion and dye-technology. Although the basic principles of the additive and subtractive processes were known, it has taken the inventive imagination of individuals and the resources of large-scale industry to evolve a practical, economic and efficient colour 'package', available to everyone, easy to use, and requiring little knowledge or experience to obtain satisfactory results. The modern photographer owes a debt to these pioneers of colour photography, for the benefits we take so much for granted today. If the nature of colour is something of a mystery and colour photography borders on the magical, it is because of the dreams and persistence of these brilliant men whose achievements we chronicle below.

1666 Sir Isaac Newton split the spectrum by refraction and established the connection between light and colour.

1704 Newton's *Opticks* on the nature of light and colour published. Later editions speculated on the function of eye and brain.

1801 Thomas Young's theory of colour vision: the tri-receptors of the retina, Red/Green and Blue.

1855 James Clerk Maxwell experimented on additive mixing of colour using Red/Green/Blue light.

1861 Demonstration of the first colour photograph by Clerk Maxwell at The Royal Institution, London, using three projectors.

1869 In *Les Couleurs en Photographie. Solution du Problème*, Louis Ducas du Hauron, a French pianist, suggested an outline of the subtractive system on which all modern processes are based. He used bichromate and coloured carbons to produce his colour photographs and also suggested a mosaic screen process. Success was limited due to the lack of a green/red sensitive emulsion at the time.

1873 Introduction of ortho- (green sensitive) emulsion based on dye-sensitization discovered by H. W. Vogel.

1892 Fred Ives of Philadelphia invented a special triple exposure camera on a single plate (photochromoscope) producing separation negatives. Using mirrors, positives could be reassembled for viewing under red/green/blue filters (Kromoscope).

1893 Charles Jasper Joly, a Dublin physicist, had a chequered screen of 200 lines per inch of alternating red, green, blue dyes. It was placed in direct contact with sensitive emulsions, during exposure and later in register with a positive.

1907 Auguste and Louis Lumière, inventors of cine-matography, manufactured their *Autochrome* plates at Lyons. Using recently introduced panchromatic emulsions, they directly coated a mosaic on to the plate, using dyed potato starch grains to produce the mosaic.

1909 Rudolf Fischer discovered 'colour develop-ment', using paraphenylene diamine, on which all modern processes depend.

1935 Mannes and Godowsky perfected a colour-coupled tri-pack film with reversal processing.

1936 Agfa introduced the first tri-pack with couplers incorporated in the emulsion layer.

Blue Mosque—Richard Tucker page 75
Red Sea—Richard Tucker
While the design and shapes are thought to engage mainly our intellectual faculties, the colour affects us very directly through our emotions. Certain mental associations attached to specific colours also tend to enhance their emotional effect. We associate blue with coolness of the water and the vastness of the ocean, while red evokes stronger feelings. Consequently powerful effects of these colours, here introduced artificially by filtration, produce a contrasting emotional mood. In the case of the "Blue Mosque" it is the splendid distance and remoteness, whilst in the "Red Sea" the violent tones contradict the natural association of sea and sky.

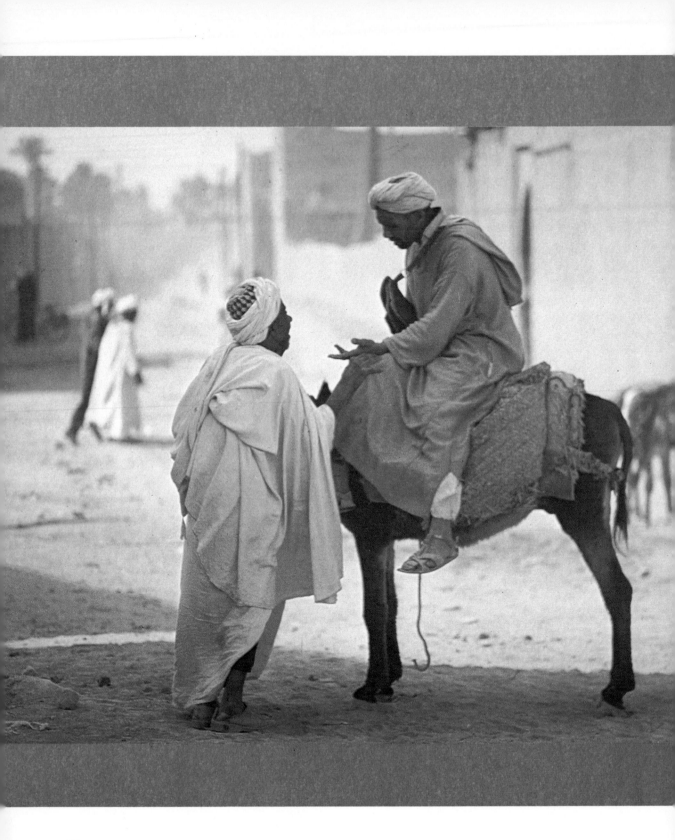

Moroccan Encounter—Christian Sauer page 76
Every photographic image consists of a mixture of elements
providing both information and satisfying visual needs. In
some the elements of information predominate, in others the
content is strongly overlayed by the needs of aesthetics.
Often the nature and the meaning of the picture is determined
by the predominance of one or the other, and the motivation
behind the picture is clearly revealed. In "Moroccan En-
counter" both tendencies are apparent and fairly evenly
stressed. The viewer is given some information to arouse his
interest but his visual enjoyment is satisfied by softness and
delicacy of light and balanced composition.

Nude in the Field—Mayotte Magnus page 78
Alan Jones' *Holding Power*—painting photographed by
Rodney Wright Watson
The pictures show a contrast of the formality and stylisation of
modern art as against the naturalism and immediacy of
photography.
Photography is the only medium which is capable of recording
an instantaneous reaction to a specific visual experience.
Because of its immediacy only photographic image possesses
freshness which can be likened to a true fragment of life.
Since most of the modern painting abandoned literal repre-
sentation, partly because of the obvious superiority of the
photograph, painters have to resort to a symbol or stylisation
of the image.

Stonehenge page 79
Photographic imagery does not rely on synthesis, but entirely
on selection. While the painter assembles the elements of
the image, the photographer must accept the whole. This
selection can be applied at both the exposure and printing
stages. In the case of Stonehenge, since the subject matter is
constant, it is the colour, the mood and the selection of view-
point and framing which give a creative opportunity to the
photographer.

78

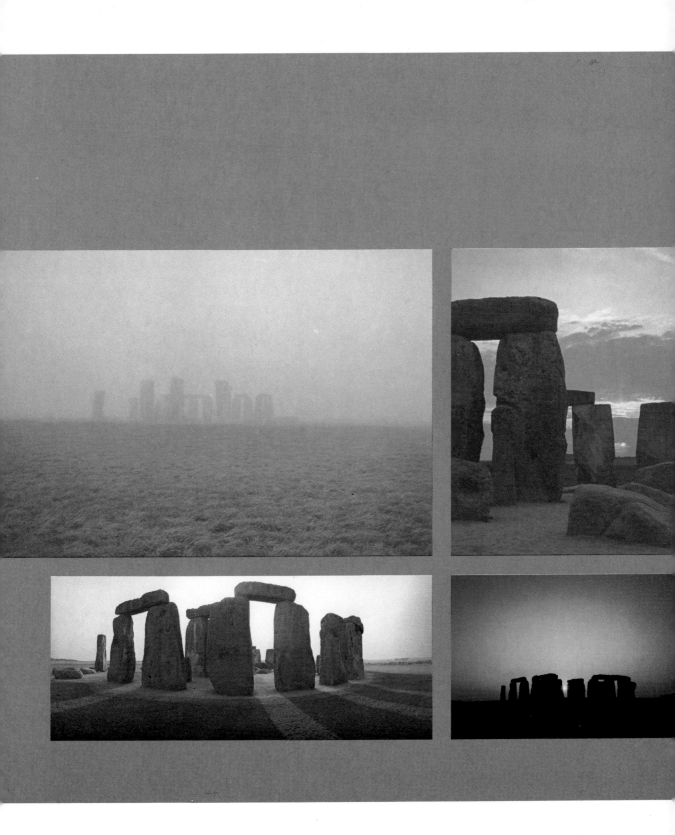

I Creative Response

"The photographer starts from an image already whole. Superficially it looks as whole as a finished painting, although it is rarely completed. The photographer completes the whole or total image by analysing a variety of whole images. So the photographer invents nothing; everything is there and visible from the start," wrote Minor White in *The Camera Mind and Eye*. The photographer's image is unique and distinct. Before the invention of photography there was no equivalent creative visual representation that could be likened to it. No other creative image maker had had a choice of "whole images" for "the invention of photography provided a radically new picture making process, a process based not on synthesis but on selection" in Szarkowski's words. It was no longer a question of piecing together parts to make a whole, no longer a process of compilation but a process of selection of complete images based on reality.

Szarkowski continued, in his stimulating book *The Photographer's Eye*, by pointing out that "The photographer's problem to see is to see not simply the reality before him, but the still, invisible picture and to make his choice in terms of the latter." Although there are obvious differences between painting and photography, the conscious visualization and analysis of these differences is often illuminating and to compare the creative processes helps towards an understanding of a photographer's problem. Almost every day, Paul Cézanne walked his favourite two miles from his home, near Aix-en-Provence, to the ramparts of Mont St. Victoire. Having arrived there, he gazed at the mountain, placed his easel in its accustomed place and, after a few more minutes of contemplation and visual analysis of the view he knew so well, began to paint. He had analysed this view many times before and there were to be many more two mile walks again.

Cézanne's complete knowledge and understanding of his mountain created a kind of mental picture of which his daily communions were a confirmation. The final painting was a synthesis of his feelings, his understanding of the inner reality of the landscape and of the actuality which he daily tried to reconcile with his mental conception.

Now the photographer must also extract "the still invisible" image from the reality of the view and formulate it as a complete picture but his method of 'seeing' and 'realization' is, in fact, totally different. If a painter like Cézanne is an explorer and investigator, digging out the truth of his image from the reality in front of him and then interpreting, digesting and

Creative Seeing

I Creative Response

II The Approach to Subject Matter

III Subject Treatment

"The photographer's problem is to see not simply the reality before him, but the still, invisible picture, and to make his choice in terms of the latter."
Szarkowski *The Photographer's Eye*

analysing it in his own mind, the photographer is far more of an inventor than an archaeologist. He sees the solution in a flash for photography is not a structural medium, nor a medium of compilation and evolution but one of discovery. The photographer is a little like a sapper who searches the ground with his mine-detector, scanning the area inch by inch until suddenly the needle of his instrument goes wild and Eureka! – he has found his image.

It is essential that this subtle difference in the manner of seeing should be clearly understood. In spite of the fact that the divergence between photography and painting is now fairly generally admitted, a majority of photographers, both professional and amateur, still appear to be inclined to use the painterly Cézanne method. Too many of these pictorial photographers seem to search the reality around them for pictures that would fit their preconceived, mental image. An image already formulated, moulded by accepted rules of composition and prompted by some other 'formula' picture they have seen. In searching for this ideal, they close their eyes to the new, exciting possibilities which stare into their lenses.

However, it could be assumed that the kind of seeing that finds an image rather than consciously assembles it, could lead to haphazard snapshots, automatic records without the intervention of the intelligence of the photographer. This is almost wholly wrong. A certain amount of randomness and chance is always present in pure photographic imagery since it is an integral part of the nature of the medium but the photographer's eye is rarely entirely aimless, nor his selection fortuitous and unpremeditated.

A good photographer acquires an almost subconscious feeling for form and timing, through a long and thorough training of his eye and perception, which will help to infuse a sense of his order and organization into the subject matter, formalizing his images and giving them a sense of structure. But since this structure is derived more from an intuitive sense than from the cold, logical application of any academic theory of composition, the image will retain that sense of life and freedom which is the fundamental core of the photographic medium. Academic and orthodox methods of composition may be perfectly suited to a painting which is, by definition, a totally subjective creation but a photograph, based on objective reality, would be ossified and deadened by the similar application of a formula or rigid convention. In colour photography, this necessity for freedom from the rigidity of rules is perhaps even greater than in black and white photography. Colour is pre-eminently an emotive medium and our responses to it are almost wholly unintellectual and spontaneous in nature. Academic formalism of colour composition in colour

The Descent—E. A. Hoffmann **page 82**
The Net—Ewald Stark
Content and form are two principal elements of any image. No significant picture can exist where one of these ingredients is missing. But their respective importance and dominance varies. Here, content is the chief element of "The Descent" while the formal arrangement positively dominates "The Net".

The Morning Train—**Raimo Gareis** **page 83**
Some photographers and critics insist that it is not possible to achieve an aesthetic result, if the image is created with a specific intention and motivation behind it. "The Morning Train" was the result of definite planning to record for posterity a series of, now almost extinct, steam trains. Does this fact diminish its intrinsic aesthetic value?

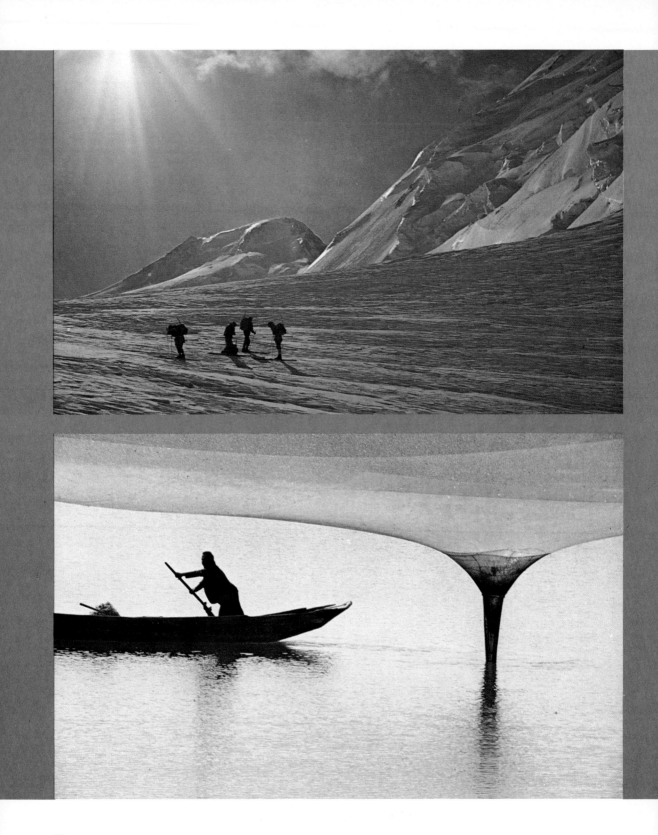

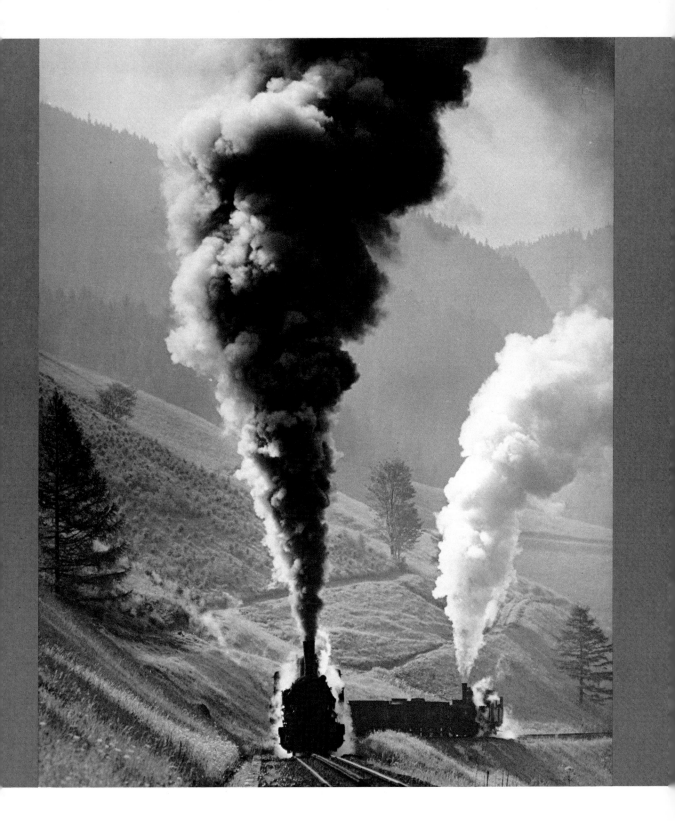

photography would be even more obviously false. Photography is a mirror image of reality and nature never achieves perfect order and symmetry.

The chaos and confusion which the 'found' image may be thought to encourage is not only curbed by the photographer's intuitive formalization but also by the discipline imposed by the natural desire to achieve a personal interpretation. An overwhelming majority of photographs are shot not by a pure chance but by a deliberate choice. A locality is chosen for its beauty or, perhaps, its unspoilt character, a person because they are of interest to the photographer. In each case, the confrontation is anticipated and a kind of mental preparation made for the encounter. The mental image of the subject is never distinct or in any way specific. It could just be a generalized feeling, usually based on previous knowledge and experience or an additional information gathered in expectation of the confrontation.

A dormant image is formulated which may undergo a complete transformation through actual contact with the subject but whatever kind of photographer – either one who likes to spend the whole evening in meditation or one who relies on purely spontaneous impressions – there is little doubt that a certain point of view is formed. Initially, it is not important whether this point of view is objective or subjective. What is important is that there should be a definite desire on the part of the photographer to exteriorize this point of view and communicate it, through his image, to a subsequent viewer. Since it is necessary to formulate this message with sufficient clarity, it has to be ordered in some way and, therefore, the organizing mind has to intervene.

The passion to create images is deeply and fixedly rooted in human nature. It already expressed itself some fifteen hundred years ago in the crude drawings at Altamira and Lascaux. It is evident now in the graffiti on the walls of stations and in public lavatories. It answers the need to express and exteriorize one's feelings and beliefs and share them with others. It was photography, with its remarkable ease of image orientation, that made it possible for a far greater number of people to express themselves.

In examining the motivating impulse behind the desire, shared by people of widely varying age groups and social strata, to seek self-expression through photography, two main factors can be discerned: the gratification of pleasure and the fulfilment of a purpose. Speaking generally, it can be said that, when motivated solely by pleasure, one is entirely free in one's pursuit of creativity, whilst if one's aim is purposeful, one is bound to be subjected by some restraints and limitations. This argument could be stretched to the extreme conclusion that if freedom is in any way curtailed, creativity would be hampered.

Indeed, there is a group of photographers, mostly of American origin, who believe that if there is a distinct orientation towards any kind of purpose or design, however mild, the resulting image can never be truly artistic and creative. They maintain that only the complete freedom of a mind entirely unhampered by intent or direction is fully conditioned to aesthetic activity. This seems rather a harsh stipulation, since it is only on a very rare occasion that one acts without any predetermination. It may be debatable whether a purely commercial advertising photograph can be described as creative but that does not mean that it need be devoid of artistry. Does the fact that the posters of Toulouse-Lautrec were commissioned for the specific purpose of publicizing the shows at the Moulin Rouge necessarily mean that they are not works of art? A glance at the photograph (p. 83) of a train taken by Dr. Gareis reveals the beauty of the image, the balance of arrangement and harmony of colours. Yet the image was highly premeditated. It required a precise planning of location and timing of the exposure and was shot for a definite purpose – it is one of some 3,500 shots in Dr. Gareis' collection of photographs of steam locomotives. It is evident that no hard and fast rules can be drawn in this kind of argument; creativity and artistic content have no measuring unit. Such discussions are largely unresolvable and any argument subject to a variety of interpretations. But perhaps an alternative criterion can be suggested.

Photography, dependent on a mechanical apparatus and mechanical image production, can be described as both an art and a craft. As Edward Steichen suggested, ''The use of the term art medium is, to say the least, misleading, for it is the artist that creates the work of art not the medium. It is the artist in photography that gives form to content by a distillation of ideas, thought, experience, insight and understanding.'' The degree of artistry or creativity has obviously not to do with the medium itself but with the attitude of the photographer both to the medium and, even more perhaps, to the subject he interprets. He transforms the contents of his image by ''his ideas, thought, experience, insight and understanding'' from a mere record to an act of creation.

The degree of creativity and meaning must depend largely on the empathy between the photographer and the subject. A deep involvement and a degree of fascination for the subject, combined with the photographer's creative ability and sensitivity, are the sole determinants of the result. If the attitude of the photographer amounts to no more than cold calculation and a cool appraisal of the visual facets of the subject and his prime purpose is to create a deliberate, predetermined effect, it would be highly unlikely that the result would transcend mere technical competence. All

true creative activity requires a combination of technical proficiency, aesthetic sensibility and personal emotional involvement. That, in addition, there might be a specific purpose is of no great consequence. After all, the haunting pictures of the Depression in the southern United States during the thirties were taken by Dorothea Lange for The Farm Security Administration and most of the poetic essays of Eugene Smith were shot for *Life Magazine*.

It can be argued that a purpose, deeply felt and understood, may be a spur and not a hindrance to creative activity. But it also could be contended that in spite of the fact that a great deal of imagery produced for a specific reason does qualify as fully creative and artistic, creativity still depends to a large extent on complete freedom of expression. Both Dorothea Lange and Eugene Smith, though working to brief, were totally free most of the time, creatively speaking. Their creative expression was never at variance with their commissioning agent who had, indeed, commissioned them precisely because of their independent, personal creative ability. The situation changes if the control becomes more pronounced and the nature of the assignment more precise and rigidly defined. Photography is precise and matter of fact, it is difficult to infuse it with a feeling of excitement and empathy when taking a shot for a predetermined result. It can be maintained that, on the whole, the scope for artistry and personal involvement must be greater when the photographer's motivation is solely the gratification of pleasure, however that may be defined.

The concept of the gratification of pleasure is, however, complex and indistinct. As we have previously seen, many of the theories on the psychology of art were based on the principle of the onset and subsequent release of tension. The act of creation and, indeed, the viewing of images constitutes some sort of discharge of tension which seems to originate in a feeling of need: perhaps some desire for information or to experience something new or an agreeable feeling through viewing something harmonious, perfect or beautiful. All these must be components but none explain the phenomenon completely. The traditional theory of art revolved round the creation of an abstract ideal of beauty. Phrases like "art is awareness of beauty" or "fundamentally, fine art is apprehension of beauty" became the stock in trade of all discussions on the nature of art. The famous *Discourses* of Sir Joshua Reynolds delivered in the form of lectures to the Royal Academy became a bible for future Academicians, who were urged that "All objects which are exhibited to our view by Nature, upon closer examination will be found to have their blemishes and defects. The most beautiful forms have something about them like weakness, minuteness or imperfections . . . The painter who aims at the great style . . . corrects

Timing page 86
Photography is an instantaneous art form fixing a moment in time by isolating it as the fourth dimension within a static frame. This transformation of time and space is unique to photographic vision, and raises that which is seen to a higher plane of awareness, beyond representation of everyday events. If the "decisive moment" has a meaning, it is a poetic symbol of life, caught in the act in a state of suspended animation. The transient, ephemeral nature of life, a fleeting gesture, the half remembered joys of childhood, a chance encounter, are the essence of photography.

Colour Temperature page 87
Colour photography not only adds realism and a sense of physical presence, but increases the emotional involvement. Although colour has strong associations with specific ideas, it also acts on a more instinctive level of empathy. The emotional tone can be either warm or cold. The colour temperature of daylight can vary from warm, on a mellow sunny afternoon, to ice cold in the deep shadow of a mountain at high altitude. The camera sees what we can only feel.

The Quality of Light page 88
Light transforms our visual landscape from the commonplace to the extraordinary. Natural light can create magical effects in the sky or water on objects and surfaces, revealing hidden potentialities of form and colour. Although artificial light cannot match the variations and subtlety of daylight in all its moods it can, artificially, create a sense of vitality and drama. In being the instrumental force that energises the photographic process light is the primary concern of the photographer's vision.

Sudden Rain—Joseph St. Anne page 89
Camera is a mechanical instrument which can in sensitive hands become highly responsive. It can produce endless pastiches of stereotyped "masterpieces" of the past or, alternatively, create spontaneous images devoid of self-consciousness and artificiality. "Sudden Rain" suggests a casual approach almost an extension of the eye without preconceptions.

A PERFORMANCE BY DUDLEY MOORE
LORNA HEILBRON IS OF ATTRACTIVE AID
TERENCE EDMOND IS PROPERLY POMPOUS
AS HER BABBITT MATE.
BILL KERR SCORES SOLIDLY WITH HIS
WELL TAKEN IMITATION OF BOGART.
THE BEVY OF DREAM-GIRLS COMPOSED
OF PATRICIA DRAKE, ANNE DE VIGIER,
JENNIFER CARLOW, JULIET KEMPSON,
ANGELA RYAN, VICKI MICHELLE AND
VIVIENNE GREEN - IS AN ORNAMENTAL
ASSET "

HERALD TRIBUNE

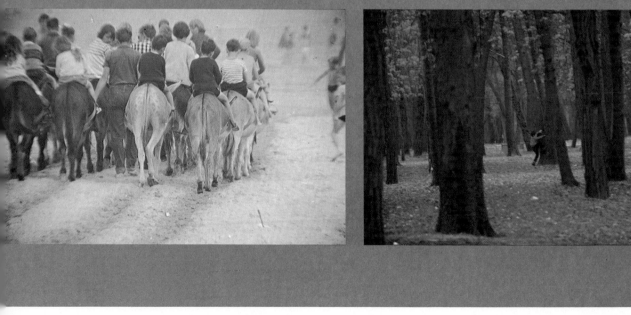

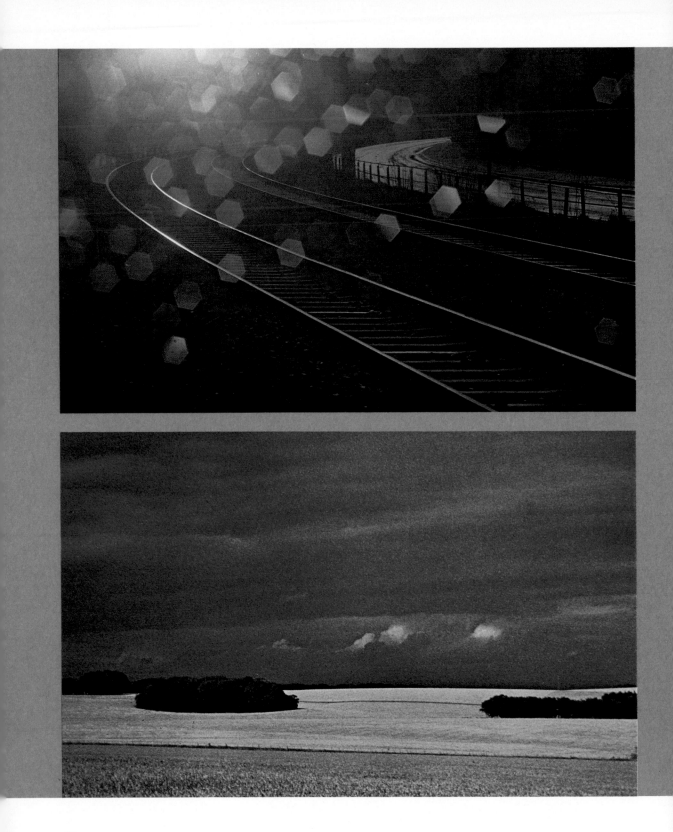

Nature by herself, her imperfect style, by her more perfect . . . The idea of the perfect state of Nature which the artist calls Ideal Beauty, is the great leading principle by which works of genius are conducted." And Coleridge, in the early nineteenth century wrote, "The awareness of beauty is at once the starting point and culmination, the presupposition and the end, of all art."

It is the very idea of 'beauty' which was the greatest weakness of these theories of art. It is patently impossible to define beauty as a fixed concept—what definition would comprehend Rembrandt's *Flayed Ox* or Goya's *Horrors of War* – works of art that are horrific and shattering but hardly beautiful. Although Edmund Burke in his *Enquiry into the Origins of our Ideas of the Sublime and Beautiful* tried to substitute the concept of sublimity for that of beauty, suggesting that "Sublimity, the elevation of mind, ought to be the principal end of all our studies", it was obvious that the essence of art should be sought not merely in any concept of beauty or sublimity but in the origin and contemplation of an emotional experience.

That does not mean to say that previous theories of art should be neglected. Gestalt theory confirmed the human need for order and form, form in this context being understood as the desire to formulate visual ideas into coherent, organized and satisfying units of perception. Sir Herbert Read's statement that "Art is the ability given to a man to separate a form from the swirling chaos of his sensations and to contemplate this form in its uniqueness" is still very pertinent today. But it is no longer the complete answer. The human need for expressiveness and the attendant psychological response to aesthetic stimuli of varying kinds have to be taken into consideration.

A useful summation of the modern approach to the philosophy of art can also be found in Read's book: "The Origins of Form in Art". "Nowhere in the modern psychology of art will you find any justification for the notion that art is a perceptual or intellectual activity concerned with the formulation of absolute or ideal types. Fundamental to all exact psychology of creative processes is the notion that art is the expression, through the senses, of states of intuition or emotion, peculiar to the individual."

Several ideas contained in this passage should be emphasized. Firstly that art is not merely concerned with an idea of beauty and that its content or subject matter cannot merely be confined to things of beauty, whatever the definition of the word. Secondly that art is very much a concern of an individual and of individual responses. Lastly that the phrase "art is the expression, through the senses, of states of intuition or emotion" applies most appropriately and fittingly to photography,

Sheer versatility of the photographic medium is one of its greatest assets. One can approach the subject of the photograph in any number of ways. In the top picture the method was largely indirect, glass of the window of the waiting room, with some remaining drops of recent rain, through which the picture was taken, acts as a kind of glistening screen. The subject itself—the track and the station—become secondary to the mood of the image and the effect of light. "The Field", on the other hand, represents a straight and direct look at the landscape in front of the photographer. The clearcut lines of the field and the dark, stormy sky command the total attention of the photographer.

Another approach to subject matter, is by using the forms and the colours of nature, as a raw material for mainly abstract pattern, through the device of differential focus. Because of a very close position of the camera the subject is dematerialised and becomes a mass of colour, light and shapes. This effect is unique to photography, since visual perception relies on constant scanning to produce a sharp image.

because of the very nature of the medium. The photographic image is created as an instantaneous response to visual and emotional stimuli. It is, as Moholy Nagy called it, "the ideal instrument of visual expression".

Every photograph contains the evidence of a number of important decisions which the photographer has to make in the moment of exposure. These decisions differ according to the circumstances and the diverse personalities of the individual photographers. But generally there are two broad areas where the decisions have to be made. These are on the content of the image and on its form. The approach and treatment of content, or subject matter, and form, or design, are the subject of the following sections. It is, however, necessary to discuss briefly the role that these decisions play in the motivation of the photographer, for although the two are inseparable and an integral part of the image, it is evident that the degree of their importance will vary greatly from picture to picture.

In Hoffmann's picture (p. 82), it is the content of the picture that is of the greatest importance. The subject is man against the elements and this theme is emphasized by the smallness of the men in contrast with the mightiness of nature, a point further emphasized by the stress laid on the contrast between the warmth of the sun and the chill of snow and ice. The form, indeed, is not entirely forgotten and the image is well integrated and balanced but the content, the story, predominates and it is, of course, this which motivated the photographer.

Stark's photograph is clearly different (p. 82). Here it was undoubtedly the formal aspects of the scene which attracted the photographer. He was obviously fascinated by the strange shape of the net and the juxtaposition of the silhouette of the boat and the rower. Again the result is highly successful but on an entirely different level. As a story, a description of content, the picture is clearly a failure. It is rather difficult to grasp the nature of the net and the boat does not quite fit the context. The colour of the net adds yet another ambiguity by its close resemblance to a sandy beach which, logically, would be in the wrong position as it looks upside down. But the image as a whole is so good and exciting, so successful from the point of view of the play of shapes, that the ambiguities of the subject matter are of no disadvantage.

In both, the importance of form, the sense of order and of balance, can be seen. It is a rare exception when an image succeeds despite a weakness in composition. Only when the subject is of an extraordinary nature, claiming all our attention, will the lack of formal quality escape unnoticed. It does not follow from this that form is necessarily more important than content. In photography, the contrary may well be true. As a medium, it

Selfportrait of Barnaby Hall pages 94, 95
An exhilarating series of instantaneous selfportraits—all movement and zest—illustrates the enchanting quality of chance and the unexpected which are one of the important affinities of photography. Only the staging is thought out and arranged and the rest is left to the deft eye of the camera recording fragments of this photographic "happening". The stage is set for chance gestures and positions of the body to be recorded. In fact, a great deal of instantaneous photography, without any staging, also depends on fortuitous coincidences of various elements creating a satisfying image.

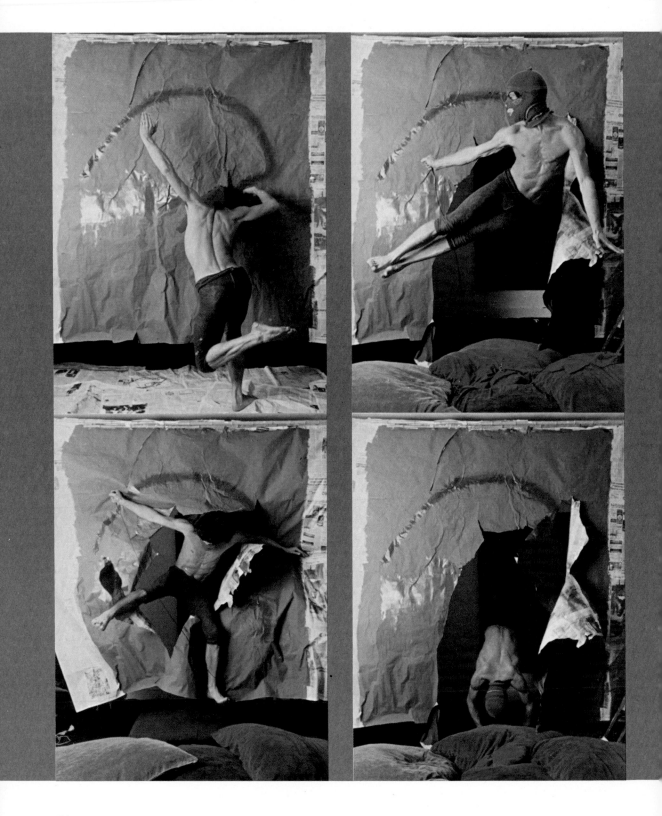

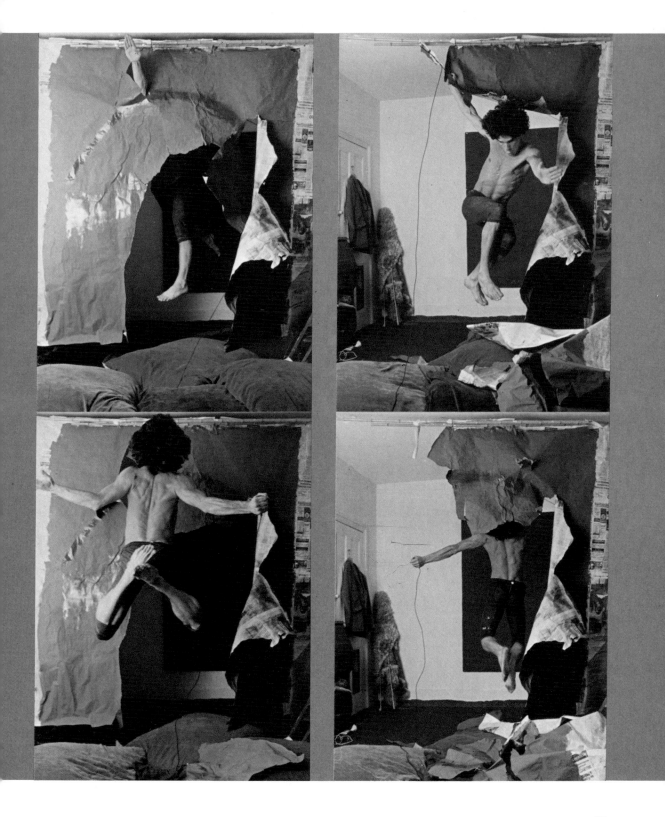

95

is so closely bound with reality that it must, by its very nature, rely heavily on subject matter. But because its field of visual enquiry is so highly unorganized, it is inevitable that, to express it in coherent form, a certain degree of formalization, of tidying-up, is necessary. In some cases, the amount of visual arrangement and systematization will be minimal and, in some, considerable. But in neither case can the photographer afford to neglect either the content or the form. It is obvious that there is no way of formulating any kind of rule governing how motivation towards content or towards form affects the perceptual quality of the image.

Once more we are reminded of the inherent difficulty of the photographic medium. The painter has all the time in the world to consider and compare the relative significance of form and content. The photographer's creative period is usually so short. At the same time, the formal parts of any image, the shapes, textures and colours, have a strong attraction of their own, and the photographer, being essentially creative, is highly sensitive to these attractions. It is not surprising that sometimes he becomes so allured by the beauty of the scene that he forgets, at least in part, the meaning and the story element of his theme. A lot of trivialization in photography stems from this difficulty. Increasingly it seems that meaningless patterns, the juxtaposition of shapes, the contrasts of textures, the seduction of colours and the incidence of light are elevated to the principle position as the *raison d'être* of the picture. The Golden Calf of form and colour may have become the villain of the piece.

Photography is a powerful and meaningful medium in the hands of a creative photographer only if he is aware of its limitations as well as of its strength. The particular power of photography lies in its ability to explore the world and its inhabitants and in the process of doing it to reveal a new and unexpected aspect of our environment. It appears to be less at ease in the pursuit of form and colour alone without any reference to reality – in other words, in pure abstraction.

Whilst the ubiquity and amazing flexibility of photography is not denied, it is certainly not at its best in dealing with non-figurative representation. Abstract images rely completely on the inter-play and inter-action of shapes, lines and colours. The inter-relation of formal elements is their sole matter. The ultimate success of an abstract image depends on the delicate and intricate relationships of shapes and colours. Consequently, in order to achieve such a sensitive modulation of respective parts, the artist must be able to exercise complete control. He must have total facility to make minute changes and fine adjustments of forms, hues and tonalities. It is clear that a photographer working in abstraction can never have such a degree

of control. Whether working with glass, coloured lights or microscopic slides, his control is only partial and cumbersome.

Abstraction, because it relies to such an extent on pure form and colour, also requires a consummate knowledge of the workings and effects of colours and shapes. This requires, in turn, total dedication and many years of practice, study and experiment. Few photographers are able or willing to offer such a degree of devotion. Some, like the American artist-photographer Wynn Bullock, have achieved a modicum of success through hard work and perseverence. But, on the whole, even the best abstract photographs remain quite obviously inferior to abstract paintings.

While photography is at a disadvantage in the realms of pure abstraction, it seems to thrive on various ways of distortion, misrepresentation and diffusion of real objects and scenes. Here the mechanical aspect of the lens, which can be adjusted and adapted, is a considerable advantage. Photography can be at its most magical with sly and humorous interpretations of objects or diffused and out-of-focus images of humans. It works well in a semi-abstract way, where natural forms are highly exaggerated, emphasized and distorted. But it is the element of reality which still clings precariously to the image that provides the core of fascination. It is the remarkable ability of our perceptual organs, which can sort out and digest and scan the misleading visual stimuli and still come up with the right diagnosis that is the source of this enchantment. We all love mysteries and even more so our ability to solve them. It is also the unexpected and the new that attract us – to see ordinary commonplace objects and scenes transformed and stage managed into totally different identities and performances.

One should not, however, underestimate the importance of form in any semi-abstract image. Success depends on an element of surprise and also on a felicitous and interesting relationship of colours and shapes, enhanced through a simplification of the image.

There remains yet another aspect of motivation to be discussed which is not so much related to straight motivation as to the manner of interpreting the subject matter. As far as form and subject matter have been concerned, we have been dealing largely with aesthetics. The interpretation of subject matter, in its broadest sense, cannot, however, be confined only to aesthetic and narrative considerations. Far more fundamental is the question of personal, emotional approach. No photographer would want to restrict his image-making solely to a mechanical and mirror-like representation. The desire to decode, unravel and interpret the meaning of life and of people is far too

strong for that. No one wishes to remain an impersonal and emotionally uninvolved recorder all the time. We want to express and to create.

Our analysis of the photographic medium has clearly indicated that it is far more reconcilable and consistent with an objective rather than subjective approach, that it is not readily suited to any attempt to bend and distort facts in order to promote personal feelings. Photography can have no part in deception, misrepresentation and the deliberate fabrication of a false impression. Apart from a question of ethics, the camera does not lie easily. But to be subjective certainly does not mean to cheat or mystify. To try to express one's feelings and thoughts honestly is not a crime or misdemeanour. That to express one's thoughts photographically may be difficult and may lead to various problems is another matter. In the last analysis, we are here dealing with a question of intellectual judgement, a problem which cannot be settled scientifically or in mathematical terms.

Is it even possible to be entirely objective; to shut out one's mind and ideas in an attempt to prevent them from influencing and guiding the action of the camera; is there such a thing as an exclusively objective photograph? A choice of angle, a deliberate avoidance of a telegraph pole, a pause for a smile to appear on the sitter's face, all these are subjective decisions. The greatest asset of a photograph is its ability to evoke emotion, to be expressive while using images of reality. A photograph can move us most deeply because of our belief in it, because what it shows is an aspect of truth.

Atmospheric Variations **pages 98, 99**
Light across water is particularly lucid and discrete, its luminosity discriminating nuances of tone and colour. Changes in light are affected by the conditions of weather, atmospheric temperature and time of the day. Surfaces of water reflect these shifting moods and changes of light. Colour film, in response to the colour temperature, can detect, more dramatically than the human eye, various hues, giving the image a particular colour bias, which enhances the "atmosphere".

II The Approach to Subject Matter

". . . as the language or vocabulary of photography has been extended, the emphasis of meaning has shifted — shifted from what the world looks like to what we feel about the world and what we want the world to mean," wrote Arnold Siskin in 1928 and it is quite true that looking at photography from a perspective of time it becomes apparent that the greatest change and progress have been achieved not so much in technique as in the significance and meaning of photographic images. Some of the results which the best workers achieved with Lew Archer's invention of wet, collodion plate, in the middle eighteen-sixties, rival technically the results obtained with the best modern panchromatic materials. And even the subtle, gentle and naturalistic colours of *Autochrome* plates, put on the market by Lumière in 1907, have a lot to be commended in comparison with much of the colour work perpetrated today.

The resolution of many technical problems, however, has made photography progressively easier and allowed photographers to shift their attention from technicalities to more profound concerns about the meaning and value of photography. Photographers of the calibre of Alfred Stieglitz, Paul Strand, Edward Weston, Cartier-Bresson, Bill Brandt, Dorothea Lange and Eugene Smith did not dwell on technique. Often employing the simplest of methods, they focused their attention on the significance and expressiveness of their work rather than on the superficial patina of slickness and gloss of technique. Yet the remarkable feature is not that some achieved greatness but how few strove to accomplish it. Considering the huge number of people who have devoted their time and energies to the pursuit of photography in the last hundred years or so, it is surprising to realize how few attained any kind of significant success or managed to create truly memorable pictures. If one further takes into account the beauty, richness and variety of the world and its inhabitants, the imagery which this vast army of photographers has extracted from it leaves a lot to be desired. There is little doubt that the standard of photography, in its widest sense, is not as high as it could be.

Perhaps it is the initial ease of photography, or its apparent mechanical, inflexible and seemingly undemanding character, which have deterred more people of intellect, sensibility and sensitivity from submitting their allegiance. Whatever the reason, it seems that literacy, intellectual ability and enquiring mind have not often been associated with the pursuit of photography, yet it is precisely these qualities which raised

Into the Light—J. Heinrich page 101
Man in the Boat—Anton Tschischka
Both pictures can be read on two levels—either entirely literally, for what they represent, or as symbols, their meaning going beyond the realistic representation. As to how they are seen, on this second level, is entirely up to each individual. The whole fascination of images often lies in their capability to be interpreted according to the needs of each individual personality. These two levels of interpretation are more closely integrated in photography than in other media.

Elongated Horse—Richard Tucker page 102
Mother and Child—Richard Tucker
Time being mainly an abstract idea, it cannot be represented in a photograph directly. It can only be translated into a visual symbol. Some symbols can be fairly obvious, like the multi-legged horse, but also much more subtle symbols can be created, leaving more to the viewers' own responses.

Through the Trees—Richard Tucker page 103
The idea of space and depth is also difficult to translate into a flat two-dimensional image. Here several symbols are employed—size perspective, (objects changing size), tonal perspective and differential focus.

Venetian Market page 104
Staten Island Ferry
Although good photography depends largely on spontaneous reaction to a visual experience, it does not necessarily mean that one should not deliberately choose a specific visual approach in order to put over the idea of the subject.
The hustle and bustle of the Venetian market on the canal goes well with a direct approach, giving space to its panoramic scale, which extends beyond the picture frame and is accented by the central placing of a man energetically shifting a case, as the main point of interest. "Staten Island Ferry" is even more open in construction with empty foreground, distant crafts, diffused colour and friendly glimmer of lights, giving accent to the idea of the end of a busy day, with the boats dwarfed by the scale of the harbour.

In Highgate Cemetery page 105
The melancholy mood of a cemetery, with its curious aura of decaying romanticism is captured by an image of complexity, where the enclosed, claustrophobic space is emphasised by overall autumnal patina.

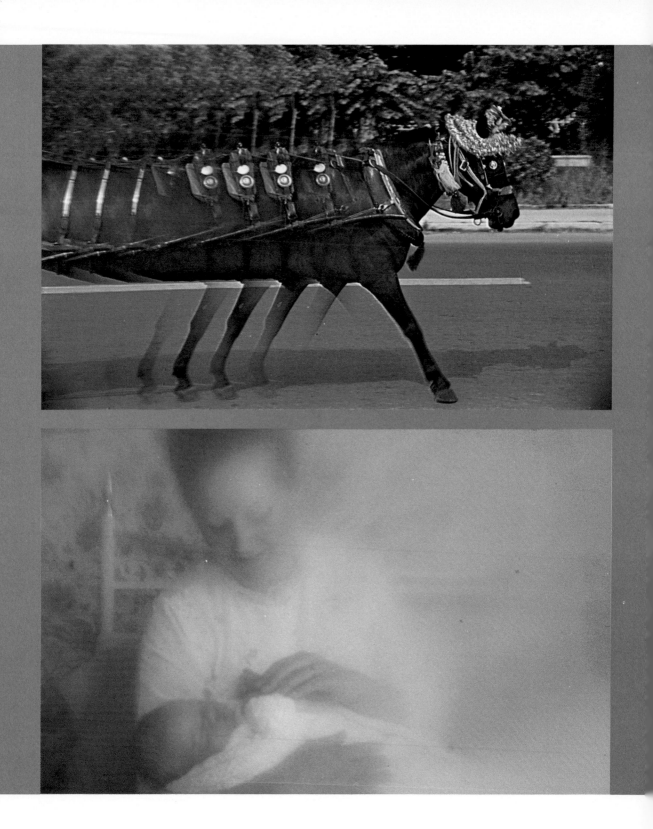

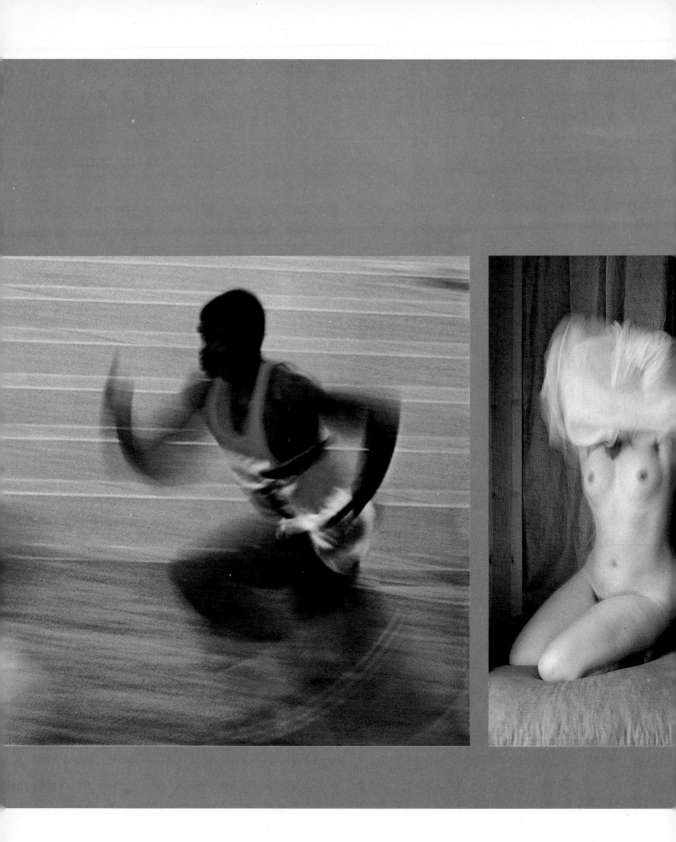

the level of creativity and significance in the work of the few. In an interview with *Harper's Bazaar*, Henri Cartier-Bresson remarked that "Thinking should be done beforehand and afterwards–never while actually taking a photograph. Success depends on the extent of one's general culture, on one's set of values, one's clarity of mind and vivacity. The thing to be feared most is the artificially contrived, the contrary to life." Few photographers treat the medium as deeply demanding and all-committing. For most it is merely a question of getting some expensive equipment, learning the rudiments of technique and then merely churning out pretty and empty pictures.

In his *Personal Credo*, Ansell Adams defined a great photograph as one "full of expression of what one feels about what is being photographed in the deepest sense, and, is, thereby a true expression of what one feels about life in its entirety". How to interpret "life in its entirety", even one's own personal expression of it, is possibly the most difficult task of all. It requires not only technical expertise, a keen sense of form and a feeling for colour, it also demands an understanding of the world and life in general. It is tempting to agree that, as Cartier-Bresson said, for a photographer general culture, a set of values and clarity of mind are far more indispensable equipment than for a painter. His work is so much more intimately connected with the society he lives in, and the general tenor and current of life, it feeds on the emotional spirit of his times and generates its vitality and veracity solely from this source. André Malraux once said that he tried "to transform destiny into awareness" and the photographer's greatest asset and obligation is to try to make others more acutely aware of the world they live in. This is precisely what such photographers as Dorothea Lange did for America in the thirties, and what David Douglas Duncan did during the Korean war.

Photography generates its significance and meaning, mainly through the inter-penetration of two, diverse elements. One is connected with the need and striving for information and its power to satisfy human curiosity, and the other with the desire to express order and harmony, what may be called the passion for beauty. The whole difficulty of creative photography hinges on the satisfactory reconciliation of these two elements. Almost every photograph constitutes a visual report, a statement of a fact. The fact may quite often be overlaid and obscured by aesthetic considerations and every photograph can be thought of as a kind of compromise between the factual image, the subject matter, and what could be flippantly called aesthetic window dressing. Generally, the most powerful photographs are those where both elements co-exist, both exercise their influence, for the most memorable images have something to say and say it with strength and beauty. There

The Runner　　　　　　　　　　　　　　　　**page 106**
A Girl Undressing—David Lavender
Though both pictures rely for their effectiveness on slow shutter speed, there could hardly be a greater contrast between the two images. While "The Runner" is all uncoiled energy, dynamic thrust and speed, and all these features are intensified by the blur of the camera, the picture of the girl is all languidity, softness and sensuous movement. The blurred arms and the nightgown give the impression of a slow-motion passage of a film. It is interesting to note how the same technique can produce such a diversity of effect in the final image.

are many photographers who are capable of producing the most enchantingly beautiful images, elegant in composition and harmonious in colour, but fewer who can express visually not only surface beauty but also meaning, who can at once delight us and make us think.

The difficulty is that information is not necessarily attractive, that a fact is often ungainly and difficult to condense. A significant and striking image needs simplicity and a kind of terseness, the message ought to be laconic yet clear, otherwise it will interfere with the other feature of the image, its visual beauty. Fortunately our perceptual mechanism is so highly sensitive and experienced that it responds to condensed signals or symbols. Symbols are very much part of photographic vocabulary, and some of them have become as generally accepted as the convention of one-point perspective in Western painting. These symbols can be of various kinds, shapes, objects, significant details and, of course, the most potent of symbols – colour.

The strength of symbols lies both in themselves and, above all, in the manner they can evoke varying responses in different individuals. The way a symbol is read is very much the question of the personality of the viewer. This can be seen if we examine *Into the Light* (p. 101) and *Man in a Boat* (p. 101). The first can be interpreted as a symbol of light, as a beginning, a renaissance, a religious experience, or as a very beautiful picture of a little church. It is not so much the locality or the element of description that one is moved by as the emotion and the mood. *Man in a Boat* is even more indistinct and evocative. It may have started by being a simple shot of a fisherman in the mist, but as an image it transcends this and has become a symbol of loneliness for some, of challenge for others, or perhaps of the call of the unknown. It may even remind some of Dante's *Divina Commedia* and the strange journey of transition to his *Inferno*.

Photographic symbols are not a set of recognized and classified signs like an alphabet and an imaginative photographer can constantly invent his own visual epigrams. Because of their variety, diversity and multiformity, we can only suggest a few more obvious photographic symbols. A symbol of strength could be a large shape of a man (or an animal) dominating the foreground; this indication of power can change instantly to that of menace and threat through a subtle change of placement or a different gesture; delicacy or minuteness can be symbolized by the contrast of a small being – a child or a bird – at the foot of something large; a figure cut at the edge would indicate a crowd; a hazy background suggests distance; a few drops on the window represent rainy weather, and a yellow leaf autumn. In each case just an indication –

a symbol – conveys the meaning perfectly. In many instances some objects can suggest a mood and a feeling and colours, of course, some of the most effective and potent symbols, are ideal emotional prompters.

A powerful image is capable of projecting different interpretations and offering divers insights. It is like a veil uncovering a multitude of visions to the viewer whose eyes are willing to explore and not merely to glance. But, however deep and significant an image is, it will have no meaning to a blind person and it can be argued that currently our civilization is slowly blunting our ability to see. After more than a century of "electric technology", as Marshall McLuhan calls it, the human race has changed radically. The unceasing bombardment of visual media – television, cinema, posters and advertisements – has much diminished the influence of "literate and mechanical culture" and rendered our perceptual apparatus satiated and desensitized to the nuances of images. Our generation now derives most of its knowledge and culture from instant images rather than written words. It has been suggested that this kind of education breeds passivity and indifference. Reading requires active participation and concentration of the mind, which encourages the creation of mental images and stimulates imagination, whilst a television set offers ready-made and predigested images. We seem to have lost some of our ability for less strident and more sustained visual enjoyment, we tend to glance cursorily rather than to stop and explore. This makes the task of the photographer more difficult and his ability to create powerful symbols even more important.

The most significant element of photography is total orientation away from synthesis and towards selectivity. The photographer selects a whole image and does not assemble it from various separate segments. This statement may imply that the photographer has only a limited number of 'whole images' at his disposal and that his actual control over the image is also slight. But fortunately nothing would be further from the truth. Edward Weston described the photographic 'image finding" process in this way: "Putting one's head under the focusing cloth is a thrill . . . To pivot the camera slowly around watching the image change on the ground-glass is a revelation, one becomes a discoverer . . . and finally the complete idea is there . . ." It is not just one or two images that any scene offers to the photographer, a whole strip of separate images pass in front of him, a strip that can be altered by a slight change in his position. His selection of an angle or distance or type of lens affects the image, thus possibly changing the meaning as well. The photographer must not, or at least should not, tamper with 'reality' so there is no question of introducing new ingredients from outside the image area, or conversely,

removing some that are within. A famous case, which serves as a warning, comes to mind. It took place in the U.S.A. in the 1930s. One of the photographers who worked for The Farm Security Administration took a picture of a skull of an animal, where it lay, in sparse grass. Later he thought that it would make a far stronger point if it was seen on a completely arid piece of ground, and having transferred the skull to a more suitable place he made another exposure. Unfortunately both pictures were published in different magazines and some ill-wisher spotted them. Whereupon a veritable campaign was started in one section of the press against the whole group of photographers working for the Administration, branding them as perpetrators of lies and misrepresentations.

A photographer is usually faced with a large slice of the image area and the meaning as well as the impact and coherence of the image will very largely depend on the photographer's selection which is finally governed by three choices. The first, and perhaps the most important, is the choice of the frame of the image: how much to include and what to avoid, how to reconcile separate parts within the image area. The second what kind of spatial orientation ought to be bestowed on the image: here again the relative position of objects or figures will be crucial, as well as the depth of space within the image. Finally the time element has to be considered: obviously the precise moment when the exposure is made may affect the meaning of the picture considerably.

The traditional precepts of pictorial photography are directly derived from the classical theory of picture composition formulated as early as 1432 by the Florentine architect and critic Alberti. According to this set of rules, the edges of the image should be as unobtrusive as possible or they will divert the attention of the viewer from the main subject matter of the image which ideally should be placed either in the centre, or on the division of thirds, or alternatively at the point of Golden Mean, but never near the edge. In this traditional theory the border of a picture is taboo and no man's land. The photographer, however, actually starts his composition with the frame. After all he must make sure that all that he wants to include in the image fits into the viewfinder. Most often his eye will travel around the frame first and then start to dissect it; "Frame is the beginning of a picture's geometry", as Szarkowski rightly observes. Although the photographic frame circumscribes the whole image, the actual image itself is always only a fragment, a fragment which the photographer has chosen as the representative part of the whole scene. It is impossible to forget and ignore the part that was left out. Thus the frame contributes to another distinct and unique facet

of photography, its quality of infinity, the edge merely indicating the end of the clause, not a full stop.

Because of photography's predisposition to chance and accident, its affinity to the adventitious, photographic images are often fascinating in their ability to quote out of context and to freeze unexpected and accidental relationships. Elliott Ervitt is a past master in selecting strange and often funny juxtapositions from commonplace situations. This type of image is created by the keen selectivity of the photographer and the abrupt cut-off of the photographic frame. By enclosing two objects the frame creates a dual relationship, the objects no longer exist alone, from now on they co-exist.

The fragmentation of an object, figure or face, right at the edge of the picture is also often employed by some photographers. Japanese print makers like Harunobu and Hokusai were perhaps the first to use it, and Degas, who among the painters almost monopolized this device, might have been influenced by them. But he was a keen photographer himself and it is unlikely that he failed to notice the effect from his and his friends' snapshots. These days a severe 'trim' seems uniquely photographic. The Japanese print maker used it for emphasis, to provide a strong, graphic image impact, but also because of the three-dimensional, plastic effect it suggests. These are precisely the qualities which suit the photographic image so well. This kind of composition, additionally, gives an impression of informality and authenticity and occasionally it provides an effect of surprise, even shock. Familiar objects shown only as a fragment, perhaps even an uncharacteristic one, attain a totally unexpected and weird appearance, as if never seen before.

The selection of a frame is the photographer's first choice, the other two, as we have said, are spatial orientation and the time element. Time and space are both indeterminate concepts. Time is a totally abstract idea which visually can only be represented as a symbol. Space is a relative term and as a concept is also abstract. It can be shown visually but only in so far as the perceptual forces of the brain will help to interpret it correctly. Hence to read it correctly depends on previous experience and to a certain extent on accepted and known terms of reference. Both time and space are normally perceived in states of transition and in a particular context, and therefore are difficult to translate into a photographic image. For two ideas, one quite abstract and the other seen normally in a three-dimensional form, have to be transposed into a totally still and two-dimensional representation. Yet the satisfactory rendering of the idea of time and of the spatial orientation of the

subject is far more important in photography than it is in any other medium.

Photography lives in a present moment, its most important value is a characteristic representation of this instant seen and experienced by the photographer in the first place and subsequently by the viewer. It is even not so much the factual, tangible record, as the intangible feel of the moment that matters, the fact that it will be gone and belong to the past in the next instant, and the fact of the simultaneity of various objects and persons suddenly found by the photographer in one place and in one fragment of time. All these are intangibles which the Italian Futurists, largely unsuccessfully, tried to show in their paintings and which can be shown in photography. The best photograph of a fragment of life is certainly not a frozen, totally immobilized image which in the process of recording has lost all sense of time and movement, and any indication of its proper relation within its environment. Photographs normally cannot indicate a duration of time, only a series of pictures or a trick exposure like our illustration on page 102 can perhaps suggest it. But an impression of a specific period of time is rarely what is sought for in a photograph. It is rather an idea of passing time, of time merely being one of the ingredients of the moment. Since nothing concrete or absolute needs to be expressed but rather something vague and evanescent and unsubstantiated; the controlled blur of an image; a certain amount of lack of focus in some parts; even the implied movement of a person as in Cartier-Bresson's famous picture of a jump over, or rather into, a puddle; hair blown by the wind, all can give a suggestion of the time element. They all can obviously also be taken as expressions of movement, since movement always implies passage of time.

The interpretation of space into motionless, flat photographic reproductions presents problems of a different kind. Whereas symbols have to be invented to give some kind of visual substance to the concept of time, the notion of space is adequately seen by us through our eyes. The difficulty is that our stereoscopic vision is capable of reconstructing spatial relationships and actually conveys a vivid three-dimensional impression of space, something that no camera, unless stereoscopic, can do. However, there are several visual clues and hints which, even reduced to a flat surface, still serve to convey some spatial information in a photographic image. Objects, and people, become progressively smaller the further away; distance becomes hazier and lighter in tone; the overlapping of objects is an additional clue. On the debit side the size of the objects has to be known from previous experience so that their relative space orientation can be judged and the lightening of the general tone with increased distance is not a reliable indication, since it alters with changing weather and conditions of light. The photographer has to add to and emphasize existing visual clues to allow for a more accurate reading of space in his photographs and this opens a whole field of possibilities to those with imagination. The relative size of objects can be varied by the use of suitable lenses so that a more realistic approximation of space can be achieved and a uniquely photographic device is also available, the variation of sharpness between near and far distance. Imaginative use of colour is, however, perhaps the greatest help from a creative point of view.

These methods and possibilities of representing space and the use of colour in the image structure are designed to help to improve the spatial clarity of the image, but because they have certain flexibility which the photographer can control, they can equally be used in order to create ambiguity and alter the meaning and significance of the subject matter. *Mother and Child* (p. 102) is an example of this. Shot through a diffuser, it is on the one hand no more than a snapshot of a moment, retaining the features of informality and authenticity and yet it also possesses qualities of an archetype, a semblance of infinity. Colour is particularly suitable for these kinds of studies, as it incorporates references to time and movement. Colour presented in a state of flux, unsharp or blurred, gives an impression of melting and dissolving, it attains a state of a liquid and a gas simultaneously, becomes intangible, translucent and somehow more brilliant, and yet mellower. It also assumes a mantle of mystery and undergoes a change from real into ghostly. *Through the Trees* (p. 103) shows something of this. The bright, fluid patches of green give it the perky actuality of the moment, but the dark, vast trunks of the trees provide the solidity of timelessness. The area in front of the trees has a quality of murky mystery and seclusion, while the bright opening, swimming in light and liquidity, contrasts with it strongly.

III Subject Treatment

In the foreword to his *Photographs*, Harry Calahan stated that "It's the subject matter that counts. I'm interested in revealing the subject in a new way to intensify it." On the same theme Edward Weston wrote, in *What is photographic beauty?*, "The photographer's power lies in his ability to re-create his subject in terms of its basic reality, and present this re-creation in such a form that the spectator feels that he is seeing not just a symbol for the object, but the thing itself revealed for the first time. Guided by the photographer's selective understanding, the penetrating power of the camera-eye can be used to produce a heightened sense of reality – a kind of super realism that reveals the vital essences of things."

Clearly both these celebrated American artist-photographers believe that the primary duty of a creative photographer is to reveal "the subject in a new way". Since its invention, photography was particularly highly esteemed for its ability to record accurately and most of the creative photographers who understood their medium did not want to relinquish this unique advantage of truthfulness and realism. Edward Weston, considered one of the most sensitive artists, was also the straightest and purest of realistic photographers. Throughout his life he used only a 10 in. × 8 in. plate camera, and in order to retain the maximum quality of the negative, never allowed his negatives to be enlarged, merely contact printing them. Yet, at the same time, neither Weston nor others wanted to use photography only as a straight recording medium, they also wanted to contribute their own feelings and, above all, their heightened way of seeing to their images. A great photographer is set apart from others by his highly developed perception which seems to notice and see much more than that of an ordinary individual. What is more, the memorable photographs, the significant images, are not necessarily the ones that depict some extraordinary subject like the surface of the moon. On the contrary, their subject matter is mostly very ordinary. It is the photographer's remarkable presentation, his way of seeing, that reveal to us images that we have never seen before. Clearly it is not the subject matter that requires investigation, but its treatment.

If we accept that the only subject matter consonant with the medium of photography is "unorganised reality", it is immediately apparent that there will be very little limitation to the range of topics for photography. Any subject concerning the world, its inhabitants and their environment is of interest to the creative photographer, with one basic stipulation, that the photographer does not try to interfere with it, that he accepts it as he finds it. His sole role is to create by an interpretation of the world and people and not by trying to adapt reality to the convenience of his image.

It is as well to emphasize this stipulation as photography is the best, and only, medium both for objective interpretation and recording of the world as it is. In order to maintain this position it must accept some responsibility as well as kudos. It is also the only visual medium which, because of its inherent authenticity, is trusted and believed in by the mass of the public. If this trust is continually abused, photography will lose its status, its integrity and dignity. A study of one of Eugene Smith's visual essays in *Life* confirms one's belief in the greatness of the medium, whereas a recent exhibition of British photography from 1840-1950 undermines this trust dangerously. So much artifice and cheating, so much propaganda photography was exhibited. Some photo-journalists, like the famous Bert Hardy, admitted laying-on his photo-journalistic shots, stage managing them artfully and passing them off as the real thing. This kind of behaviour is not in the best interests of photography. One might say cynically that it would not matter if it remained undetected, but the trouble is not so much that photography does not lie as that it lies so badly.

Before coming to a systematic analysis of various manners of subject treatment one important issue should be settled. It concerns diverse derivative processes like colour separation, solarization, *Agfacontour* or bas relief. In one sense these could be classed as synthetic and artificial, however, none of these processes pretends to be anything but theatrical and artificial, there is no attempt to deceive, they are quite honest in their guile. They can possibly be defined as graphic and painterly processes using a photograph as a decisive starting point and with figurative photographic elements often playing an important part.

Before we examine individual groups of subject matter, let us suppose that the subject matter is not entirely accidental or spontaneous, but one which was chosen beforehand, and hence the photographer has time for reflection. This reflection is not designed to produce a formula for an image but to allow the photographer to evaluate the nature of the subject and to decide a general course of action. Obviously the method of treatment chosen is synonymous with the interpretation of the subject. For the end product of subject treatment is the expressiveness of the image. In each case the photographer must decide what it is that makes him want to photograph this particular subject; which are the most important features of the subject and which specific elements reveal the sub-

ject's nature and characteristics. These are basic questions which should also pass through the mind of the photographer if his picture is taken on the spur of the moment but they must be far more seriously considered in the preparation of a session. An analysis of *In Highgate Cemetery* (p. 105) serves as an example. The overall intention was to capture the melancholy and rather strangely romantic mood of a cemetery where time seems suspended indefinitely. These constituted the reflections before the session and they seemed to fit with autumn colours of browns and dull greens. With this general idea in mind, the figure of a fallen angel with overlapping clusters of brown leaves was discovered during the walk around the cemetery and immediately fitted the general theme. Various remarks of significant photographers serve as a confirmation of the theory that photography works best as a kind of combination of prior mental preparation and subsequent direct reaction to visual experiences.

The treatment of subject matter can be divided into five general but distinct groups, each representing a twin relationship of direct opposites.

Subject Treatment	Possible Procedure
Direct	Confrontation
or indirect	or manipulation
Static	Frozen time
or dynamic	or symbolic time
Order	Simple or complex
or disorder	organization
Whole	Panorama
or part	or detail
Reality	Representation
or fantasy	or transformation

This list can obviously be extended and further interpretative values added, as hardness or softness; contrast or harmony; equilibrium or disequilibrium and with points relating to colour treatment like strong or delicate colours; overall cast of one expressive colour or not; warm or cold composition. But, for the sake of simplicity, let us keep to the main list as far as possible.

The first comment which comes to mind is that any decision about the choice of treatment involves the whole list and not only a few items. The essence of every image is its inherent complexity, not of component visual parts but of the multiplicity of aesthetic considerations. Photography may be a marvellously simple and straightforward discipline in the hands of a sensitive expert but one can be sure that it took long years both practice and thinking in order to fashion it into its mature neatness and facility. The greatest difficulty in analysing specific, practical decisions of an aesthetic nature is the necessity of defining various

concepts, relating to meaning, feeling and form, into words, which are invariably less than adequate. Even an attempt at a systematic and rational study of pictures themselves often seems ineffectual and superfluous. Words cannot stand in place of images, and their meaning can be interpreted in so many ways by different individuals. As a compromise solution a sequence of ten photographs is reproduced on the following pages (117-121). Each of them is selected to illustrate one of the items on our list but there is inevitably wide interconnection between most of them.

The first two portraits represent, respectively, the direct and indirect approach. William Tucker is confronted in a simple manner and photographed in the process of assembling his sculpture. The photographer merely underlined the fact of physical action within the image by using the strong diagonal of the arm, which is also a contrast to the predominantly circular shapes. The protrait of Peter Sedgley, which completes the pair and illustrates the indirect approach, is fairly similar from a formal point of view. It is also an action picture and hence its emphasis on diagonal arrangement which resembles that in the other portrait. The difference lies in the treatment of colour. The light is normal daylight in the first and consequently the colours are natural. In the second the unnatural ultra-violet creates bizarre colour effects which clearly manipulate the portrait and exemplifies an indirect approach. In contrast the portrait of Henry Moore reproduced on page 132 seems to be, and is, completely direct and natural. And yet one of its features is in the contrast between the vastness and, by extension, significance of his work and the comparatively small figure of the artist. Clearly it can be argued that the main point of interpretation is indirect, it is merely suggested by implication.

An analysis of the medium establishes that photography has a very strong affinity to directness and bluntness and yet the dividing line between straight confrontation and manipulation is forever shifting and illusive. It is easy to separate very obvious direct and indirect examples, like Eric Hoskins' *Barn Owl* (p. 119) and the *Agfacontour* example (p. 209) but the less obvious will always present some problems in classification. It may be said that if the image has real quality it matters little to what specific compartment it is allotted and that this insistence on identification and semantics is unnecessary. Most good images, however, are the result of clarity of mind and understanding of one's motives and some time spent on clarification and general discussion can be of concrete value.

A number of our other illustrations also show this duality of meaning and purpose; it may well be that certain ambiguities in the image are an integral part of

its quality. The second pair of pictures, *The Band* (p. 117) and *The White Road* (p. 117), chosen to illustrate static and dynamic features, also exhibit some vagueness and uncertainty in their meaning. *The Band* is undoubtedly manipulated (through the use of zoom lens, with focus shifted during the exposure) and yet it can also be considered as a very direct expression of the subject. The main feature of the pair is the quality of stillness in one as opposed to the extreme expression of energy and movement in the other. *The White Road* is not only static, it expresses a kind of arrested, frozen moment, when not even a breath of wind disturbs the tranquillity and calm of the landscape. Even in expressing immobility various modes of stillness can be distinguished. *Barn Owl*, for example, is frozen only for an instant, the flurry of movement and agitation immediately following can be anticipated, but the road is silent and peaceful seemingly for ever. *Two Gulls* (p. 120) from the third pair is less easily classifiable. It is a picture of movement and yet it is predominantly still and calm, demonstrating that to show arrested movement is not synonymous with the expression of movement. On the contrary, motion frozen by shutter speed becomes almost obsessively still, as if killed by the camera. Undoubtedly *The Band* is far more kinetic than either of the two pictures of birds. From these examples we can see that there are a great number of ways of interpreting movement and dynamic quality; the diagonal arm of Tucker, perhaps because of its very orderly and balanced composition, is as much or perhaps even more dynamic than the birds in flight.

This leads us to a consideration of the third pair of contrasts, *Two Gulls* and *Moroccan Town* (p. 120), illustrating order and disorder and the first pair which is mainly concerned with form and design. The main problem here is the choice of formal arrangement, simple or complex or any variant in between. However, form and design is clearly one of the most important elements influencing the meaning and mood of the image, so initially it is the nature of the subject matter which dictates the form the image will assume, as we can see from our examples. In the first, *Two Gulls,* the subject is a romantic and serene picture of a setting sun on the sea – all is calm and composure, hence a simple and orderly composition. The second, *Moroccan Town,* is rather 'busy', crowded with people, tents and a seeming jumble of houses—and yet, even there, one can discern certain orderly features – lines of walls, the grouping of the white tents and red houses. No image can afford to be entirely chaotic, for then it will fail in its first function, to interest and to communicate.

A further point worth emphasizing is the difference in formal structure between the two quiet and highly organized images, *Two Gulls* and *The White Road*. The order and simplicity of the seascape is far more dynamic than that of the landscape. *The White Road* is entirely symmetrical and because of that positively static, whereas the picture of the gulls, though less dynamic than *The Band* as we noted, is clearly more forceful than the road. Symmetry and asymmetry are important features of photographic design and contribute not only to elements of form but are also an integral part of interpretation of meaning and mood.

An examination of the fourth pair of pictures directs our attention to the intimate interconnection between the various ways of subject treatment and the methods of composition and design. *Sand Dune* (p. 120) and *The Fruit Stall* (p. 120) could have been chosen to illustrate, at least partly, all the enumerated features of subject treatment, except reality and fantasy. *Sand Dune* is direct, static, ordered, detailed; *The Fruit Stall* is in turn manipulated (very wide angle lens), dynamic, complex and a kind of panoramic image. Both pictures needed the presence of all these elements in order to give an adequate expression to their respective themes. From this the conclusion can be drawn that it is always more difficult to express simplicity and order through a large slice of 'reality', it is also more difficult to convey a quality of stillness through a landscape unless it is a very simple one. Detail is invariably more convenient to handle, to compose and to formalize. The old, traditional instruction to a beginner, "Come closer to your subject", was founded on common sense but it is applicable and logical only if it is consonant with the main theme of the picture.

Finally the last pair of pictures, *Barn Owl* and *Fantasy* (p. 118), shows the greatest contrast, the antithesis lying both in the profound difference of treatment and in the subject matter itself. Reality and fantasy rarely meet but the extremes in our case show an even greater polarity. It is not only the opposition of the respective subjects or the design, but a more fundamental divergence based on the capabilities of the photographic medium as a whole. We have emphasized that the medium has a strong bias towards authenticity and does not effectively function on the level of fantasy. Fantasy is not the same, of course, as surreality for photography functions well with the disorientation of meaning. But fantasy involves a distortion or reversal of reality and, as the dictionary suggests, fancy, hallucination, or the invention of unreality and the creation of heightened states of mind. This is clearly not photography's domain. It would be impossible to deny that some highly successful pictures have been created in the realm of fancy (with photographic means) but they are no more than an exception to the rule.

As can be seen from the previous particularized analysis, the elements and tendencies influencing the manner in which subject matter is used are many and

to those we have already discussed should be added the use of colour and the search for originality.

There is a natural tendency, or more aptly, a temptation, when using a camera loaded with highly sensitive colour film to try to live up to it and capture COLOUR; to be on the look out for truly colourful subjects and disdain or perhaps not even notice less vivid ones. A glance through this book, which is illustrated only in colour, shows that photographs do not have to be rainbow-tinted in order to be distinctive and interesting, colour does not have to shout to be attractive. Perhaps the influence of photography's older half-brother, the painting, prompts some photographers to compete with paintings. But photography is wholly concerned with the representation and interpretation of reality and the world, the subject matter of photography is far from being in technicolour. Gaudy and ostentatious examples can be found both in the natural and man-made environment: peacocks display their shimmering tails; market-places can be alive with colour and the sun at sunset sometimes seems to be dripping blood; the Las Vegas and Southends of this world are ugly with frantic display of shouting colour.

Such examples, however, are exceptions, not the rule. If one takes a closer look at the world, it can be seen that reality is not as colourful as some photographs make us believe. The eye is not attuned to excessive colour, it is often disturbed rather than pleased by it and, because of this, highly-coloured photographs tend to look false and wrong. A study of a book illustrated by a fine colour photographer such as Ernst Haas or Horst Bauman is a revelation. There is so much beauty in delicate, monochrome tone, so much subtlety and virtuosity. The world is largely monochrome and their photographs show it at its best. Haas' brooding Manhattan giants, seen in a silhouette against the burnt yellow of the afternoon sun, are far more effective and moving as symbols of a town than the gaudy colours of billboards, flashing neon lights and multicoloured crowds. Haas often deliberately lessens the impact of colour, reduces its intensity and subdues its contrasts; in a large field of muted tone, a small contrast of bright hue will shine like a star, pleasing but not shocking. A great photographer knows his limits and rarely approaches them, let alone crosses them. Restraint is a strength not a weakness.

In this section of the book we have been dealing with creative seeing and it is appropriate that it should end with some discussion on the most important of all elements in imaginative seeing, originality. Can a photograph, which is essentially a more or less faithful record of reality, be original; does not originality have to spring from the subject itself, which is, or supposed to be, largely beyond the control of the photographer as a passive commentator and recorder? But originality also demands initiatory action, the ability to think and react individually, to originate something new.

It is difficult to think of anything that is still untouched by the eye of the camera. True originality in photography, however, does not lie in the selection of unfamiliar subject matter, it lies, as we have said, in the realm of the visual transformation of known subject matter, in, as Calahan said, "revealing the subject in a new way". Originality is a process of discrimination and judgement and not only of a bare choice, of finding a new meaning in an object or person, or even grafting a new significance to something known or commonplace, as Weston did with his *Pepper*. Possibly the most original post-war photographic book is Bill Brandt's *Perspective of Nudes*, not because of its basic subject which has been over-abundantly photographed since the invention of photography but because no one before had seen it in this particular way. As a series of photographs based on nude female form it was a revelation. The word "based" is quite deliberate, since Brandt's photographs are more in the manner of abstracts or even sculpture than pure representation of beautiful bodies. They are nearer to Henry Moore's archetypes than to anything known in photography. Perhaps the book was so much hated and criticized by small-minded extremist pictorialists because of its very originality.

It is impossible to define originality precisely and satisfactorily; originality is something that did not exist before, it can be seen, recognized and admired but rarely expected in advance. It can be found in such varied sources as a paraphrase of a subject, showing it in a different and yet familiar guise—a spoon looking like a giant excavator or the Eiffel Tower like a hat pin. It can find its genesis in a newly invented form—a fish emerging from some reflections of twigs in the water or bicycle handlebars transformed into an aggressive pair of horns. It could be founded on a play of colours, either as an artful juxtaposition or a sudden anomaly of rendering, in the ambiguity of space or the frozen translation of movement in a pose or gesture. Originality can be thought of as a state of mind, expressing a conscious desire for something new and unexpected.

There is nothing as refreshing, as joyous and spirited as invention and nothing as depressing and deadening as a cliché and stereotype. Alas, no other medium could be charged and convicted of more stale imitations, second hand renditions and rehashed images than photography. Photography, particularly pictorial photography, has always shown the greatest resistance to change. In amateur photography it sometimes seems that cliché is a virtue and originality a villain. During the last hundred years, painting has undergone radical transformations many times, from Realism to Impres-

sionism, to Fauvism, to Cubism, to Constructivism, to Surrealism, to name but a few. In the same period of time there were several original workers and trend setters in photography but their influence was ephemeral and their originality did not disturb the triumphant march of pictorialism which progressed like the seasons, with some changes in weather but essentially the same. People still place their tripods at the foot of 'Sea of Steps' in Wells Cathedral in the spot which Frederick H. Evans brilliantly selected in 1907, and the patch in front of Buttermere in the Lake District is getting progressively balder from the cohorts of 'creative' photographers.

It seems that some photographers deliberately avoid the unorthodox and unconventional and constantly gravitate towards already tested and superficially successful themes and subjects. Originality, in contrast, demands departure from beaten tracks, it requires the play of ideas, even stemming from the unconscious, and the conscious treatment of images of imagination, it thrives on the conversion of ideas into symbols or the inversion of their meaning. With its enormous scope for flexibility and its diversity of creative means and methods, its comparative newness, its spontaneity and its not yet fully explored character, photography is an ideal medium for originality stemming from truly creative seeing.

Approach to Subject Matter **pages 117-120**
The five pairs of pictures represent five different possibilities of approach and treatment of subject matter, each pair representing a twin relationship of direct opposites:

Subject Treatment	Possible Procedure	Illust.
Direct or Indirect	Confrontation or Manipulation	a and b
Static or Dynamic	Frozen Time or Dynamic Time	c and d
Order or Disorder	Simple or Complex Organisation	i and h
Whole or Part	Panorama or Detail	j and g
Reality or Fantasy	Representation or Transformation	f and e

a. *Portrait of William Tucker*
b. *Portrait of Peter Sedgley*
c. *The White Road*—Richard Tucker
d. *The Band*—Richard Tucker
e. *Fantasy*—Marc Lavrillier
f. *Barn Owl*—Eric Hosking
g. *The Sand Dune*—Christian Sauer
h. *Moroccan Town*—Christian Sauer
i. *Two Gulls*—Richard Tucker
j. *The Fruit Stall*—Richard Tucker

g

h

i

j

120

Picture Making in Colour

I **Elements of Picture Making**

II **Visual Dynamics**

III **Relationships**

"Search for coherence or clarity of form is the basic drive in artistic creation."

Adrian Stokes

I Elements of Picture Making

Photography has suffered from simplistic slogans, like Kodak's famous "You press the button, we do the rest" and many photographic magazines, by reproducing images simple both in technique and in intellectual content, have promoted the attitude that photography is excessively easy. This may have encouraged the sales of photographic materials and cheap cameras but it has not profited photography in an aesthetic sense. Images of extreme superficiality, as well as facility, are the result. Good, thoughtful photography demands a great deal of effort and application and is as much a question of intellect as it is of technical proficiency. Johannes Itten liked to represent creative activity in the form of an equation: subconscious perception + intuitive thought + positive knowledge = composition of creative image.

Creative decisions while taking a photograph can be seen as three successive steps or three quick flashes of recognition which are never quite deliberate nor separate from each other; the first is a kind of preliminary scrutiny or investigation of the subject as a whole, a panoramic sweeping glance; the second is the sudden narrowing down of the field of vision to the most pertinent area, the isolation of the subject and the selection of the important from the less important features; the third is when the selected rudiments of the image are given a specific and distinct framework of arrangement and structure.

Every image, however humble and insignificant, needs some visual discipline or synthesis of its parts in order to provide the viewer with an understanding of its incipient coherence. The human perceptual apparatus is attracted by order and rejects chaos. Whilst some order is obviously necessary to the photographic as to any other graphic image, it is clear that photography cannot make use of an arbitrary collection of principles to be indiscriminately applied. As Edward Weston forcefully stated, "When subject matter is forced to fit into preconceived patterns there can be no freshness of vision. Following rules of composition can only lead to tedious repetition." Precise rules of composition are anathema to photography. Photography's primary strength lies in the *free* exploration of reality and the formalization of the image must be deduced from observation of the subject matter, not imposed upon it. The approach of many pictorial photographers is more like that of the Synthetic Cubist painters who conceived the form first and fitted the subject to it. This is obviously fundamentally wrong. In photography the needs of subject matter must always be the guiding, creative element and the formal arrangement of the image must come as a direct influence of the character and nature

of the subject, the form being closely dependent on the subject content. Additionally, one must emphasize that the meaning and expressiveness, the degree to which something can be said or implied by a photographic image, is one of the most characteristic and important facets of photography. Therefore every element of picture making in photography must be subordinated, at least partly, to the task of the externalization and clarification of its meaning. Every shape, line or pattern, every inflexion of colour, every object or gesture must carry the meaning of a photograph a step further so that the image expresses something beyond mere visual pleasure. Our discussion of the visual elements of picture-making is thus essentially related primarily to the meaning of the image and only secondarily to the graphic, decorative features.

The ingredients of picture-making technique can broadly be divided into two groups: one containing those components pertaining to the content of the image and the other to those playing part in the formal structure of the image. Unavoidably these elements cannot be rigidly classified as elements pertaining to the content of the image necessarily can affect the quality and meaning of the image as a whole. The foremost example of this is human interest. It can be objected that human interest is a subject pure and simple but the importance of the human element in photography is so formidable that it must be discussed as one of the elements affecting the image as a whole and not merely as one of many possible subjects for a photograph. Other elements primarily relating to content are: treatment of space and time; atmosphere and mood; colour in its expressive guise (both natural and unnatural) and light and its effects on meaning; distortion, disorientation and juxtaposition; montage and derivative processes. Elements which affect the image and its meaning through certain aspects of form are very numerous and interactive and include: the proportion of the image; frame; angle of view; focal length of the lens; differential focus; placement within the image; colour contrasts and harmonies; scattered element of colour; relation of colours to black or white; blur of the image; various linear projections; various shapes and their interaction; directional forces and lines; close-ups; overall colour; effect of size of the colour shapes; placement in relation to edge; form of light; contrast from light to dark; filters for special effects.

It would be unrealistic to expect a photographer to use this whole array of visual weaponry in each image he makes. But if he understands and assimilates them all, so that they are available to him as problem solving methods, or to provide specific effects, he will be capable of coping with any eventuality. Most, if not all of these elements, are well known to photographers but

they know them almost as if in abstract, having merely read about them or seen them used in some photographs. Thorough and positive familiarity is only achieved by personal application and practical tests. An effective knowledge of the elements of picture making is like the mastery of a wide vocabulary which can only be made use of when thoroughly assimilated. It is not only a question of technical expertise but of the fundamental grasp of the particular visual effects of each of these expedients, the effect they have on the image as a whole, and, of course, on the spectator.

In enumerating our first group of elements of visual representation, the importance of human interest was clearly indicated. The human eye is almost invariably first drawn most strongly to the representation of another human being. The human body, its position, specific gestures, the expressions of the face, will always carry the greatest amount of meaningful information, and will engage most of the viewer's interest. And since it also represents a specific shape and form it plays a part as an element of composition, its forceful character must be clearly understood and evaluated. The powerful effect of human interest is often underestimated in pictorial photography in which, typically, a figure was self-consciously added as a balancing element to a landscape. The effect was a general destruction of the authenticity of the image, solidifying it into a static entity and disrupting the compositional balance as the human interest was so powerful that it overwhelmed the rest of the image. Photographers frequently tended to miscalculate the dual force of the human body both as a content-subject interest and as a very powerful recognizable shape. The human perceptual apparatus shows a marked preference for recognizable shapes, thus a dark circular shape roughly the size of the head will never be as visually strong as the head itself. Because of this apparent significance of the human interest, it is an element that must be used with considerable caution. Through this concentration of interest on one point, perfectly natural gestures or expressions suddenly frozen in a photographic image may become false and too obvious.

However, the fact remains that humans and their activities are the most prolific source of photographic imagery. Two of our illustrations exemplify the strength of attraction of the human subject from the point of view of design, *Sunset* (p. 132) and a portrait of Henry Moore (p. 132). In both the main centre of interest is approximately of the same size and similarly placed. But in the portrait, the small figure of the sculptor does not need the assistance of vivid colour in order to balance the large area of the sculpture. Imagine the setting sun to be almost even in colour with the rest of the image it would hardly stand out at all. The conclusion is that the human subject may sometimes require a certain

amount of playing down in order to prevent it from upsetting the overall equilibrium of the picture. The visual vigour of human interest is also very well illustrated by *Japanese Garden* (p. 131). The whole image consists of a gentle interplay of modulated, out of focus, reddish-brown and green patches and the small human figure does not depart from the general colour scheme. Yet by virtue of its identity it creates a focal point both as a compositional device and as a purveyor of the meaning.

Japanese Garden is also a good example of the use of space as part of meaningful content. Soft foliage, created by differential focusing, in contrast with the sharper and smaller figure of a woman, provides a specific kind of spatial orientation. It is very much a part of the theme–serenity, seclusion, intimacy, meditation and daintiness, and the general treatment of the subject also evokes a quality of timelessness. Both space effects and symbols indicating the concept of time are intimately involved with the extension of the meaning and content of the image. They have already been discussed in general terms and will be further dealt with from a more practical point of view in the next chapter but it should be added here that colour is particularly important in conveying the idea of time. Specific colouring can suggest the time of the day, or of the year. Colour also has a certain quality of intimacy, due to its emotive values, so that it can be associated with isolated moments and memories. For example, sepia toned photographs invariably suggest nostalgia for bygone days, hence warm hued colours, reddish and brownish, have the same tendency.

It must now be evident how different aspects of picture making tend to overlap in their effects so that it becomes difficult to tell where one ends and the other begins. *Sahara* (p. 133) perhaps does not instantly conjure up the great desert but it does undoubtedly evoke a feeling of immense space. The tones of the mountains, though essentially of one colour, create this effect by gradually becoming lighter as the distance increases. Normally this kind of effect is represented by the increasingly lighter bluish tones of the distance but here, because of the subject matter and also because of certain flare caused by shooting into the sun, the whole image is suffused with a striking tone of gold. This gold tonality both creates space and, to a great extent, affects the mood of the image.

Creating an effect of specific atmosphere or mood is yet another important element of picture making. In a common parlance 'mood' is usually associated specifically, and rather superficially, with a feeling of sentimentality, fancy, reverie and dream. A picture of mood is usually supposed to hover on the borderline of reality and unreality and *Sahara* falls at least partly into this category. A mood, however, can be exhilarating as well as sentimental and in the domain of conveying a mood colour is a supreme master.

A short series of shots of Stonehenge is reproduced here as an example (p. 79). Taken at different seasons and times of the day, each picture is dominated by one overall hue, from the cool, remote blue of a dull morning to the blazing, all-enveloping red of the setting sun. Though the subject remains constant, the mood changes dramatically. Each time of the day is distinguished by customary, though normally rarely noticed, characteristic colouring. Just before the sun adds its bright yellow glow to an early morning, the world displays, surprisingly, a great deal of interesting colour, mostly in the range of steely blues and violets. Midday is the time of sharp, hard and clear colours and the late afternoon sun adds a golden glow and is much more mellow than the yellow of the morning. Sunset is mainly reddish, but it may change to a surprising extent according to weather and geographical position. As before sunrise, the time after sunset can be quite fascinating for a colour photographer, furnishing often unexpected results.

Strangely, the amateur photographer tends to shun the unexpected, yet truly spectacular effects can be achieved only by exploring unorthodox situations. The results of photographing in the late evening and early morning cannot be readily predicted. The low level of light will naturally require long exposures from a tripod and long exposures may bring the effects of so called reciprocity failure which can be corrected, if necessary, by an appropriate filter but, if uncorrected, can produce some extremely interesting and mood invoking results. Briefly, reciprocity failure represents the failure of the emulsion to function with normal efficiency with unusually long exposure times, so that at longer exposures, doubling the exposure does not double the increase of density of the film, can be compensated in monochrome film by longer exposures but in colour emulsion, prolonged exposures will not affect separate colour layers in the film uniformly. Usually the red layer is most affected and may produce distinct cyan cast in the sky after the sunset, still with some residue of red. A longer exposure and a pink filter would correct it but this is only one suggestion, experiments with longer exposures, perhaps with neutral density filters, in order to necessitate the increase, could be quite effective.

Not only prolonged exposures in fading light but also deliberate overexposure in normal light can produce gratifying results. *Agfachrome 50* particularly works well in delicate pastel shades achieved by calculated overexposure as can be seen in *The Girl with a Teddy Bear* (p. 135). It works especially well when the contrast in the range of colours is not too great and when the

hues are not too pure and too bright or fully saturated. Overcast and slightly misty lighting conditions are also suitable for delicate work and some photographers may like the bleached effect of brightly lit but over-exposed scenes. The range of overexposures has to be experimented with; for perceptible results a minimum two stops overexposure would be indicated, three or even four stops overexposure may give very ethereal effects, especially if it is possible to compensate by very slightly longer development and it is a particularly suitable method for combining two or even three colour transparencies together. Varying development times in order to modify results again extends the range of possibilities. Considerable underexposure and compensating prolongation of development times is especially interesting; it changes the colours progressively towards warmer hues and also increases grain.

Once one departs from the beaten track and orthodox procedures the potentialities for creative variations are endless. It is the advice to beginners, usually included with each roll of film, that the best colour is achieved between 11 a.m. and 3 p.m., with the sun behind the camera, which creates the annual flood of ordinary and dull pictures. It is true that this kind of advice leads to the least mistakes and complete failures but it also leads to mediocrity and sameness. Beaumont Newhall wrote in his preface to Arnold Newman's beautiful portraits, "Avoidance of trite, banal and the obvious, demands visual imagination." This visual imagination can only be achieved by departure from normality, and the stimulating effect of the out-of-ordinary. The discomfort of bad weather and the fear of exposing precious instruments to wind and rain account for many a lost opportunity. It is quite evident that brilliant colours will not be captured in rain, mist or hail, but then one can rarely get more interesting, moody and muted colours than in testing weather conditions. A large umbrella, a tripod and a lot of perseverance can often produce beautiful effects and longer exposures may increase the atmospheric effects by blurring the rain and movements of passers-by.

Perhaps we have been placing too much emphasis on muted and delicate colours, though there is little doubt that these are the most aesthetically stimulating but obviously colour can also be used in a totally different way. Excess or deliberate garishness can be the aim. Bright, strong contrasts of colour can create sensations of exuberance, joy, even restlessness. Combinations of reds, oranges and bright yellows will create an impression of unease, agitation and turbulence. Scattered patches of bright colour can convey similar effects; the eye is made to jump from one patch to the other creating tension and discomfort, inducing a mood of disturbance.

There remains yet another aspect of picture making which is both purely photographic and at the same time has the power to extend and magnify the meaning of the subject – the use of close-up. While talking about close-ups Edward Weston quotes William Blake's "Man is led to believe a lie, when he sees with, and not through the eye", and then he goes on to say "And the camera – the lens – can do that very thing – enable one to see through the eye, augmenting the eye, seeing more than the eye sees, exaggerating details, recording surfaces, textures that human hand could not render with the most skill and labour." Photography can transcend the eye in accuracy of observation. There is also, in a beautifully detailed close-up, a curious feeling of the authenticity of the actual object, a kind of super-reality, which some contemporary American painters try to achieve without much success, while the camera does it effortlessly. One is liable these days to forget about this particular capacity of the camera to reveal things and details the eye merely skims over. There is also, curiously enough, much less attention paid to the actual beauty of photographic quality. In the days of Stieglitz and Steichen at the turn of the century, with the different surfaces of printing paper, the different methods of newly emerging colour, photographers were in love with the actual feel of photographic quality, its fine detail, smoothness of texture, quality of tone. These days with more standardized methods of production this 'feel' of quality is largely lost, the close-up is almost the only reminder. A close-up records the details of a surface, the texture and granularity, it imparts an almost tactile feeling of the materials, the brittleness of stone, the tenderness of the skin, the slippery quality of ice. It also invariably brings the subject near to us, as if within touching distance, and conveys a feeling of intimacy and of a very close rapport and, in spite of using only a small part of the subject, can convey a great deal of its meaning and enhance the significance of the theme.

One of the paradoxes of photography, as it is reflected currently in a large cross-section of work done by amateurs in photographic societies and some sections of professionals, is a sense of restriction. It is as if one of the leading fashion designers were preparing a new spring collection and for all his creations he used only two colours, perhaps two different types of cloth and one variety of buttons. The simile is ludicrous but not so far from the truth. Photography is a remarkably flexible medium and its flexibility is even more extended in that its image is a joint effort of an extremely clever and versatile instrument and of an intelligent, thinking and sensitive operator. Take away one partner and all sorts of limitations result, bind them together and the possibilities of the permutations of the sophisticated machine, guided and abetted by the human brain, are without number.

II Visual Dynamics

In *Art Now*, Sir Herbert Read observed that "Art may flourish in a rank and barbaric manner from an excess of animal vitality, but it withers and dies in the arid excesses of reason", an apt and suitable reflection when applied to photography. For whilst "an excess of animal vitality" is never amiss in a photograph, it certainly dies from an "excess of reason" as it all but died in the hands of the pictorial doctrine – from saturation with symmetry, from chillingly meticulous order and antiseptic, genteel sentiments. Photography is a robust and dynamic medium, its image is born in a flash and it must retain the vitality of the moment. It works in the present and is about 'now, this instant' having no time to waste on trivia, fripperies and punctilious manners. There is a certain virile roughness in the best of photography, it can be soft and gentle if necessary but is not at its best with an excess of affectation and dandyism. It is a medium of strong words and direct opinions, not half-truths and veiled allusions. Hence it does not function very well with any kind of restraint or within a strict code and discipline. The speed and flexibility of photographic picture making are obviously geared to freedom of expression.

Photography above all is a medium of freedom. Therefore, as we have emphasized, it is not a creative medium that can utilize the precepts of classical composition or accept the premeditated order and predictability of classical balance. The fundamental affinities of any medium must be the basic consideration. The exuberance, high spirits and lack of internal discipline of Impressionism did not readily fit into the thoughtful and precise medium of painting. Thus Impressionism as a movement did not last long and its best exponents, like Cézanne and Renoir, soon abandoned its illusory freedom, while impressionist technique attained dignity and solidity with the strict rules of Seurat's almost academic Pointillism. Similarly in photography. As soon as some Victorian 'fine-art' photographers, like Peach Robinson and Rejlander, started to 'create' narrative compositions in classical styles of their fellow painters, the creative originality of the medium immediately evaporated. The same happened with the 'fine-art' pictorialists at the beginning of this century. For example, one of the most admired landscape photographers of the Royal Photographic Society, M. O'Dell, used to go for long holidays in Provence with a very limited number of photographic plates. There, leisurely, he proceeded to take idealized landscapes where every cloud and every twig were in an exact spot, and nothing was allowed to upset the meticulous classical balance of his pictures. At the end of his holiday he was back in England, each plate

bearing a latent image of a masterpiece, but not a single honest photograph. He may have been a fine artist but he certainly worked in the wrong medium.

In one of his infrequent articles, Paul Strand once remarked "... composition, design etc., cannot be fixed by rules, they are not in themselves a static prescription by which you can make a photograph or anything that has meaning. They signify merely the way of synthesis and simplification which creative individuals have found for themselves. If you have something to say about life, you must also find a way of saying it clearly. And if you achieve that clarity of both perception and the ability to record it, you will have created your own composition, your own kind of design, personal to you, related to other people's yet your own." Obviously dogmatic statements should be avoided, whether advocating stringent geometrical rules or total freedom, which may lead to chaos, in the creation of a photographic image. The answer must lie somewhere in the middle. For, although as Josef Albers avers "No theory of composition leads by itself to production of art", Johannes Itten cautiously adds that "Knowledge of the laws of design need not imprison, it can liberate from indecision and vacillating perception." There is no intention, on the following pages, to construct a set of rules and regulations which can be applied to photography, for this kind of theory not only does not exist, it would contradict all that is known about photography as a medium. However, having analysed the medium, it is possible to assemble a body of information about the way the human mind reacts to certain stimuli of colour, line, shape or arrangement, which can serve not as an immutable doctrine but as a series of formative suggestions for photographers.

Were one forced to formulate a general but positive opinion on the most important aspect in the structure of a photographic image it would be that the principle of dynamic balance should form the basis. The obvious difference between classical, academic balance and a dynamic one hinges on the way the human perceptual forces respond to them. As we have seen, various psychological experiments on perception established quite conclusively that human perception has a marked preference for order, symmetry and simplicity of arrangement. Briefly, when we see a picture which is totally balanced, either through symmetrical arrangement or through the perfect counter-balancing of all its elements in an equal distribution of visual stimuli, the human brain remains calm and undisturbed. Alternatively, when we see an image less accurately balanced, we try to adjust the disequilibrium visually and hence experience a certain emotional tension. When a picture is in a total disequilibrium, for example, a figure on a plain background placed completely on one side with nothing at all to counterbalance it on the other, the

displeasure and tension of our perceptual forces is such that the image may be totally rejected.

The difference between classical and dynamic balance is clearly shown in *Sunset in Mauritius* (p. 134) and the portrait of Richard Lester (p. 134). The former is in almost complete equilibrium: on both sides of the picture there is a pair of palm trees, equal in size and equidistant from the edge; the sun is in the centre and the only slightly unbalancing feature is the small cloud on the left-hand side. Richard Lester's portrait is an almost direct opposite. The head and shoulders of the film director are very much in the lower right corner of the picture, but a large sign 'Viewing T' runs in a diagonal right through, ending in the opposite corner to the head. The head is also balanced by a large area of faint faces of film stars and stills to the left, much larger than the square of the door containing the figure. Thus the balance in the picture is an uneven one; no sooner has the eye come to rest on the human 'interest' than it is sent across the picture, by way of the sign, then to explore the photographs before coming back to the face. The eye is active but not repelled, the dynamic balance creates visual involvement and excitement.

Clearly dynamic balance creates a state of visual exhilaration and stimulation by its lack of symmetry and static order. It also engenders a kind of visual tension and perhaps unease but it is an unease of fascination and not displeasure. This kind of expressiveness is highly desirable in a photograph because it, uniquely, helps to convey a state of actuality and vitality. It also allows the viewer to actively participate in the experience, not merely look passively.

Colour, inevitably, is a very powerful component in dynamic composition. It is notable that in the symmetrically balanced *Sunset in Mauritius* the colour does not interfere with the calm arrangement simply because it is almost even throughout the image. The balance could easily be activated and changed to a dynamic one if, say, one of the palm trees was in a strong hue of blue. The fact that Richard Lester wears a shocking-pink shirt makes the picture much more striking and the dynamic equilibrium far stronger. It should also be stressed that the very small head and shoulders of the man successfully balance an enormously larger area not only because of the elements of human interest and colour accentuation but also because of the effect of isolation. The man, in his corner, is clearly separated from the rest of the picture. Secluded and isolated shapes and patches of colour always exert a stronger perceptual influence than ones that are parts of the whole. This is well exemplified in the portraits of Henry Moore and Francis Bacon. Both are clear examples of dynamic composition and in both the small heads of the sitters

are separated and isolated on even toned ground and thus exert a stronger visual weight.

Another fundamental and general aspect of image structure concerns the overall simplicity of pictures. The painter has little difficulty in simplifying his arrangements, eliminating all but the most fundamental features of his composition. It is not so easy for a photographer. He cannot ignore what is in front of him, he must reconcile himself with the fact of unalterable reality. However, as we have seen, he does have at his disposal various methods of image selection. Both he and his camera are highly mobile as, on certain occasions, is his subject. Whatever method he may employ, and the need for simplicity applies as much to colour as to design and content, as long as the clarity and the meaning of his image are not impaired, the simpler it will be and the greater likelihood of its success. A simple image is always more striking and its message comes over more clearly than through a complex one. It is only when the meaning and the theme specifically call for it that complexity should be considered. Complicated and complex images are rarely successful as they place so great a demand on the viewers' attention and patience.

The ability to abstract a segment of an image from a large vista, to select not just any portion but the best and most relevant, presents a great difficulty to many photographers. It is a visual talent but also an acquired skill. This faculty to grasp, virtually simultaneously, the totality of a scene and isolate and note specific details is, in a nutshell, the creative photographer's so-called 'seeing eye'. At the beginning stages in learning photography the old-fashioned device of a piece of cardboard with a rectangular cut out in the shape of a photographic frame is helpful in developing this faculty. It is used by film directors, even such an old hand as Hitchcock has been photographed peering through a framed eyeglass, and by professional photographers in studios; a screen of a plate camera is nothing more than just such a cut-out frame. Anything that improves the chance of good photographs should not be despised. Such a frame does not have to be very large, 20 cm × 16 cm is ideal, with a 6 cm × 7 cm rectangle cut out in the middle. Held very near to the eye, this gives one a frame of a standard lens and at the same time effectively shields the rest of the scene so that the eye is not distracted. This simple contrivance helps in various ways: it shows the relationship of objects and their shapes, within the frame, much more clearly; it affords a much better idea of the inter-action of colour areas and patches; since one eye naturally shuts in order to see better, it automatically gives one a better conception of how the three-dimensional scene is translated into the flat area of a photograph; it makes the directional lines within the image much more apparent, an important factor in overall design; it suggests the proportions of the picture, making a choice of either horizontal or upright more clearly determinable and it demonstrates immediately the simplicity or complexity of the image. The viewfinder also performs these functions but never as clearly, and the very fact that the release cannot be pressed, as it can with the viewfinder, leads to more thought and precision. The 'cut-out' frame is perhaps a somehow cumbersome device, not readily fitting with the spontaneous and immediate nature of photography. It is not suggested for any kind of situation where the subject matter is fluctuating, as in a portrait session or a street scene, but it can be an excellent system of *teaching* rapid perception. After a while the photographer will see 'the frame' without actually using it, it will become a part of his sensory apparatus recalled at will, because his eye has been trained to see.

The defect of so much of photographic imagery, presented by many amateurs and professionals alike, is that the subject matter, an object, a person, is merely placed in the middle of a viewfinder, an exposure made without further ado, and the entire image restricted to its representation and description. Crudely, these pictures proclaim: "Look at this, aren't I lucky to have seen it, isn't it interesting and beautiful?" The second part of the creative activity, the origination of an aesthetic, photographic image is thus forgotten. To see something worth photographing is surely only the first stage in photography, the second stage should be to *utilize* this discovery in creation of a beautiful and arresting *image* in which the main subject matter becomes perhaps the most important but only part of the complete image: the trees in the background, a telephone booth in the foreground, a bookshelf at the side, these should become an integral part of the image to establish a composition of dynamic balance in relation to the main subject. A fitting visual counter-balance to the main subject, both as a form and as a meaning, should be sought. It could be a picture on the wall to balance a head, or, as in the case of the photograph of Henry Moore, the shape of the sculpture, or the sign and an area of film-stills, as in the picture of Richard Lester. These are interconnected together to form the whole, a meaningful picture in a dynamic composition. It is undeniable that there are other methods of image structure in photography, but equally that dynamic balance is the most consistent with the character of the medium.

While dynamic balance is the most appropriate basic method for photographic composition, a strong, dynamic image requires both the forceful balance of its parts and vigorous directional lines. Since it is the vitality of the photographic image that we are trying to express, this vitality and force can be further emphasized by implying, or actually showing, certain

prominent lines which effectively act as directional lines. A line is like an arrow pointing to a certain spot, and forcing our eye towards it. With its implied mobility a line may add another element to the liveliness of an image. Virtually anything can become a directional, active line, the edge of a sculpture, the borderline of a sign, a stalk of grass, the horizon. The line can be bold, almost brutal, as in the portrait of Richard Lester, or only very gently implied, as in *Highgate Cemetery*, by the general direction of odd yellow leaves.

The direction or slant of a directional line gives the image a specific, expressive force. A horizontal line, the least dynamic, suggests peace, calm and stability, like the line of horizon in *White Tree* (p. 26). A vertical is also stable but much less passive, as can be seen in *Row of Trees* (p. 136), where vertical lines are used as the main structure of the image; a certain vitality is created by contrasting them with horizontal lines and also by an unusual trim. Curved lines, as in the portrait of Henry Moore, also suggest vitality but in a more indirect, gentle way, while jagged lines chiefly convey an impression of roughness, unapproachability and aggressiveness. The diagonal line is perhaps the most important directional line in photographic images. Since the elements of design are a vital part of the expressiveness of an image, the diagonal, with its character of animation, verve, eagerness and energy, may add just these aspects of vitality to a photograph which we have argued are truly photographic. A diagonal may also suggest movement and drive, indicate action and speed, time and timelessness. If used properly it can constitute the most important feature of a photographic design, as in *Bareback Riders* (p. 11), where the diagonal is constantly repeated in both directions, adding to the feeling of movement, agility and speed.

Shapes and their placement are obviously also very important in giving the image a quality of vitality and movement but it is above all directional lines which produce the effect of rhythm and visual coherence. According to the results of numerous psychological experiments in perception, images are read, or seen, in a sequence. Even though a photograph is seen at a glance, during this brief instant the eye traverses the photograph in a certain order. It is important to establish this order as, armed with this knowledge, we can assist the eye in its journey across a picture. On experimental evidence we know that the eye tends to look first at the left side of an image, unless it is blocked from so doing by, for example, something particularly bright or colourful on the right hand side. Why this should be so cannot be fully explained but it may be connected with our customary way of reading from left to right. Thus the 'pleasingness' of an image can be enhanced by helping

the eye along, or its aggressiveness and tension heightened by 'offending' the eye and making it read the picture the wrong way round, as in the portrait of Richard Lester. The way we look at images changes some aspects of balance within the picture. For example, the same shape placed on the left of the picture seems heavier than on the right and in order to balance this tendency of the eye, the right side ought to be strengthened if perfect balance is required. In the same way, a diagonal line running from the left lower corner to the right upper seems to ascend and one from the left upper corner to the right lower seems to descend. Again certain aspects of meaning can be stressed and expressed in this way for uplifting or depressing lines can help to accentuate the mood of a picture.

We have already indicated how shapes and their placement may affect the dynamics of an image. But apart from their inter-action in dynamic balance, shapes have their own identity which also contributes to the mood or meaning within the image.

It is possible to enumerate some general visual aspects of certain shapes, the aggressiveness of a triangle with its two diagonals, the stability and weight of the horizontal and vertical lines of a square or rectangle, the serenity, restraint and passivity of a circle. The less regular the shape, the less its visual impact as the eye is attracted to regular shapes and tends to ignore haphazard and irregular ones. But even less regular shapes have certain specific qualities, rugged and angular ones are uneasy and irritating for the eye, while smooth flowing ones are pleasant and soothing. One can see how the regular circle of the hat pulls the eye to the top of *A Gondolier's Hat* (p. 150). It would have been far less attractive if it were irregular.

The tone of a shape also has a visual 'weight'. White, as we have mentioned, is heavier perceptually than black simply because its brightness pulls the eye more strongly towards it, hence its visual force. Consequently, a larger area of black is needed to balance white's visual force. The placement of shapes is of crucial importance. The edges of the image are the most active areas, therefore, in a composition, shapes placed nearer to the edge 'feel' heavier than ones nearer to the centre. Thus a small shape near the border of the print exerts a very strong perceptual pull and will require a much larger shape, nearer the middle, to counterbalance its gravitational pull. The placement of the hat in *A Gondolier's Hat* in such an unusual position is a provision of dynamic balance, in order to accentuate the flowing, moving element of the water by providing a subconscious 'pull and push' within the image.

We have discussed the directionality of lines, but shapes can also play a certain part in the field. While discussing *Highgate Cemetery*, it was pointed out that the yellow leaves created a line of direction. The reason is that their similarity, in this case similarity of colour as well as of shape, forces us, subconsciously, to join them together and create a line. The same kind of phenomenon happens with the absence of colour when shapes closely resemble each other. The eye notices their affinity and joins them by going from one to the other, creating a visual path. Colour is an extremely efficient and efficacious method of binding the image in a rhythmic sequence. The eye is immediately attracted by a similar colour, especially if it occurs in small but distinct patches of bright colour which act as a flare-path for the eye. The same method of attracting the eye to a specific point in the picture may also be used for the purpose of general balance or even in order to enhance the meaning. If, for example, a small object in the background has an important bearing within the picture, say in emphasizing a characteristic trait of character in a portrait, the eye of the viewer may be attracted towards it by placing near it a colour accent similar to the one of the main subject.

Needless to say, the sheer extent of a shape, its physical volume, is critical to the overall balance of the picture. It applies both to the contrast of dark and light areas and, more emphatically, to contrasting fields of colour. The juxtaposition of a large area of even tone with a small one in a contrasting tone effectively contributes to a picture's dynamic balance. The large mass of a dark shape can be easily balanced by a small white object placed near the edge and prominently isolated. It is, however, in the realm of colour that effects of contrast of extension are most fascinating. At this stage we must mention briefly some of the general features of individual colours as these are important in determining the relationships of combinations of colour.

Yellow, as Goethe noted, is the brightest, the most aggressive of all colours, but also the most joyous and dazzling. A relatively small area of yellow is very strong and will attract the attention of the viewer. It is also a fairly warm colour and hence advances towards the viewer. Red, although much less visually powerful, is considered the most exciting and stimulating colour. It is also the warmest of the hues, the most strongly advancing perceptually, consequently it can play a relatively prominent part in dynamic compositions. A red object placed in the distance seems to surge forward adding depth and vitality to the image. It is obviously an exciting colour to use, nevertheless to say, as do some critics, that "A bit of red makes a picture" is nonsense. The whole idea of photography is to reveal and interpret reality and not merely to perpetrate technicolour effects. Because of this slight melodramatic quality, red

Japanese Garden—Otto Kneule page 131
As one would expect, we are more interested in other people than in anything else. How others live, their appearance and customs arouse our constant curiosity. Consequently the visual attraction of a human figure in a picture is often far greater than one would expect, in relation to their respective size and colour. Though taking no more than a minute part of the total space and not especially dominant in colour, the figure of the woman is the major focal point.

Sunset—Richard Tucker (page 132)
Portrait of Henry Moore
These two characteristic examples of dynamically balanced composition in photography are very similar in their image structure. In both the centre of interest—the red sun and the head of the sculptor—are fairly small in size and placed well to the side of the frame, and in each case this focal point is balanced by far larger, more irregular and less defined mass of tone. The head, by virtue of its human interest, does not require a strong contrast of colour to retain its visual importance.

Sahara—Hans Roth page 133
It is quite remarkable that often in photography some pictures succeed, in spite of the fact, that it is very difficult to identify the exact reason for their attraction. Virtually one tone and one colour image, without remarkable design, or without symbols to indicate space or size, like *Sahara* somehow manages to convey splendour, remoteness, inaccessibility and a quality of blinding light, all at the same time. The reason must lie in the powerful realistic expressiveness of photography, which often works in conjunction with our visual memory and our ability to associate certain feelings with specific images and places.

Sunset in Mauritius—Gordon Ferguson page 134
Portrait of Richard Lester
A clear comparison of classical and dynamic balance in photographic composition is shown in the symmetrical arrangement of *Sunset in Mauritius* as contrasted by the strongly assymmetrical structure of the portrait. The head of Richard Lester is balanced by a large area of film stills, creating a conflict of interest. The dynamism of the image is further accentuated by a strong diagonal line.

Girl with a Teddy Bear—Wim Noordhoek page 135
Here a dynamic composition is used for an essentially gentle and static subject. It is easy to imagine that the picture would lose some of its attraction if it was composed entirely symmetrically. As it is the assymmetry creates a great deal of visual liveliness. Overexposure desaturates the colours which add softness to the image of the little girl, and, to a certain extent, balances out the dynamism of the composition. The interest of an image often relies on this kind of play of various elements, which add to the sophistication of the photograph.

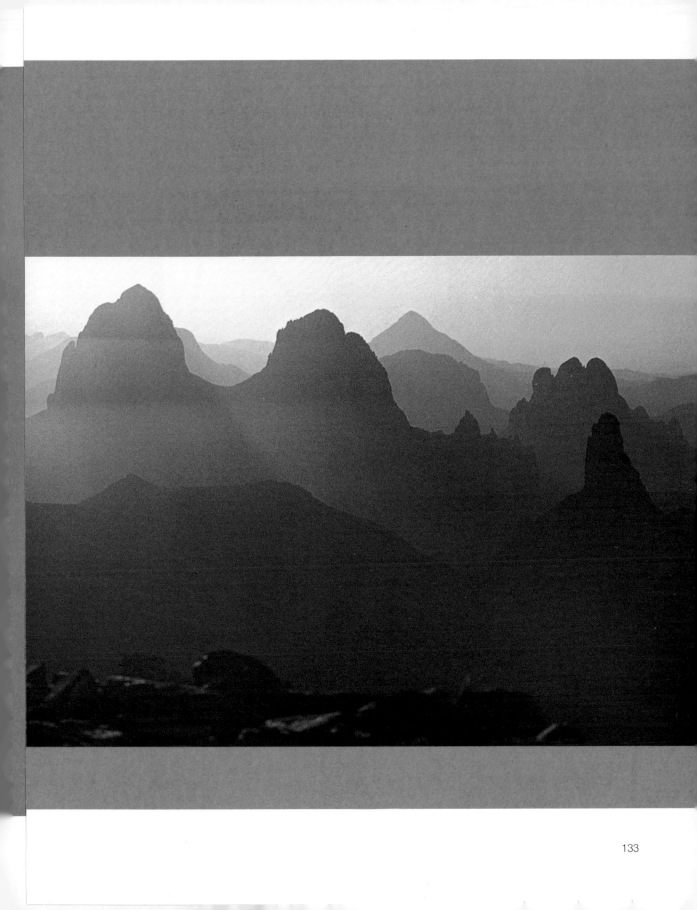

is even avoided by some serious workers although this attitude also seems too extreme. The third warm colour is orange, and of the three it can be the most biting and energetic. It is almost as brilliant as yellow, but for some it carries a note of ostentation.

While yellow is often associated with the shape of a triangle, because of the aggressiveness of both, and red with the shape of a square, because of its heaviness, blue, the coldest of the hues, is frequently associated with a circle. Both represent passivity, coolness, restraint and depth. Blue also seems to be unobtrusive and the least intimate of colours, hence it appears to retreat away from us. It does, however, inspire a certain feeling of security and confidence and is sometimes associated with spirituality and mysticism. Green is certainly the most restful colour. It has the tranquillity of nature and is suited well to subjects whose theme is youthfulness, hope, spring and rebirth. In direct contrast to yellow, violet and purple are static and sedate and the dimmest and least resonant colours. If they are important in the picture they should be strongly accentuated otherwise they tend to vanish.

In some cases an understanding of a meaning that colours are capable of conveying may help to infuse a picture with a suitable mood, for its whole character can be affected by a colour accent. But it is in one particular sphere that a knowledge of the general characteristics of colour can be most pertinent. Because colours vary so much in their intensity and the force which they exert on the viewer and also because of their strange ability to advance and to recede, colours can create a semblance of movement within the image, quite apart from any other effects. Paul Klee, one of the finest teachers of colour theory at the Bauhaus, laid particular stress on this feature of colour mobility. No colour 'moves' by itself as much as it does in juxtaposition to other colours. Colours, as we know, attract and repel each other, hence the theory of colour harmony and contrast, and these seemingly magnetic relationships between colours create the subconscious feeling of movement. The strongest source of this motive power, which originates a kinetic force within the image, is the contrast of complementary colours, called by Klee "a diametrical relationship"; particularly powerful are the three main complementary pairs, red-green, yellow-violet and blue-orange. Two patches of colour, one red and the other green, placed within the image, will immediately establish a kind of fluctuating link and a kind of internal movement will be generated as the eye is propelled on the path from one to another.

Another possible source of apparent movement between colours, but of a much less violent kind, is created when neighbouring colours have a distinct tinge of each other, say a pure blue colour placed next to a bluish-red

Row of Trees—Wim Noordhoek **page 136**
Main directional lines of the image design often lend a specific character to the expressive quality of the picture. In this case the verticals of the trees promote stability and provide the image with a sense of dignity and strength. They are counterbalanced by contrasting horizontals. The overall texture of shimmering, delicate leaves additionally creates a kind of kinetic movement. This effect is mainly caused by the compression of space, the exclusion of the sky line and the use of a long focus lens.

colour. The second colour seems to have a tendency to merge with the pure hue, and this merging creates a sense of gently oscillating movement. This phenomenon is partly self-creating, since objects usually become slightly invaded by the colour of objects next to them through reflection. Also both simultaneous and successive contrasts bring a certain visual, though illusory, colour cast of complementary hue, which again will contribute to the apparent fluctuation as the eye moves from colour to colour. The warm-cold relationship also prompts this reaction. Since warm colours (red, yellow, orange) tend to advance to the front of the image and cold hues (blue, violet and green) seem to recede to the back, it naturally creates a feeling of movement but since it is movement into depth it is not very strong.

The importance of the warm-cold polarity lies mainly in the effect it creates of spatial inter-action and in photography the indication of three-dimensional space can be essential. Basically there are five different methods of emphasizing spatial depth in photographs. The first relies on the inter-action of colour, particularly on the warm-cold contrast especially to suggest distance. In landscape photography, the feeling of space is strengthened by the blue of the distance. This blue is largely the result of the second method of rendering space – namely aerial perspective. The further away we stand, the greater the amount of atmosphere that divides us from the view, hence it becomes both lighter in tone and bluer. This effect can be controlled to a limited extent by the use of appropriate filters. A U.V. filter mitigates the effect of atmospheric distance and makes distant objects clearer and as if nearer. A bluish filter may partially reverse this procedure. The third method of showing space is also derived from the natural way of seeing: spatial depth is emphasized by the gradual diminution of receding objects or lines converging towards one central point. The positioning of the camera will also affect space reading, a high viewpoint, for example, may reduce apparent distance. The choice of viewpoint will always affect the fourth method of space rendering considerably. Since this concerns the overlapping of objects, these obviously will change according to the relative position. Overlapping is a very effective way of dealing with space as large, partially included shapes in the foreground, overlapping smaller ones in the second plane, increase the plasticity in the images, particularly if overlapping is combined with the fifth, most uniquely photographic way of suggesting space in photographs, differential focusing. Rendering distant objects sharply in focus and overlapping them by closer ones diffused by soft focus is perhaps the most interesting and effective way of recording spatial inter-action. Colour adds to this effect tremendously because of its ability, if treated unsharply, to become diffuse and almost immaterial.

The Green Leaf (p. 148) combines several of these methods. The most strongly featured is the reaction of colours, the red seems to hover very near and the colder, green leaf seems far away. The effect of differential focusing is similarly prominent, the blurring of the near red forms contrasting strongly with the sharp distant green patch. Aerial perspective is also used to a small extent in the bluish distance of one portion of the picture and, of course, the overlapping of the forms further assists the illusion of depth. *Little Ballerina* (p. 147) also employs more than one method of three-dimensional rendering simultaneously, only the colour effect is not used. Differential focusing is very prominent as are the effects of overlapping forms and their difference in size, between near and distant, creating an extremely vivid impression of three-dimensional space.

A blur, due to movement during exposure, is indeed the most fascinating and truly unique feature of photography. It conveys an impression of movement in time as clearly and as distinctly as it could possibly be expressed in a static, two-dimensional reproduction in any medium. It is also, despite a large degree of distortion and displacement from a normal image, an extremely realistic method of recording objects in motion. Its correlation to straight photography is similar to that of Impressionism to academic painting. Impressionism could be described equally as the first modern avant-garde movement or the last potent expression of true realism. Although the Impressionists' method of representation was fairly unorthodox, their aims and purpose were entirely straightforward – to convey the impression of the scene as it really appears to the eye, a distinct parallel to photography. For the method of the blur may be highly unusual but the aim is also to achieve the greatest faithfulness to the original visual impression. If one looks at *The Juggler* (p. 149), it is difficult not to agree that it is the most representative and realistic rendering of a juggler's activity. Continuous and smooth motion is precisely what juggling is about; if this movement were stopped with a fast shutter speed, the illusion would be lost. *The Juggler* demonstrates one of the methods of achieving a planned, if largely unpredictable, blur. The camera was kept entirely motionless during a half-second exposure. Another method is to move, or pan, the camera in the direction of the movement during a shorter exposure than was used for *The Juggler*.

There is no way of estimating the length of exposure needed to produce the necessary blur, obviously the faster the movement of the subject, the shorter the exposure needed to achieve a certain amount of blur. For example, when holding a camera still in front of speeding race horses, an exposure as short as one sixtieth of a second will record some blur, while for a

slowly moving ballerina as much as half a second may be necessary. For a zoom lens effect, as in *The Band* (p. 117), the camera again must be stationary, on a tripod, and the exposure long enough (in this case it was half a second) to allow for a certain shift of the zoom lens. There are other methods of conveying movement, not so much by an actual blur as through several consecutive exposures on the same frame of the film. This can be achieved with an electronic flash flashing several times during the movement of the subject, with a lens of the camera open, and the film only being exposed during the duration of the flash. Perhaps more interesting is another version of shooting with a flash unit. The subject is lit with additional light and the lens is open for a fraction of a second before the flash is fired, thus recording a blurred image of the subject which is suddenly frozen by the flash exposure.

III Relationships

It is most unusual in a photograph to find the subject and treatment confined to one single element or effect. Although images work best when relatively simple, most photographs convey and communicate a certain meaning and it would be virtually impossible to express a meaning without the relationship of at least two visual ingredients. Our perceptual apparatus works best when given a task of reconciling some element with another, for, as Johannes Itten suggests, "The mind and eye achieve distinct perception through comparison and contrast." Pictures like *The Tree in the Mist* (p. 162) are rare in their utter simplicity, one object, one colour, one idea. Yet for all its simplicity, it required the collaboration of several features to achieve its expressiveness. It needed a subject, the tree, the effect of a colour, in this case an almost monochrome but with a moody cast of pinky-yellow, specific weather conditions, a morning mist, and finally the secondary subject, the sun, barely breaking through the mist and the branches of the tree. Even in this simple picture, several elements were necessary to express the message and meaning clearly; to achieve this in a more complex image obviously requires the presence of all the elements that can contribute to creative picture making, used in a variety of combinations and relationships.

Relationships exist largely through "comparison and contrast". The basic photographic structure we advocate, dynamic balance, is nothing but a certain relationship of shapes and colours or colour and design. Colour is said to affect us emotionally and design to engage our intellect. Whatever the truth of this, we are affected by both and there is little doubt that it is their combination that produces the strongest perceptual image. Since both colour and design are capable of possessing emotional content, aiming in a specific direction they can work in collaboration or in direct opposition. It is more usual to try to add their expressive qualities together, in order to create the maximum intensity of a mood or meaning; *Tree Silhouettes* (p. 162) is an example of such an attempt. Both the colours and shapes evoke a feeling of tension and instability. There is something somehow menacing and foreboding in the stretched, tortured outlines of the branches and the strident, almost hysterical, yellow-orange of the sun and sky adds to this effect. But the emotional direction of colour and design need not always coincide. Matching serenity and delicacy of colour with violent design, for example, can result in some powerful images, a brutal murder always seems more dramatic when committed in a quiet and charming little village. In photography, such a contrast of colour and design would naturally produce a certain emotional response,

it may, however, lack a sense of direction unless it is linked directly to reality. The relationship of opposites works best in photography when it reinforces the meaning. Contrasts play an extremely important part in photographic as in all imagery. Contrast within the picture, whether of colour, formal structure, or subject matter, or a combination of any or all of these, create a state of excitement and tension, which is the essence of photography.

The most significant contrast of formal structure is the principle of dynamic balance, where shapes and colours are played off against one another until a state of cautious equilibrium is achieved. Dynamic balance is involved in all the formal relationships within the image but it is interesting to examine, more closely, its operation in the relationship between background and foreground. A strong relationship between the two was largely avoided in painting until the advent of photography and the arrival and subsequent popularity, especially among artists, of Japanese prints. In their bold use of distinct and strong forms in the first plane of the picture, these prints and ordinary snapshots suddenly revealed various compositional possibilities. Curiously, in the past centuries of Western art, it was mostly artists who had availed themselves of the services of the camera obscura who accentuated the foreground more distinctly. An example is Vermeer, with his tables covered with carpets, carved chairs and decorative flooring. On the whole, the artists of the Renaissance and after preferred a clear vista with no objects obstructing the main subject view. The Japanese print maker was not afraid to show a fragment of an arm and shoulder boldly in the foreground, something that a Western artist was most reluctant to do in spite of its three-dimensional possibilities. It was the photographer who started to utilize this compositional device fully almost assuming a monopoly of its effect. Naturally enough, for in everyday life the foreground is very much a part of the scene. We try not to upset chairs looming ahead of us, step around the tables, and avoid treading on the cat's paws. Therefore it is only by deliberate clearing away of these paraphernalia that, normally, an entirely clear picture of the near and far distance can be achieved. The painter constantly used to do this kind of clearing up but in photography, though it might on occasions improve the clarity of the image, it would certainly destroy authenticity.

The advantages of using foreground effects are considerable: the image becomes more realistic and intimate, as if these near objects are touchable and within reach; the scene is bound into a consistent whole, an internal rhythm is created, the proportions between near and far indicated more clearly. In the area of the three-dimensional space and plasticity of the image the advantages are most marked. The inclusion of a near foreground provides the picture with an effect of a sweep into the distance, working on several levels: large-small relationship, unsharp-sharp, darker-lighter and the overlapping of shapes. Every photographer knows how disappointing a landscape can be when recorded in a photograph. Large, beautiful vistas are somehow diminished and far less impressive than in reality. A strong and appropriate foreground may very well restore its vastness and splendour, the eye compares, sees large and imposing familiar objects and on their basis reassesses the rest. *Mountain Desert* (p. 163) exemplifies this. The presence of sharp, menacing shapes of rocks in the first plane of *Mountain Desert* give the image an immense power and the far distance assumes a greater authority and awesomeness through a direct comparison.

Often the foreground can contribute a sense of intimacy and naturalness—it gives an impression of bringing the viewer into the picture—as well as improving the spatial relationship. Colour can play a very prominent part in the foreground and background relationship. Out-of-focus colour, its softness and translucent quality, can be used as a compositional foil and as an element of space inter-action. It can also provide a distinct enhancement of the overall mood of the picture—distinctly cool or warm tones of the foreground may give an emotional and visual cue to the image viewing—as if putting the viewer into a correct frame of mind for the forthcoming enjoyment of the visual experience. In discussing the relationship of foreground and background a brief mention should be made of the possible choice of a background colour, if such a choice is feasible and desirable. As part of the image, the background must conform with the rest and play its role in emphasizing the general theme and meaning of the image. However, a background of cool hues, greens and blues, enhances the three-dimensional effect of the picture, allowing the subject, particularly when it is in warmer colours, to stand out and advance towards the viewer. Warm-coloured backgrounds, reds and oranges, cause a certain amount of ambiguity and confusion in the mind of the viewer since they seem to advance and yet are clearly in the distance.

Wassily Kandinsky, the first abstract painter, once remarked that "A picture is nothing more and nothing less than organised colour." While it would be difficult and misleading to reduce a colour photograph to such a minimum requirement, it is none the less true that a photographer, during the time of making an exposure, should be able, briefly, to see the image as an area of ground divided into certain fields of colour. For this brief second, the meaning of the subject matter, all the figurative elements of the picture, should be of secondary importance and the viability of the image as a combination of patches of colour should be consid-

ered. What is seen in this moment of concentration are abstract values of the image, its visual balance, lines, shapes and colour. The relationship of colour areas within an image can of itself generate emotion. In combination with the story element of the subject matter, this emotive quality should enhance and reinforce the effectiveness of the image. Colour cannot be treated merely as part of the scene, and the more the merrier as some photographers tend to think. It can be the most valuable aid to expressiveness for, as Weston said, "You can say things with colour that cannot be said in black and white." And since every act of seeing is a perceptual judgment and act of comparison, it is in relationship between one another that colours come into their own.

Certain relationships between colours have been discussed and alluded to in the preceding chapters but it would now be useful to examine the question in more detail as its complexity can be seen in enumerating even some of the relationships which can be found in a photographic image. These include: the relationship of colours to black, to white and to grey; the contrast of hues; simultaneous contrast; the relationship of warm and cold hues; contrasts of the quality, extension and placement of colour; the design relationship of colour areas. Black, white and grey are sometimes referred to as non-colours, but they play an important part in colour composition. Both black and white affect colour considerably by their proximity. All colours seen against a black background seem to increase in luminosity and strength, while those surrounded by white lose some of their brilliance and purity. Colours in juxtaposition to black and white change appreciably, the real colour being no longer the same as the one perceived. Black and white not only affect the colours when placed next to them but also when mixed with them, the contrast of dark and light, as we have seen, influencing the nature of the image to a great extent. The image will always appear too dark if the areas of dark and light are equal. It is only if approximately two-thirds of the picture consists of lighter tones and one-third of dark that the image appears tonally balanced as black absorbs a great deal of light.

Contrasts of hue are the basis of the theories of colour harmony and contrast previously discussed when it was noted that the contrast of pure primary colours is the strongest and most vigorous. A picture like *Through the Leaves* (p. 91), where all three primaries are involved, expresses joy and vitality. Bright and piercing hues of pure colours are exceptionally suited to vigorous images but not necessarily to realistic and commonplace ones as they induce a sense of heightened experience, almost emotional intoxication, with its consequent evanescence. Agitation and a reaction can also be aroused by a use of contrast as in *The Green Leaf,*

Sunset and *The Fruit Stall*. Juxtapositions of this kind provoke a visual explosion and photographers aiming for restraint and naturalism should treat pure complementaries with considerable caution concentrating instead on the harmonies of contrast derived from the relationship of colours of the secondary and even third order.

Looking at the colour circle (p. 63), one can see that the secondary colours are these which result from a mixture of two primaries. Primaries are certainly not the most natural and lifelike colours, these are partly secondary colours but predominantly colours of the third order, those resulting from the mixture of two secondary colours, like green and orange, or violet and green or violet and orange. George Field's nine part colour triangle (fig. 63) shows the relationship between the three primaries, their secondary and the third order of colours clearly. Thus between violet and orange we see brown, between violet and green lives olive and between orange and green, ochre. These three tertiary colours are those most often found in nature, their combination produces the least exhilarating shocks but also the most satisfaction: *Highgate Cemetery*, for example, contains the harmony of all three tertiary colours (brown, ochre and olive) plus two secondary colours, orange and green, and no primary at all. Francis Bacon's portrait was restricted to ochre, brown and orange. The colour combination of *Into the Light*, to give another example, can be found in the other corner of Field's triangle, harmonizing blue-green, olive and greens. Field's triangle is particularly useful in finding harmonious relationships as opposed to harmonious contrasts, each side of the triangle giving a lovely range of harmonious colours or, alternatively, each corner also indicating a good harmonious arrangement. Thus the combination of the red/brown/orange/ochre/yellow band is a warm band of harmonies, whereas the blue/violet/green/olive corner of the triangle contains an attractive range of cool ones.

Simultaneous contrast has been discussed but it is worth mentioning here that its effect, still inexplicable scientifically, adds sparkle to the contrast of complementaries by reinforcing them with an additional hue automatically created by the eye. It should also be mentioned that the eye, by summoning up the complementary to balance the primary observed, creates its own relationship, adding to the visual interest and stimulating perceptual activity. Consequently, the photographer should not be afraid to use an excess of one colour without a compensating area of a complementary. The eye provides its own counterbalance by simultaneous contrast and creates, at the same time, its own excitement. Hence an over-careful and too balanced composition of complementaries can sometimes defeat this purpose and produce a static feeling,

in spite of the actual active harmony of the contrasts. Simultaneous contrast works best with a grey area of tone adjacent to an area of primary colour. The eye descending from the observation of the primary colour to the grey space will immediately conjure up a complementary on its surface, so that an area of grey next to one of red will give an illusion of greenness. Grey can thus be a complementary and a harmony to any colour, its essential lack of colour is counterbalanced by the phenomenon of illusory colour. At the same time grey has a softening influence, reducing a too great visual jump between strong colours and serving as an efficient buffer and mediator. Grey may not be very effective in painting, although some painters influenced by photography, Corot for example, adored it, he even invented a new grey, called naturally *Corot-gris,* but it can be very beautiful in colour photography.

The relationship of warm and cold hues has also been discussed. Obviously virtually the whole of the right side of the colour circle, from yellow down to violet, is in the warm range of colours, while the left side tends towards coldness of tone to varying degrees. Hence the relationship is also one of contrasting complementaries. The warm/cold relationship can be extremely vigorous where both, orange and blue for example, are direct opposites on the colour circle and where the 'temperature' difference is the most extreme. On the other hand, it can also be fairly gentle, as in the combination of fairly warm yellow/orange and gently cool yellow/green. *The Houses of Parliament* (p. 166) is also moderate and temperate but composed not so much from close neighbours as from tranquil opposites, pale blue/green and pale pink/violet. The combination is soft though the colours come from the opposite side of the circle, mainly because of the relative desaturation and impurity of the colours. Since we have pointed out that the cold/warm relationship is an aid to three-dimensional representation, it is interesting to note the reverse effect in this photograph. The warm tones, all at the back of the image, seem to push forward in front of the cool foreground. A certain visual ambiguity results and the building seems to hover in space very near the viewer.

The example of *The Houses of Parliament* may also serve to illustrate a further contrast, the contrast of quality or purity of colours. It may seem that a bright, highly saturated colour can be enhanced when contrasted with a weak, desaturated one. But, in fact, as soon as a pure colour is part of a composition, the contrast of quality can no longer be judged or even noticed. It can only be seen when dealing with one colour in various stages of purity as in *Sahara* or *The Lonely Tree.* In both, the comparative strength of one colour, varying within one picture, can be seen, and it is this variation that provides the interest of the image.

Some specifically photographic effects are liable to affect the purity of a hue and degrade it quite considerably without weakening its visual appeal. Both these examples are the results of shooting straight into the light, which affects the colour mainly through flare. Though this may, and often does, affect the saturation and brilliance of colour it also creates interesting side-effects, primarily of mood. The same applies to deliberate over and under-exposure of colour films: both naturally affect the quality of colour. *The Houses of Parliament* was slightly over-exposed, hence the colours are flattened and deprived of part of their brilliance.

The Houses of Parliament is interesting from yet another point of view. The picture is unusual because it is almost equally divided between two colours, contained in two equal areas. This equilibrium of colour areas is rare. Photographic images mostly exploit the tension arising from the disequilibrium of the size of patches of colour. Contrasts of hues are affected not only by colours and their quality but also by their quantity, the size of the area they occupy, and, further, the relative size of areas of different colours. As we know, there is no reliable and accurate method of measuring the relative perceptual force of each colour and Goethe's estimate, made nearly two centuries ago, seems as accurate as any. In some cases the placement of colour, such as the contrast of a small spot of colour near or surrounded by a much larger area of a different colour, is more important than the size of the colour area. In photography, particularly, this kind of colour accent can play a significant part in the meaning and intelligibility of an image. When placement is considered, the areas near the edge of the image are the most vulnerable ones. The placement of a small spot of pure colour, particularly one of high brilliance like yellow, orange or red, near or overlapping the frame creates an enormously strong magnet for the eye, which will need a great deal of counterbalancing in other areas if some kind of stable equilibrium is required in the image. Small patches of colour have a kind of life of their own and if an image contains a number of them, they may be a source of disturbance and chaos. If, on the other hand, some kind of similarity and patterning exists between them they assume a great importance, creating directional lines between them and affecting both the balance and the meaning of the picture. It is here that the selectivity and simplification of the image must take place, small areas of conflicting colours act against coherence and simplicity and rarely please the eye or clarify and emphasize the meaning.

So far, practically all the relationships discussed have pertained to the abstract qualities of form and colour. But our purpose must be to match these abstract qualities with the figurative aspects of meaning and to do this relationships of meaning and literal interpret-

ations should also be examined. Let us start, not from reason and logic, but from the opposite. Photography is undeniably an extremely serious and profound medium of expression. However, considering photographers' output as a whole, a certain bias towards pomposity and solemnity can be detected, especially amongst amateurs. Even among professionals, few photographers seem to have devoted any of their talents to the exploitation of humour and even fewer to the strangeness and surreality of the world around us. Robert Doisneau is perhaps the funniest photographer and Elliot Ervitt possibly the nearest in his approach to surrealism and yet the world as a whole is full of strange and bizarre coincidences, fortuitous meetings of most unlikely objects and happenings. Take, for example, *Sculpture in a Field* (p. 161), here is a modern, gleaming sculpture in a rustic environment with a horse peacefully trotting along behind. The two are certainly out of context and it is their totally unexpected juxtaposition that makes the picture so fascinating.

There is no intention to suggest that a photographer should make these coincidences happen (this one was certainly unpremeditated). There is little need to manipulate in order to find the bizarre and the absurd, life is full of opportunities. All that is required is to be sympathetically attuned to the anomalies of life as well as its dull normality. Freud suggested that our conscious existence is only the tip of an iceberg, ninety-nine per cent of our real selves lying submerged in the ocean of our subconscious. Without advocating that photography should start hunting spirits, we suggest that it may be admirably suited to the exploitation of meanings which are not strictly obvious and totally logical. The realism of photography is exceptionally well suited to take advantage of the pursuit of ambiguities. It is when the viewers' confidence is being undermined by photographic surrealism that an element of magic appears. Objects half-included in the frame, magnified almost out of recognition, can assume a new identity and prompt an unusual train of thought; the juxtaposition of different, instantly recognizable objects taken out of context by either long or short focus can also create weird effects, as can photography at low levels of light. To be a straight photographer does not necessarily mean that one cannot exploit the inanities of our environment and question some social taboos even if this sometimes were to cause pain, as in so many of Diane Arbus' disturbing photographs. The world would be a poorer place to live in if the photographers, the true chroniclers of our time, confined their subjects only to beauty and reason.

The combination of images also opens a variety of possibilities. This can be either a series of images illustrating variations on a theme, a sequential record of a short happening, or visual play with a shape or colour and its various transformations. Additionally there are various uses of several images in one picture, either by double printing, the superimposition of two transparencies, or by making a collage of images. The series of Stonehenge we illustrate (p. 79) shows the change of mood of the subject with the change of light and colour and is a fairly representative example of an orthodox creative photo-sequence. There is no reason why such a sequence should not be shot in a more adventurous way, exploiting shape and colour. Some younger American photographers have been known to use sequences in a most outrageous way, suggesting almost supernatural happenings and transformations.

The combination of images revolves around the idea of a progression of several shots – the eye looking at one picture then moving along to the next. If this idea were pushed to its logical conclusion, it would result in a sort of cinema strip and a form better exploited by the cinema than by still photography. The photographer, therefore, should use his own medium fully rather than try to imitate the possibilities of another. The creative photographic image should aim to retain a certain completeness, it should be able to stand on its own. There is, however, a possible compromise solution, the use of a pair of pictures. This is rather an old idea used in some magazines between the wars and consists of two pictures on adjacent pages which have something visual in common – the repetition of a shape in two entirely different objects, a perceptual resemblance between a human and an animal, sometimes poignant or sometimes humorous. These were generally monochrome pictures, but it seems that some interesting visual statements could be made in this way with colour, perhaps showing one picture next to another using juxtaposing colour or harmonizing the colour and contrasting the meaning. The use of two frames of a film as one, printing them, or projecting them in a reduced form, together can also be particularly interesting if the two frames are placed one on top of the other and are shown to be shot separately and yet making a visual statement together, half a person in the top and the other half in the bottom for example. This could be considered as yet another way of introducing an element of surrealism.

Finally we must examine a single image incorporating within it more than one exposure. The simplest and most popular method, particularly among professional photographers, is a 'sandwich'. One of the attractive features of this combination of two transparencies is the element of control. A professional can plan both exposures meticulously so they fit one into the other with utmost precision. One of the well known exponents of this method is Sam Haskins and he often uses it to combine a picture of a girl with some other background.

Since the nature of Haskins' images is frequently fantastic and surrealist, for example his extensive series of pictures on the theme of an apple, where the girl is within an apple or an oversize apple fits a whole room, it would not be possible to shoot his ideas in an ordinary way. This method, however, does require a very careful and meticulously planned procedure including an initial sketch of the idea and probably several test shots. The sandwich method can also be considered from an entirely different point of view. Instead of the precision, the chance and fortuity which are such an essential feature of the photographic medium can be exploited. Sometimes two images shot at different times and places suddenly combined with each other can produce a strange and unforeseen result. Alternatively, some shots taken with a possibility of later fusion can retain a sufficient freedom and element of chance and not merely suggest the static quality of pre-planning. In both cases one ought to experiment since the attraction of the method is its flexibility and unpredictability. Note that, generally, two slightly overexposed colour slides will be easier to fit together than two under or even correctly exposed ones, since, in the latter cases, opacity will prevent the second picture from being seen clearly.

Similar yet different results can be obtained through the medium of double exposure. Again the procedure can be planned to the last detail, including a sketch, or it can be treated in a freer and more relaxed manner. The free approach may result in many failures but it may also bring the rewards of an occasional master-piece. Once again extensive experiments are recommended but some obvious points may be mentioned. In the first place, one must have a camera which allows for double exposure; further one must remember that the first exposure is liable to 'consume' most of the sensitivity of the emulsion, so relatively little is left for the second exposure, only the parts of the transparency which received a relatively small amount of exposure in the first exposure are still available for the second one. Thus one should remember that the subject of the second exposure will be seen only in the dark areas of the first one, unless the second exposure is very much increased in which case some of the first exposure can be at least partly obliterated. It is obvious that both exposures do not have to be of equal strength since the illusion of strangeness can be enhanced by parts of the subject being as it were translucent and ghost-like, an effect employed by some unscrupulous photographers in their recording of so-called spirits or fairies.

Colour Seen Through the Camera

I Light

II Image

"Photography is an art; it uses its own means; it has its own original standard of aesthetic. The source from which it draws its creative power is Nature."

A. A. Disderi, *L'Art de la Photographie*

I Light

Colour is light and light is colour; all photographs are records of light, its patterns and its nuances. A photographer works with light as a painter works with colour, he has to fashion the light as the sculptor shapes his wood or marble. Light can be as intractable as stone and must be treated with sensitivity and respect. Light itself is as invisible and intangible as air, with modulating surfaces light is merely radiation. The world of outer space is as black and empty as that of the visual world of a blind man. Photography as an instrument of the visual sense, exploring surfaces, enjoying the qualities of light itself, transforms the world we see: form and texture, presence and atmosphere are revealed through the action of light on the objects that modulate it. When we look we see the objective world through the action of light, but when we photograph, we see the light through the objects that fashion it. In visual perception the light is secondary to the knowledge we acquire of our visual environment and conditioning of our responses towards it. But light becomes the primary function in photographic recording, and a higher level of awareness of its potentialities is essential if the medium is to be fully exploited. The objective world becomes secondary, a modulator of light, by which images are formed and form is expressed. Light is the instrument by which the formal characteristics of the image most reveal themselves.

Selection of subject material, arrangement and viewpoint, control the visual elements and expose the structural framework of the image. The selection and control of the light is less structural and more tactile, exploring the surfaces with feeling by creating an emotive response. Light, the carrier of information, is also capable of being a symbolic language of form and feeling, dealing directly with the senses, resonating in harmony with them. We react emotionally to the effect of light, recognizing its life-giving power, and, in the natural rhythms of the day, with the changing patterns of light, seeing visible expression given to the co-existence of time and space and our own being. Light has always been used in art to symbolize wisdom, knowledge and understanding, linking mind and matter, the spiritual with earthly existence. We endowed the sun with mystical associations, we still worship and are instinctively drawn towards it. The quality of light and its evocative nature are at their most mysterious and potent at the beginning and end of the day, near the transition between night and day, at the equipoise of light and dark, of warm and cold. When the elements of light and weather combine with the colours of nature, it can be very beautiful and moving. Photography, more than any other medium, can express these feelings,

tonally in black and white or more seductively in full colour. Through the plasticity of light, its sensuality, the photographer comes near to the quality of poetry, expressive, but beyond explanation, mysterious yet meaningful.

The negative image of light, the shadow, is a metamorphism of the solid object that creates it, delineating its shape and concrete existence in a transposed form. The cast shadow, attached to the object, superimposes surfaces surrounding the object which will either define the object in space or fuse it into a complex pattern of light and shade. The ghostly presence of these projected images can equally well disguise the solid form, in space, working on a pictorial plane, it imposes a structure of light and dark on the natural forms. Moholy Nagy considered in his writings on photography that light, the motive force behind the medium, could be isolated from the camera image, thus breaking away from Renaissance naturalism and perspective into an era of pure form. By means of 'camera-less photography' he exploited the direct relationship between light and shadow in his photograms and light modulators, kinetic sculptures which cast shadows and reflected light on to a surface. Influenced by the formal values of Constructivism and the 'automatism' of the Surrealist movement, Moholy Nagy and Man Ray with his rayograms pursued the plastic qualities of light and shadow to create a new form of visual expression. Real and objective in its manner of creation, the image itself was unreal, an abstraction from life, "oxidized residues" as Man Ray described his photographs in 1934. Harsh lighting and sharp shadows create graphic symbols, imposing their pattern and meaning on the visual landscape. Shadows themselves are full of portent, signs that are rich in meaning, with a psychic presence exploited by Surrealist painters such as De Chirico, who painted his mythical landscapes lit by a merciless light or by Expressionist films during the 1920s, casting shadows into the future of menace and warning.

The quality of natural light can be very diverse in intensity, contrast and colour. It can be highly directional, causing dark shadows, or omni-directional, flooding the scene with soft light and gentle shadows. The subtlety of the lighting is dependent upon the degree of diffusion. Sunlight can be as harsh and brilliant as a Mediterranean afternoon, with a dark blue cloudless sky, producing deep shadows with blinding white-washed walls. Photographed to retain the highlights the shadows are black and impenetrable, as in a Surrealist landscape, and the light as sharp as in a dream.

The visual effects of lighting contrasts are most dramatic in monochrome and with the tonal controls of

Little Ballerinas page 147
A frame in a photograph is far more important than in any other medium of representation. It not only confines the content of the image but also activates a kind of projection beyond its limits. Every photograph is a fragment of reality. The photographer works essentially with an unorganised reality, as his theme, and cannot isolate his subject from its environment or disregard its surroundings. Part of an image that is left out beyond the limits of the frame will always, to a lesser or greater extent, exert its influence on the part which is included. The actual image may contain only a few objects or people, but it may suggest an extension of activity beyond the artificial boundaries of the frame.

The Green Leaf—Richard Tucker page 148
One of the best known colour relationships is the contrast of warm and cold hues. Warm tones create an illusion of advancing towards the viewer, while the cool colours appear to recede away into distance. This phenomenon produces two effects—it enhances the three-dimensional quality of the image, and at the same time, gives an impression of a kind of internal movement or fluctuation.

The Juggler page 149
The characteristic blur created through a slow shutter speed of a camera is one of the truly unique features of photography. No other medium can record a movement in such a curiously realistic way, because in fact blur often describes a whole or part of the motion, creating a record of a certain brief segment of time—a service in tennis, jump of a horse or a step of a dance. It also reveals a new vision, which the eye is too slow to see, a new aspect of perception, sometimes containing an element of beauty not even suspected to exist.

146

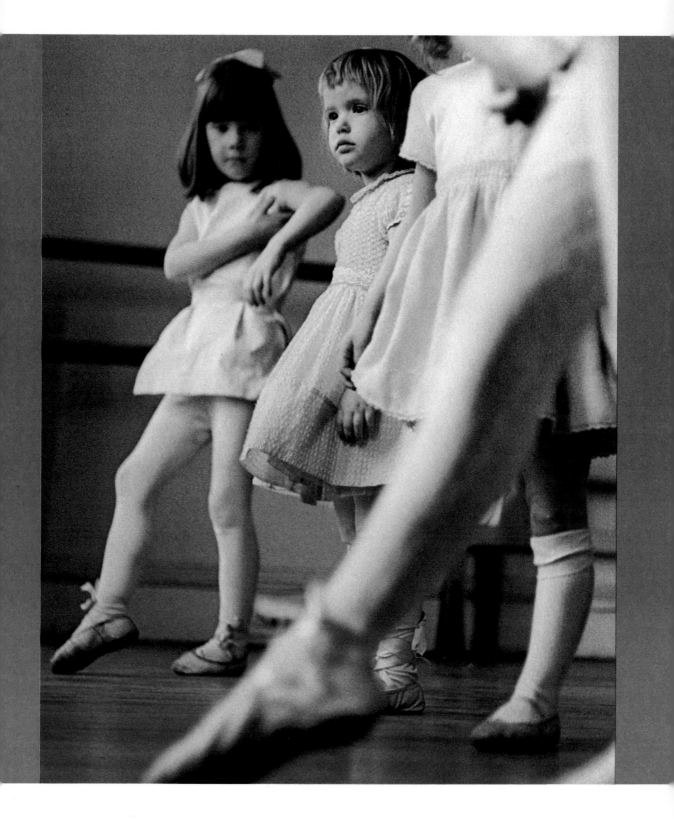

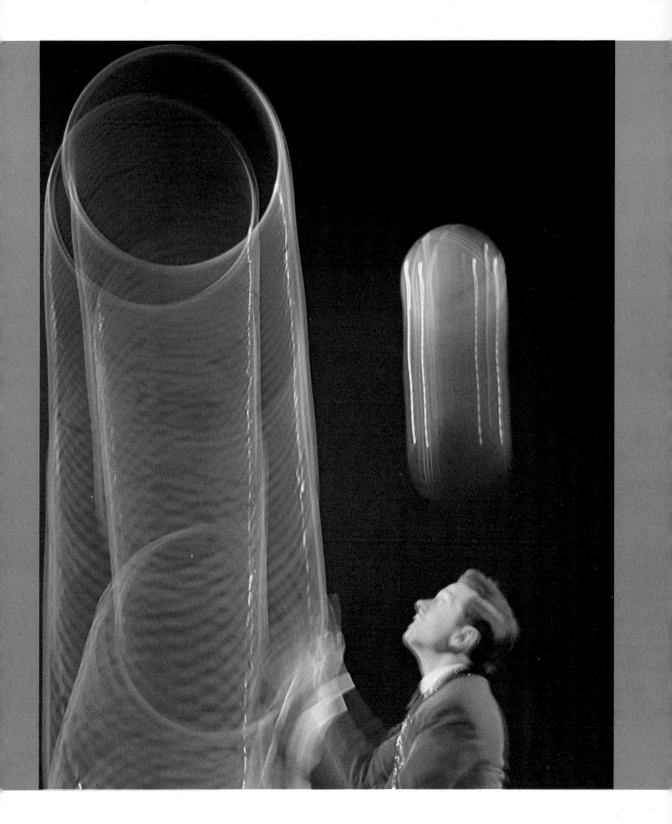

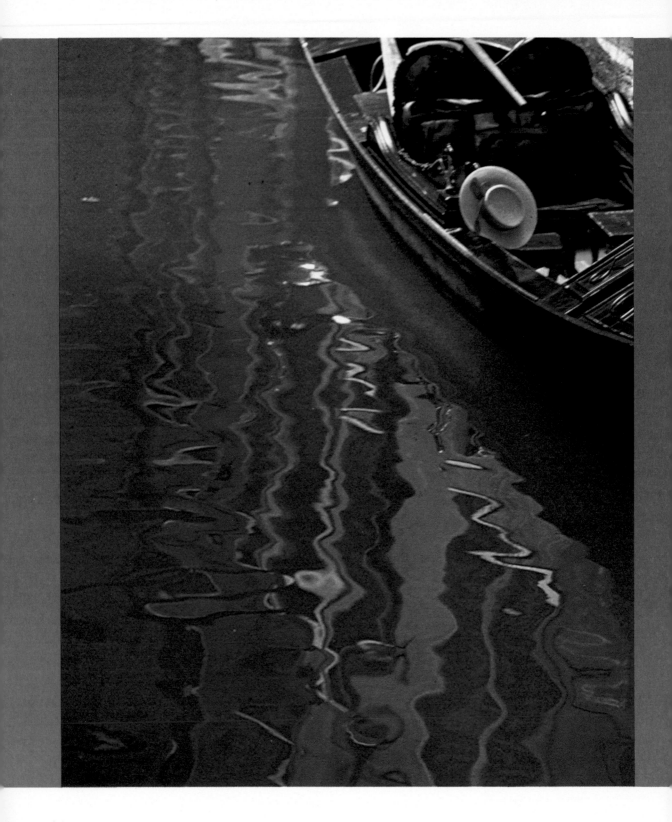

heavy or contrasty black and white printing. The modern master of the harsh lighting effect is Bill Brandt with his dark brooding landscapes, or his enigmatic portraits transfixed by an unearthly light. Brandt was a pupil of Man Ray in the later twenties, and has carried with him throughout his long career the metaphysical light and shade of Surrealism; a collection of his work was published in 1966 under the title *Shadow of Light*. In a shorter career, which ended before Brandt's had begun, another photographer of light began documenting Paris at the turn of the century. Eugène Atget took most of his photographs in the morning just after dawn, when the streets and parks of Paris were devoid of people. This gives his pictures an unreal look which attracted the attention of the Surrealists. At dawn the city is in a state of suspended animation, and the quality of the light is ethereal, soft and grey adding to the atmosphere of an hallucination.

The soft, diffuse light of early morning is magical, having a pearly, limpid clarity, producing delicate tones and cool colours that are so evocative. The diffusion caused by cloud cover on an overcast day is similar in its level of contrast but without the pristine nature of early light. Grey days have a neutrality which suits direct observation and documentation, where the subject and the event are of intrinsic interest and need only to be recorded with empathy. Flat lighting is ideal for the photography of people and natural portraiture, where the contrast is low, and the subject features can clearly be seen, or where natural colours within the subject can be seen, without the imposition of tonal patterns created by directional light. Omni-directional light is particularly suitable for colour photography which is less dependent on tonal values and with its greater naturalism has a greater affinity to a soft, translucent quality of light than the harder formal values created by direct sunlight. Naturalism almost demands a diffusion of the light source whilst retaining some sense of direction to reveal the beauty of form of the subject rather than the formal values of the image. What the diffused light loses in terms of tonal vitality, contrast and shadow definition, it gains handsomely in tactile subtlety, direct contrast and the quality of the highlights.

The highlights are particularly important to the visual quality of colour transparencies. The tactile nature of an object is as much determined by the highlights and mid-tones as the shadows and the surface qualities of hardness or softness are revealed more in the highlights than elsewhere. The specular character of the highlights of shiny surfaces in particular, like metal, glass and water, are created by the characteristic of the light source, a diffused, large source giving subtle, broad tones and a point-source giving pinpoint highlights that are brilliant but hard like diamonds. Pearl-

Hat of a Gondolier page 150
A camera is such a painstakingly accurate recorder of reality, that one forgets to notice that the photograph is in fact failing to register one of the essential elements of the scene—its movement. Motion, in a photograph, can only be indicated by a symbol. But it can be, at least partially, simulated by the illusory fluctuations between colours, and also through the scanning movement of the eye during the viewing of the image. Human perception seeks order and stability. Thus if the image is symmetrically composed the eye is satisfied. But if a strong assymmetry is created, the eye, in its attempt to restore equilibrium, tries to push the off-centrally placed area of interest more into the middle and its efforts create a sub-conscious movement within the image.

like highlight comes from a gentle light which is not necessarily flat in direction. One of the most beautifying light-sources is window light, the classical North Light of the painter's studio. Light falling on a subject close to a window is the perfect compromise between strongly directional light, which describes solid form and spatial tones within a subject and soft diffused light which caresses the surface of the objects revealing their intimate texture and tactile values.

Both in colour and monochrome, the direction of light can, of course transform any subject on which it falls. By photographing at certain times of day the direction as well as the quality of the light can be controlled. Frontal lighting exploits the body colours of the subject, whereas *contre-jour* effects diminish them, creating shape and emphasizing tone and spatial form. If combined with controlled under-exposure, the result can be a dramatic silhouette destroying colour for a graphic effect of black and white simplicity. With oblique or side lighting, particularly in the late afternoon when the sun is lower and the shadows are longer and more luminous, the richness of the light enhances colours, by increasing their saturation, and, at the same time, outlines the spatial and structural form within the picture. This period in the day is ideal for colour photography when both colour and form are balanced, the shadows record detail and cool colours and the light promotes warmth and vitality.

The energy of the late afternoon sun is diminished by dusk, when there is often an increase in cloud cover. Then, in the fading light, it is possible to produce effects as magical as the period just after dawn. Natural light at this time of day is very special, the quintessence of the day, brief in duration. Under its spell colour becomes both vibrant and subtle, with delicate soft gradations of warm and cold tones.

The final factor in the equation of natural light and colour is the elements. Great Britain is richly endowed with weather, having more in a season than most countries have in a whole year. The weather is an endless source of fascination to the English, but the variable pattern in the seasonal climate makes it an almost perfect country for colour photography. Changing patterns of light have inspired such great artists and colourists as Turner and Constable to create their finest works of art. Landscape, sea and sky are natural subjects for the camera and here the quality of light is so important as to be the subject itself. The photography of light does not need artificial light modulators as devised by Moholy Nagy, however ingenious, when nature provides such a multiplicity of visual delights of her own. Photographing the weather creates the mood of a moment, and if the effect is transient, as before an impending storm when the sunlight can have the

brilliance of a spotlight, gives it a heightened reality. Less dramatic but equally evocative is the transformation that takes place in a commonplace scene when filtered through a veil of mist or sea-fog; tones become compressed and colour muted, as the solid forms dissolve into translucency. It is as if one were photographing the air between the camera and the subject. Heavy rain or snow can similarly disperse the light to great visual effect, the dull greyness of the light is counterpointed by the shiny reflection of wet surfaces giving accent to the leaden mid-tones.

The colour photographer should be an all-weather creature, sensitive to the lighting conditions available, willing to exploit its many facets for their visual and emotional values. He depends upon light to create but is not necessarily subservient to it. Choosing his moment, he can capture its many intangible qualities that are so expressive of human emotions.

Natural light from the sun is the standard by which we judge a colour when buying a suit or matching fabrics. This implies that daylight is spectrally superior to other sources of light, in purity and constancy. This 'white light' is certainly difficult to match artificially but it is not a standardized light source. The apparent constancy is an illusion, based on a mental habit and the colour adaptation of human perception. The eye automatically adjusts any colour it sees to the expectation of 'white light', irrespective of the actual colour of the light source. Such perceptual flexibility does not apply to colour films which are totally analytical in their observations and incapable of the psychological compensations of matching what the eye sees to what the mind knows.

The incandescent energy from the sun produces radiant heat and light. We depend on the atmospheric blanket for protection from its most damaging rays and for a retention of its heat. The angle of incidence, which varies by the hour and from season to season, determines the quality of light that reaches us. The atmosphere acts as a screen, filtering out the shorter wavelengths, scattering them by diffusion to give the blackness of outer space the colour of blue sky. The clouds in the sky reflect the direct light from the sun or completely obscure it, screening the direct rays into a diffuse pattern of soft light. All these varying filter factors effect the spectral distribution of natural light because the radiant energy of a long wavelength is less easily scattered than the shorter blue radiation. The angle of the sun to the horizon determines the depth of the atmospheric filter layer and consequently the proportion of red to blue light reaching us. The actinic quality, recorded by colour film, reveals these changes in 'colour temperature' of natural radiation from the mixture of direct rays from the sun, the scattered blue light from the sky and the reflected light from the clouds.

The colour of radiant energy can conveniently be measured on a comparative numerical scale devised by W. T. Kelvin, the British physicist. The light is visually matched to a theoretical 'black body radiator' which has a surface temperature measured in absolute degrees (°K). Energy radiating from an incandescent source with a surface temperature of 3,000°K has a colour equivalent to 3,000°K on the colour temperature scale. Daylight has a colour temperature that can vary from as low as 2,000°K at sunset, which is as warm as candlelight, to the reflected light from a blue sky reaching colour temperature values as high as 27,000°K. Colour (daylight) films are matched to an average of the most common values found. At midday under a combination of direct sunlight, blue skies and a few fluffy white clouds the colour temperature of the light is equivalent to 5,800°K. The colour variation throughout the day, dependent on weather conditions, can be from about 4,000°K on a late afternoon to 7,000°K on a grey overcast day. *Agfachrome 50 S*, CT 18/21, and *Agfacolor* negative films are balanced to a mean value of 5,500°K. These colour shifts, to warm or cold, are recorded by the film more clearly than we see them directly.

Neutrality is not an absolute necessity, for a natural colour cast can enhance the mood or evoke an atmosphere sympathetic to the subject. To create visual effects it is often better to exploit these colour shifts in the light, rather than try to correct them. Colour correction filters are, however, available for use on the camera during exposure to balance the light to the colour sensitivity of the film. Filters are available in various series, to correct colour shifts of a warm and cold bias in orange and blue of differing intensity. A comparison of filters from Agfa-Gevaert CT series and Kodak-Wratten series is given below, with filter factors.

Agfa-Gevaert CT Series	Kodak-Wratten		
A Orange Shift	81/82 Series	Filter Factor	
CTO 1	81	$\frac{1}{3}$ stop	
CTO 2	81A	$\frac{1}{3}$	
CTO 4	81C	$\frac{1}{2}$	
CTO 8			
*CTO 12	85B	1	
Blue Series			
CTB 1	82	$\frac{1}{3}$	
CTB 2	82A	$\frac{1}{2}$	
CTB 4	82C	1	
CTB 8		$1\frac{2}{3}$	
*CTB 12	80B	$2\frac{1}{3}$	
Ultra-violet			
Haze	1A	–	

*These filters can be used to convert daylight film to tungsten light exposure (CTB 12), or tungsten film (*Agfachrome* 50 L) to use in daylight (CTO 12).

The balance of light to the film is most desirable in critical subjects where accurate or pleasant colour rendering are more important than atmosphere. Agfa films are particularly suited to the rendering of subtle greys and neutral tones, *Agfachrome* 50 S reproducing cool greys and black particularly well without filtration, whilst CT 18/21 give a slightly richer and warmer rendition of these tonal values. Flesh tones are subtle colours requiring accurate colour balance and are less acceptable if they are too blue. Some orange filtration on the camera, under cool lighting conditions is therefore desirable. The most likely lighting conditions necessitating a colour correction are in the open shade on a clear sunny day, when the shadow areas are lit entirely by blue sky, or under heavy overcast conditions when the colour temperature is about 7,000°K. The excessive blue can be neutralized with an Agfa colour temperature filter with an orange shift: CTO 2 for overcast conditions and the stronger CTO 4 for blue skylight or open shade. As a general prevention against any blue shift, it is possible to have a 'skylight' or ultra-violet (haze) filter on the camera permanently. If warm results are preferred, a CTO 1 filter may be substituted.

Colour correction to reduce excessive warmth due to the lighting conditions is more rare and should be used with greater caution, as over-correction could be worse than none. Using an Agfa colour temperature CTB series, yellowish winter light may be neutralized by a CTB 1 or 2, as can the orange light at sunset be minimized by the stronger blue CTB 4. Interesting colour effects at dusk or by the light of an orange sunset can be created by using film balanced to tungsten light, 3,100°K (*Agfachrome* 50 L), the colour contrast between the orange sun and the intensified blue shadows can be most vibrant. The mixing of artificial light and daylight which reproduces a brilliant blue is equally dramatic.

The colour of a sky of varying shades of blue can be intensified by the use of a polarizing filter on the camera. The area of sky at 90° to the direction of the sun has much of the scattered light polarized, so that a glass filter which prevents the passing of such light when rotated in the opposite polar-plane, will substantially darken the sky tone, increasing the saturation and colour without having any adverse effect upon the other colours in the picture. The polar filter must be neutral in colour and specially designed for colour photography, so as not to change the overall colour balance.

Man-made light is a poor substitute for natural light but we need it to extend our day and to supplement the far more brilliant and spectrally rich sunlight on which our lives depend. For photography artificial light has all the deficiencies of low intensity and lack of colour continuity. Incandescent sources, such as candle, electric

light bulb, studio and photoflood, quartz-iodine, tungsten halogen and even arc lamps have all been used to take pictures. Each has its own characteristics and colour balance. The size of the light source, whether it is a pint-point such as an arc lamp or broad like some studio reflectors, give the highlight and shadow qualities a particular effect. In an age when Expressionism was in vogue sharp shadows and spot-lights dominated studio lighting. Today when naturalism is the dominant style, studio lighting consists of heavily diffused banks of broad light, flooding the subject with delicate soft light or imitating the subtle gradations of window light. The tonal richness that this lighting creates is very sensual and has the qualities associated with a Dutch interior or Rembrandt painting.

Incandescent sources have limitations in colour photography. The colour temperature depends on the operating temperature of the source which may vary. Electric light sources of all types are dependent upon the constancy of the main's voltage and their age, as they grow older they mellow and their colour temperature drops and even small fluctuations in voltage can produce dramatic changes in colour. Films balanced to artificial light, like *Agfachrome* 50 L, need an exposure to light of 3,100°K to produce a neutral colour rendition. Only studio lamps specially designed for photography have matched values.

Each different source of light needs colour filter correction when used with artificial light film. Equivalent corrections are given below to match the light to the film.

	Colour temperature	Filter correction
Candle light	2,000°K	CTB 12
60 watt household bulb	2,600°K	CTB 4
100 watt household bulb	2,800°K	CTB 2
Type B, or studio tungsten, projector bulbs, tungsten halogen	3,100-3,200°K	—
Photofloods and over-run quartz-iodine lamps	3,800°K	CTO 2
Low intensity carbon arc	4,000°K	CTO 8
High intensity carbon arc	7,000°K	CTO 12

In the case of 'available light' as found in domestic situations such as household filament, gas, paraffin or even candle light, it is probably better to leave the colour balance uncorrected as it will give a rich, warm glow in harmony with the visual atmosphere of the scene. Light sources on the blue side of neutral must be corrected to give acceptable results.

Flash photography, in particular electronic flash, has largely replaced other artificial sources because of their variability and the long exposures they necessitate. Electronic flash is the perfect artificial light for colour photography. The intensity of the light is very high, reaching values near that of the sun in the largest studio units (10,000 joules). The duration of the flash can be very short, between 1/200 to 1/50,000 second, allowing fast action to be frozen without blurring the image. Finally the colour temperature is designed to match that of the colour balance of daylight films (CT 18/21, *Agfachrome* 50 S) at 5,500°-6,000°K. Because the electrical energy is stored in a large capacitor before discharge, through the tube, the main's voltage is not critical for consistent output.

The only disadvantage of this paragon of photographic virtue is its initial cost. A portable battery unit can cost as much as a camera and a large professional studio console as much as a motor-car. The speed of the flash makes the light 'invisible' to the eye, which causes difficulties in visualization and judging the effect of the light pattern and its exposure. The first problem is easily solved by 'modelling lights' in the studio, or by experience on location shooting with a battery portable. Exposure estimation is most reliably solved by using a flash meter (Bowens, Balcar or Gossen Ascor) which operates normally by taking incident light readings. Without a meter the photographer is almost literally in the dark and is forced to guess the correct aperture for exposure, basing his judgement partly on guide numbers or the flash calculator attached to the equipment but more on previous experience of similar situations. As with all photographic operations it is experience and knowledge of the familiar equipment – films, materials, developers and processes – gained by continuous use over a period that ensure reliable results, make it possible to anticipate the outcome and enable one to visualize the picture in the mind before the image is recorded.

$$\text{Exposure } (f\text{ no.}) = \frac{\text{Guide no. (power of flash)}}{\text{Distance (subject-flash)}}$$

II Image

The remarkable flexibility and versatility of the camera provides the photographer with a virtually unlimited opportunity to express his creative intentions. But to do this the photographer has to grasp the operational scope of the camera. The choice of the format of the image is the first thing to consider. In smaller cameras, the choice lies between three formats: the 35 mm camera whose negative size is roughly 3·5 cm × 2·5 cm, a narrow and slightly too long shape; square format cameras, 6 cm × 6 cm, are adaptable to any kind of shape by masking or trimming but this involves a loss of a certain area of the image unless a choice of a fairly unorthodox and awkward square shape is made. The ideal, from the creative point of view, is the 6 cm × 7 cm camera where the actual shape of the negative is visually pleasing and no loss of the image area is incurred. Needless to say these cameras have a number of disadvantages, like weight and expense.

One should not, perhaps, discuss the ideal shape of the image, since the shape, like all else in the photographic image, should be controlled and influenced by the requirements of the subject. This is what usually happens in black and white photography, the image being trimmed or masked during enlargement according to the visual demands of the theme and the creative sensitivity of the photographer. The production of a colour print is similar but the same does not apply in the case of a colour transparency. Theoretically, trimming or masking a part of the image in order to improve the format should not present any difficulty. In practice, many photographers are reluctant to slice off any part of a colourful image and consequently one frequently comes across colour photographs which could easily be improved by a slight modification to their format. The problem of the ultimate trim can be learned and the reluctance to amputate overcome, what is less easy is the actual composition within the format size during the shooting session. It is at this stage that the damage can be done which is difficult to repair later on. Photographers are prone to compose within the frame of the camera and to arrange visually lines and shapes to fit the frame, forgetting that a certain amount of the image will have to be eventually disposed of. It is at this stage that a square or too long composition is imparted to the image which may later prove difficult to alter. Some photographers trace limiting lines on their viewfinders, others fit in masks. Both methods are rather inconvenient to use, there is no real alternative to conscious schooling of the eye or changing to a different format camera if necessary.

The shape of the image, the actual space enclosed as part of the field of vision, has yet another important feature. The question is not only what is included and its format but also how it is included and what was the position of the camera in relation to the subject. The actual viewpoint decides more than anything else the proportions and the perspective of the scene and the objects included for the perspective of the image is governed solely by the choice of the angle of view and not by the lens. The problem of perspective is how to relate the actual image as it is seen in a photograph with that seen with the eyes. When we look at a scene, straight on, from our own height, the normal vision of our eyes extends over about 50° of the area, with the horizon bisecting this field in the middle and all the objects falling into their proper place within it. Seen from this angle, perspective works by showing us the objects gradually diminishing in size as they get further away from us and straight lines receding into the distance point towards the vanishing point of one point perspective which is located in the middle of the field of vision. This is precisely the kind of view that a normal focal length lens is designed to produce. Obviously there is no such thing as a standard lens for all negative sizes, each negative size requiring a different lens. Thus the normal field of vision of our eyes corresponds to a lens whose focal length is approximately the same as the length of the diagonal of the size of the negative: for example, a 35 mm negative being approximately 24 mm × 36 mm, its diagonal is 43 mm, and consequently its standard lens is usually between 45-50 mm. With 6 cm × 6 cm cameras, the diagonal of the negative is 80 mm and hence it is usually fitted with a 80 mm focal length lens.

The problem of perspective, the field of vision and the focal length of the lens is more clearly understood by imagining that the camera and its viewfinder is merely a frame through which we look at the scene in front of us. A frame of about 25 cm × 20 cm held at a distance of about 25 cm from our eyes approximates fairly closely to the eyes' field of vision. Now, if we hold the frame farther away from our eyes, the amount seen in it diminishes but objects themselves grow larger in relation to the frame, whilst if we bring the frame nearer to our face the reverse will be true. However, in each case the proportions of objects to one another and to the frame remain constant if we keep our head still. This is precisely what the long and short focal lenses do, they bring the view as it is, unchanged, nearer to us, showing less of it in the viewfinder in the case of a long focus lens, and extending the field as a whole in the case of a short one. This can be seen clearly from our illustrations (p. 164). The scene and the relationship of objects to one another in the pictures shot from exactly the same spot, first with a telephoto lens and then with a normal focus lens, does not show any change of

perspective, the telephoto lens merely brings things nearer and makes them larger. This is why a longer focus lens should be used if we do not want to alter the proportions of the objects. What happens when we approach more closely to the subject rather than keep our viewing position stationary and use a long focus lens is that the proportions and the perspective of the image change because we have altered our position and our viewing spot in relation to the subject.

Even greater changes in perspective and proportions will occur when the frame is tilted in relation to the subject. Supposing we tilt the top of our picture frame forward towards the scene, the picture plane would then be closer to the object in the upper half of the scene than in the lower. Thus objects in the upper half will be reproduced on a larger scale than in the lower and vertical parallel lines would seem further apart in the top. Distortion of perceived perspective occurs only through the change of our viewpoint, our angle of view and departure from the normal field of vision. Wide angle lens used from a distance do not distort perspective, it is only when they are used near to the subject that the distortion begins to appear. If we look at a line of telegraph poles receding into the distance, it is in the first few nearer to us that the jump in proportion is so large – the second pole is half the size of the first, while the 25th is only 24/25ths smaller than the one before it. The distance from the nose to the ear in the face seen from some ten metres away is so small in comparison to this gap that again it is barely perceptible, while when we look at the same face from the distance of 50 cm the nose seems at least twice the size of the ear. Again the difference lies in the viewpoint. Indeed a wide angle lens accentuates this discrepancy in size because its field of view is artificially made wider than that of our eyes, being 100° as opposed to a normal 50°.

The question of perspective in relation to the focal lens of a camera has been dealt with in a comparatively extensive and elementary way because it often appears to be misunderstood by a large section of photographers. Naturally these discrepancies and visual distortions brought about largely by a change in the viewing position are made more apparent in a photograph than they are in normal vision. For while our vision is constantly shifting and changing its angles and viewpoints, the photograph is frozen in one of them only. The camera also lacks an additional feature of vision, its marvellous ability to adjust and minimize at will the vagaries of seeing. In the past, these distortions in the photographic image were emphasized by the traditional, pictorial photographers' limited aims of beauty, serenity and calm, approximating as closely as possible to an idealized painterly image. These days both the public and photographers are more accustomed to looking at photographic images which some-

times extend and amplify our perception, rather than merely attempting to bring it close to visualization under ideal conditions, and photographers while being aware of these 'defects' of the camera deliberately utilize them in their pursuit of heightened awareness and a greater expressiveness of meaning.

As we have shown, the photographic image can turn distortion into a symbol, and the camera, guided by the hands of a skilful photographer, can alter the apparent perspective and proportions of the image in a totally predictable yet creatively controlled manner. It is in co-operation with the second feature of the camera's operational scope, differential focusing, that these two elements can combine to provide a versatile and flexible image making tool. Deliberate change and adjustment of proportions of objects to one another, for the purpose of emphasis or whatever, is seen even more strikingly if accompanied by different degrees of sharpness of the image. If the camera is focused on a certain area, within the scene being photographed, other parts, both nearer and further away, will appear less sharp in varying degrees. If only an ideal degree of precise sharpness were acceptable, the sole area in focus would be the one which corresponded to the actual spot where focusing occurred during the exposure. Fortunately, the ability of the eye to be able to discern sharpness precisely is also limited. Consequently there is a fairly wide margin of visual tolerance between a point that is totally sharp, a true pin-point sharpness, and one that is more diffused. This range of apparent sharpness on both sides of a true point is called the circle of confusion. In order to be able to define the degree of acceptable sharpness, a system of measurement has been devised. This is simply two black lines placed close to each other and the precise distance from these lines at which the eye will cease to see them as separate lines and sees them as one is measured. For average eyesight this is about a thousand times the distance between the two lines.

Were the eye not tolerant to a degree of sharpness, it would not be possible to have a sharp image of a scene which extends into depth. Since it is only at one point, see figure , that a beam of light coming from the point of the object comes to a sharp point on the film, it follows that an object nearer or further than the one in focus will not be represented by a point but by a diffuse circle. But the elements that affect the eye's tolerance need to be established so that we can arrive at some idea of how far, at a given time and with given photographic equipment, objects can be apart and still appear in acceptable focus in the photograph. From the diagram it can be seen that there are two areas to be taken into consideration: the area on both sides of the film, called the depth of focus, and the one on the side of the object photographed, called the depth of field. We can disregard

here the depth of focus which is usually covered by the aperture of the lens, and which is, in any case, more of a concern to the manufacturer than the photographer. It is the depth of field which is in the photographer's control.

The acceptable circle of confusion obviously affects the depth of field; the stricter our requirements, the shallower the allowable depth of field to retain visual sharpness, and it is also influenced by three other features: the stop-aperture of the lens – the smaller the opening, the larger the f-number and hence the greater the depth of field; the focal length of the lens – the shorter the focal length, the greater the depth and finally the distance between the object photographed and the lens. The example of the telegraph poles illustrates this well – the nearer the camera approaches the object the greater the apparent distance between objects and hence the shallower the depth of field. Whereas the plane of depth of focus (within the camera) is equidistant from the film laterally, it is not always so conveniently symmetrical, being greater at a distance from the camera, smaller nearer to it. This makes it complicated to produce a simple mathematical formula governing the use of the depth of field. Fortunately we can adduce an additional feature which helps the approximate estimation of the depth of field. For any one number of aperture, focal length of the lens, and circle of confusion, there is a precise point, between camera and infinity (the point so far away from the lens that we cannot visually discern any variations in the space placement of objects beyond which everything is registered perceptibly sharp on the film). This point is called the hyperfocal distance. A camera focused at this point registers everything sharply from infinity to one half of the hyperfocal distance. Most cameras and lenses are provided with depth of field charts for each aperture and these can be consulted if necessary. From the practical point of view, it is sometimes important to know, especially while photographing action or an event, how one should set the camera in order to keep the vital area in constant focus. This is called zone focusing, and most cameras are provided with a device showing the extent of focus at any given time which will help in this zone focusing.

Most traditional, orthodox photography was concerned with retaining a maximum of focus. Particularly so with colour, since it was assumed that colour areas photographed out of focus lose their brilliance and saturation, and with it most of their attraction. This is, however, highly debatable. As many of the illustrations reproduced in this book clearly attest, colour can be exceedingly beautiful, even if it is entirely unsharp, sometimes even more so. It is far more logical to assume that, as with the distortions and exaggerations of the lens, the effect achieved by varying degrees of

sharpness should be used deliberately and appropriately as a vital part of the camera's operational controls, contributing to even greater expressiveness of the image. Hence the understanding of the control of the focus can be applied either to achieve as great a degree of sharpness as is feasible or to keep it only in certain areas, throwing the rest out of focus in order to produce a specific effect. Sometimes even the overall unsharpness of the image can be very effective, and the increasing trend towards the use of differential focusing is particularly discernible among younger photographers in their search for a greater degree of control and flexibility.

Earlier in this book the point was raised that part of the reason why photography failed to make a larger impact as an independent, creative medium of expression, and why its status still remains comparatively low, is the fact that photographers tried to keep their medium rigid, and were positively reluctant to use all the possibilities and assets of photography. Both the use of perspective and differential focusing are excellent examples of this point. One of the first rules a prospective portrait photographer had drummed into his head was the apparently cardinal and immutable one that only long focus lenses were suitable for portraiture. Short lenses supposedly meant instant disaster. Because a long, cumbersome lens had to be used in a fairly restricted place, only head and shoulders could be included at best. This led to dull, descriptive portraiture and prevented the use of the sitter's environment. A shorter lens, used with care, will not show any perceptible distortion and will give a far greater flexibility of procedure and a greater chance to use the imagination. A similar argument can be extended against the reluctance to use out-of-focus colour. The camera should be free of all rigid, restrictive rules if its full potential is to be realized.

Colour recorded by Film

"Of all the means of expression, photography is the only one that fixes for forever the precise and transitory moment."

Henri Cartier-Bresson

I Film and its Characteristics

The era of modern colour materials, after a long process of discovery and invention to establish the basic principles of subtractive synthesis and chromogenic development, began with the introduction of the tri-pack emulsion. This made it possible to expose and develop a colour photograph, with a conventional camera, followed by a processing stage. A direct positive colour image was created by the action of light and chemicals on to a piece of film. The achievement of the early pioneers of photography had been repeated successfully in colour nearly one hundred years later, for in 1839 Daguerre had published the results of his diapositive process. A colour photograph had been a dream of the early pioneers who were conscious of the lack of colour in their transfixed images of reality and in spite of their ingenious endeavours to add colour, all attempts were only partially successful, impractical or highly laborious and inconvenient.

As early as 1869 Louis Ducos de Hauron had suggested a tri-pack system of separation negatives and had partially succeeded in producing the first colour photograph on paper by a process of assembling three separate dye images. The principle as stated by de Hauron was: "By photographic techniques already known and by the interposition of three coloured media (red, green, blue filter separations), three monochrome prints, one red, one yellow, the third blue, and then to form, by the superimposition or the mingling of these three prints, one unique print in which will be found reproduced at once the colour and form of nature." If we substitute the more modern description of magenta, yellow and cyan for his contemporary description of red, yellow and blue, we have the basis for all integral tripack systems available today. The principles were sound, but the materials were inadequate. The collodion plate he used proved to be a severe handicap. Sensitive only to blue light and little to green and red, his separation negatives were not balanced. The exposures he used indicate this unbalance: 1-2 seconds for the blue filter; 2-3 minutes for the green; 25-30 minutes for the red. Yet he managed to make colour prints, using thin sheets of gelatine with bichromate and dyed carbon to produce the positive colour on paper. The results, though biased, looked remarkably natural and an effective rendition of colours as seen.

Not until 1935/6 did it become possible to record colour photographically using a single exposure and a conventional camera and avoid all the serious limitations of the earlier additive processes. Modern colour photography began when Agfa in Germany and Kodak in America completed the work of the many pioneers and

made available to the public a mass-produced colour system that was simple to use. This was the integral tripack using the reversal process to make a coloured diapositive image. Just as the Daguerreotype was a 'camera original', so was the modern colour diapositive. Both were soon followed by a more flexible negative/positive printing system.

The basis of all colour photographs whether produced directly in a tri-pack system such as *Agfacolor CT 18* or *21* or by a secondary printing process such as the negative/positive system using *Agfacolor CNS* film and *MCN* paper, is a set of colour separations of the original subject. These are three negative images in silver halide emulsions made in the camera by exposure to the original subject. Before the invention of the modern tripack systems, the three negatives were made by three individual exposures to three light-sensitive emulsions. On development in a conventional reducing agent such as metol/hydroquinone, a negative silver image was produced. The negative is an inverse record of the light reflected from the original subject. If one negative is made by exposure through a red filter, it will be a record of the red light from the original subject. A second and third exposure, through green and blue filters, will produce separate information on two more negative emulsions, containing the complete record of the red, green and blue components originally reflected from the subject and recorded photographically by the camera. The three emulsions can be combined into a three-layer pack, so that the three colour separations can be made simultaneously with a single exposure. The colour analysis into red, green and blue components could not be made through filters on the lens as only one exposure is involved. The analysis of the spectral light reflected from the subject must be separated into the additive primaries by the colour sensitivities of the triple emulsion pack.

If the top layer is only blue sensitive, the middle layer green, and the bottom layer red sensitive, we will record only the respective components of light to which they are sensitive. The blue sensitive layer will record a silver negative image of the blue light; the green sensitive layer will record a silver negative image of the green light; the red sensitive layer will record a silver negative image of the red light. Therefore with one camera exposure and subsequent monochrome development, the tripack emulsion produces simultaneously and in register all the information in three silver images to reconstitute the original subject.

The three records in silver each represent one third of the spectral and tonal information of the original. It is essential that the parts of the spectrum to which they are sensitive, are matched. For example, when a neutral colour is recorded the three colour sensitive layers each must react to give equivalent amounts of exposure and silver density. When the monochrome images are transformed chemically into dye images, the relative amounts of yellow, magenta and cyan produced must absorb equivalent amounts of the spectrum to give a neutral grey tone on viewing the superimposed layers. Only then will the photograph be in balance tonally and spectrally with the subject as recorded.

Because the relative speeds of the three layers are fixed, and controlled within fine limits during manufacture, the tripack emulsion cannot visually adapt to changes in the spectral distribution of the light source used for the exposure. It 'sees' analytically and records faithfully the relative light energy as a direct relationship between the exposure, spectral sensitivity and the light absorption of dye amounts produced. The layers have no capacity for adaptation as do the three receptors of the human eye. This means that colour materials need very precise control to achieve the balance of light to colour needed to give a visually acceptable representation. Not only must the relative speeds and contrasts of the emulsions be matched to the light characteristics but when exposed the light must match the 'fixed' characteristics of the integral tripack. The human eye in combination with the expectations of the brain has great powers of adaptation. All 'colourless' light sources, irrespective of 'colour temperature' and spectral distribution, are seen as white light: daylight, artificial light, incandescent or fluorescent are white light to the eye. The integral tri-pack, devoid of any psychological dimension, is inflexible and records objectively the relative energy distribution as colour, it sees photochemically in a fixed proportion. The tolerance that the eye extends to the natural world does not extend to the photographic image. The colour variation it does not wish to see in the light source, it observes as a distinct colour cast in the photograph. This unfortunate double-standard causes problems for the manufacturer and user of colour materials.

Neutrality and colour balance are expected in the photograph, irrespective of the natural variations found in light to which the emulsion is exposed. This necessitates the relative speeds of the emulsion of the tripack being balanced to the most common light sources. *Agfachrome 50 S*, for example, is matched to daylight, with a colour temperature of 5,500°K while the sensitivities of the red, green, blue layers of *Agfachrome 50 L* are balanced to give neutrality when exposed to tungsten light with a colour temperature of 3,100°K. Any other colour temperature will unbalance the colour separation negatives and consequently give an apparent colour cast to the final image reproduced. Colour separated negatives need to be reversed in tone to make positive images which can be done in situ by a

reversal processing or they can be printed by a second stage process to produce an image on another piece of paper or film. The positive images produced must also be converted from monochrome silver to colour dye images in order to reproduce the original colours. As the three images are superimposed in exact register in the integral tri-pack, the conversion into the subtractive primaries of yellow, magenta and cyan is necessary. This conversion of the silver image to a dye image has been the most difficult problem of the pioneers of colour photography.

The principles of the subtractive dye system used today were proposed by Charles Cros and Louis Ducos de Hauron working independently in the 1860s. They suggested the making of three coloured images in the subtractive primaries, yellow, magenta and cyan, from the separation negatives exposed to the additive primaries of light through red, green and blue filters on the camera. By combining the colour separation by additive analysis of light with the subtractive mixing of pigments they had the basis for all the modern colour processes which eventually replaced the simpler but inefficient additive system of the time. In his seminal book *Les Couleurs en Photographie. Solution du Problème* published in 1869, de Hauron proposed the additive mosaic screen process, in 1907 put into practical mass-production by the Lumière Brothers in the *Autochrome* plates using dyed starch grains of red, green and blue. This plate was the first practical solution to the problem of converting the black and white images of light analysis into an integral image in colour dyes without having to resort to the inconvenience of the assembly of three separate dye images. De Hauron's proposals of 1869 for subtractive synthesis had to wait even longer for a complete solution to innumerable practical problems before an integral coloured image could be produced with a single camera exposure and a chemical process that would produce three dye images of yellow, magenta and cyan in situ and in automatic register. After a long struggle, the first viable commercial subtractive colour system was finally produced in 1935/6 with the introduction of *Kodachrome* in America and *Agfacolor* in Germany.

Before this date, however, subtractive colour photographs were possible by a method of laborious assembly of three separate dye images. Nearly one hundred years ago, in 1877, de Hauron produced a colour photograph, *A View over Augoulême,* which still survives. As a prototype of the modern process it was a great achievement because it was made without the aid of panchromatic emulsions and using, as we have seen, defective materials. De Hauron also solved the other major problem, how to convert the silver image into a dye image. Using thin sheets of unhardened gelatine containing carbon pigments of the subtractive prim-

Portrait of Lynn Seymour—Mayotte Magnus page 161
Colour can play a very prominent part in the foreground and background relationship. Out-of-focus colour, its softness and translucent quality can be used as a compositional foil and as an element of space interaction. In this case, the whole image is in warm and pleasing hues and the foreground fruit and flowers play an important part in establishing a mood of sensuous warmth and femininity, as well as giving an overall harmony to the picture.

Tree in the Mist—Richard Tucker page 162
Tree Silhouettes—Richard Tucker
Though colour is far more emotive than shape, there is little doubt that both can affect us emotionally. The design of the image and the combination of colours can endow a picture with a feeling of serenity or one of tension. In the top picture both colour and design create a mood of calm, colours are soft and muted and the arrangement symmetrical, whereas in the lower picture the reverse is true. The shapes of trees and branches seem to be tortured, exaggerated by the unnatural perspective and viewpoint, while the strident tones of of orange and yellow of the sky add to the tension of the image.

Mountain Desert—Klaus Ott page 163
Foreground of the image is often important in creating an illusion of space and plasticity, especially if it is different in structure and in colour from the main area of the image. The intensity of detail and sharpness add to tactile sensation of realism, in this colour print from Agfacolor 80S Professional negative film.

Henry Moore's sculptures in Much Hadham page 164
The wide angle lens does not distort by virtue of its shorter focal length. The exaggerated perspective is a function of the camera position only. The focal length of the lens merely dictates the angle of view. The same image size of the sculpture can be obtained either by using a wide angle (28mm) lens close to the subject (bottom left), or by a more distant view by using a long focus lens (200mm). Although the size of the sculpture is similar, in both pictures, the perspective between foreground and background is not. Identical image to the bottom right picture can be obtained by enlarging the central portion of the top picture. This is due to their identical camera positions.

The Boys' Orchestra in Vienna (both photographs) page 165
—Gert Koshofer
A pair of pictures shows the comparative performance of a wide angle and a long focus lens, with both photographs taken from identical positions. In the top picture the 20mm lens was used, hence the field of view was of extreme wide angle—100°—and the perspective of the picture accentuated. The long focus lens—200mm—in the lower picture, narrows the angle of acceptance to a mere 10°, so that the frame excludes the two young musicians and brings the conductor into close-up. It is he now who becomes the centre of attention, separated from the background by differential focus, a characteristic feature of long lenses.

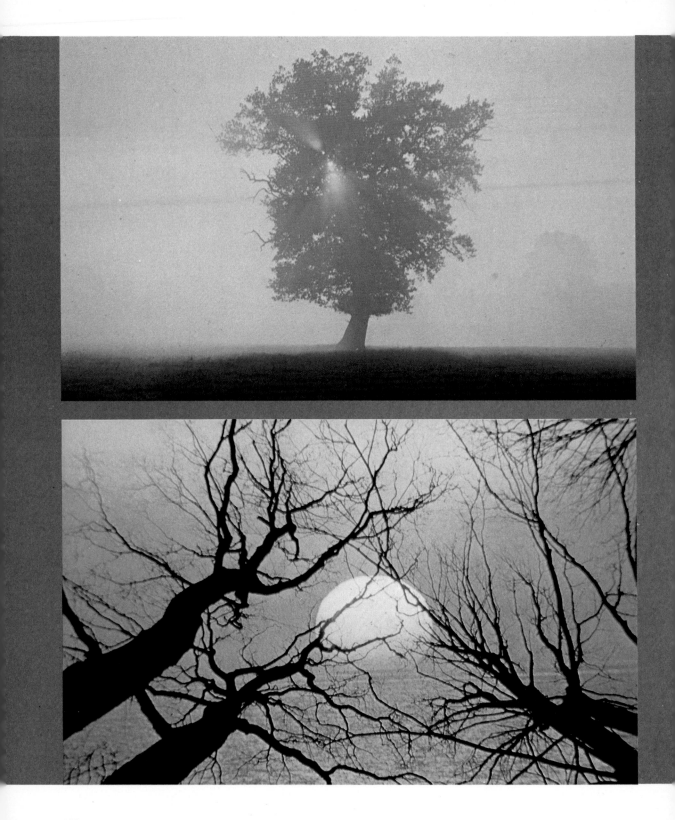

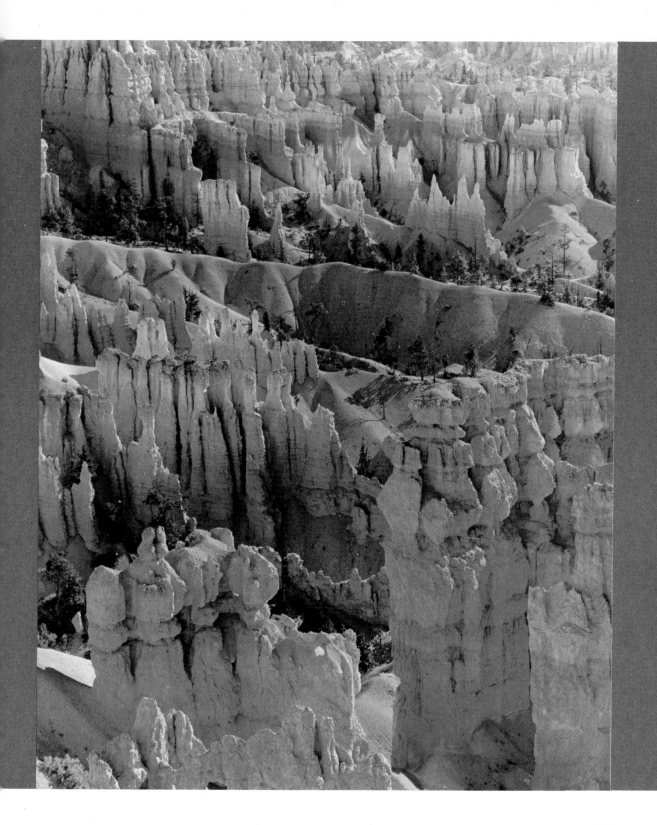

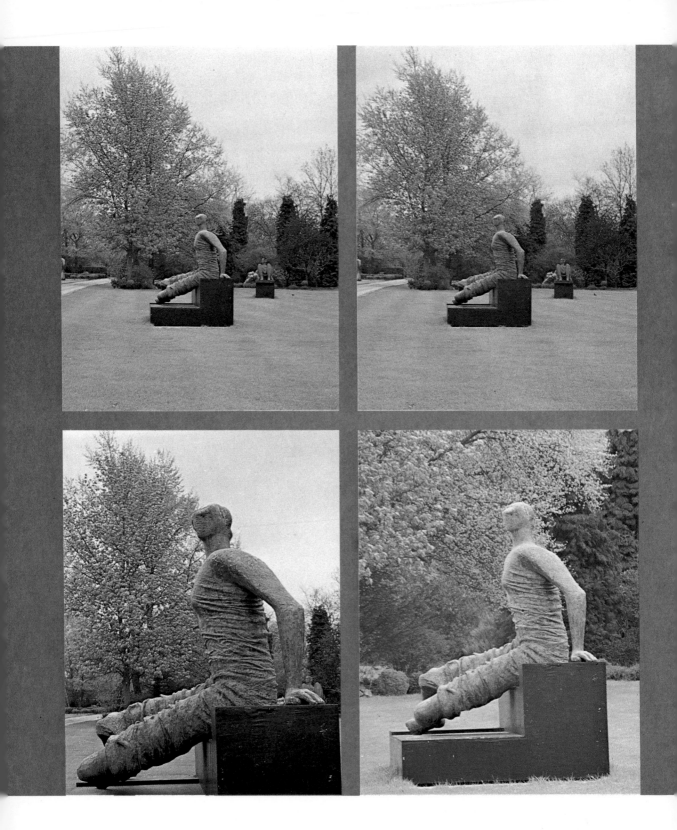

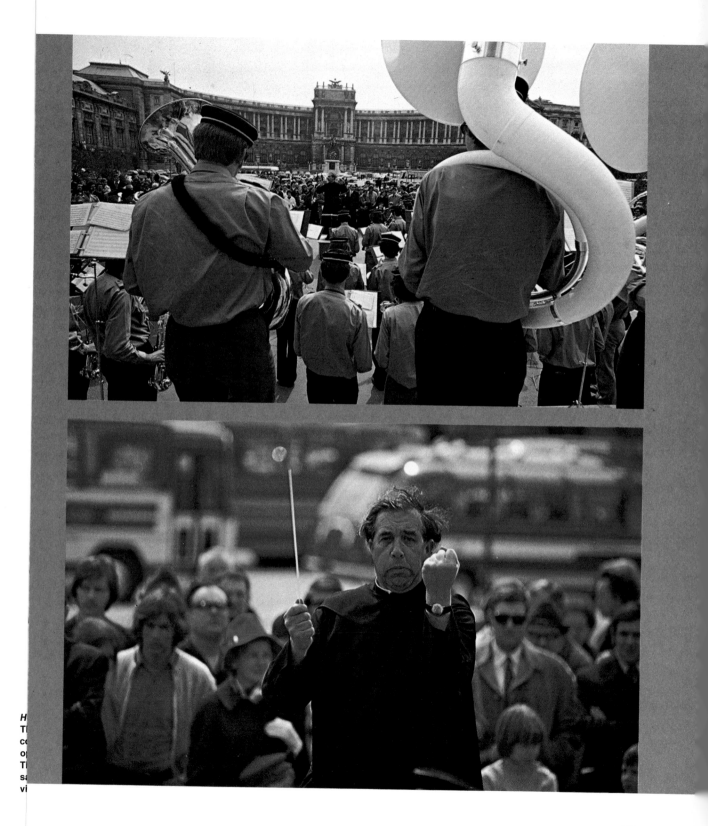

the latent silver halide image in a single chemical process. They were not able to achieve this ideal in practice although they did market a single emulsion *Chromal* paper which produced a single dye image. The main difficulty was the solubility of the coupling agents themselves which in a multi-layer film tended to wander, in solution, from layer to layer destroying the colour integrity of the three separate images. Chemists at I. G. Farben finally fixed the location of the coupling agents in the emulsion by the use of long chain molecule derivatives, thus preventing diffusion between the layers. The first colour film producing three subtractive dye images by direct colour development in one stage was *Agfacolor* reversal film, marketed in 1936.

The eventual system universally adopted after a century of photographic and colour technology was the integral tripack. It was the most sophisticated and elegant solution to the combined problems of separation and synthesis of colour. Photographic technology had solved the problem of dye-sensitization by 1906 with the first genuine panchro-emulsion while Siegrist's and Fischer's discovery of 1912 ensured an insoluble dye. In the 1920s two professional musicians, Leopold Mannes and Leo Godowsky, enthusiastic amateur photographers since their schooldays, were working to perfect an integral colour film. Dissatisfied with their earlier attempts to improve the additive process, they turned to de Hauron's subtractive synthesis. Working in kitchens, bathrooms and hotel bedrooms, they attempted to produce a two-layer emulsion, recoating emulsions removed from plates bought from the local photographic shop. One (ortho) recorded blue and green and the other (panchro) red. The slower ortho emulsion was dyed yellow to prevent any blue light reaching the lower panchro layer which was blue and red sensitive only, thus a two-colour separation was achieved. They took out their first patent which converted the silver image to a cyan image in 1921. The method involved was that of using ferricyanide to bleach the silver image and reaction with a ferric iron salt to produce a prussian blue or cyan coloured dye to replace the bleached silver image.

The problem of separately toning the two images, one to cyan and one to red, was achieved by a controlled diffusion of the chemicals through the stratified layer so that each could be treated independently. Using Traube's silver iodide mordant process, the bottom layer was selectively bleached and toned cyan and then the upper layer, a metallic silver image, dye-toned red. The method of controlling the rate of diffusion was extremely problematical. It involved the use of agents such as glycerine and isopropyl alcohol to slow down the process of diffusion so that selective penetration of only one layer could be achieved before it was terminated. This elaborate and difficult procedure was finally abandoned by Mannes and Godowsky in favour of the conversion by colour development discovered, but not exploited, by Fischer and Siegrist.

Multi-layer films were practical by the 1930s as engineering and coating techniques improved, and the integral tripack a manufacturing possibility. These pioneering experiments, using controlled diffusion of a multi-layered film and chromogenic development to produce the dye images, were taken up by Eastman Kodak and developed by further research into the three-colour process of the original *Kodachrome*, first marketed in 1935. "Man" and "God", as they were affectionately known by their friends, had achieved the culmination of the long search involving many professional scientists and amateur photographers by their enthusiasm and devotion. It had taken a long time from the dream of Niépce in 1827, who wrote, "But I must succeed in fixing the colours", to the achievement of modern colour photography with its fixed separate dye images, integrated into a single multi-layered emulsion.

Whilst the Mannes and Godowsky experiments finally led to using colour couplers incorporated in the processing chemicals and a laboratory controlled introduction of the dye images, involving selective and separate colour development of each layer consistent with their earliest patents, an alternative to the problem of dye synthesis was being evolved in Germany. Using Fischer's principle of colour development, the most flexible and elegant solution was to incorporate the colour couplers into the three layers of the integral tri-pack and using para-phenylene-diamine as the reducing agent in the developer produce simultaneously in all three layers the silver images based on the colour separation negatives and their appropriately coloured dye images. Inclusion of the dye couplers into the emulsion had been suggested by Fischer and Siegrist. The problem to be solved was to make the chemicals stable in such an environment and prevent their migration from one layer to another when processing took place. This movement of the dye couplers diffused the images and destroyed the colour separation of the three layers.

The search for suitable organic compounds which would couple with the oxidized para-phenylene-diamine to give an appropriate yellow, magenta and cyan dye, and to find a suitable method of dispersion within the gelatine emulsion that would not interfere with the action of the silver halides or their sensitizing compounds, and at the same time to prevent these couplers from migrating in solution away from the silver images into another layer took nearly twenty-five years of research to solve. Farben's chemists overcame each of these difficulties to produce the first colour tripack that could be colour-developed in one single step. All

the complexities of photo-chemistry were contained within the emulsion, to allow a simple processing procedure to be adopted so that the photographer might be able to process his own colour photographs. A direct reversal colour film with couplers anchored in their respective emulsion layers was marketed in 1936 in Germany. The Agfa researchers had found that by making the organic molecules of the couplers larger, by linking with long chain hydrocarbons, it was possible to retain its mobility and disperse it in the fluid emulsion but its extra-molecular size and length would prevent any change of position once the gelatine 'lattice' structure had set.

The Agfa-Gevaert colour reversal films of today rely on the same film structure and processing principles. For the general public *Agfacolor CT 18* is a process paid film with a film speed of 50 ASA (or 18 DIN) or *CT 21* at a higher speed rating of 100 ASA (or 21 DIN); for the professional market, and for user processing, Agfa-Gevaert supply *Agfachrome 50 S* and *50 L* in 35 mm roll and sheet film sizes. *Agfachrome 50 S* is colour balanced to daylight exposures at 5,500°K. *Agfachrome 50 L* is balanced to artificial light of a colour temperature of 3,100°K. Both have emulsion speed ratings of 50 ASA (18 DIN); the S-type is designed for short exposures between 1/1,000 to 1/30 second and the L-type to be used for long exposures between $\frac{1}{4}$ and 10 seconds for roll films and 1-60 seconds for sheet films. *Agfachrome* films are processed in *Agfachrome Process 41* chemicals in 1-litre kits or as separate units in 1-litre and larger sizes.

II Camera Controls

The basic requirements of a camera have not changed since the days of the camera obscura which predates the invention of photography. The smaller versions of cameras used by William Fox-Talbot, which he left lying about his house at Lacock Abbey and his family called "mousetraps", were only a few inches in dimension and consisted of a cubic wooden box with a microscope lens at one end and a piece of light sensitive paper at the other. Fox-Talbot realized that by using a small image in conjunction with his microscope lens the intensity of light exposing the paper would be much greater and the exposure time could be substantially reduced. These first miniature cameras took pictures only about one inch square, and are a prototype of today's sophisticated 35 mm cameras. The progressive development in camera design is one of increasing complexity of the optical and mechanical parts and one of diminishing size. The early cameras, using coated plates of up to 10 in × 8 in, were of heavy and bulky construction manufactured like pieces of furniture of polished mahogany and brass; the most commonplace cameras today are mass-produced highly engineered products designed to the limits of an advanced technology. They are small enough to fit into a pocket and many are almost completely automatic in their technical operations.

The development of the photographic process has been carried out on two broad fronts: one in camera design based on optics and engineering, the other on emulsion technology based on chemistry and physics. The basic aim of both was to speed up and simplify the process. In the early days the tools of the photographer were hand-made, the plate being sensitized by the photographer on the spot immediately before exposure. The camera was made by a craftsman and was simple in design, with only the bare essentials and the minimum of controls. It had a lens to let in light and expose an image on a film-plane and a light-tight box, with a bellows arrangement to allow focusing. There was no shutter mechanism, only a lens-cap, and no secondary viewfinder, only a ground-glass screen. Exposure was estimated or guessed at by the experience of the photographer and his knowledge of the capabilities of his light-sensitive plate to react to the available light. Light intensity was assessed visually by the experienced eye and not measured by an unbiased photo-electric cell. There was no standardization of "emulsion speeds" as they were not individually made and not mass-produced until the 1880s. The controls were totally in the hands of the craftsman photographer. It was an inconvenient, skilled operation to make a photograph. The process was slow and the time-exposures long.

The photographic image is created by the lens and is recorded as a negative image in the camera by the action of light. As we have stressed, this is the vital moment of creativity, the time when all the decisions have to be made, emotionally, aesthetically and technically. What follows after is necessary only to turn the visualization into a tangible reality. Technically, the progress of photography can be measured in time and exposure values, the shutter mechanism which controls the time of exposure and the lens diaphragm which controls the brightness of the image. Improvements in film speeds as new processes were developed reduced exposures from hours to less than a second:

1829	*Exposure time*
First photograph by Niépce	8 hours
1839	
Daguerreotype	20 minutes
1840	
Fox-Talbot's Calotype	1 minute
1851	
Fred Scott Archer – Wet Collodion	2 seconds
1877	
Wratten – Dry Plate – Gelatine Emulsion	1/10 second

Improvements in optics increased the image intensity tenfold and more as apertures of f 4.5 replaced those of the earlier f 16 lenses. These factors combined to give a dramatic reduction in shutter speed, finally allowing movement to be photographed. By the 1880s, the advent of the dry-plate and 'instantaneous' exposure times opened up the medium to the casual amateur and allowed the recording of everyday events without the necessity of heavy tripods or long-held poses. The informal image or snapshot had arrived. Shutters were designed and mechanized, with spring-loaded movements to control the exposure times. Focal plane and leaf-shutters had been developed and were in use on many cameras. The simple box camera had a shutter speed of 1/25 second and did much to popularize photography amongst the general public.

In 1878, Edward Muybridge performed his famous experiment of motion-study of a galloping horse to settle a wager. He took a rapid sequence of action pictures using multiple cameras and twelve lenses with sequence tripping shutters. The shutter speed was about 1/1,000 second and the rapid sequence of twelve photographs analysed the position of the horse's legs. The speed of the wet collodion plates did not allow an exposure of such a short duration to give a satisfactory image but Muybridge ingeniously solved the problem by photographing the horse in silhouette only. The dark horse was arranged to gallop past the cameras against a brilliant white background, consisting of a slanting reflector coated in rock salt which gave off a blinding light sufficient to record an image at this very high shutter speed. The negatives were still underexposed but were sufficient to record the essential outline of movement.

The pictures created a controversy because the photographic facts contradicted the conventions of artistic practice in the representation of horses in motion. The rocking horse posture traditionally and universally used in painting was proved to be not true to nature. The world of art was most reluctant to accept the evidence of a machine and, rather trusting in the vision of the eye, rejected the camera's objective vision as being unnatural and unartistic. If there was to be a choice between scientific accuracy or the impression of the senses, the persistence of vision of the eye should take precedence over the instantaneous fixation of the lens. Both photographers and artists objected to this rendering of motion. Emerson, author of *Naturalistic Photography*, protested that "The impression of the quick exposures should be as seen by the eye, for nothing is more inartistic than some positions of a galloping horse, such as are never seen by the eye but yet exist in reality, and have been recorded by Mr Muybridge", and Rodin claimed that ". . . it is the artist who is truthful and it is photography which lies, for in reality time does not stop, and if the artist succeeds in producing the impression of a movement which takes several moments for accomplishment, his work is certainly much less conventional than the scientific image, where time is abruptly suspended."

As we have argued before, the discrepancy between the eye and the camera is a most vital factor in the understanding of the medium of photography. It illuminates clearly the role of the photographer who must act as intermediary between the thinking eye and the seeing camera. He must impress his artistic vision upon the camera, and upon the film he must counteract the deficiency between the dynamic and spatial complexity of the visual world and the flat, compressed dimensions of the static image recorded by the camera. The photographer must learn to think like a camera and see like the film in order to exploit the differences between this limited vision and human perception. Technically, he must also know the limits of his film's capabilities to record what the camera sees through the lens.

In spite of the realism of the image and its naturalistic appearance, the photographic process is an extremely limited one when it comes to recording the full range of colours in nature or the extremes of brightness of reflected light. The colours are inevitably reduced in brilliance and the tone range is considerably compressed. It just is not possible to record all that nature provides or that the eye takes in without loss or distortion. We know that when the eye scans and selects it is highly adaptable and will adjust its vision, both in

sensitivity and focus, to accommodate the subject of attention. The camera, being much less accommodating in its visual facility, is limited to a fixed outlook, with its controls of overexposure unable to match the full range of the visual experience before it. If the eye cannot see rapid movement so clearly as the instantaneous camera lens, in terms of light sensitivity and latitude it is infinitely superior. The continuously adaptable retina can cope with extreme illumination levels, from a moonlight night to a sunlit beach (0·01-10,000 lux) without any great difficulty. This represents a luminosity ratio of one million to one and is a measure of the latitude of human perception to adapt to its environment. The latitude of a photographic colour reversal emulsion to tolerate errors in exposure levels is at maximum two to one (or one f-stop). Even this variation, on a colour transparency, will produce noticeable visual effects in the recorded image.

Latitude, as a measure of performance, is the capability of the film to accommodate a range of luminosity within the subject image and translate these brightness variations into a linear tonal scale. There are limits to this exposure range *within the image*, that can effectively be reproduced photographically. This will vary depending on the film's characteristics: one of soft gradation, with an exposure ratio, or subject brightness ratio, of approximately 200:1 for a colour negative film, compares with the more contrasting gradation of reversal colour materials where the subject brightness ratio that can be accommodated is only about 50:1 maximum. The gradation of the emulsion also limits the subject contrast that can be accommodated. The image contrast is somewhat lower than that of the subject photographed, due to internal reflections within the lens construction. This flare factor can help to reduce the range of exposures representing the image brightness and this ratio in effect increases the latitude of the film.

The contrast ratio of a subject with a full range of tones from black to white lit by direct sunlight, but without specular highlights, would be about 200:1. This might be reduced to a quarter (50:1) by the camera flare. The original subject could thus be just accommodated on a reversal film, as the exposure latitude is also 50:1, whereas there is four times the latitude necessary for colour negative film. The exposure for the reversal film is critical and any error will result in tonal losses of the subject. The latitude for error using the negative film is by comparison quite generous, with a 4:1 differential between gradation and image contrast, allowing for an exposure margin of two stops, see fig. p. 171. A subject of lower contrast, say 100:1, will double the exposure latitude of both films.

Exposure Latitude
In negative films the exposure latitude is dependant upon the subject contrast within the zone of correct exposure.

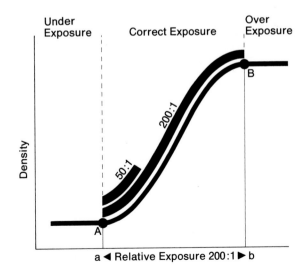

The human eye has much greater latitude, accommodating a brightness ratio of 1,000:1. It also adjusts its retinal sensitivity to variations of overall illuminations and is fitted with an automatic iris diaphragm f 2–f 11. The dramatic difference in performance between camera and eye is caused by the ability of the retina and its millions of light-receptor cells to adjust their sensitivity according to the signal strength, just like the automatic volume control on a tape-recorder. The silver halide grains acting as the light receptors in the colour film have no signal 'feed back' mechanism to moderate their chemical reaction. Consequently the film either over or under-reacts with the inevitable distortion of the recorded signal, the emulsion gives a fixed response to the light stimuli and can only cope with a limited variation in amplitude or intensity. The sensitivity of the retina can vary by a factor of 1,000,000 times, whereas film emulsion is measured at a given numerical speed (ASA/DIN), standardized and measured during manufacture to fixed and narrow tolerances. Throughout the history of photography there have been progressive increases in the speeds of emulsions, and increasingly more accurate methods of determining film-speed have been devised under international agreements from the earliest measure to the present ASA/BS system for colour films established in 1963.

There were many difficulties in establishing a measurement of film-speed because it needed to be scientifically sound, based on the laboratory techniques of sensitometry, and at the same time give a useful practical guide to exposure estimation in the field. Measuring the characteristics of the film, plotted as a graph of silver or dye density against relative exposure, the problem was to decide which point on the curve could be taken as a critical assessment of the film's speed. The complete curve gave its overall performance, its exposure latitude, its density range and contrast gradient.

The speed of an emulsion for a reversal colour film is characterized by the exposure required to record the highlights within the subject brightness range, where point A is the recorded highlight and point B is the shadow, represented by values of a and b on the relative exposure axis (see fig. opposite). Thus an exposure of a will satisfactorily record the highlight detail of the subject at a minimum dye density of 0·2 without tonal compression. The correctly exposed transparency is 'keyed' to point A, where the highlights recorded are not 'burnt out', so that subtle detail is lost or too dense. In the diagram, the speed is based on points A and B, i.e. the useful H/L and shadow densities (0·2 and 2·0) and the speed value calculated on a formula of exposure a and b. If exposure estimation is fixed by the position of the point A, the recording of the mid-tones and shadow detail are determined automatically by the exposure and density range of the characteristic curve.

Reversal Film Speed
The sensitivity of a reversal film is determined by the correct recording of highlights (Point A) on the characteristic curve of the emulsion.

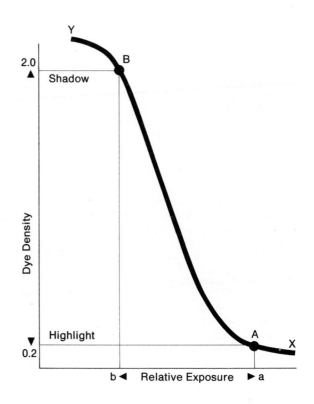

The range of subject brightness values that can be accommodated is limited by the length of the straight line portion of the curve and ultimately by the maximum density available (point Y).

A subject of extreme contrast cannot therefore be fully recorded on the reversal film. If the highlights are an important part of the subject content or visual effect, they must be fixed at point A. This will mean that the shadows of our long range, or contrasting subject, will not be recorded as they will all be compressed into the top shoulder of the curve (Y and B) with little or no differentiation between the tones recorded. If, however, the shadow areas and the subject detail of the darker areas of the image are more vital to the visual effect than the highlights, which are perhaps small or un-important, they could be allowed to 'burn out', with loss of detail and tonal gradation, by moving the exposure estimation point from A to X. This would compress all the highlights into the lens contrast toe of the curve (A-X), in order to ensure that the significant shadow areas were not placed on the shoulder of the curve and compressed.

This choice is the decision of the photographer, who must anticipate the problem of excessive contrast within his field of view. He must visualize the final effect of the image as recorded, not as seen through the viewfinder. His own eyes, with the superior powers of adaptation to brightness values, give a false im-pression of what the colour film is capable of recording. It needs a conscious mental adaptation of the brain to make the eye see what the camera and film will eventually record. Only with experience of taking many photographs and using one type of film can one familiarize the mind's eye to see as the film sees, and hope to make a permanent record of the impressions visualized at the moment of exposure.

The exposure estimation is therefore not a mere mechanical process but a finely-balanced option for the photographer to assess. The conversion of the subject brightness range of the reflected light into a range of satisfactory tonal values in the final image is not only based on objective criteria of light intensity and film sensitivity, but also on the subjective intentions of the photographer. The objective criteria can be measured and controlled by scientific and technical facilities within the photographic process. The critical estimation of exposure that will suit the subjective needs of the photographer are a matter for his judgment alone. The use of exposure meters, ASA ratings, or automatic cameras is a vital asset, but they cannot by themselves remove the aesthetic and technical control which are the final responsibility of the photographer himself.

The exposure meter is more accurately called a 'light-meter' as it can only measure light intensity and be used as a guide to calculate an exposure value. It measures the total light intensity it receives and cannot see the distribution of light within the tonal values of the subject. The photo-electric cell, on which the measurements of exposure are based, records light values in an inflexible manner and without adaptation, closely matching the performance of the film. These quanta of light are directly converted into exposure values of lens apertures and shutter speeds. Because they are much more inflexible than the eye, they are more reliable in measuring the overall light intensity and can be relied upon to give as unbiased a reading of the light value as the film. They are designed and calibrated to key the exposure to a fixed point on the characteristic curve. The reflected light meter is based on an average and is keyed to the centre of the curve, whereas an incident light cell reacts to the brightest point and is keyed to the highlight.

Exposure systems, as devised, are designed to give satisfactory results under the most common circum-stances and normal average conditions. It is a balanced compromise that will give effective performance com-bined with the maximum frequency of success. All built-in systems, whether fully automatic or semi-automatic, rely on reflected light readings which measure the total amount of light energy as viewed from the camera position. If they are 'through-the-lens' (TTL) metering systems, they measure the light as seen at the film-plane and are more accurate than other coupled meters where the angle-of-view of the meter is not necessarily the same as that of the lens in use. These types of meter average the total energy, or 'integrate' its subject brightness range, including those very dark or very bright areas which are beyond the range of the film to record. They integrate the tonal values to a mid-point on the characteristic curve and are calibrated to give a mid-grey tone half-way between black and white when all the tonal areas are averaged out. This keys the picture to an average mid-grey and is effective with the majority of subjects. It does not give entirely satisfactory information with subject matter that is not average. Many of the most interesting and pleasing pictures are far from average, either tonally or aesthetically, they often contain large areas of black or white, without detail, sometimes without any areas of mid-tone at all. Other pictures have shadow areas full of subtle detail and blocked-up highlights, deliber-ately designed to create a subjective mood. Some images are created to give a feeling of light and space, full of brilliant highlight detail and luminous mid-tones.

Through the choice of subject matter it is often necess-ary, for the sake of pictorial effect, to depart from the norm in order to record what is inherent in the subject

Exposure Subject and Contrast
Reversal exposure keyed to Mid tone (M) by reflected light readings

Under Exposure Zone of correct Exposure

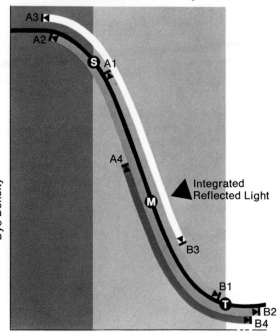

Dye Density

Integrated
Reflected Light

Exposure

Characteristic Curve of Reversal Emulsion

Aperture Correction

Integrated Reflected Light Readings keyed to point M.

1. **Average Subject.** A_1—B_1
 i.e. Mid-grey when integrated, without excessive lighting contrast,
 resulting in correct exposure estimation.

 None

2. **High-Contrast Subject.** A_2—B_2
 i.e. Mid-grey when integrated, but with excessive lighting and tonal contrast,
 resulting in incorrect exposure estimation with either:—
 (i) Burnt out highlights;
 or (ii) Blocked up shadows.

 (i) close 1 stop
 or (ii) open ½ stop

3. **High-Key Subject.** A_3—B_3
 i.e. Near white when integrated,
 resulting in *underexposure*.

 open ½ stop

4. **Low-Key Subject.** A_4—B_4
 i.e. Dark grey when integrated,
 resulting in *overexposure*.

 close 1 stop

itself. Technical control of the tone values, using exposure manipulation, can distort the original and create a more pleasing effect, enhancing that which is only visualized by the photographer and recorded by the film and not inherent in the subject as seen by the eye. There is no one method of exposure estimation that will suit all circumstances. With so many variables between the subject and the image created by a single exposure of the camera, it requires a variety of methods to accommodate our requirements of a 'correct' exposure. Basically, there are two positions on the characteristic curve to which we key our exposure value, see fig. p. 174.

1. The mid-point (M) which is in the centre of the zone of correct exposure. This is based on average readings made separately from parts of the subject or by a single integrated reading from the camera position. The readings are made by reflected light, using a meter calibrated to fix the mid-tone in the centre of the zone of correct exposure. It is a method that will suit the majority of situations of lighting and subject matter.

2. The 'toe' of the curve (T) where the minimum density is recorded. This keys the exposure to the highlights in a positive reversal film, or to the shadows in the case of a negative emulsion. Although this method appears to give less margin for error than the mid-tone key, being at the limit of the zone of correct exposure, it can in practice be more reliable than the integrated average method of exposure assessment. The mid-tone method assumes that the shadow and highlights will automatically fall within the zone of correct exposure. This is not so in the case of non-average subject matter. When the subject will not integrate to mid-grey, or is full of contrasts, it is sometimes much better to key the exposure to a more critical point on the 'toe' at the end of the tonal scale. With colour negative films it is necessary to take a shadow reading from the subject, that is the lowest needle reading given by pointing the meter at the darker parts of the subject, to locate the exposure on the toe of the curve. This method will tend to overexpose, which ensures good shadow detail on the negative. This tendency to generous exposure suits the colour negative, as errors of overexposure can be

Zone System of Exposure
Close-up reflected light readings, "keyed" on a tone scale, are adjusted to the mid-point (M).

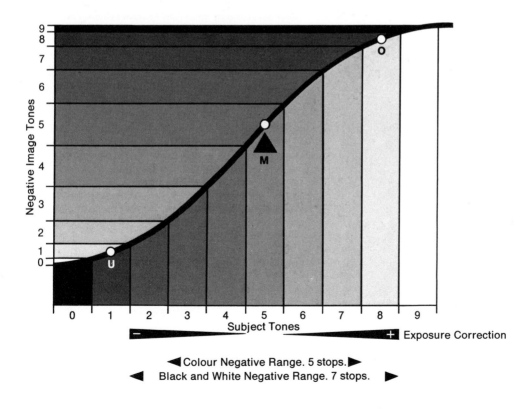

compensated in the printing stage. Underexposure is less tolerant and results in loss of shadow detail and consequent poor print quality. The procedure of taking minimum needle readings is best suited to negative materials only because any errors of exposure will be within the positive tolerance of this material. Colour negative films have little tolerance for underexposure ($\frac{1}{2}$ stop) but considerable degrees for overexposure (2-4 stops), depending on the tonal characteristics of the subject.

A more elaborate and sophisticated method of keying the exposure to a particular tone using reflected light readings was developed by Ansel Adams in his "Keytone" method described in "The Negative" (see fig. p. 175). Adams devised a tone system of ten steps of grey (0-9) within the tonal scale, from black to white, representing an exposure scale of ten stops. A black and white film can only accommodate seven stops and colour negative about five stops. The highlights or shadows must inevitably be compressed. Fortunately, in nature, an absolute black does not exist as some light is always reflected from surrounding areas and this, combined with internal lens reflections, tends to reduce the overall contrast to manageable proportions. Using this method with negative film, one can read any "keytone" using the meter close up to the appropriate area.

An adjustment is then made in f-stops to bring the exposure value in line with the meter calibration, which is only valid for zone 5. For example, if a reflected light reading is taken on a white highlight zone 8-9, an adjustment of three stops will be necessary to bring it back to zone 5, i.e. if the meter reads f 16, set the camera to give three stops more light: f 5.6. If a shadow reading is taken from a dark part of the subject (zone 1-2), the calibrated reading must likewise be adjusted by three stops in the opposite direction, i.e. from f 8 on the meter to f 22 on the camera iris. Similarly, a 'flesh-tone' (zone 6) is one stop lighter than mid-grey (zone 5) and requires a camera adjustment by opening up one stop. This zone system of Ansel Adams is greatly simplified if the readings are taken on a Weston meter, which is designed to make the adjustments automatically by taking the various positions on the calculator dial to represent the zones. The arrow is mid-grey (zone 5), the O reading is the highlight (zone 8-9), the U reading is the shadow zone (0-2) and C is 'flesh-tone' (zone 6).

Using built-in meters or TTL systems which require needle matching to set the exposure values directly, or even with fully automatic cameras where it is possible to locate the needle in the viewfinder by a half-pressure on the exposure button, before exposure, it is still possible to correct for 'false' average readings, by an intelligent use of the camera controls. Understanding

Portraits—Gert Koshofer page 177
Keytone and Exposure
The ordinary rarely excites the imagination. It is too safe and too predictable to hold attention for long. Art which relies upon contrasting elements to stimulate, requires the taking of risks beyond the normal. Extremes of light, the use of high and low key, heighten the visual impact of the photograph. All risks, however, involve dangers and when working at the limits of contrast and tonality of the material, any misjudgement of the exposure would be visually detrimental.
Using reflected light readings, low key subjects tend to be overexposed and high key images underexposed. When conditions are not "average", reflected light readings are unreliable without some compensation. Incident light readings are much more consistent.

Two Sisters—Mayotte Magnus page 178
The picture is based on a French XVIth century painting "La Belle Gabrielle and Her Sister" by an unknown artist.
Photography, due to its immediacy and unaffected realism, possesses an informality which can transform a highly stylised and artificial situation into one full of charm and humour. The formal setting with an old-fashioned vignette of the leaves, contrasts well to the natural enjoyment of sharing a joke between the two sisters.

Man and the Universe—Mayotte Magnus page 179
The splendour of the sky, at the moment of its change from the brilliance of the day to the magic of dusk, endows the scene with a symbolic aura. The picture verges on the borderlines of pathos and artificiality but is prevented from falling into excess by the naturalism of the camera, and the picture becomes a kind of ritualistic, pagan hymn to the God of Light.

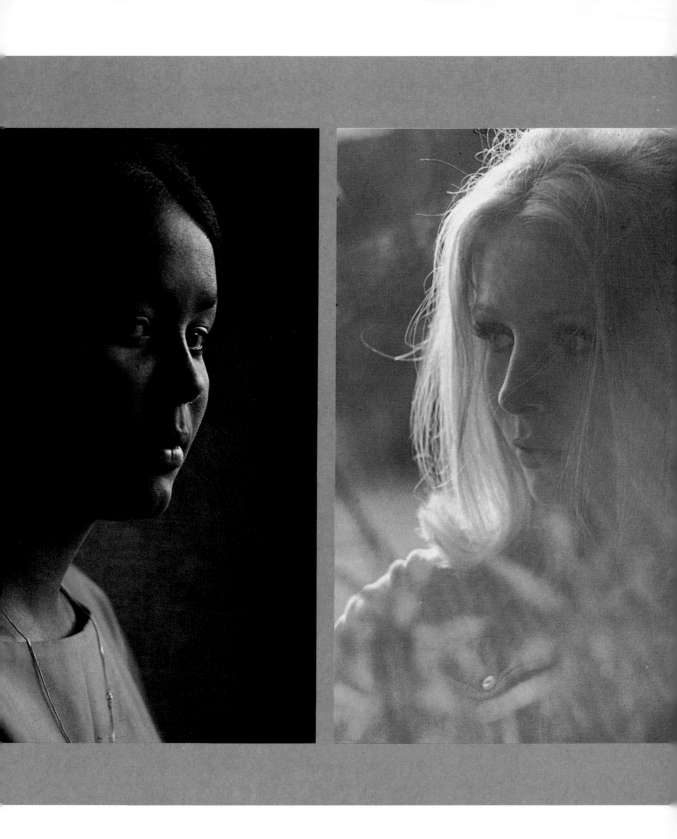

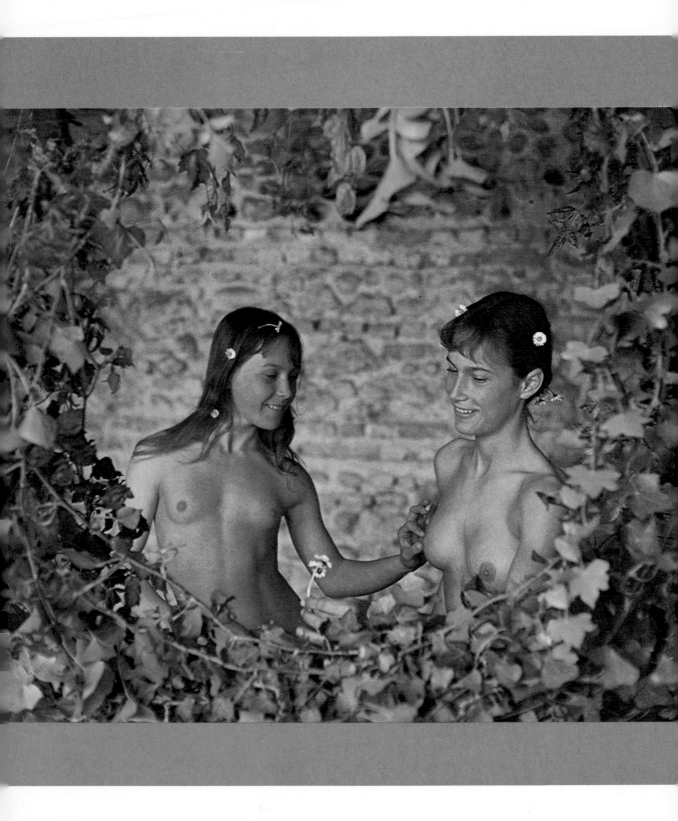

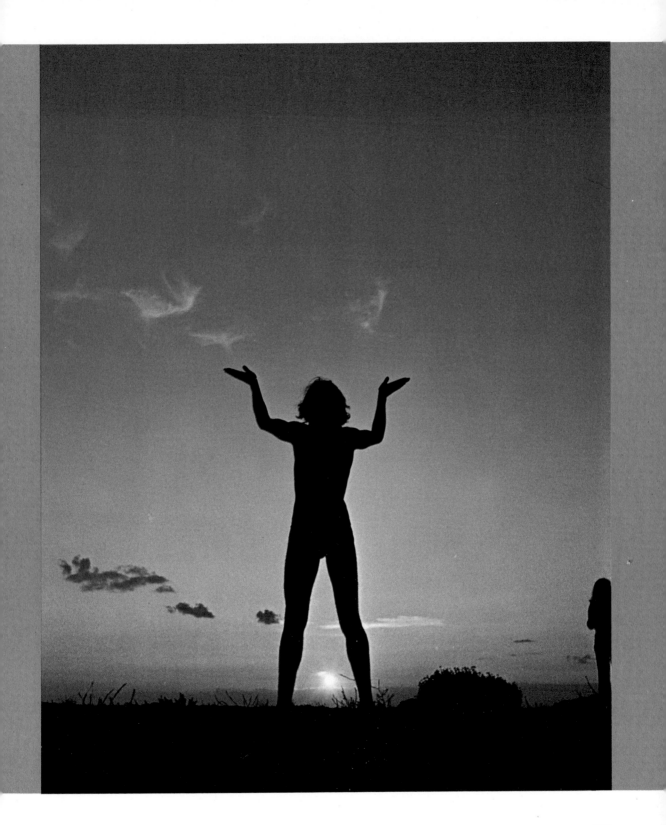

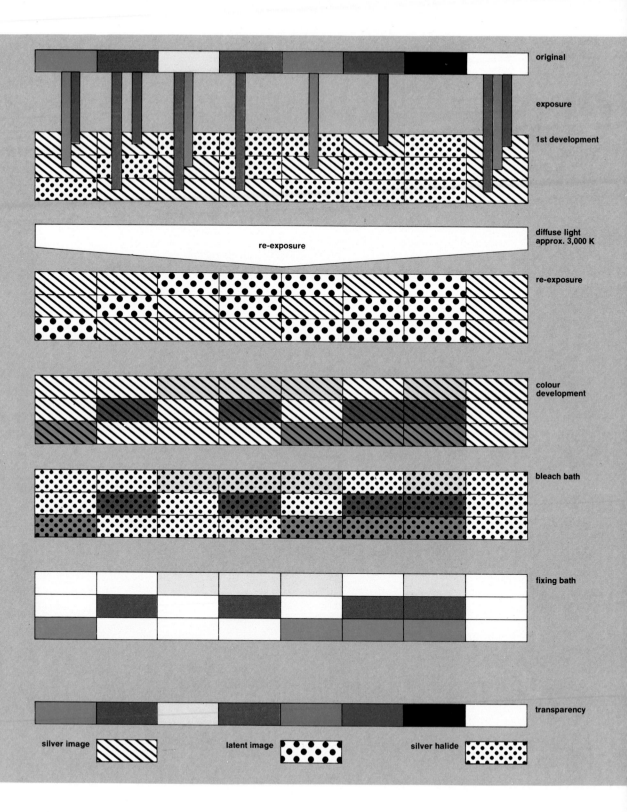

original

exposure

1st development

diffuse light approx. 3,000 K

re-exposure

re-exposure

colour development

bleach bath

fixing bath

transparency

silver image

latent image

silver halide

180

the need to take corrective action with non-average subjects or lighting, the needle can be set to give additional exposure by pointing the camera viewfinder downwards to exclude any sky or highlight area within the frame of the viewfinder, zeroing the needle and setting the exposure controls before reframing on the subject and firing the shutter. Similarly, if the subject and its treatment demands less exposure than average, for instance at dusk or when a silhouette effect is required, zero the meter needle at the highest reading obtainable from the sky or light area before framing the subject. Errors in readings or failure to make the necessary adjustments are invariably caused by the light from the sky or other bright highlight unbalancing the system of reflected light readings.

Reading the intensity of the light-source falling on the subject, that is incident light, is a method of overcoming the wide variations in reflectivity within the subject and the problem it causes in estimating exposure. An incident light meter measures the light falling on a white hemi-spherical cone covering a metered photo-cell, rather than the subject itself. It is calibrated to give an exposure estimation, as if it were a highlight reading, on the characteristic curve (zone 8-9). (See fig. p. 175.) In the case of a reversal colour the incident light reading is keyed to the 'toe' of the characteristic curve (see point T, on fig. p. 174). Because light from the subject itself is not measured, variations in tonality or contrasts are not included in the estimation. As the critical point in the tonal scale is the highlight on a transparency, this method is ideal for colour reversal films. For this purpose it is much more reliable than reflected light readings. High-key and low-key subjects will be given the same exposure, if lit by the same intensity of incident light. With back-lighting the meter must be positioned to face the camera, so that the light falling on the translucent cone is similar to that falling on the subject. As the acceptance angle of the cone to light is 160°, the meter will give reliable readings under these conditions, which are problematical when using a reflected light meter.

Incident light meters are more reliable and give more stable needle readings under conditions of unusual or contrasting lighting. They key the exposure automatically, without adjustment, to the highlight which is most suitable for colour transparencies. All the tones fall into place correctly on the characteristic curve. The only doubt is that a very bright reflective subject matter, such as snow or beach scenes, could be overexposed as the incident method does not allow for their high reflectivity. This is easily compensated by reducing the exposure by about one stop.

Finally, as a rule of thumb, remember that it is better, when in doubt, to err on the side of greatest latitude.

Processing the Camera Record **page 180**
The camera exposure records three images, separating the red, green and blue components from the reflected light of the subject. After the first development, the negative silver images are chemically reversed by a second colour development, following re-exposure. Three positive dye images are produced which after the removal of the silver negative records, during bleaching and fixing, represent a faithful reproduction of the original colours, as photographed by the camera.

With colour negatives, where errors can be compensated in the printing process, there is considerable latitude for *overexposure*, so give negative emulsion the benefit of the doubt and be generous in the exposure. The opposite is true of colour reversal film, as there is no secondary chance, exposures must be more accurately assessed. Tolerances are one stop, either way, at maximum. But again, if in doubt, it is far preferable visually to *underexpose*. Never give anything extra unless you want pale washed-out colours. Deliberate underexposure adds increased saturation to the visual effect, enriches the colour image, and adds a new dimension to the colours as seen.

Reciprocity Failure
Exposure is a function of light intensity and time duration. If either the intensity of light or the time are excessive, the effect of the amount of light energy in producing an image photographically is no longer directly proportional and the reciprocal relationship between image density and exposure as a constancy breaks down. In effect, this means that the film speed as a fixed value (ASA/DIN) no longer holds outside of a given range of exposure times. Speed ratings are measured at a designated exposure time and this value holds for a range of shutter speeds within acceptable tolerance limits. *Agfachrome 50 S* and *CT 18* are designed for daylight exposures between 1/30 second and 1/1,000 second. Exposures longer than 1/30 second are likely to produce a colour cast, the shift being towards the yellow or yellow-green, due to differential failure between the three emulsion layers. This can be corrected by use of a complementary colour filter, i.e. 05, 10 blue or 05 magenta. Exposure estimation should allow for any filter factor. The overall loss in speed, up to 5 seconds duration, should be less than a third of a stop, i.e. for a meter setting of 5 seconds exposure, give the *50 S* film 6 seconds actual exposure to compensate for overall reciprocity failure effect.

Ideally, for long exposures, in daylight (that is exceeding 1 second), it is preferable to use *Agfachrome 50 L* film which is designed for exposures between 1-8 seconds for roll film, and use a colour conversion filter on the camera to balance the colour temperature (CTO 12). Colour negative film *CNS* or *CNS 2* are also affected by reciprocity failure, if exposures are beyond there commended limits. Both are designed for daylight and flash, and exposures between 1/1,000 second and 1/30 second. In excess of 1 second, an allowance should be made for loss of speed, i.e. 5 seconds meter reading would need a 10 seconds exposure to compensate.

III Process Controls

The objective of the processing of colour films, either negative or positive reversal, is to develop and fix the image. The latent image created in the camera is invisible, it needs development. The exposed silver halide is firstly converted into silver and by a process of colour coupling a negative or positive dye is produced chemically, in conjunction with the negative camera image. The process requires a number of stages of chemical action, which must be controlled to prescribed limits if the final colour image is to be technically satisfactory. The controls are those available to any chemical process and as the objective is to produce consistency of action, standardization of the variables is the principle of all colour processing. The processing action at each stage needs to be brought under objective control. It is not an activity that requires creative decisions, which generally have been made before and up to the time of the camera exposure.

Processing of colour films, reversal or negative, requires routine discipline and craftsmanship of technique to achieve consistent and successful results. The controls are limited and negative in character. It is rather a question of avoiding errors and processing faults than taking any positive action to manipulate the image. All the errors can be easily avoided by invariable technique in carrying out a series of routine procedures. Any variations in processing control results in colour casts on transparencies or overall density variations. With colour negatives, faulty processing can result in difficulties in the printing stage and produce prints of unsatisfactory tonal and colour gradation.

The number of chemical baths and processing stages varies, depending on the process but the general principles remain constant. All stages require precise control, within certain limits, but the development stages are the most critical as they create the images. All other stages are secondary and, although vital, do not determine directly the tonality and contrast of the photographic record. The development stages are capable of variation of image control, both in terms of boosting the film speed, correcting known errors in exposure, or adjusting the contrast within fine limits, similarly to black and white photography. As these image-forming processes are continuous, they can be under or over-developed if special circumstances require it. All the other stages in the process, such as washing, bleaching and fixing, are standardized and proceed to completion. The only error here is one of insufficiency.

The variables in any processing stage which need standardizing are:

1 *Chemical composition*
The strengths of the solution are designed by the manufacturer and processing kits are constituted to give correct concentrations when made up to the prescribed instructions on the package. Process 41 for *Agfachrome* 50; N kit for *Agfacolor* CN17, CNS, CNS 2 or 80S.

Changes in composition do occur after make-up through oxidation or deterioration due to ageing over the limited life of the chemicals in solution. As the solutions are used to process films, there are also significant changes as the chemicals are exhausted and by-products are accumulated.

2 *Time and temperature control*
Chemical activity is a function of temperature and time duration. The solutions must be pre-heated to a fixed temperature (20°C or 24°C) for *Agfachrome* (Reversal) Process 41, and 20°C for *Agfacolor* (Negative) N chemicals. The tolerance for temperature variations during processing is 0·2°C for developer stages. For other stages a greater degree of temperature variation is allowed. (See Processing Tables in Appendix.) The temperature can be controlled in a water bath during processing. The washing stages are best controlled by the use of a mixer tap on the hot/cold water supply. All temperatures should be checked with an accurate thermometer before pouring into the developing tank or immersing film.

3 *The agitation of solutions*
This processing variable is the most difficult to standardize, as it is a non-continuous operation requiring strict adherence to the recommended instructions. These procedures vary depending on the volume of solutions being used and the type of tank employed to immerse the film. During processing the chemical reaction, particularly during development, exhausts the concentration in the immediate area to the surface of the emulsion. By-products, such as potassium bromide, also build up in these areas and restrain the rate of development. It is therefore essential that adequate dispersal throughout the bulk of the solution takes place. Inadequate or excessive agitation will affect the overall image density and result in local variations causing uneven development. Poor agitation or ineffective washing will also result in staining in some of the intermediary stages. Faulty control over the agitation and washing causes more processing faults than any other cause. Rigid adherence to the procedures cannot be over-emphasized. An effective way of ensuring this is to record the step-by-step verbal instructions on a cassette tape-recorder, timed to the processing steps,

so that the intermittent agitation can be followed exactly every time. This method is ideal as it ensures precise timing, including the draining stages at the end of each step, as well as 'automating' the necessary agitation control.

The instructions for processing in small tanks using spiral film-holders is to agitate continuously for the first 30 seconds-1 minute at the beginning of each stage, and subsequently twice every minute for the remainder. Inversion every 2 seconds during the agitation is recommended.

REVERSAL PROCESSING
There are five basic stages in colour reversal processing:

	Agfachrome Code
1 First developer	Process 41 FD
2 Stop bath	Process 41 ST
3 Colour developer	Process 41 CD
4 Bleach bath	Process 41 BL
5 Fixing bath	Process 41 FX

A reversal exposure takes place before the colour development.

1 *First developer* (41 FD) to convert the latent images from silver halide to three separation negatives in metallic silver. As this stage produces the initial camera records it is the most critical of all the steps in the complete process. The process controls of time/temperature and agitation are particularly critical and will affect the overall density and colour balance of the final transparency. The black and white developer used is a silver solvent type, as it will help to clear the highlights at the reversal stage, making them more brilliant.

The effective speed of the reversal film can be increased by over-development at this stage in the process. In the *Agfachrome* process, increasing the first developer time by 20% gives a one stop increase in film speed. Over-development will tend to give a colour shift in the final transparency towards the green. Under-development will give a tendency towards a magenta bias.
Normal development times Process 41.
First developer (code 41 FD) –
 18-20 mins. at 20°C ± 0·2°C
 13-14 mins. at 24°C ± 0·2°C

For small tanks, the maximum time (20 minutes) is recommended. Times are for complete immersion, starting when the tank is full and ending when the tank is fully drained. Filling and emptying of the tank should be rapid (5-8 seconds) to avoid uneven development.

The storage life of the first developer in full, dark, stoppered bottles is from two to four weeks without significant changes in activity. Use after this time is possible, without replenishment, by using a slight increase in development time but no guarantee of completely satisfactory results can be given.

The processing capacity for one litre of developer is 30 units, where a 120/135 roll-film is 4 units or 8 films in total. Time compensation can be applied to counteract the loss of chemical activity of the solution. For example, as a guide, give an extra minute for every three films processed, and an extra minute for every fortnight beyond the storage limit. Therefore, by the time the eighth film is processed the development time could be 24 minutes.

2 *First wash* to remove excess alkali developer and prolong the life of the stop bath. It has a brief duration ($\frac{1}{4}$ minute) to prevent prolongation of developing action or possible staining.

3 *Stop bath* (41 ST) is acidic and abruptly terminates the developing process within the emulsion. After a duration of 4 minutes (20°C) or 3 minutes (24°C) the partly processed film can be exposed to light without detriment to the negative records.

4 *Second wash* removes all the chemical from the previous baths, particularly the remains of the developing agents. It is essential that this wash is thorough, with frequent changes of water at the correct processing temperature. Duration of washing is 10 minutes at 20°C or 7 minutes at 24°C. Contamination of the colour developer, which forms the positive dye images, by any first developer, produces drastic colour changes in the final transparency.

5 *Re-exposure*. At this stage the tri-pack contains both the three silver negative images and, associated with them in each layer, the original unexposed silver halides which were not reduced in the first developer. These silver salts represent a positive image and are capable of being developed as a silver and dye image in a developer containing para-phenylene-diamine. However, before this process takes place, complete 'fogging' or re-exposure must take place in all three layers to guarantee the total latentification of the silver halides, so that complete reversal of the negative camera images is achieved. The middle layer, because it is shielded from the light by the dense silver images of the outside layers, is in danger of not being adequately re-exposed, so that the magenta dye image will be incomplete and not fully represent a positive reversal of the green separation negative with which it is twinned within the middle layer of the tri-pack. Therefore a complementary reversal colour image in each layer depends on the residual silver halides being completely exposed and fully developed in the coupling developer. Each side of the film must be exposed to a strong light (500 watt or photoflood at 3 feet) for a minimum of 30 seconds. If the films are exposed in transparent or metal spirals they should be immersed in a bath of water to prevent excessive heating. The exposure should be made at either end of the spiral, by rotating the reel, or the light, in a circular motion to ensure the light reaches the central areas within the coil of film, and no shading occurs. The exposure time for each end should be doubled to 1 minute each if this procedure is adopted.

6 *Colour development* (41 CD). The residual halide is developed as three positive silver images and the incorporated colour couplers react with the oxidation by-products of the developing agent, para-phenylene-diamine, to give three insoluble dye images which make up the final image. The density of the resulting dye images depends on the total quantity of halides left after the first development. The colour development is a reaction that goes to completion, as all available halide is converted to silver. Under-development at this stage results in loss of maximum black and colour distortion in the shadow areas. Although this positive image-forming is not so critical as that of the first developer, the coupling operation is a complex one, and needs careful control if faults in colour rendition are to be avoided. Processing times are 14 minutes at 20°C or 11 minutes at 24°C $\pm 0 \cdot 2$°C.

7 *Third wash* removes traces of colour developer prior to the silver bleaching stage. This wash is 20 minutes at 20°C or 14 minutes at 24°C. To ensure complete removal of colour developer from all layers is quite difficult, particularly in the bottom cyan layer. Failure to do so results in a reaction between any remaining couplers present to produce bluish or magenta stains in the highlight area. These faults are avoidable with effective washing using the correct water temperatures and frequent changes of water.

8 *Bleach bath* (41 BL) converts all the silver images, both negative and positive, made at the two developing stages, into silver salts. It also converts the colloidal silver layer, which acts as a yellow filter, preventing blue light passing beyond the blue sensitive top layer. Finally it removes the black anti-halation backing to the film base. Times of processing are 5 minutes at 20°C or 4 minutes at 24°C.

9 *Fourth wash* is a short wash to remove the majority of bleach chemicals to prevent contamination of the fixing bath. Any carry-over reduces the keeping properties of the fixer, resulting in sulphur precipitation. Washing time is 5 minutes at 20°C or 4 minutes at 24°C.

10 *Fixing bath* (41 FX) dissolves out the silver salts by conversion into soluble thiosulphate compounds which are finally removed in the following wash. This leaves

only the positive dye images in each layer, which represent, in super-imposition within the tri-pack film, the original colour as photographed. Processing times are 5 minutes at 20°C or 4 minutes at 24°C.

11 *Final wash* removes the soluble silver compounds from the film and all remaining processing chemicals. Failure to give an effective final wash will affect the stability and keeping properties of the transparency and result in deterioration of the dye images. The times for wash are 10 minutes at 20°C or 7 minutes at 24°C.

12 *Stabilizing bath* consists of a wetting agent to prevent drying spots (5 ml of 0·5% solution of Agfa Agepon® per litre) and a formalin hardener (12 ml formalin 40% solution per litre) to increase dye stability. The film is soaked in this diluted solution and drained before drying. Other photographic wetting agents can be used, but avoid exceeding the stated concentration as this could result in uneven drying and 'streaking'. Do not rinse or wash after stabilization.

13 *Drying* is a process, where physical damage is the major risk, that needs careful handling to avoid any problems. After extensive processing the multi-layered structure is extremely delicate and soft. Remove films from processing spirals with care, hang up and allow the films to drain off excess stabilizer. It is not advised to wipe the emulsion surface, although the film base may be sponged with a chamois to avoid surface marks. Dry in a warm, dust-free atmosphere, or drying cabinet. Do not use heat or fan-drying when time allows as this increases the risk of embedding dust particles in the emulsion surface. Natural air drying is preferable to forced heat drying. If heat is used it should not exceed 30°C.

NEGATIVE PROCESSING

Colour negative processes follow the basic principles outlined in the theory of tri-pack emulsions. They record three silver images by the exposure within the camera. Three colour separation negatives are developed as monochrome records in metallic silver, just as in black and white photography. The couplers incorporated in each layer react with the by-products of reduction during development in those areas exposed, proportionally to the amount of silver produced. Simultaneously, therefore, three dye images in yellow, magenta and cyan are produced of the negative records of colour separation.

Colour development is followed by a bleach bath to reconvert the metallic silver to silver salts, and finally fixing removes completely the monochrome separation negatives leaving only the dye images. In colour and tone, they represent a colour negative of the original subject. All the colour values are complementary to the subject as exposed, i.e. the sky is yellow, the grass is magenta and the Union Jack, the Stars and Stripes or the French Tricolour are cyan, black and yellow.

Agfacolor negative materials come in two types: CN 17 Universal* is an unmasked colour negative, speed rated at 17 DIN/40 ASA; and CNS negative, which is a masked material, to improve colour reproduction and saturation on printing. These integral masks are produced automatically within the magenta and cyan layers on colour development, and give the processed negative an overall orange appearance not seen in the unmasked CN 17 U. *Agfacolor* CNS is rated at 20 DIN/80 ASA. For sub-miniature (110) size a special *Agfacolor* pocket special film is made similar to CNS but of higher definition to increase sharpness of the enlargements. Process controls are minimal, and it is advised for all but experimental purposes, that standard operating procedures be followed as outlined by the manufacturer. It is unadvisable to attempt to 'up-rate' colour negative film and compensate by over-development. This can only result in loss of shadow detail as the colour negative has little exposure latitude for underexposure. Over-development will increase the contrast of the negative and unbalance the contrast relationship with *Agfacolor* paper MCN type 7 or 4. Variation from the standard development time could result in a 'mismatch' in the contrasts of the individual dye images. If this occurs, it is then impossible to completely correct the colour balance at the printing stage, across the entire tonal range. For example, it could produce a print, correctly balanced in the mid-tones, but showing green shadow areas and magenta highlights.

*CN 17 now obsolete. CNS and *Agfacolor* 80S Professional, both double masked films, now available.

Processing kits are supplied as a 1-litre unit (N kit). Separate packs for individual baths are also available for 5-litre working solutions.

Agitation at all stages using the inversion method with spiral tanks is similar to that described earlier. After pouring in solution quickly tap base of tank on workbench to dislodge any air bubbles, then invert every 10 seconds during the first minute of each stage. For the remainder, repeat twice per minute, before pouring out solutions as quickly as possible. Allow draining within the total process time. The processing stages are as follows:

1 *Colour developer S* (code NPS I). The solution is a conventional colour coupling developer, employing para-phenylene-diamine at high alkalinity (pH 11). The solution will keep in full, tightly-stoppered, dark bottles for six weeks if not partly used. After some film has been processed, the by-products make the developer solution much more unstable and it is not advised to prolong its use beyond a few days, if complete reliability is to be guaranteed. The total capacity for 1 litre of solution is six films (any size). When using small inversion agitation tanks, it is economical to divide the solution between two 500 ml storage bottles, and use one for the first three films and the other for the second three films. This will avoid mixing used and unused developer and prolong their storage life. Processing time is 8 minutes at 20°C±0·2°C. This time could be increased by 1 minute for the third and sixth films, to compensate for any loss of activity.

2 *Intermediate bath* (code NZW). This bath contains sodium sulphate, to which one must add 30 ml of Developer S per litre. The function of this solution is to retard the development process greatly, although some development does still take place. Correct agitation is essential to avoid any possibility of uneven development. Duration of process is 4 minutes at 20°C±0·5°C.

3 *First wash*. Wash with frequent change of water at a temperature of 14-20°C to stop development and remove all traces of chemicals. If any developer remains in the emulsion after this stage, magenta fogging will take place in the bleaching stage.

4 *Bleach bath* (code NII). The three silver negative images are converted to silver salts in this stage, together with the colloidal silver anti-halation backing, and the yellow filter layer between the top and middle layer. The colour masks are also completed in CNS film at this stage in the process, so it is essential to adhere to the correct conditions of 4 minutes at 20°C±0·5°C. The solution has a storage life of three months in dark bottles.

5 *Second wash* removes bleach chemical, which might otherwise contaminate and shorten the life of the fixing bath. Use several changes of water at 14-20°C, washing for 6 minutes.

6 *Fixing bath* (code N III). This bath converts silver salts to soluble compounds, finally removing the original silver negative images, leaving only the colour-coupled dyes in the multi-layered film.

7 *Final wash*. To remove all traces of processing chemicals and soluble silver compounds, wash for 10 minutes in running water at 14-20°C. A final rinse in bath containing diluted wetting agent (5 ml of 0·5% Agepon + 12 mls formalin 40% solution) for a minute completes the process.

8 *Drying*. Handle the wet film with extreme care and dry in dust-free atmosphere not exceeding 30°C. Do not wipe emulsion surface.

Colour Printing

Colour Printing

"The photographer must intervene as little as possible, so as not to lose the objective charm which it naturally possesses . . . Photography should register and give us documents."

Henri Matisse

Colour printing offers the ultimate goal for the photographer – to produce, by his own hand and according to his own personal requirements, a colour print that can be viewed in normal room-light without the artificial aids of magnifiers, illuminators or projectors. Just as the daguerreotype was made obsolete by the monochrome print process, so the objective of colour photography has always been to supersede the reversal process with a colour print. Earlier attempts, from du Hauron onwards, were complex and difficult, requiring skilled manipulation of separate images to assemble them in register to produce the final subtractive print on paper. The modern negative/positive process employs an integral tri-pack, which records the colour values of the subject, in negative tones and complementary colours. A similar tri-pack emulsion coated on to paper becomes the positive print material from which the original colours can be reconstituted by the conventional process of printing the colour negative. The difficult hand-manipulation of earlier colour printing has been eliminated and basic skills and photographic technique are enough to produce successfully your own prints today. Colour printing needs only a clear understanding of the basic principles of colour mixing, of light and dyes, to make the necessary colour balance corrections to control the process effectively. As with black and white printing, experience and judgement are essential to produce the best results. Judgement of the correct exposure in printing is partly a matter of subjective preference, whether a print is neutral or if a particular colour bias is preferred can only be decided by experience. The opportunity for the photographer to control the colour print, from camera exposure to colour enlargement, brings back some of the craftsmanship and satisfaction enjoyed in the monochrome era of photography of earlier days, which has increasingly been taken away as the cameras and processes have become more and more automated. By way of compensation, automation increases the reliability of results and allows the photographer to concentrate upon the creative aspects of his craft.

Colour printing can be done with the most basic of equipment, using a simple enlarger, with a colour-filter drawer, and a few dishes, to the more sophisticated and convenient set-up which employs a colour enlarger with a dial-in dichroic filter head and colour analyser and automated colour processing with a rotary drum controlled from a punched card programmer. From the simple amateur darkroom to the professional custom laboratory, there are many variants. The quality of the end-product is not determined by the degree of automation but by the judgement of the operator and

his standards of assessment. The most primitive of equipment is capable of producing superior results to that of the automated laboratory. The methods used by the professional laboratory rely on quality control, which means standardization and efficiency rather than personal judgement and sensitive perception. Making colour prints requires a high degree of personal assessment, based in the end on trial and error methods. These methods are time-consuming and in these expensive times only the dedicated amateur has enough free time to pursue the ultimate in colour printing – the one-off, hand-made print, perfected by visual assessment and the trial and error methods of the test strip. Colour printing can be slow and laborious, requiring a well-disciplined technique, but it is also extremely satisfying to the individual. The professional, short of time, cannot afford such luxury or satisfaction within the process itself and must pursue his photographic art through the 'camera original', the reversal process.

Being a two-stage process, employing two sets of emulsions, the negative acts as a reversed image of the original subject, containing all the visual and colour information, coded in reverse order. This inverse code is restored to its original form in the print stage. The procedure involves exposing colour printing paper to the projected light of the negative image under the enlarger. The white light from the enlarger bulb is modified or modulated by the negative in the carrier. This coloured light, in the form of a complementary image, exposes the paper and the three emulsions produce a latent image to red, green and blue light to which they are sensitized. The colour paper using subtractive colour couplers, when processed in a colour developer, produces three dye images in cyan, magenta and yellow. These three images viewed as a superimposed single image of the tri-pack restore the original tones and colours of the subject photographed.

As an example of the negative/positive process at work (see fig. p. 194), take as our subject the two complementary colours, yellow and blue.

1 *Yellow*
(a) Negative – Original subject radiates Yellow light.
 Stage – Yellow light is Red + Green light.
 – Exposes Red + Green layers.
 – Couples to give Cyan + Magenta dyes.
 – Cyan + Magenta = *Blue negative image.*
(b) Positive – Blue dye image transmits Blue light.
 Print – Blue light exposes Blue sensitive layer.
 Stage – Yellow coupler reacts to give *Yellow*
 positive image.
2 *Blue*
(a) Negative – Original subject radiates Blue light.
 Stage – Exposes Blue layer with Yellow coupler.
 – Couples to give *Yellow negative image.*

(b) Positive – Yellow dye image transmits Yellow light.
 Print – Yellow light is Red + Green light.
 Stage – Exposes Red + Green layers in paper.
 – Couples to give Cyan + Magenta dyes.
 – Cyan + Magenta = *Blue positive image.*

The negative stage is the light modulating process and the colours respond as follows:

By absorption:
Yellow dye controls Blue light only.
Magenta dye controls Green light only.
Cyan dye controls Red light only.

By transmission:
Yellow dye passes Green + Red light.
Magenta dye passes Blue + Red light.
Cyan dye passes Blue + Green light.

The positive stage is the light exposure process and the light reacts as follows:

Blue light produces a Yellow dye image.
Green light produces a Magenta dye image.
Red light produces a Cyan dye image.
Superimposing dye images –
Yellow + Magenta = Red.
Yellow + Cyan = Green.
Magenta + Cyan = Blue.

From these two responses it can be seen that the yellow dye in the negative, for instance, controls the amounts of yellow dye produced in the positive. More yellow dye in the path of the printing light, by reducing the relative amount of blue light, selectively controls the exposure of the blue-sensitive layer in the colour paper producing the yellow image. By using a series of yellow filters in the enlarger between the light source and the colour negative, it is therefore possible to control the overall amount of yellow dye and the relative density of the yellow image that goes to make up the final positive print. The amount of yellow dye determines the colour balance of the print in relationship to its neutrality to the other colours. If the yellow is not balanced to the other two colours a colour cast is observed; if there is a deficiency of yellow dye, a blue cast is seen. Similarly with the other layers.

Therefore the yellow filters control and can correct a yellow or blue cast, the magenta filters can eliminate a magenta or green cast and the red filtration adjust a red or cyan cast. Increasing the yellow filtration reduces the exposure of blue light to the yellow forming layer, thus reducing the amount of dye produced. Increasing the amount of yellow filters in the light source of the enlarger diminishes the excess dye of a yellow cast; decreasing the filtration of yellow will remove a blue cast, by producing more yellow dye in the colour print.

This can be summarized as a simple rule: *A colour cast is removed by a filter of the same colour*.

This allows the printing stage to be used to control and manipulate the overall colour balance of the print image; to produce a visual quality which can be varied in tonal density by exposure control and colour density by filtration control. The positive image is controlled by manipulating the light of the enlarger during exposure.

The chemical processing of the paper is a routine operation requiring only consistency, standardization of variables to reproduce the dye images in exact proportion to the light exposure given during printing.

In order to control the colour and density of the final print image the enlarging light source must be controlled within precise limits. Uncontrolled variations in light output must first be eliminated. As exposure is a function of light intensity and time duration, these factors must both be determinable precisely. The intensity is fixed by stabilizing the voltage of the electrical energy to the incandescent lamp and then exposure is controllable by means of a timing device in the lighting circuit to measure the duration accurately. Having eliminated all other variables the overall density of the final image now becomes a direct function of exposure time.

The variations in colour balance produced during the camera exposure and translated into negative dye images must be counterbalanced at the printing stage by matching the dye images and relative exposure of the tri-pack layers. By means of a combination of colour filters in the enlarger system, the light is controlled spectrally so that each layer can receive a balanced proportion of the overall exposure. Hence by a filtration system, using yellow, magenta and cyan filters of various absorption densities in combination, it is possible to control with precision the colour balance in the positive print. The spectral quality of the enlarger lamp must be standardized in order that repeatable and consistent results are obtained from test exposures to final print. This is effected by using the voltage stabilizer transformer which smooths out fluctuations in the mains voltage supply and ensures a standard colour quality. Thus our exposure controls are as follows:

1 Density control = exposure time.
2 Colour control = filter combination.

These factors can be determined by trial and error using test strips and visual assessment or a visual test calculator using a mosaic filter pattern (Unicube or Simmadot) or an electronic analyser which measures photo-electrically the colour components of the negative (Durst or Melico). Overall density and exposure timing are estimated by similar methods using 'stepped'

exposures and visual assessment, or an exposure meter-reading on the colour analyser. The test calculators employ a 'step-wedge' to help exposure estimation. The use of visual test aids, such as the Mitchell-Unicube calculators, help to estimate the correct exposure and filter pack combination for a given colour negative by exposing a small test strip (approximately 5 in × 4 in) through a mosaic set of filters of various colours and densities. The Unicube is arranged as a hexagonal pattern of small colour patches giving ninety combinations of yellow, magenta and cyan filtration. In the centre is a clear patch representing zero filtration. The objective of such systems is to eliminate more than one test on each negative. They operate on a principle of diffusing the projected image on the base board, using a lens diffuser, which integrates the colour negative image to one colour value. Thus each colour patch is exposed uniformly to the diffused light from the enlarger. Through the mosaic, the test print reacts to ninety-one different filter combinations which, after processing, can be judged visually. The colours recorded on the paper will be complementary to the filters that produced them, i.e. a yellow filter (density 20) will produce a colour shift of 20 Blue from that of the central (no filter) patch. By visually assessing the colour shifts across the mosaic to locate the one which is a neutral grey, it is possible to find the equivalent filter pack that will print the negative to a neutral colour balance.

This type of system, because the neutral evaluation is based on a diffused light from the negative in the enlarger, assumes that the colours of the subject are uniformly distributed across the colour spectrum and that when averaged out or mixed by optical diffusion will be themselves neutral grey. In the majority of cases this is approximately true, and this integrated average will represent an effective guide to the final filter pack for the negative. If, however, one colour does predominate in the subject as photographed, for example, an all-red sunset, the system will over-compensate to neutralize the natural colour bias; the print will be given a cyan cast, if it is balanced to the most neutral patch on the mosaic.

In practice, this might be anticipated and a colour patch, representing the subject bias, could be chosen instead of the neutral patch, for instance, a 20 Red patch would counteract the cyan cast in the all red picture. An error due to the subject bias is rare and any compensation is unlikely to exceed a filter density of 20.

The main difficulty in colour evaluation is to identify the direction of shift in the final print, if further correction is necessary. When looking at the print one does not evaluate a neutral colour patch but an overall cast superimposed upon the natural image colours. These

colours can obscure the nature of the colour cast. For example, it is impossible to see a green cast in the picture area composed of a green field or even its complementary magenta which would be cancelled out by the local image colour. Always examine those areas within the print or test strip which are neutral themselves, particularly in the mid-tones. If none are available, look critically at the highlights, or white areas, for a colour cast. The 'flesh-tones' are also critical areas although they are not neutral themselves, but can be used as an area for visual assessment, but they are, however, not as reliable a guide to colour correction as neutral areas. Skin tones vary from person to person and false judgements as to the overall cast can be easily made. Skin colour which looks too magenta in the print can in fact be due to a lack of yellow (i.e. a blue cast), rather than the magenta cast it appears at first sight. A cyan cast can also be concealed in a flesh tone. Confirmation can often be established by examining the highlights of the hair for the true colour cast. Look at the overall picture area. Test strips which show only a small area can be deceptive unless a critical or neutral portion of the total picture is chosen. Overall, if the print appears to be too cold, there is an excess of either blue, cyan or magenta dye. It is sometimes difficult to identify which of these is the colour cast, when it is overlaid on a colourful image. Magenta and blue can be confused, as can blue and cyan. Similarly, if the print looks too warm, it might be difficult to separate a red from a yellow cast. A green cast can easily be overlooked because it is an ambiguous colour, being neither warm nor cold. The eye is more tolerant to some colours than others and green, a harmonious and natural colour, is much more acceptable than its complementary magenta. Warm colours generally are psychologically and visually more pleasing than cold, which makes a cyan cast much more unacceptable than a red. Similarly, a blue cast is less tolerable than a yellow bias within the colour print.

All of these factors come into play when making a visual assessment. What is the correct colour for a print is a matter of preference rather than cold fact. Neutrality may be the objective but in the final analysis personal preference and the particular demands of the pictorial content must influence one's judgement. Mood and emotion are an integral part of colour expression and deliberate colour bias may enhance the overall effect. Colour printing allows very fine control over this creative element in the picture-making process. When making a visual assessment, it is necessary to consider the viewing conditions. If the final print is to be seen under daylight, the test should be viewed, ideally, under similar conditions. A print evaluated in tungsten light will appear too cold when seen in the light of day. Fluorescent daylight tubes (Philips TL-F65 W/55) are therefore preferable as a light source when working in

Male Nude—Peter Gauditz page 191
Contrast and Tone
The beauty of natural colour is never better revealed than in a photograph of limited colour range, that is rich in tonality. Colour enhances the realism of the image and the tonal values evoke a strong feeling of presence and sensuality. The long tone range with fine detail in both highlights and shadows are fully exploited with subtle fidelity in the colour print shot on colour negative film, Agfacolor 80 Professional.

Portrait of Terry Frost page 192
Portrait of David Hockney page 193
Photography eventually liberated portraiture from the artificiality of the studio and conventionality of a stylised pose in the Victorian tradition. Each age develops its own style. The present age has adopted naturalism as an expression of greater freedom and more open values of life. Contemporary portraiture shows a more casual approach in accepting natural behaviour of the sitters, in their everyday surroundings, as seen in available light. There is little doubt that photography, with its immediacy, its avidity for truth and its insatiable curiosity about life and people, is an ideal medium for naturalistic portraiture.

**Illustration of the Agfacolor
negative - positive process** page 194

Colour comparison chart page 195
To make it easier to understand the principle of the colour diagram some important filter combinations have been reproduced in the colour comparison chart. In this way it is possible to demonstrate in a striking way the qualitative and quantitative change and the complementary colour of a colour cast. Owing to the slight difference in printed colours and the photographic original it is not possible to guarantee an absolutely exact comparison with a colour cast filter test but recognition of the colour cast is facilitated; and this is particularly the case when filter assessment has to be undertaken under unfavourable lighting conditions (artificial light).

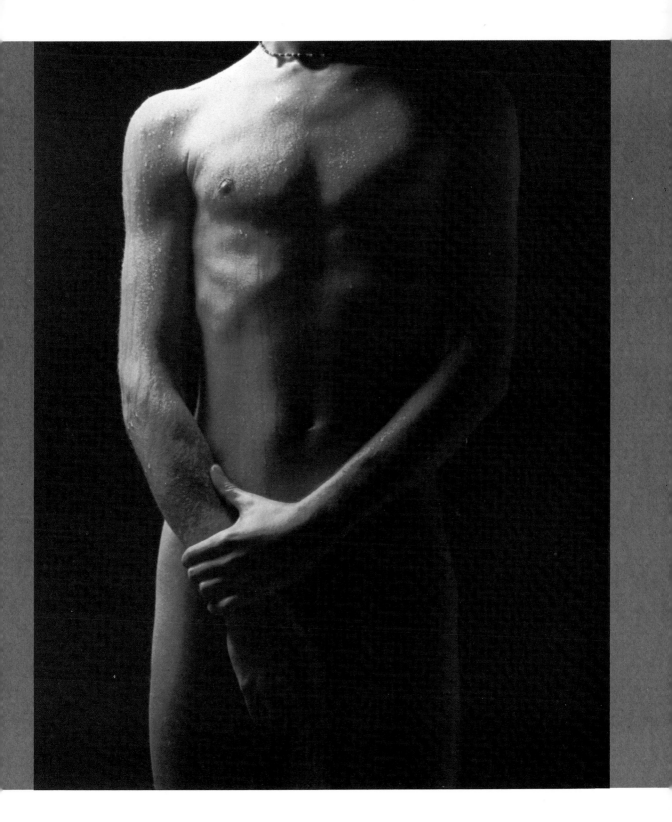

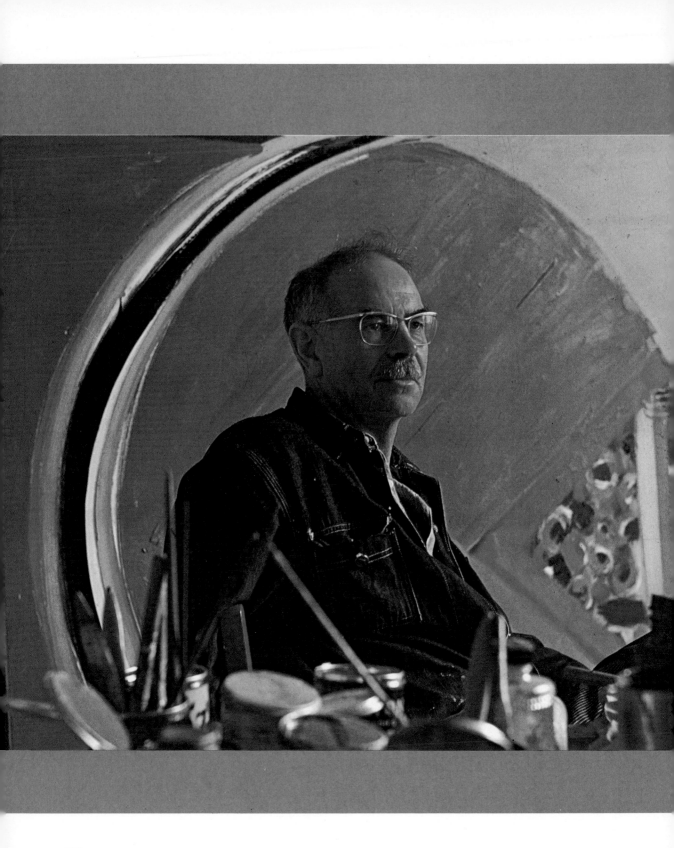

192

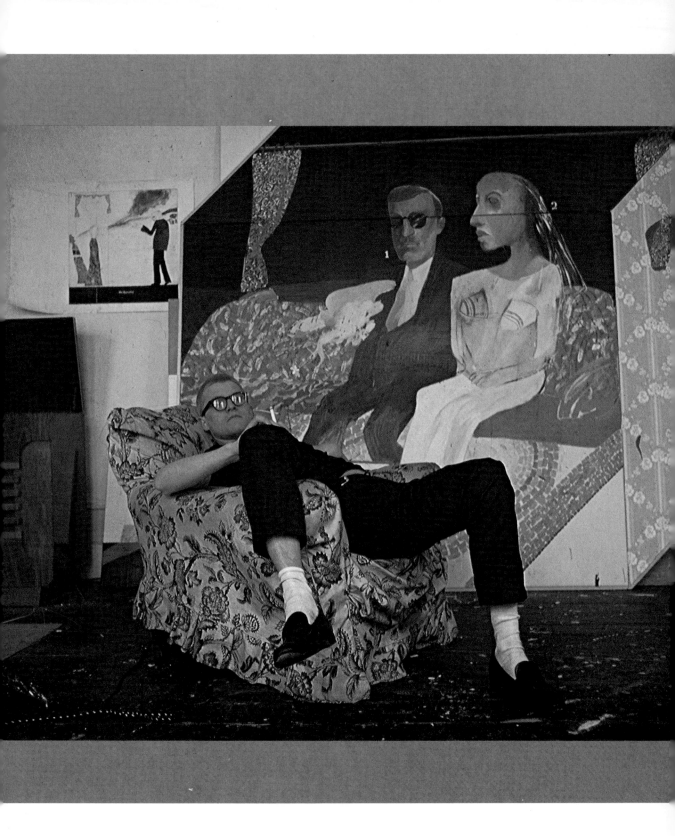

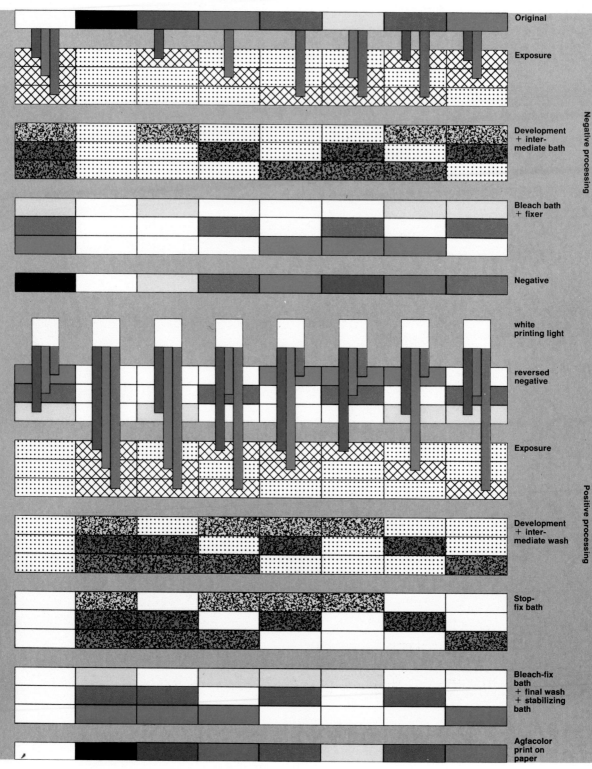

Original

Exposure

Development + inter- mediate bath

Bleach bath + fixer

Negative

white printing light

reversed negative

Exposure

Development + inter- mediate wash

Stop- fix bath

Bleach-fix bath + final wash + stabilizing bath

Agfacolor print on paper

Negative processing

Positive processing

194

Blue Cyan

−99 99 −70 99 −30 99 −−99

−99 70 −40 40 −20 40 −−40 30−99

−99 30 −40 20 −20 20 −−20 20−40 70−99

−99− −40− −20− Grey Density 1 20−20 40−40 99−99

enta Green

30 99− 20 40− 20 20− 20−− 40−20 99−70

70 99− 40 40− 40 20− 40−− 99−30

99 99− 99 70− 99 30− 99−−

Red Yellow

Colour Asses
Visual colour
a discriminat
be sensitised
colours. To d
between mag
colour casts
Small colour
of the picture
Any doubts a
mate strengt
suspect colo
plementary c
cast of 10 cya

195

change in the exposure of 10% is necessary for each of the following filter changes:

Yellow density = 30Y.
Magenta density = 10M.
Cyan density = 20C.

In making filter changes to neutralize colour cast in the test print, one needs to be familiar with the combinations of the subtractive primaries, and how they are complementary to the secondary colours, i.e. Yellow is complementary to Blue (or Minus Blue). This means that adding blue to the filter pack can be achieved by removing yellow filters. The alternative method would be to add blue made up from equal values of magenta and cyan filters, i.e.:

+20 Blue = −20Y, or
+20 Blue = (+20M + 20C).

When making filter changes always remove filters in preference to adding them as this only increases the exposure time. For example, if the test print had a filtration of 60Y + 20M, and a change of 20 Blue was necessary for correction, it would be desirable to remove 20Y rather than add 20M + 20C;
i.e. 60Y + 20M (−20Y) = 40Y + 20M rather than 60Y + 20M (+20M + 20C) = 60Y + 40M + 20C.

The second combination is exactly the same in colour value as the first but it does contain a larger number of filters, and a proportion of neutral density, because all three subtractive primaries are present in the pack. This is unnecessary and only adds to the exposure time. Having identified the colour cast in the print by visual assessment, both its colour and density, the corrections to the filter pack, or colour head, can be applied using the basic rule:

A colour cast is removed by a filter of the same colour.

Taking the simplest case first, as an example, the test print is too yellow. This is confirmed by viewing through a blue viewing filter (20B). The cast is removed by printing through an addition of 10Y to the filter pack.

Original pack is 20Y + 10M at 10 seconds.
Correction is +10Y

New pack 30Y + 10M at 11 seconds.

The exposure is increased by 10% due to an increase in the number of filters, as the 30Y is made from a 20Y + 10Y combination.

Further examples are as follows, starting with a test exposure at 20Y + 10M at 10 seconds.

Colour cast	20 Red	10 Green	20 Green
Old pack	20Y + 10M	20Y + 10M	20Y + 10M
Correction	20Y + 20M	− 10M	− 20M
New pack	40Y + 30M	20Y only	*20Y − 10M
Filter factor	+30%	−20%	+10%
New exposure	13 secs.	8 secs.	11 secs.

*Filter pack of 20Y − 10M is equivalent to
20Y + 10G or
20Y + (10Y + 10C)
The new pack is therefore 30Y + 10C.

The use of a colour head, instead of separate gelatine filter packs in the filter drawer, is much more convenient. Colour and density changes can be 'dialled in' on a graduated scale, which avoids any physical handling of individual filters. Three sets of glass filters for continuous filtrations from 0-200 are mounted in a projected light source (Agfacolor-head) or continuous variable interference, 'dichroic' filters in the Durst colour enlargers (0-100). The colour-heads are the ideal system as it allows continuous and rapid filter changes, and can be further sophisticated by the employment of an electronic colour analyser, to eliminate much of the preliminary test exposures. This saves both time and paper wastage, although initial setting-up for the colour paper batch and final print assessment must still be done visually, relying on personal judgement.

It is advisable when colour printing to purchase a supply of paper manufactured and packaged from a single batch. This is because there are significant differences in colour balance between each batch, which would require a new basic filtration when used. The batch numbers and the filter factors are marked on the package of *Agfacolor* paper which will give an indication of any changes necessary. The large numbers represent a filtration to Yellow: Magenta: Cyan to a standard test negative. For example, if the new batch is designated 50: 20:−
i.e. 50Y + 20M
and the old batch is 30Y
by subtraction, 20Y + 20M is the correction needed for the change to the new package of colour paper.

For printing negatives, *Agfacolor* papers MCN are made in two types of base support. Type 7 – on a baryta-coated double weight paper base; surfaces available are glossy and silk texture. Type 4 – coated on a polyethylene (PE) resin-treated paper, which prevents chemical absorption into the paper fibres. The plastic surface imparts a natural high gloss to the processed paper, without glazing, and can because of its impermeability use shorter wash times and rapid drying. Surfaces available are high gloss, semi-matt and silk texture. Colour paper is sensitive to the complete

spectrum, i.e. panchromatic, and must be handled only in complete darkness, or using a safelight specially designed and tested for its use. *Agfacolor* Paper MCN 111 can be safely handled under darkroom illumination using an Agfa-Gevaert safelight Screen No. 08, providing a 15-watt bulb is used and that it is at least 30 inches away from the work-bench. Brighter illumination can be had by using a discontinuous light source, such as the Durst Sanat sodium vapour lamp and dichroic filter, or the Aeroprint Vibrovision fluorescent safelight.

MCN 111 paper and PA chemicals are being replaced by plastic coated (PE) paper and process 82 a. 85 chemicals. 85 kit is supplied for small users.

Agfacolor paper is a tri-pack emulsion similar in principle and structure to the colour negative material. The processing stages required are correspondingly similar in outline. The Pa Process, for *Agfacolor* Paper, Type 7:
1 Colour developer – Pa I/60
2 Stop fix – PPa II/K
3 Bleach fix – PPa III/K
4 Stabilizer – Pa VI/S

The paper Pa Process can be carried out using a variety of processing methods, from simple dish development at room temperature (20°C) to tank and rotary drums operated by hand; or semi or fully-automatic one-shot drum processing units operating at higher temperatures (25° or 30°C) with thermostatic control. Dish development is easy to control, without complex equipment, similarly to black and white printing in a conventional darkroom. The temperature of the developer is critical ±0·5°C but can be maintained in a warm room without difficulty for the duration of the first stage of the process. The temperature control of other stages is less demanding and presents no problems.

Rotary drum processors using a one-shot system are more convenient as the process can be carried out in full daylight once the drum is loaded. Higher temperatures can be used (25°C or 30°C) provided the solutions are pre-heated and maintained during the process period, using a water bath. Although the chemicals are used only once, which gives a uniform chemical reaction, the drum system of rotary continuous agitation requires only very small volumes of solution for each sheet of paper. For a 10 in × 8 in drum as little as 2 ozs of developer are needed. There are a number of designs for ensuring consistent agitation, from the hand-rotation method on the work-bench (Durst), or in the water bath, at high temperatures, to the cradle-mounted systems (Paterson) which can be either hand-cranked, or motorized units, with automatic temperature control (Wilkinson). The more automatic processors are most suitable for the higher processing

temperatures, and shorter times, where greater control is possible over the process variables.

The Pa Process for *Agfacolor* MCN/Type 7 paper is as follows:

Bath	Code	Process Time (minutes)			Tolerance
		Temperature			
		20°C	25°C	30°C	
Paper developer	Pa I/60	5	3	2*	0·5°C
Wash*	—	2½	1¾	½	6°C**
Stop-fix	PPa II/K	5	1¾	1	2°C
Bleach-fix	PPa III/K	5	3½	3	2°C
Final wash	—	10	5¼	5	6°C
Stabilizer	Pa VI/S	2½	1¾	1	2°C
Total time (minutes)		30	17	12½	

*For the 30°C process, the colour developer must be diluted 2:1 with water (i.e. 2 parts developer and 1 part water).

**The first wash is part of the development process and, within the temperature tolerance limits stated, should be maintained at a consistent temperature ±1°C of the chosen temperature.

The processed print can be assessed for colour and density during the wet stage, at a point one minute into the final wash. The colour balance of the wet print can be judged, and corrected if necessary, after only 18½ minutes (20°C), 11 minutes (25°C) or 7½ minutes (30°C).

Agfacolor (PE) plastic-coated paper can be processed at higher temperatures (42°C), and if there is little carry-over of developer in the processor, the stop-bath can be eliminated. With shorter wash-times inherent with this type of material the total process time can be reduced to as little as 9 minutes using a one-shot rotary drum processor. The process 85 is designed for photo-finishers using automatic equipment and is only available in large volume units (5/35 litre). For smaller users and hand-operations a modified Pa Process is available, which is universal for all *Agfacolor* papers, Type 7 and Type 4. This universal process has the following modifications on the standard Pa Process:

1 A stop-bath (3% glacial acetic acid) replaces the stop-fix PPa II/K.
2 A rinse follows this stop-bath (there is no wash immediately after development).
3 The paper should not be exposed to white light until the prints have been in the bleach-fix for at least ½ minute.

4 With 30°C processing the colour developer is diluted in the proportion 2 parts developer to 1 part water.
5 Wash times are reduced by one-third for PE paper.

The modified processing for one-shot drum processors employ the following procedures and timing:

1 The drum which is completely dry is loaded with the exposed paper, emulsion inwards, in the darkroom. Processing can now take place in daylight.
2 Pre-soak the paper for 1 minute in warm water by filling drum to overflowing in the vertical position. This warms the drum, so that the first processing solution can be poured in at room temperature, without pre-heating. If the room temperature is 20°C, the pre-soak temperature for a 20°C process is 20°C; for a 25°C process it is 32°C; for a 30°C process, 42°C.
3 Drain out pre-soak water, at appropriate temperature, and pour in developer with tank in vertical position. The solution is held in a small reservoir built in the lid, until drum is rotated in the horizontal position. This ensures accurate timing of each stage.
4 Agitation is by hand rolling, to and fro, on a level surface completing a complete revolution in each direction.
5 A rinse requires one change of water and a wash at least three. The final wash can be carried out in running water in a dish instead of in the drum, followed by stabilization in a dish.

For the various process temperatures the timings are summarized as follows:

"One-Shot" Processing of Agfacolor PE Papers in Processing Drums

Processing Stage	Time (mins.) for processing at:–	
	25°C (77°F)	30°C (86°F)
Pre-soak (see table for temp.)	1	1
Developer 82 u. 85 CD	$2\frac{1}{2}$	2
Rinse	$\frac{1}{4}$	$\frac{1}{4}$
Bleach-Fix 85 u. 86 BX	$2\frac{1}{2}$	2
Wash	$2\frac{1}{2}$	2
Final-Bath 85 Fl	1	1

Process 85 chemicals are available in the form of a 1 litre kit and also in packs to make 5 litres each of Developer, Bleach-fix and Final bath.

The 1 litre kit contains packs to make 1 litre each of Bleach-Fix and Final bath and TWO packs of Developer to make two separate Developer solutions of 1 litre each. When using this kit with the Processing Drums both the Bleach-Fix and Final bath may be used twice. The chemicals in the kit will thus be used up at an even rate.

	Processing temperature °C			
Room temp. °C	20	25	30	35
15	26	36	45	—
20	20	32	41	—
25	—	25	36	45
30	—	—	30	42

Above table gives the temperature of pre-soak water for required process temperature at various room temperatures. Intermediate values may easily be estimated.

The drying of PE coated paper is best achieved by hot air fan, rather than by conventional dryer/glazing machines, as only surface moisture has to be removed, and evaporation cannot take place through the base. Prints will also dry rapidly, without heat, at room temperature without curling.

Mounting of plastic coated colour paper can be carried out using dry-mounting tissue up to 12 in × 15 in sizes. Particular care should be observed in not exceeding 80°C (185°F), as PE coating tends to melt at higher temperatures. It is also essential that both print and mount are absolutely dry, as any moisture will be trapped because of the impervious coated surface of the paper, and will prevent proper adhesion. Paterson Thermal Mountant may also be used, as well as cold mounting methods such as self-adhesive film (Lomacoll) or aerosol spray mount (Scotch).

Artificial and Derivative Processes

"Working directly with light and chemistry so transforms the subject as to hide the identity of the original, and creates new form, the ensuing violation of the medium employed is the most perfect assurance of the author's convictions. A certain amount of contempt for the material employed to express an idea is indispensable to the purest realization of this idea." These words were written by Man Ray in 1934.

A colour photograph reproduces the natural world; how the camera sees is essentially naturalistic. The pictorial value of the photographic image is dependent upon the sensitive eye of the photographer. Through the creative choice of viewpoint and subject matter and the organization of the formal elements of design, he 'makes' his statement within the viewfinder at the moment of exposure. The image may be enhanced or the statement dramatized in the processing and printing stages but in essence the picture is already fixed and unalterable. Such an approach requires a response to nature and an imaginative eye for a visual effect, a degree of respect for the subject matter and restraint on the part of the photographer. The desire to control the visual material offered by nature, however, is very strong and opportunities within straight photography are naturally limited but there is considerable scope for manipulation, or visual distortion, both before the camera exposure and more particularly afterwards, during processing and printing. Taking the original camera image, mutations or colour derivatives can be synthesized.

The desire to distort the naturalistic image of photography is stimulated by the wish for greater personal expression and imaginative freedom and to escape the familiar and often banal experiences of everyday realities. To create an image beyond the vision of the retina is to enter an alternative world of fantasy where logic and reason, fact and structure are no longer restraints to the imagination, where all things are possible; to pass through the "mirror of nature" into the looking-glass world of Alice. Such a visual dream world is populated with strange sights and fantastic colours, where wishes are fulfilled, the sun always shines, and the colours are forever bright. It becomes a landscape of extremes, of black and white contrasts of alternating emotions, the violent colours of Expressionism or the sensual delights of childhood colours.

Colour derivations are a means to this end. Both the camera exposure and photographic processing offer some freedom of expression, a release from the tyran-

Artificial and Derivative Processes

"Up to and including the instant of exposure, the photographer is working in an undeniably *subjective* way."
W. Eugene Smith

202

ny of the naturalistic image and the tangible presence of 'the real', from which it is derived. When the imagination, however, is set completely free there is an attendant danger that it will be seduced by its own creative power into an orgasm of colour. Freedom from natural restraints is a heavy responsibility, requiring sound judgement and self-imposed discipline, if visual chaos and emotional anarchy are to be avoided. A balance must be struck. The real difficulty in colour derivations from the photographic norm does not lie in the complexity of some of the processes involved or the element of chance that such distortions include but in the need to have a clear visualization of the outcome of the derivations and knowledge of the preconceptions which initiate them. Subjectivity of intent must be equated with objectivity in the execution for the final realization to be truly meaningful or visually effective. The techniques and materials available for experiment are in themselves a source of fascination and there are almost endless variations and combinations of visual and chemical manipulation to exploit. Image shape and contrast can be altered from the photographic norm, both before and after camera exposure, by optical or chemical processes. Colour can be created, almost at will, giving the photographer some of the freedom of choice taken for granted by the painter.

When using black and white negatives as the origin, tonal separations can be made from which component colour images completely under the control of darkroom techniques can be derived. Using a combination of negatives, or a series of separate exposures, an entirely new image can be constructed, coloured by synthesis rather than by the process of natural selection to which we are limited in straight photography. It is the answer to a Fauvist dream, with yellow skies and magenta fields, replacing the familiar and predictably subtle blues, greens and greys. Replacing subtle harmonies with the violent sensations of contrasting hues and high saturation, which act as a visual assault on our senses, we are left with *colour*–colour for its own sake, colour as sensation.

The multiplicity of variants, in technique and visual effect, are considerable, and if used in combination with colour, almost limitless. When we depart from the natural image we are entering unknown territory, without definable boundaries. When art freed itself from naturalism at the beginning of this century it opened up new horizons. Alvin L. Coburn, who produced the first abstract photograph in 1916 by the use of mirrors, prisms and multiple exposure, proclaimed, "Why should not the camera also throw off the shackles of conventional representation and attempt something fresh and untried?" Multiple images and composites had been known earlier from photographic sources, and were as different in motivation as the allegorical montages of O. G. Rejlander and the scientific investigation of Jules Marey and his fragmented images of motion. All techniques today stem from the same use of light for creating a juxtaposition of images, either in the camera or later during printing. In Moholy Nagy's 'photograms' light was modulated directly by objects casting shadow images on photographic paper, similarly in Max Ernst's 'frottages', surface imprints were reproduced as abstract images. Using natural objects in the same manner, photographic imprints can be made under the enlarger with abstract negatives of *cliche verre* techniques. Jerry Uelsman introduced abstract elements upon a photographic image, transforming its meaning from realism to poetry, by using textures created from smoked glass, oil and water mixtures, and even lettuce leaves.

Colour synthesis, a product of light, is another variant closely related to art movements. Colour theories based on the natural harmonies of representational painting have been challenged by a more sensual and psychological outlook, based on feeling and individuality rather than convention and symbolism. Imitation is no longer the only valid approach to colour, nature the only arbiter of choice. Colour has become more fragmented, arbitrary, more abstract, the Pointillist dots of Seurat becoming the *Homage to the Square* of Joseph Albers, a series of formal abstract paintings of interacting coloured squares. Impressionism, based on theories of retinal vision, mutated to the linear optical illusions of Op Art. The vibrations of light intensified the colours. Brighter and more vibrant, when divorced from naturalism, colour became pure sensation.

Synthesized colour can be derived from the naturalistic colours of the tri-pack film or introduced into the monochrome image of black and white photography. Colour can be created by the action of light on tri-pack materials during colour printing. The quality of the light is controlled by subtractive filtration, when using the negative/positive system of colour-printmaking or by duplication when using the positive/positive reversal process. Recopying transparencies allows control of overall colour and, if desired, progressively increases contrast. The use of selective masks can adjust individual tones and colours, as complete colour separation allows total control of colour values. The revival of older processes such as bromoil, gum bichromate and dye transfer has taken place because of the colour revolution, even hand-colouring has made a come-back recently and artists are incorporating photographic silk-screened images into their artworks. Colour prints can be hand-controlled by selective bleaching of the dye-images produced in colour-coupled tri-packs. And specialist materials, such as Agfa *Aviphot*® Duplicating Film and *Agfacontour,* often designed for scientific use, can be annexed into the service of the art of colour photography.

203

D 0-0,6

D 0,6-1,2

D 1,2-1,8

D 1,8-2,4

D 2,4-3,0

**Variation of equidensity location
(demonstrated with grey wedge)**

-50-

50--

100--

150--

Variation of equidensity width

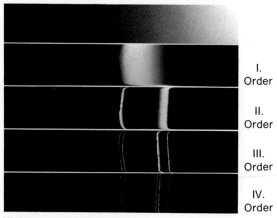

I.
Order

II.
Order

III.
Order

IV.
Order

Higher order equidensities

Aviphot Color Duplicating Film, formerly Scientia Color Film, is a high contrast, high definition tri-pack film, which is balanced to 3,200°K. Designed for photomicrography it has a speed corresponding to 2 ASA, although its high contrast (gamma = 3) prevents an accurate comparison. Available in 35 mm. rolls and sheet film, it has potentiality for colour derivations as this contrast can be exploited. Although it is possible to produce direct reversal positives, it is best used for derivations as a high contrast colour negative. The film is developed with *Agfacolor* paper chemicals (Pa Process) at 20°C using the standard times.

Agfacontour, a specialized monochrome 'negative' material, also has a great potential in the production of colour derivatives. By copying colour originals, from reversal or negative film, colour separations or tonal compressions can be made, which, when recopied in colour, combine the modified images into a visual derivation with a strong graphic impact. It is a high contrast material, with the ability to record only part of the tonal scale at any given exposure. All other areas of tone, either above or below this narrow range of densities, are recorded as flat undetailed black silver, without gradation.

A single copy, from a positive original, will result in a negative with the tonal detail limited to one narrow section from the full tonal scale. Detail in all other areas will be lost, and the contrast substantially increased. Which part of the tonal scale is recorded depends upon the level of exposure and by test-strips any part, from shadow, mid-tone or highlight, can be selected. If three separations of tone are chosen, using three different exposures, the graduated tonal scale can be reduced to three separate tonal areas, recorded on three individual negatives. These tonal separations can then be used to print one positive combination image, in tone or colour, representing the reduced and simplified detail of the continuous tone original. This effect is commonly called 'posterization'.

Agfacontour is a mixed emulsion of silver chloride and silver bromide. This unusual material produces a silver image of high contrast, on exposure to light, which is part negative, part positive, somewhat like that of a solarized negative or a bas-relief, a combination of a negative and positive print, but easily achieved by one exposure and processing in a specially designed developer. The fogging exposure, normally applied during development to solarize an image and imprint the positive on to the image, is not necessary. The negative image is achieved by chemically developing the slower silver chloride to a high contrast, that is, the highlights are recorded in the *Agfacontour* as black. The positive image is produced at the same time by physical development, due to the presence of colloidal silver sulphide

in the silver chloride emulsion which blackens the area receiving little or no exposure. Hence, the shadow areas are reproduced as black. Only in the mid-tones is a graduated negative image produced, using a silver bromide emulsion which records the areas of medium exposure beyond the sensitivity range of the slower chloride emulsion. The blacking effect of the physical development process is restarted in these areas by the release of bromide. Thus a narrow band of tone is flanked on either side by blank areas of dark silver. This narrows our 'window on the world', as if it were shuttered to restrict the tonal view. It produces a distorted view where black and white are indistinguishable and tonal areas are reduced to a linear outline.

The bands of tone recorded, called 'equidensities', are capable of precise control. Their position is fixed on the tonal scale by the exposure level. The width of the band can be narrowed, if desired, by controlling the relative amount of blue light during exposure, using a yellow filtration, a 100Y filter in the light source will record a very narrow band of equidensities. In a photograph with strong linear contrasts within the subject, such as a *contre-jour* or silhouette, this narrowing is likely to produce a line or contour image, outlining the areas of high contrast. The effect is controllable within fine limits, where, previously, similar effects produced by solarization and the Mackie line effect were notoriously difficult to control.

The contour line can be achieved using *Agfacontour* with any subject, irrespective of its tonal distribution, by producing a second order copy from the original, that is, the first order *Agfacontour* image is recopied a second time both increasing the contrast and producing a contour line rather than areas of flat tone (see fig. p. 204). The material is available as sheet film (5 in. x 4 in., 10 in. x 8 in.) and, when combining separations or producing second generation copies for a contour effect, it is advisable to employ a punch-register pin to locate the images exactly, when contact printing these intermediary derivatives. After registration, the combined images can be enlarged together as a sandwich to produce the final print if colour derivative negatives are made as intermediates by means of Agfacolor Positive M film or dye coupling. Alternatively, using larger sheet film sizes (10 in. x 8 in.), one can make the final combined colour image using a contact printing frame and individual exposures for each enlarged monochrome negative, located on a pin-register by controlling the colour with differing filtrations for the *Agfacolor* MCN paper.

Agfacontour is easily handled in the darkroom, being blue/green sensitive only a red safelight is permissible (R5 dark red or R3 light red). It is of slow speed, somewhat less than bromide paper, and requiring conven-ventional monochrome development with a specially compounded *Agfacontour* developer for 2 minutes at 20°C. A stop bath of 3% acetic acid is essential to prevent staining. The introduction of colour is achieved in the final print by various means. The *Agfacontour* derivative negatives can be printed any colour, irrespective of the original from which they were derived. If the original is a reversal transparency, the colour information should be recorded separately by using separation tricolour filters (blue U 449, green U 531, red L 622) on to panchro sheet film (Agfapan® Professional 100) as an intermediary before converting to *Agfacontour*, which would not be sensitive through a red separation filter. If the contour images are tonally separated, by differential exposures rather than colour exposure, they can be made directly on to *Agfacontour* film. The silver images are converted into dye images by either:

A. Printing negatives separately, using individual exposures to coloured light, on to either *Agfacolor* Paper (MCN III) or Positive M Film. The colour produced from each exposure would be complementary to the filter used, i.e. a yellow image would be printed with a blue filter (Blue U 438, or 200M + 200C in the colour head of the enlarger). Three exposures through the three contour negatives, using an appropriate filter combination, complete the colour print.

B. The silver images produced via *Agfacontour* can be converted by colour coupling into dye images of yellow, magenta or cyan, depending on the dye coupler introduced into the colour developer used. Copies printed on to high contrast material such as Gevalith Ortho 081 p are processed directly in the *Agfacolor* Negative (NPS) colour developer, to which has been added a small quantity of an appropriate colour coupler. (See Appendix for details.)

Alternatively, the same result can be obtained by using Johnson's *Colourform* chemicals to convert from silver to dye images. Indirect colour development can also be used by processing films with the high contrast Gevalith Ortho 081 p in either Gevaline® G 7 p for 3-4 minutes, or for 2-3 minutes in a print developer such as Neutol® liquid NE. The silver images produced are fixed and thoroughly washed before rebleaching in *Agfacolor* Negative Bleach (N II) for six minutes. After rewashing the silver halide image can be redeveloped in the colour coupled developer as for the direct method. The main advantage of this method is that it can be carried out in daylight and all the separations can be colour coupled at the same time. A number of such colour dye images can be used together in the enlarger to make a print on to *Agfacolor* MCN Paper, using a single exposure through the superimposed negatives.

C. The monochrome derivatives can be converted to colour images by printing on Agfa *Transparex* film,

designed for making single colour transparencies for overhead projectors. This material is available in a range of colours – red, yellow, green, blue, orange, violet, as well as black and opaque white and can be exposed on any thermographic copying machine by contact printing. The method is only suitable for line negatives as the *Transparex* will not produce continuous tones. The exposed film on a polyester base is rapidly processed in water by wiping off with a wet sponge on a flat inclined surface. After removing excess water the print dries rapidly in a few seconds. The finished *Transparex®* prints can be superimposed to give a combination of coloured images, which can be used as a colour negative in the enlarger and printed on *Agfacolor* paper, or Positive M film, in reversed complementary colours. As an alternative, large *Transparex* 10 in. x 8 in. prints can be produced by direct contact printing, in the thermographic copier, from enlarged bromide prints made of the *Agfacontour* separations. As the system produces a positive from a positive original, a bromide print will copy as a monochromatic coloured transparency. Several colours combined in register could result in the final colour image as a transparency or as an overlay on a white mount, a colour print.

The variations of effect, both tonally and in choice of colour, give the photographer enormous scope for his imagination. The fragmentation of the originals and their synthesis into new forms requires considerable experience in use before the final effects can be visualized. This perhaps is both the excitement of the process and its creative limitation.

The so-called solarized image was in fact originally an error in photographic technique. Chance and accidental error have played a significant part in human discovery from penicillin to the West Indies. Photography is no exception, from Daguerre's apparently accidental discovery of the developing properties of mercury vapour, due to a broken thermometer, to Sabattier's carelessness, when in 1862 he fogged some wet-collodion plates during development to produce a part negative/part positive image with a line effect surrounding areas of high tonal contrast. This effect has been named after him, and is the correct term for what is now commonly and incorrectly known as solarization today.

The 'Sabattier effect' was rediscovered in the early 1920s by Man Ray who exploited it for its visual and surrealistic overtones, as the chance effect was consistent with the Surrealists' automatism, and their search for poetry of chance juxtapositions, "free from any control by the reason, independent of any aesthetic or moral preoccupation", as put by André Breton in his definition of Surrealism. The idea of the spontaneity of thought, of mind over matter, of the Id over the Ego

Interior—Cressida Pemberton-Pigott page 207
Colour Control
Synthesis of colour can be achieved in the darkroom particularly when using the negative/positive system. Colour printing allows manipulation of the image beyond that possible in the camera. Triple exposure of the negative to a series of colour filters, or changes of focus between exposures, combined with a fine colour sense can produce delicate effects to delight the eye. A charming domestic scene is given an added dimension by sensitive observation and restraint in colour control at the printing stage. Considerable aesthetic judgement and the ability to visualise the final effect is required, if success is to be achieved in making colour derivatives.

Dutch Landscape page 208
Colour Derivations
A loss of photographic realism can be counteracted by degrees of abstraction. Using a technique of double printing, through colour screens, images can be combined in the enlarger. The coarse granularity can otherwise be achieved by high magnification enlargement from small parts of colour negatives, giving a "pointillist" effect, which although entirely consistent with a photographic approach, is reminiscent of the retinal structure of Impressionism and OP-Art.

Church on The Hill—Hans H. Siwik page 209
Almost complete abstraction and restructuring of the image can be achieved by the use of Agfacontour. It can create a sense of "other-worldliness", a landscape of dreams, where all things are possible and logic and expectations are denied. Colour is synthesised at will by means of colour separation and reconstruction.

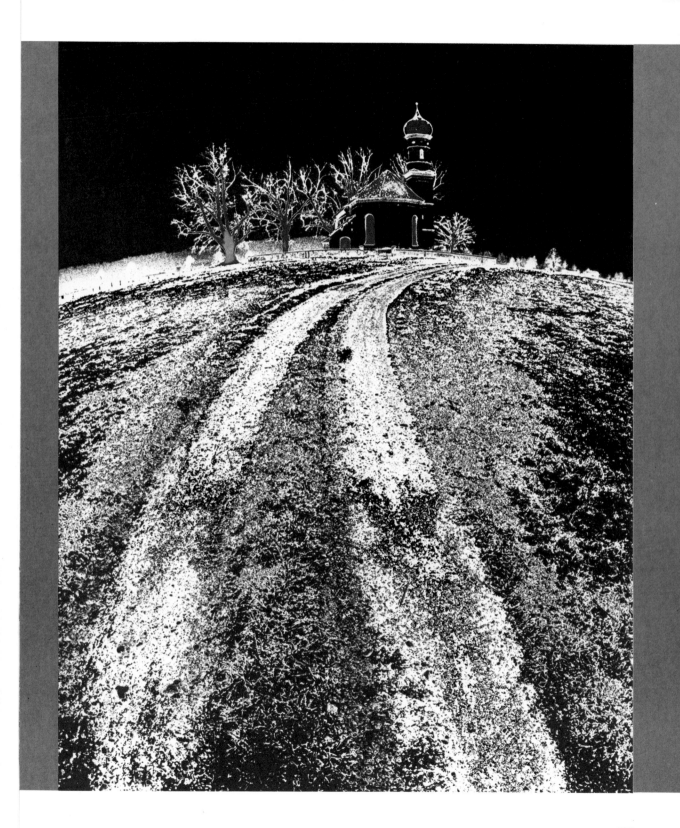

and white films, at the first developer of reversal colour processing and two-thirds during colour development of colour negative tri-packs or print film. To increase the edge effect at the juxtaposition of areas of high contrast it is recommended that normal agitation procedures are stopped during the second stage of development of the fogged film. The visual effect is very much dependent upon the relative exposures between the copy image and the solarization image. A series of test strips are essential to judge for the best effect. A checkerboard system of horizontal printing steps and vertical fogging steps will give the maximum information. As a guide, the initial image exposure would be 1 stop less than for a normal process, and the fogging exposure would be 3–10 seconds to a colour light source (safelight or enlarger) at a distance of one to two feet.

When using black and white solarized negatives, the colour derivatives can be made by direct colour printing by using three separate colour filtration exposures in register in the carrier of the enlarger. Alternatively, as described in detail in the information on *Agfacontour*, it is possible to colour couple the silver images to make dye images by colour development, or copy on Agfa Positive M film by contact printing with pin-register frame, or use Agfa *Transparex* film to produce separate dye images in a range of monochromatic colours for the final negative/positive printing. If the final negatives are dye images, they can be superimposed or sandwiched in register and printed with a single exposure in the enlarger using colour paper or print film. The variation in methods is determined by the requirements of the effects needed and the convenience of the individual stages required. The route taken must depend on the material and equipment available, the final size of the colour derivative needed and economy of time and material. Economy can be achieved by using the shortest possible route, the minimum number of intermediate stages and enlarging only at the final stage of printing. If the originals are 35 mm., it is advisable for intermediates to be enlarged images on 5 in. x 4 in. film. Contact printing at all intermediate stages is preferable as pin-registration is readily available. Unless pin-registration in the negative carrier is available, the final enlargement must be achieved by means of a single composite negative, or a sandwich of intermediates bound in register, so that a single exposure print can be made.

Finally, when the stages involved are planned to coincide with a final positive print image, consideration must be given to the reversals of tones, positive to negative, negative to positive, or positive to positive, in the case of *Transparex* or *Agfachrome*®, deciding if an odd or even number of stages is necessary.

Agfachrome Processing

Special development to correct an exposure

Varying the conditions in the first developer affects first and foremost the colour transparency's overall density. This fact can be taken advantage of, in special circumstances, to deliberately lighten Agfachrome Professional slides by over-development, or keep them darker by under-development, and in this way to correct originally unavoidable or just noticed mistakes in exposure. Using the development time specified for the equipment as a base, the rule is, to correct for:

underexposure by 1 stop (equivalent to setting the film speed 3 DIN too high) lengthen first development by 20%

overexposure by 1 stop (equivalent to setting the film speed 3 DIN too low) shorten first development by 20%

This would mean, for example, lengthening the standard first development time of 12·5 minutes (24°C process) to 15 minutes, or shortening it to 10 minutes. Fractional values – say a correction for only $\frac{1}{2}$ stop – can be corrected for by proportional adjustments of the time (in this case by $\pm10\%$). It is not advisable to correct wrong exposures over ±1 stop, as this causes a marked deterioration in the colour quality of Agfachrome transparencies.

Films are occasionally developed so that their effective speed is increased if the film speed, which can be raised by 3 DIN when taking the picture, is the deciding factor. In special circumstances, when the content of the picture takes preference over accurate colour rendering, the film speed can be raised by 6 DIN by lengthening first developing time by 40%. It should be stressed, however, that this is only to be used as a last resort. In such cases it is imperative to run a test development first with film with the same emulsion number.

Any extension of first development reduces the density of, in particular, the darkest or unexposed areas of the film. Development to increase speed by up to 1 stop will generally not lower the density values below 3.0, and so not adversely affect the quality of the picture. The gradation of the transparencies does not, despite assertions to the contrary, change to any significant degree. The relative grades of contrast within a picture do not then become harsher or softer.

The time variations given above for corrections of Agfachrome film speeds apply to first development only. All the other processing times remain the same. Maximum development time in 1st developer should not exceed 20 minutes.

Appendix

Agfachrome Processing

Processing of Agfacolor PE sheet paper

Processing tables

Agfachrome films can – as already indicated – either be developed with the 20°C (68°F) process, which takes about 95 minutes, or the 24°C (75°F) process, which takes about 70 minutes. The times and temperatures for these two processes are given in the following table.

Times and temperatures for the Agfachrome processes

Processing bath	Code	Tank processing				Rotary processor	
		20°C process		24°C process		24°C process	
		Time min.	Temp. °C	Time Time	Temp. °C	Time min.	Temp. °C
Processing in the dark							
Water pre-bath	—	none	none	none	none	5	24±0.2
First developer	41FD	18—20	20±0.2	13—14	24±0.2	12—13	24±0.2
First wash	—	$\frac{1}{4}$	14—20	$\frac{1}{4}$	20—24	none	none
Stop bath	41 ST	4	18—20	3	22—24	3	22—24
Continuation in the light							
Second wash	—	10	14—20	7	20—24	7	22—24
Re-exposure	of each side of film $\frac{1}{2}$ min. (600 Watt 3ft. away)						
Colour developer	41 CD	14	20±0.5	11	24±0.2	10	24±0.2
Third wash	—	20	14—20	14	20—24	14	22—24
Bleach bath	41 BL	5	18—20	4	22—24	4	22—24
Fourth wash	—	6	14—20	4	20—24	none	none
Fixing bath	41 FX	5	18—20	4	22—24	4	22—24
Final wash	—	10	14—20	7	20—24	7	22—24
Stabilising bath	formula	1	18—20	1	22—24	1	22—24

Processing data for Agfacolor Negative Films

Bath	Code	Processing time in min.	Temperature in °C	Working capacity in films per litre	Useful life of fresh solutions
1. Film Developer S	NPS I	8	20±0.2	6	6 weeks
2. Intermediate Bath[1])	NZW	4	20±0.5	6	6 weeks
3. First Wash (thorough)	—	14	14—20	—	—
4. Bleach Bath[2])	N II	6	20±0.5	6	3 months
5. Second Wash	—	6	14—20	—	—
6. Fixer	N III	6	20±1	6	3 months
7. Final Wash	—	10	14—20	—	—
8. Agepon Bath (0.5%)	—	1	20±1	10	1 week

Footnotes:
1) 3% Colour Developer must be added to the Intermediate Bath (30 ml per litre NZW).
2) The stated bleaching conditions should be adhered to exactly as the mask of masked Agfacolor Negative Film CNS is formed to the prescribed density in the Bleach Bath.

Processing of PE sheet paper

Development in dishes and drums* without replenishment

Bath	Chemicals	Processing time at			
		20°C	22.5°C	25°C	30°C
Developer	82 u. 85 CD	10'	7'30''	5'	3'
Stop bath	acetic acid (5%)	2'	2'	1–2'	1–2'
Wash	—	2'	2'	1–2'	1–2'
Bleach-fix bath	82 u. 85 BX-R + 82 u. 85 BX-S	6'	6'	5'	4'
Wash	—	6'	6'	6'	4'
Final bath	85 FI + 5 ml formalin per litre	2'	2'	2'	2'
Brief wash	—	ca. 10''	ca. 10''	ca. 10''	ca. 10''

Brief processing in drum processors

Bath	Chemicals	Processing time at 42°C	Working capacity
Prelim. wash	—	1 min.	—
Developer	82 u. 85 CD	1.75 min.	0.5 m²/l
Stop bath	acetic acid (5%)	0.5 min.	1.5 m²/l
Wash	—	0.5 min.	—
Bleach-fix bath	85 u. 86 BX	2.5 min.	1.5 m²/l
Wash	—	3 × 0.5 min.	—
Final bath	85 Fl + 5 ml formalin per litre	1 min.	1.5 m²/l

Total processing time: about 9 minutes

* A preliminary wash for 1 minute at a suitable temperature is recommended for drum processors (e.g. Unitub, Jobo Colordrum, Durst-Codrum, Simmard) before pouring in the developer.

The 42°C process has to be used with rotary processors and requires very good consistency of developer temperature and a preliminary wash adjusted to a suitable temperature.

The chemicals of Processing Kit 85 (to make 1 litre) are particularly suitable for the brief processing method.

Instructions for preparing yellow, red (magenta) and blue (cyan) colour couplers

a) Yellow colour coupler
Dissolve 1 g of the yellow coupler in about 100 cc Agfacolor film developer S and add water to this solution to make 1 litre.

b) Red colour coupler
Paste up 1 g of the red coupler in about 10 cc methyl alcohol, preferably in a test tube, and then dissolve in 2–5 cc dilute caustic soda solution (1 n or 5%), stirring with a glass rod. The dissolved red coupler should be poured into 1 litre Agfacolor film developer S, stirring well.

c) Blue colour coupler
Dissolve 1 g of the blue coupler as described under b).

Note: Agfa-Gevaert can supply the colour couplers on request (yellow/red/blue) – each packed in ten 1 g units.

Intermediate colours can also be obtained by mixing suitable colour couplers dissolved in the developer, e.g. red-orange shades by mixing developer solution containing yellow or red couplers.

The fixing process following the first wash was introduced so that it is possible to see, at an early stage in processing, whether the correct exposure has been given. If it is not necessary to know this the fixing operation can be omitted.

During washing films should not be in contact, particularly films of different colours, as the colours are not completely retained by the film and may mark off onto films of another colour.

Development can of course be adapted to various requirements both as regards the amount of coupler added and development time. The figures given should only be regarded as a guide.

Developer solutions containing couplers do not keep for long and should therefore be freshly prepared immediately before using them. It should also be noted that light fastness of the developed dyes is limited.

Processing table: Colour Coupling of Silver Images

Bath	Code	Processing times in minutes	
		Direct development	Indirect development
Agfacolor bleach bath	N II		6
Wash			10
Agfacolor film developer + colour coupler	NPS	3–6	3–6
Wash		10	10
Agfacolor bleach bath*	N II	5	5
Agfacolor fixing bath*	N III	5	5
Final wash		10	10
Agepon after-bath		1	1

* Agfacolor Bleach-Fix Bath K (PPa III K) can be used instead of Agfa color Bleach and Fixing Bath following colour development.

Bibliography

A. Books on Visual Theory and Aesthetics

Rudolf ARNHEIM, *Art and Visual Perception*, Faber & Faber, 1954
 Visual Thinking, Faber & Faber, 1970
Andre BAZIN, *What is Cinema*, Vol. I, Univ. of California Press, 1971
R. BARTHES, *Mythologies*, Jonathan Cape, 1972
Charles BIEDERMAN, *Art as the Evolution of Visual Knowledge*, Red Wing U.S.A., 1948
E. CASSIRER, *Language and Myth.*, Harpers, 1946
R. G. COLLINGWOOD, *Essays in Philosophy of Art*, Indiana University Press, 1964
Jean GIMPEL, *The Cult of Art*, Weidenfeld and Nicolson, 1968
N. GOODMAN, *Language of Art*, Oxford Univ. Press, 1969
E. H. GOMBRICH, *Art and Illusion*, Phaidon Press, 1959
GOMBRICH, HOCHBERG and BLACK, *Art, Perception and Reality*, J. Hopkins U.P., 1972
M. JEAN, *The History of Surrealism*, Weidenfeld and Nicolson, 1960
Immanuel KANT, Critique of Judgement
Paul KLEE, *On Modern Art*, Faber & Faber, 1966
 The Thinking Eye, Vol. I, Lund Humphries, London, 1962
N. KNOBLER, *The Visual Dialogue*, Holt, Reinhart, Winston, 1967
Siegfried KRACAUER, *Theory of Film*, Oxford University Press, N.Y., 1965
Hans and Shulamith KREITEL, *Psychology of the Arts,* Duke University Press, 1972
Susanne K. LANGER, *Feeling and Form,* Routledge & Kegan Paul, 1953
André MALRAUX, *Psychology of Art*, Vol. I, Museum Without Walls, Secker & Warburg, 1949
Marshall McLUHAN, *Guttenberg Galaxy*, Routledge & Kegan Paul, 1962
 Understanding Media, Sphere, 1964
G. MAST and M. COHEN, *Film Theory and Criticism*, Oxford Univ. Press, 1974
Laszlo MOHOLY-NAGY, *Vision in Motion*, Theobald Paul, 1961
G. G. MUELLER, *The Science of Art*, Rapp & Whitnig, 1967
Lewis MUMFORD, *Art and Technics*, Routledge & Kegan Paul, 1952
 Technique and Civilisation, Routledge, 1934
Sir Herbert READ, *Art and Society*, Faber & Faber, 1966
 The Meaning of Art, Faber & Faber, 1931
 The Origins of Form in Art, Thames & Hudson, 1965
 Education through Art, Faber & Faber, 1956
F. E. SPARSHOTT, *The Structure of Aesthetics*, Routledge & Kegan Paul, 1963
Patrick TREVOR-ROPER, *The World through Blunted Sight*, Thames & Hudson, 1970
Eliseo VIVAS and Murray KRIEGER, *The Problems of Aesthetics,* Holt, Reinhart & Winston, 1953
B. L. WHORF, *Language; Thought, Reality*, M.I.T., 1956
R. WOLLHEIM, *Art and its Objects*, Penguin Books, 1968

B. Books on Colour and Photographic Science

Josef ALBERS, *Interaction of Colour*, Yale Univ. Press, 1963
H. BERGER, *Agfacolor*, Girdet, W. Germany, 1967
Faber BIRREN (Ed), Munsell, *A Grammar of Color*, Van Nostrand, Reinholt, 1965
 Color – *A Survey in Words and Pictures*, University Books N.Y., 1963
 Principles of Color, Reinholt, 1968
 The Story of Colour, The Crimson Press, U.S.A., 1941
L. P. CLERC, *Photography, Theory and Practice*, Volumes I, III and VI, Focal Press, 1970
J. H. COOTE, *Colour Prints* (30th Edition), Focal Press, 1968
M. E. CHEVREUL, *The Principles of Harmony and Contrasts of Colours*, New York, 1967
J. S. FRIEDMAN, *History of Colour Photography*, Focal Press, 1968
R. W. G. HUNT, *Reproduction of Colour*, Fountain Press, 1967
Johan Wolfgang von GOETHE, *The Theory of Colours*, John Murray, 1970

Johannes ITTEN, *Art of Colour*, Reinholt Pub., N.Y., 1961
 Design and Form, Thames & Hudson, 1964
R. L. GREGORY, *Eye and Brain*, Weidenfeld and Nicolson, 1966
 The Intelligent Eye, Weidenfeld and Nicolson, 1970
J. HOCHBERG, *Perception*, Prentice-Hall, 1964
G. G. MUELLER and M. RUDOLPH, *Light and Vision*, Time & Life Books, 1969
C. W. K. MUNDLE, *Perception: Facts and Theories*, Oxford Univ. Press, 1971
C. B. NEBLETTE, *Fundamentals of Photography*, Van Nostrand Reinholt, 1970
Michael LANGFORD, *Advanced Photography*, Focal Press, 1969
O. N. ROOD, *Modern Chromatics*, Van Nostrand Reinholt, 1973
P. SLOANE, *Colour; Basic Principles*, Studio Vista, 1969
M. D. VERNON, *The Psychology of Perception*, Penguin Books, 1962
E. S. WALL, *The History of Three-Colour Photography*, Focal Press, 1970
W. D. WRIGHT, *The Rays are not Coloured*, Hilger, 1967

C. Books on Photography

Ansel ADAMS, *The Negative*, Fountain Press, 1968
Bill BRANDT, *Shadow of Light*, Bodley Head, 1966
Henri CARTIER-BRESSON, *The World of Cartier-Bresson*, Thames & Hudson, 1968
Andreas FEININGER, *The Complete Colour Photographer*, Thames and Hudson, 1969
A. GASSAM, *A Chronology of Photography*, Handbook Co., Ohio, U.S.A., 1972
Helmutt GERNSHEIM, *Creative Photography*, Faber & Faber, 1962
 A History of Photography, Thames & Hudson, 1969
R. GAREIS and T. M. SCHEERER, *Creative Colour Photography*, Fountain Press, 1969
V. KAHMEN, *Photography as Art*, Studio Vista, 1975
Dorothea LANGE, *Portfolio – Museum of Modern Art*, N.Y. Publ., 1966
N. LYONS (Edit), *Photographers on Photography*, Prentice-Hall, U.S.A., 1966
LIFE, *Library of Photography*, Color, Time & Life, 1970
Beaumont NEWHALL, *History of Photography*, Museum of Mod. Art, 1949
Aaron SCHARF, *Art and Photography*, Allan Lane, 1968
John SZARKOWSKI, *The Photographer's Eye*, Mus. of Modern Art, 1966
C. L. THOMSON, *Colour Films* (8th Ed), Focal Press, 1968
M. WHITE, *The Zone System Manual*, Fountain Press, 1969

Agfa-Gevaert Booklets

Agfacolor User Processing *(2nd Edition 1975)*
(The Negative-Positive Process)

This new version has brought this publication up-to-date with our new chemicals and materials for developing and printing. As before, the book deals with the making up of processing solutions for negative film, equipment for exposure and development, filters for subtractive colour correction, processing test prints, colour casts, enlarging and finishing prints, on our MCN and P.E. papers. There is a section on colour science which deals with colour rendering in the Agfacolor process, colour temperature and balance. A fault-finding guide and their causes on negative processing and on print processing, together with filter factor tables. An interesting and highly informative book for the serious amateur who wishes to develop and print his own colour material.
(104 pages with coloured illustrations.)

Agfachrome Professional Films—Processing

This deals with the setting up of laboratory equipment for processing Agfachrome films, i.e. small tanks, rotary processors etc., together with information on flooring, power points, light traps, plumbing and water filters. There are also full instructions and practical hints on the making up of the Agfachrome Process 41, together with diagrams and step-by-step sketches. This book also gives details of reversal processing temperature, time, agitation, re-exposure of films, replenishment of bath, sensitometry control and quality control. There is also a comprehensive section dealing with colour assessment, processing faults, and storage. A book for the serious minded amateur as well as the Professional Photographer.
(105 pages with coloured illustrations) 154E.

Agfacontour in Photographics

Agfacontour, a film which opens up new possibilities for composition in commercial art by the use of abstraction and restriction of the subject matter to lines or areas. This book deals with the photographic properties, equipment and processing of Agfacontour. The practical examples described in this book include line originals, colour graphics copying with colour filters, copying on Agfacolor paper and Agfachrome 50L film. Also included is the processing table for Agfacolor paper, Gevalith Ortho, and Agfacolor positive film. The aim of this booklet is to provide graphic artists and keen amateur photographers with full details on the principle, processing and application of Agfacontour film.
(40 pages with coloured illustrations) 151E.

ACKNOWLEDGMENTS

In the writing and production of this book many people made valuable contributions both in advising on the text and in supplying the pictures. Initially, Audrey Tapson of Agfa-Gevaert Ltd. Great Britain, whose contribution was fundamental, as without her enthusiasm and perseverance, and solving of many difficulties, this book would not have appeared. We should like, also, to thank all the photographers whose images both serve as examples of the text, but mainly make the book more beautiful to look at. In particular our thanks are due to Richard Tucker who opened for our inspection and selection his immense store of photographs. We owe our thanks also, in great measure, to Marina Henderson, who patiently unravelled the mysteries of our grammar and hidden meaning, as well as making a valiant attempt to reconcile our somewhat diverse styles.

Naturally we want to thank Agfa-Gevaert Ltd. for sponsoring the book and to Gert Koshofer and Christian Sauer of Agfa-Gevaert AG head office at Leverkusen, who also designed the book, for their sympathetic help and encouragement.

We should like to thank the following photographers for allowing us to reproduce their work.

Joseph St. Anne 89
Gordon Ferguson 134
Raimo Gareis 14, 83
Peter Gauditz 191
Barnaby Hall 94, 95
J. Heinrich 101
E. A. Hoffmann 82
Eric Hosking 119
Otto Kneule 131
Gert Koshofer 39, 90, 164, 177
David Lavender 12, 28, 30, 31, 106
Marc Lavrillier 118
Mayotte Magnus 78, 161, 178, 179
Wim Noordhoek 135, 136
Klaus Ott 163
Cressida Pemberton-Pigott 207
Hans Roth 133
Brian Salter 90
Christian Sauer 76, 120
Hans H. Siwik 209
Ewald Stark 26, 82
Anton Tschischka 101
Richard Tucker 25, 34, 75, 91, 102, 103, 117, 120, 132, 148, 162, 210
Rodney Wright Watson 78
Photographs not listed are by the authors.